Farms, Factories, and Families

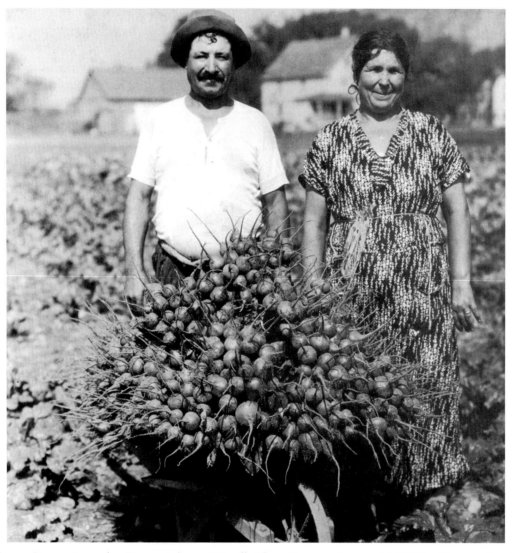

Pasquale and Anna Perrotti on the Perrotti farm, Woodbridge, Connecticut, mid-1930s. Caccavalle family archives.

Farms, Factories, and Families

Italian American Women of Connecticut

To Cathy ~ in honor of Italian American women who did it all!

Crthy V. Riccio

Anthony V. Riccio

July 7, 2014

From the heart

Foreword by

Mary Ann McDonald Carolan

excelsior editions

State University of New York Press
Albany, New York

Author photo © Robert Carlo

Published by State University of New York Press, Albany

Excelsior Editions is an imprint of State University of New York Press

For information, contact State University of New York Press, Albany, NY
www.sunypress.edu

Production by Jenn Bennett
Marketing by Fran Keneston

Library of Congress Cataloging-in-Publication Data

Riccio, Anthony V.
 Farms, factories, and families : Italian American women of Connecticut / Anthony V. Riccio.
 pages cm
 Includes bibliographical references and index.
 ISBN 978-1-4384-5231-9 (hardcover : alk. paper)
 1. Italian American women—Connecticut—History. 2. Italian American women—Connecticut—
Biography. 3. Italian American families—Connecticut—History. 4. Italian Americans—Connecticut—
History. 5. Women—Connecticut—History. 6. Connecticut—Social conditions—20th century. I. Title.
 F105.I8R53 2014
 920.00925'1—dc23
 [B] 2013029956

10 9 8 7 6 5 4 3 2 1

To the many women, Italian and non-Italian, who helped me along my way.

Contents

List of Illustrations

Foreword

With *Farms, Factories, and Families: Italian American Women of Connecticut*, Anthony Riccio has assembled a rich array of stories about the transition from the old world to the new, Italy to America. This expansive volume offers new insights into the Italian American experience as it focuses on stories about women in Connecticut. Continuing in the genre of his two earlier volumes on Boston and New Haven, Riccio offers the reader oral histories, mainly from a female perspective, with contributions from men about their grandmothers, mothers, aunts, or sisters. Markedly different from the "official" history of textbooks, this collection of conversations, now preserved in written form, gives voice to individual subjects' stories. The authenticity and detail of these inspiring and arresting accounts convey both the joy and pain of female immigrants' lives.

By concentrating on Italian American women, Riccio has broadened our understanding of an ethnic community whose history has been described mostly from a male vantage point. Social historians note that the first wave of migration from Italy to the United States in the late nineteenth and early twentieth centuries was primarily a male phenomenon. Previous studies by Italian-born Baptist minister Antonio Mangano (*Sons of Italy: A Social and Religious Study of Italians in America* [1917]) and sociologist Michael La Sorte (*La Merica: Images of Italian Greenhorn Experiences* [1985]) have centered mostly on the lives of men. Miriam Cohen, on the other hand, chronicled the working lives of Italian American females in *Workshop to Office: Two Generations of Italian American Women in New York, 1900–1950* (1993). Riccio's text adds nuance and complexity to the story of the Italian American experience by focusing on the more personal and private aspects of women's employment and domestic lives.

In the first half of the twentieth century, Italian American women, like their male counterparts, were born into a life of work. From a very young age, they were expected to assist in the house and on the farm; if necessary, they would leave school to help support

the typically large family. Nonetheless, their accounts of unending chores before and after school and grueling jobs in sweatshops and factories are often punctuated by laughter. Like their mothers and grandmothers before them, these women toiled from dawn to dusk with hardly a complaint. Riccio's fearless subjects tell matter-of-factly of cutting heads off chickens, chopping wood, hefting fifty-pound bags of vegetables onto trucks, or operating dangerous machinery on the factory floor.

Life on Connecticut's farms was far from idyllic, as these stories illustrate. From the early age of four or five, girls helped out by doing chores. Adolescents worked in the fields before school and returned there at the end of the day. Women gave birth and were back tending crops shortly afterward. Throughout the year, there was always plenty to be done, whether drying seeds in preparation for the next year's crop, planting and then protecting hot beds against the elements in the winter, harvesting fruits and vegetables, and bringing them to market or canning them for later use. These stories give the reader a new appreciation for the demanding physical work associated with farming as well as for the critical financial decisions necessary for successful land management. Those interested in issues of sustainability and organic farming today will find a wealth of information in Riccio's subjects' precise accounts of their work on the farm.

Sweatshops and factories were hardly ideal workplaces. Italian women, trained by their own mothers, were particularly well prepared to work as seamstresses in the garment industry in Connecticut. These women literally sweated through the summer in crowded, unventilated spaces and then froze in the winter in unheated workshops. Before unionization, a movement in which many Italian American women played an integral role, female workers were prohibited from what today we consider basic rights such as conversing with colleagues or attending to personal hygiene. In factories, young women operated heavy machinery, handled dangerous, toxic chemicals, and inhaled noxious fumes. They were determined to show that, contrary to the limited expectations that others had of their gender and ethnicity, they could work just as hard and long as men. Indeed, several women proudly tell of earning more than their fathers.

Whether in the city or on the farm, women often controlled the finances. Family members surrendered their paychecks to the matriarch who in turn made critical decisions about purchases, savings, and investments. We read of poor women who managed to scrimp and save enough discretionary funds (typically change or other small sums) so that the family could either purchase outright a piece of property or place a hefty down payment on a home or farm. The dream of owning property, after all, had compelled many

Italians to immigrate to America in the first place. Land ownership was not an option in southern Italy, from which the vast majority of immigrants hailed, because of the entrenched system of tenant farming.

Italian women worked these financial miracles while also cooking, cleaning, and sewing for the family. Children loved, but also feared, their mothers who did not pity themselves, nor indulge their offspring. By articulating expectations of respect for authority and duty to the family, these Italian American women inculcated in their children the values of their native Italy. In countless stories, we read of the obligations and joys associated with family responsibilities and allegiances.

Family provided the foundation for the larger community that extended outside the Italian American home, into the neighborhood. Many immigrants lived in close proximity to their *paesani*, people who hailed from the same town or city in Italy. Shared traditions, cuisine, and dialect provided solace to those who found themselves in a strange new world. In addition to establishing mutual aid societies like men did before them, Italian American women formed networks to care for sick and orphaned children, give advice about work or offer moral support. Christian values permeated the lives of Italian American women who reached out to those in need of food, shelter, or employment. Their sense of hospitality was legendary; women fed neighborhood children or extended families on a regular basis. Whereas most Italian American women enjoyed friendships within their own ethnic group, they also befriended women of other nationalities and races. Many of Riccio's subjects speak of close relationships with African Americans, stemming either from life in multiethnic neighborhoods or work in factories.

Riccio's subjects recount the concerns of the working class. Indeed, many endured daily hardships, and even hunger. Although material goods were scarce, the lives of Italian American women were quite full. In the 1960s, John Bruhn and Stewart Wolf analyzed a society similar to those that we read about in Riccio's book. This study, entitled *The Roseto Story: An Anatomy of Health* (1979), describes the behaviors and characteristics of residents of Roseto, a town in northeastern Pennsylvania whose original inhabitants came from Roseto Valfortore, a small town in the mountains of Apulia. The researchers documented a homogenous society based on traditional values (including clearly defined roles for men and women, children, parents, and grandparents) that also embraced religion (Roman Catholicism) as part of daily life. The surprisingly good health of the Rosetans, despite their smoking and drinking habits and high fat diets, resulted in a remarkably low incidence of cardiovascular disease. Bruhn and Wolf

hypothesized that these health benefits resulted from the lack of stress that Rosetans felt on account of intangibles such as community support, respect for the elderly, and general contentment with life. The benefits of such a lifestyle were so impressive that the term *Roseto Effect* was coined to describe the positive impact of social networks on health and longevity. Judging by the age and good nature of Riccio's subjects, they certainly benefited from the same supportive networks, built around family and community, which the Rosetans enjoyed.

Taken together, the stories in *Farms, Factories and Families* clearly demonstrate the importance of women's roles in the private sphere of the home or in public arenas such as factories or shops. Male and female subjects alike acknowledge that women wielded the real power in Italian American families, creating a situation that was at odds with the supposedly patriarchal society in which they lived. Riccio's celebration of Italian American women underscores an essential conundrum: although most women worked outside the home and controlled the family purse strings, while saving to purchase property or fund a child's education, the expectations of male dominance (and thus female subjugation) remained. At work, women were paid less than men for the same tasks while at home their lives were highly circumscribed. Sisters made sacrifices so that their brothers could attend college. Young women who excelled at school would leave to join the workforce in order to help pay for their male siblings' tuition. Very few women were allowed to finish high school, let alone attend college. For most of Riccio's Italian American female subjects, higher education was not an option. It would take another generation for Italian American women to be educated like their brothers.

The memories and accompanying photographs of women born in the first part of the twentieth century narrate a culture that seems disparate from contemporary America. The apparent simplicity of the time belied the enormous challenges that the United States faced, including the Depression and World War II. The frank recollections in Riccio's book give us a new appreciation of the important contributions to the foundations of modern society by Italian American women during critical times in our country's history. These accounts also allow us to trace the economic development of Connecticut, a state that still boasts the highest per capita population of Italian Americans.

The stories in *Farms, Factories, and Families: Italian American Women of Connecticut* highlight the universal challenges faced by immigrants from other eras, including our own. Immigrants then and now confront obstacles such as learning another language or assimilating to different cultural values and mores.

Perhaps the accounts recorded here can help inform the current debates on immigration and force a greater awareness of how much these immigrants, with their unschooled wisdom, have to teach us about today's realities.

This collection of stories also reminds us of the importance of recording our own histories for future generations. Although Riccio's text focuses on Italian American women, it reminds us of the myriad contributions of our female forebears no matter their ethnicity. While reading these stories, I thought of my maternal grandmother, Maud Galvin Kelly, who worked as an executive secretary at two factories in Waterbury, Scovill Manufacturing and Chase Brass and Copper, during and after World War II. There was no doubt in her mind that her only child, my mother, would attend college. She did not stop at college, however, but went on to complete her doctorate in education and enjoy a career as a college professor. My paternal grandmother, Margaret Kelly McDonald, taught school in Naugatuck after finishing college and graduate studies. She was forced to leave her position when she married my grandfather in 1929 since, as she explained to me, teaching jobs were for single women. Riccio's text has given me a new sense of appreciation for the hard work and steadfastness of the women who made my life, education, and career possible.

Farms, Factories, and Families: Italian American Women of Connecticut provides a foundation for understanding the Italian American experience in Connecticut. We realize the sacrifices that Italian American women made so that future generations might enjoy a certain standard of living and stature in the community. Their courage and determination in the face of true adversity allowed them to overcome the obstacles of poverty, discrimination, and sexism, oftentimes without the benefit of formal education or state assistance. Through a combination of tenacity and grace, these Italian American women left their mark at home and in their communities. Thanks to Anthony Riccio's book, they continue to inspire us today.

Mary Ann McDonald Carolan
Fairfield University

Preface

On a warm summer night in July 2005, I paid a visit to my ninety-one-year-old mother, Lena, at the Laurelwoods Nursing Home in East Haven, Connecticut, where she had been suffering from Parkinson's, a relentless disease that ravaged her once-strong body, slowly destroying her nervous system. The illness mercifully spared her mind, which never dimmed, and she continued weaving stories and reciting old proverbs in Italian to the end, her voice dignified in ghostly whispers as if from the spirit world. Sitting in the family room where many second and third generation Italian Americans were visiting elderly parents and grandparents that night, the scene called to mind the proverb I had heard many times in southern Italy and at home, "*Una mama campa cento figli, ma cento figli non campano una mama,* A mother can raise a hundred children, but a hundred children cannot raise one mother." Laurelwoods Nursing Home validated what the prophetic Old World voice foretold: by the time of my visit, nursing homes had forever replaced the Italian family as main caregiver to its elderly members; the Italian notion of having many children who would look after parents in old age had faded from Italian American cultural memory. Sadly, nursing homes became the final resting place for many remarkable yet unheralded Italian American women of my mother's generation who, in younger days, had worked long hours in sweatshops and gritty factories throughout Connecticut to raise and educate their families. Now, in the last stage of their lives, their children who had attained the American dream with college degrees and successful professional careers could no longer care for them.

The family room at Laurelwoods became the main gathering place where visiting families reminisced and reflected upon happier times in the lives of once-vibrant loved ones now confined to hospital beds, endless rounds of strong medications, and hours of sitting aimlessly in wheelchairs. I struck up a friendly conversation with Joe Notarino and his wife Joanna, who were visiting Joanna's father, Jerry Ruocco, a spry ninety-seven-year-old musician and

factory worker. Jerry, whose real name was Gennaro, had in the 1920s delivered bananas on dusty dirt roads from New Haven to Guilford by horse and wagon for Mr. Guglielmo, a Sicilian immigrant who had his surname changed to Williams, and was known in New Haven as "The Banana King." John wove the moving story of his mother Lucia, whose life trajectory reflected the larger scale of experiences of Italian American women of her generation: their restricted lives in southern Italy, their frightening voyages in steerage to America, their struggles against male authority at home and abuses in the workplace, their selfless dedication to family and community, their resourcefulness to nurture their children despite scarce resources, and their quiet inner strength to persevere in the face of adversity.

Lucia Acquarulo was born in 1892 to a poor family of twelve children in the picturesque fishing village of Amalfi in the southern region of Campania. The town's breathtaking beauty along the winding Amalfi coast, though blessed with long days of brilliant sunshine, pristine beaches, and warm Mediterranean breezes, obscured the poverty of its people trapped at the bottom economic rung of a feudal caste system. Amalfitani men plied the ancient trade of fishing in local waters and tended vineyards and lemon groves on terraced slopes overlooking the Mediterranean. Women learned dressmaking and made clothing, embroidered and crocheted at home for their clients; some ran small shops selling vegetables from their gardens and the daily catch their fisherman husbands provided. Others worked as *donne di servizi*, house maids, for the wealthy or in local hotels.

By the time Lucia reached school age at the turn of the century, the political reforms of the Unification (1861) had become a cruel hoax: Rather than uniting the country, the Northern-based government in Turin imposed higher taxes on the South, which funneled tax revenues to regions of the North to fund its industries, road and rail projects, and the upgrading of school systems. Many southern Italians—*pescatori*, fishermen, considered the poorest of the poor, *massari*, farmers, who could barely eke out a living on the small farms they owned, and *braccianti*, sharecroppers, who worked seasonally—recognized the hopelessness of an economy based on disproportionate land ownership of a small class of *latifondisti*, large land owners, triggering one of the greatest outsourcings of a country's labor force in history. From 1880 to 1920, the Italian government watched from the sidelines as conditions in the South worsened to the point where more than four million people, 80 percent hailing from the Mezzogiorno, voted with their feet, and emigrated to the United States, South America, Northern Europe, Northern Africa, and Australia. Immigration fever had first captured the imagination

of the region's young single and married men who left wives and families behind to venture to Connecticut in search of work. Some had been sponsored by agents of Sargent & Co. who combed through economically depressed villages like Amalfi, offering unskilled men jobs on production lines of their mammoth lock, coffin, and tool manufacturing plant on New Haven's waterfront.

Like all adolescent children of her era in southern Italy, Lucia obediently followed the time-honored rite of passage from childhood to womanhood as soon as she could hold a sewing needle in her hands, learning traditional skills reserved for girls of her *contadino*, social class. It was a girl's ability to sew, maintain a spotlessly clean home, tend gardens, and demonstrate thriftiness to feed many mouths with scarce resources that would guarantee marriage to a suitable husband. Despite Lucia's well-honed domestic skills and maturity beyond her years, Luisa and Pasquale Acquarulo foresaw a bleak future for their thirteen-year-old daughter in Amalfi, recognizing her only hope for deliverance pointed in the direction of America. In their eyes, the promise of America would make the pain of permanent separation worthwhile. After all, they reasoned, their oldest daughter Catarina had emigrated a few years earlier and had written encouraging letters about her new life on Franklin Street in the heart of New Haven's industrial district. Young Lucia would

soon take part in the flight of adolescent girls who set off for America joining legions of married women. Husbands had emigrated, saved enough money, and sent for their wives and children. The new face of the mass exodus now included many young girls like Lucia who were sent to America in the company of trusted male chaperones.

Lucia became, in effect, one of countless indentured female servants in the service of older sisters and brothers in the New World who needed help raising families. Other young girls left Italy under even more difficult circumstances; some were ostracized to America in the name of family honor, their punishment for becoming too friendly with boys whose family did not meet with a father's approval. Others, like my grandmother, Cesarina Russo, left at sixteen in defiance of male authority: When her father forbade her marriage to the young man she loved, she packed her suitcase and sailed to America to live with her brother in New Haven, Connecticut. Like many peasant women who had experienced the grinding poverty of southern Italy, my grandmother harbored searing memories of her homeland, and never returned.

With the heartbreaking knowledge of never seeing her daughter again, Luisa summoned her sisters in the next town of Atrani, expert weavers who owned a prized loom, to make pillows, sheets, tablecloths, and blankets. The night before Lucia's departure for

the bay of Naples in 1905, her aunts presented their young niece with the all-important *corredo,* dowry, for a future wedding in the New World they would never attend. Lucia's towels, carefully folded so that the fancy crocheted letter "A" for Acquarulo faced outward, were the last items packed in her wooden steamer trunk for the long journey across the Atlantic.

Arriving by horse and wagon at the port of Naples amidst the hustle and confusion of roving ticket agents, food vendors, baggage carriers, seamen, hucksters, thieves, and merchants selling pictures of patron saints, Pasquale helped his bewildered daughter make her way through the crowd to the ship's gangplank with cousin Adamo Acquarulo, her chaperone for the journey. With shrill ship's whistles and bellowing horns signaling departure, the *Principe di Piemonte* creaked and groaned, slowly pulling away from the dock. Lucia stood by the deck railing and recognized Pasquale, a tall man with broad shoulders, standing out amid the crowd of animated well-wishers. Waving to her father as the vessel turned toward open waters, Pasquale smiled and whistled back to her until he slowly melted into the gesturing throng, disappearing from view.

For thirty days at sea aboard the slow-moving, ill-equipped, and overcrowded boat, Lucia, who had never ventured beyond the confines of her small town, experienced the nightmarish specter of life in steerage. Drinking water was scarce, and living quarters were woefully cramped with passengers, many of them sick who infected others in such close quarters. Lack of running water for personal hygiene or washing clothes made life miserable even for those who were not ill. Seemingly eternal days of rough seas and dank air in the belly of the ship made others seasick with no place to vomit. Women stood by helplessly as they watched weakened children perish from disease, often burying little sons and daughters at sea. One morning Lucia woke up to the cries of men shouting from the deck, "*Ó latte e vacca pe criaturi!* Cow's milk for the babies!" which they ladled out in small tin cups for desperate women no longer able to breastfeed their famished children.

Thirty days into the journey, on a cloudless morning in November, the constant rumbling of the ship's engines suddenly ceased and excited passengers crying "*Terra! Terra!*" scrambled to the deck where Adamo and Lucia saw the pencil-thin outline of the Statue of Liberty appear in the distance. From Ellis Island, the two cousins boarded the Richard Peck to New Haven harbor and docked at pier 25 in the shadow of the colossal Sargent & Co. factory building where many newly arrived Amalfitani were busy at work. There to meet them with open arms were Catarina and her five children, who walked Lucia to their drafty cold water flat in a row of tenement houses on Franklin Street where she would begin her new life.

Lucia joined the first waves of Italian immigrants entering the urban landscape of a booming industrialized American city whose host culture viewed Southern Italian ways and lifestyle with suspicion. Her Wooster Square neighborhood mirrored the formation of many Little Italies in Connecticut's cities and towns—Middletown's East Side, Pawcatuck's Downerville, Hartford's Front Street, Stamford's West End, Waterbury's North End, Bridgeport's The Hollow, and Naugatuck's Little Italy—self-contained communities where Italian traditions were kept alive, provincial dialects were the official spoken language, and people with Lucia's classic Mediterranean features of long black hair, dark eyes, and olive complexion were common sights.

Lucia settled into her new life in New Haven caring for her little cousins while Catarina and her husband worked the day shift at L. Candee Company, making rubber boots. The growing number of Italian immigrant women entering the workforce became part of an industrialized women's movement that altered Connecticut's nativist attitude toward foreigners. The strong work ethic and high productivity of Italian women caught the attention of L. Candee Company's foremen who wisely overlooked popular prejudices of the day and offered them round-the-clock working hours. Two decades later during the Depression, Italian American working women in Connecticut's industries joined their male counterparts to organize into unions with binding contracts that forever changed workplace rules, gaining fair wages, shortened work hours, and better working conditions for future generations.

Learning new American ways from her older sister, Lucia, who never had seen the inside of a factory floor in the old country, followed the path of assimilation with more than a thousand fellow immigrants in the fast-paced world of bosses and clocks at L. Candee Company, cutting rubber insoles for boots. By age twenty, with her dowry in place and some money set aside, it was time to marry. Many Italians in Connecticut continued the old world custom of *amasciata*, matchmaking, where respected family figures chose spouses for single men and women. Lucia's sister selected her husband, a young man who lived on the next street in the neighborhood. On a Sunday afternoon in April 1913, under the watchful eye of family and friends at his home, Lucia was introduced to her future husband, Peter Notarino, a fellow worker at the L. Candee Company. Peter had been abandoned by his mother on the steps of Saint Andrew's Cathedral in Amalfi and left to the care of the nuns who gave him the surname Notarino. Growing up in a monastery, he emigrated to New Haven thanks to Concetta and Raffaele Barbara who had adopted him. Orphaned children in Italy and in Connecticut's Italian American communities were

considered spiritually adopted and protected by the Virgin Mary; they carried the special title of *Figli d'a Madonna*, "Children of the Virgin Mary."

After their marriage in 1913, Lucia and Peter moved to 65 Hamilton Street in the Wooster Square community, an Italian American enclave teeming with large families crammed into beehive tenement houses, streets strung with newly established family-run businesses, mutual benefit societies where newly arrived immigrants found help, and pulsating street life with local neighborhood legends known as "Zi' Prevete," "Guapitello," "Chi Da Morte," "Jimmy Moosh," and "Sammy the Gee." During Prohibition, Lucia befriended one such character, her next door neighbor, "Antonette A Moonashine," nicknamed for being a bootlegger who supplemented her miserable wages at the factory by making bathtub gin. Whenever Lucia noticed government agents suddenly descending on their street to raid homes, she yelled across the alleyway to Antonette in a secret code of Italian dialect, alerting her to pull the plug.

In the 1920s, Italian working men often found themselves unemployed because of slowdowns, disruptive strikes for better working conditions, and permanent factory shutdowns. Before the advent of unemployment and hospitalization benefits, economic survival of families often fell upon women who entered the workforce, joining men on the produc-

tion lines. By 1922, with four children, Peter contracted tuberculosis and was forced to leave his job at Seamless Rubber. Lucia did what most tough-minded women of her era did to provide for struggling families: hearing that Sargent & Co. was paying time and one-third after forty-eight hours of work, she took the strenuous and often hazardous job as a presser, stamping out steel parts for Sargent locks. It had only been a few months earlier when her cousin, known as "O-Babe-Babe" Barbara, lost three fingers on the same pressing machine, and opted to receive a one-time settlement of fifteen hundred dollars, leaving the company to work as a taxi driver.

With her husband out of work in an age before day care, Lucia had the added responsibility of raising her four young children. Staying attentive to the dangers of the pressing machine while always meeting daily production quotas, Lucia's thoughts remained steadfastly with her children. Her peace of mind rested on the view from the Pressing Department's street-level window that offered a view of Waterside Park and the scene of her four children playing on the seesaw and merry-go-round. There in the distance she could check on nine-year-old son Anthony watching over seven-year-old Frank, five-year-old Ralph, and three-year-old Concetta until the high-pitched blast of the factory whistle signaled the end of her shift, and the family walked home to their ten dol-

lars a month apartment on nearby Collis Street. From their kitchen window on the second floor the children could look down on Waterside Park, where groups of immigrant men played animated games of bocce until sundown and picked *cicorea*, dandelions, along the edges of the playing field for *insalata*, salad, for the evening's supper table.

By the 1940s, the Acquarulo family had grown to twelve children. To make ends meet, the youngest boys worked on busy street corners shining shoes and selling newspapers. As they grew into manhood, they graduated to full-time jobs at Seamless Rubber Company and New Haven Quilt & Pad Company; the girls toiled on the production lines of New Haven Clock Company and Winchester Repeating Arms. Like many women who managed the family economy, Lucia wisely put aside some of the money her children contributed with their hard-earned weekly paychecks.

In December 1948, Lucia and the Notarino family realized the American dream of home ownership. Dressed in her finest handmade outfit for the house closing, her silver hair braided in the traditional Italian *tuppo*, a bun on top of her head, the diminutive Lucia confidently reached into her dress, unsnapped the clasp of her well-worn, black leather *sachetta*, palm-sized purse, carefully unfolded thirty hundred dollar bills into a neat stack, and triumphantly handed it to the lawyer as the down payment for the deed

to the family's new home on 201 Hamilton Street in New Haven's Wooster Square neighborhood. Known by everyone as a quiet woman who kept to herself, Lucia swelled with pride knowing the Notarino family finally had a roof over their head, no longer obligated to monthly rents, shabby apartments, and the whims of landlords. The poor immigrant mother who had once hocked her wedding ring to feed her large family during the Depression had become a property owner with her own financing, an unimaginable accomplishment for any woman of her class in Italy.

On Sunday afternoons, with her children and grandchildren gathered around the dinner table, the conversation often shifted to her life in Italy. From postcards and photographs of Amalfi the family had seen and stories they had heard about its spectacular coastline, Lucia was often asked why she left such a beautiful place as a young girl. Lucia, a picture of Italian motherliness and common sense who never learned "American," as she called it, smiled and answered in her own lingo of Neapolitan dialect, working-class patois of New Havenese, and English, "Ma why I gotta go back a Amalfi fo? *Nun ci sta niénte.* There's a nothing pe me ova there."

Like Lucia's inquisitive children, Italian Americans yearn to connect with their past. Some with enough affluence rent farmhouses in Tuscany or condominiums on the Amalfi coast to bring them closer to

their Italian roots. Others make pilgrimages to Italian neighborhoods such as Boston's North End, where upscale Italian restaurants and boutiques have long replaced old mom and pop stores, and tenement buildings that once housed large immigrant families have been converted into luxury condominiums for professionals. Some patronize restaurants where Italian American gangster movies are showcased on wide screens; others tune in to *Jersey Shore* or *The Sopranos*, whose dim-witted, promiscuous young women and violent thugs have become iconic representatives of Italian Americans. Italian American culture is largely unwritten yet transmitted through the spoken word, an ancient oral tradition passed down through the generations by storytelling. The last vestiges of our cultural history reside in the hard-earned testimonies of many peasant women like Lucia who escaped rural poverty in Italy, crossed the Atlantic in steerage, and found urban poverty in America's working class during the 1920s and the Depression. Few women of Lucia's generation are left to pass on their stories; with the passage of time, just as the figure of Lucia's father whistling from the dock slowly disappeared from sight, we gradually lose our history. As Italian Americans, we not only stand on the shoulders of our fathers and grandfathers, but on the virtues of dedicated women who taught values at home by example: righteous behavior, the importance of family honor, empathy for the less fortunate, respect for elders, and selfless devotion to family. Many sacrificed aspirations for careers as nurses, school teachers, and bookkeepers, leaving school at fourteen to toil in terrible sweatshops and factories for the economic well-being of their families. Some helped pay for higher education reserved for their brothers who became prominent doctors and lawyers. The stories told by Italian American women narrators in this book finally reveal their behind the scenes roles as the glue that held our families and culture together.

For many third and fourth generation Italian Americans who have lost contact with their roots, whose parents and grandparents have passed away without documentation, and slowly fade from memory, the refrain is always "Oh how I wish I asked my mother that question," or, "I don't know where my grandmother came from in Italy—isn't that sad?" Reconnecting to our cultural history—learning who we are and where we came from—often comes when we turn off our televisions and ask our mothers and grandmothers simple questions about their life experiences. Ask them to tell their stories, and listen carefully, before it is too late. Indeed, I was fortunate to find these elderly Italian American women storytellers throughout the state of Connecticut—and some elderly men who spoke about their mothers, grandmothers, wives, and sisters—who graciously shared

their life experiences with me, and in doing so, created a lasting cultural mosaic we can be proud to share as Italian Americans. This book is dedicated to the many women I was fortunate enough to visit and interview in nursing homes, senior centers, and in their homes whose nearly forgotten stories will now come to light, enriching us, and reconnecting us to our true cultural roots.

Acknowledgments

After *The Italian American Experience in New Haven* was published in 2006, I realized there was an unexplored story about Italian Americans that had to come to light. After recording hundreds of Italian American storytellers in New Haven and Boston, I recognized that Italian American women, with quiet inner strength, had always been the glue that held Italian families together. For six years, I traveled throughout the state of Connecticut recording the life experiences of elderly Italian American women. I am forever indebted to the many women who welcomed me into their homes and shared their compelling stories, some in their native southern dialects of Italian, and in English. They also granted me access to their autobiographies, letters, poetry, journals, old photographs of their villages in Italy, and slice of life images during their lifetimes in Connecticut. Along the way I interviewed Italian American men who described the profound influence their mothers, grandmothers, sisters, and wives had on their lives. I found many Italian American men who still held on to the memory of their deceased mothers and grandmothers as stars to guide them.

This book would have not been possible without the goodwill and generosity of the following Italian Americans who granted me permission to record their life stories: Sister Cecilia Adorni, Florence Adriani, Annunziata Adriani, Natalie Aiello Adamzyk, Mary Altieri, Anna Leone Aiello, Nick Aiello, Louise Aiello, Anna Grazio Amatruda, Theresa Argento, Cecilia Ferrara Asor, Diana Proto Avino, Angelina Baldino, Norma Barbieri, Linda Barone, Rosemarie Mulé Berry, Josephine Landini Brandini, Kathy Bozzi, Josephine Parlato Bonfiglio, Pat Damiata Bourne, Fannie Buonome, Anna Perrotti Caccavalle, Deb Caccavalle, Andrew Calabrese Sr., Gene Calzetta, Frances Calzetta, Joe Carbone, Mary Carbone, Louis Ceruzzi, Tony Chipello, Theresa Cipriano, Marie Pizzanello Coburn, Andrew Consiglio,Filomena Consiglio, Lena Corvo, Joanne Cotugno, Pietro Covello, Joseph Criscuolo, Marie Criscuolo, Maria Cusano, Catherine Cuccuru.

Also: Anthony D'Addetto, Lena D'Amato, Alphonse D'Angelo, Rosalie DaSilva, Rose D'Auria, Antonette DeAngelo, Frank DeAngelo, Agnes Luciani DeFilippo, Luisa DeLauro, Rosa DeLauro, Julia Angelina DeLeone, Mae Dell'Amura, Marion Sperandeo DeNegre, Mary DeNittis, Theresa Grazio Diamonte, Sister Bridget Esposito, Mary Perrotti D'Eugenio, Florence DeFeo, Laura DeGregorio, Gaetana DeLaura, Anna Dickerson, Rose DiGirolamo, Josephine DiGiuseppe, Norine D'Onofrio Natalina DiPietro, Laura Fulin Edelberg, Anthony Esposito, Anna Fasano, Marilyn Faulise, Celestina Fauliso, Epiphany Faulise, Josephine Faulise, Anna DeGennaro Febbraio, Carlotta Fernicola, Joseph Fiore Jr., Mary Florenzano, Anna Ruffino Foreman, Rosalie Forni, Lucia Falbo Fulin, Florence Fusco, Trofemina Gagliardi, Sal Garibaldi, Theresa Grego, Francesca Grillo, Elizabeth Barbiero Hepp, Joanna Becce Clapps Herman, Nick Iannone, Jane Iannone, Therese Incarnato, Teresa Laudano, Natalie Leone Linteau, Grace Loglisci, Sonny Luciani, Angelina Gambardella Maluchnik, Lorraine Mangione, Ralph Marcarelli, Christina Marino, Diane Mastromarino, Pat Mastromarino, Lucille Muro Marturano, Antoinette Tommasi Mazzotta, Michael Mele, Edward Morrone, Lucia Mulé, Nick Mulé.

Also: Giuseppina Naclerio, Joanne Notarino, Joseph Notarino, Marietta Scalzo Notaro, Rose Nuzzo, Rose Pagano Onofrio, Antonia Becce Padula, Betty Panza, Jennie Panza, Vincenza Parise, Ferdinand Parlato, Angie Paul, Betty Paul, Pat Perrotti, Mary Pesce, Betty Petruzelo, Norine Polio, Caroline Pompano, Grace Pompano, Ben Possidente, Catherine Possidente, Rosalind Proto, Darlene Cipriano Ragozzine, Concettina Rapuano, Eraclito Rapuano, Luigi Rapuano, Filomena Ruffino, Tina Ruffino. Erminia Ruggerio, Gloria Ruggerio, Mickey Ruggerio, Rose Ruggerio, Mary Ruggiero, Rita Ruggiero, Gennaro Ruocco, Loretta Vitale Saks, Anna Sagnella, Anna Sammataro, Jerry Santore, Marie Santore, Louise Bombace Savo, Maria Sciarini, Barbara Scioscia Reed, Betty Chessa Scioscia, Mary Scrivani, Vittoria Becce Semprini, Charlene Senical, Grace Serio, Rose Serio, Marie Serra, Althea Gabriel Simmons, Jean Simone, Susan Sirico, Yolanda Smeriglio, Vittoria Del Monaco Suppa, Adele Ursone, Julia Ursone, Michelina Venditti, Georgina Vitale, Theresa Vitale, and Antoinette Zuccarelli.

I am very grateful to many others who contributed to this book. I wish to thank Bridget Mariano of the Naugatuck Historical Society for sharing oral history tapes and archival photographs of Italian American women of Naugatuck; their stories added richness to the history of that part of the state which would have been overlooked. I also owe a great deal of gratitude to Jennifer Noll who graciously shared her oral history tapes from the research she conducted during the

1990s with Italian American women garment workers in New Haven. Her recordings added important details to the working lives of Italian American women that would have been lost to the slipstream of history. I want to thank my friend Professor Stephen Lassonde of Harvard University for his gracious donation of oral history tapes he conducted of Italian American women. I also wish to thank my friend and colleague at Yale University, Christopher Killheffer, for his expert editing and valuable suggestions for the essays. I owe a great deal of gratitude to my friend Tom Ouimet for sharing his technical wizardry, bringing out the best in the photographs, and for keeping me on an even keel during the many twists and turns on the long road to publication. I also wish to extend thanks to another colleague and friend, Todd Gilman, Librarian for Literature in English at Yale University, for his editing of the oral histories.

Because of the many contributions of these Italian American women who graciously shared their life experiences with me, I sincerely believe this book belongs more to them than me. It is my hope that I given their legacies the respect and honor they deserve.

The Historical Roots of Southern Italian Women

The cultural heredity of the Italian American storytellers in this book runs deep into the ancient soil of Calabria, Campania, Basilicata, Puglia, Sicily, and Sardinia. Southern Italian women of the lower classes are treated as background figures in history, silent partners who toiled and struggled through the ages alongside men. While foreign armies conquered their territory, women stood on the sidelines of an occupied land whose pivotal position in the Mediterranean divided East from West. The island of Sicily, less than one hundred miles from Northern Africa and two miles from the mainland, made southern Italy a natural stepping stone for civilizations migrating north to Europe.

Don Fabrizio, the Sicilian noble portrayed in Tomaso di Lampedusa's nineteenth-century novel *The Leopard*, somberly described the indelible marks the long history of foreign invasions left on the people of southern Italy: "For over twenty-five centuries, we've been bearing the weight of superb and heterogeneous civilizations, all from outside, none made by ourselves, none that we could call our own."[1] Don Fabrizio's broad sweep of southern Italy's history began with Greek colonists, followed by Roman administrators, Lombard gastalds, Byzantine governors, Muslim imams, Turkish crusaders, French barons, and Spanish viceroys who conquered and divided the South, leaving their cultural influences on Southern customs, cuisine, architecture, and language.

Southern Italy's first occupiers were ambitious men from Greece known as *ekistes*, who led expeditions to subjugate native tribes, establishing colonies along the perimeters of its eastern and western coastlines, and around the island of Sicily.[2] Armed with superior military and city-building skills, the Greeks laid the foundation of a social hierarchy where a small landowning class of aristocrats held the reins of political and economic power. Greek colonizers named their land "Magna Grecia," or Greater Greece, and sometimes incorporated native people into their newly founded cities, or imposed harsher methods, taking women into their homes as slaves.[3] In the seventh

century BC, Greek settlers of Selinunte on Sicily's south coast were granted permission to mix their foreign blood with native Emylian women of nearby Segesta in formal marriage agreements known as *epigamia*.[4] While we know that the lives of indigenous tribes—the Sicels, Sicanians, and Elymians of Sicily, the Lapigi of Puglia, the Oenotrians of Basilicata and Calabria, the Balari, Corsi, Sardi, and Iloai of Sardinia, and the Samnites of Campania, were centered on shepherding and agriculture, no historical accounts that may have shed more light on the lives of women have survived.

Archeological evidence reveals that native tribes in Sicily were quickly incorporated into Greek settlements from their centers of habitation through war or assimilation, and institutions and customs of Greek colonizers were adopted.[5] Houses where rooms were partitioned into male and female spaces unearthed from the eighth and seventh centuries at Erea (Campania), Megara Iblea (Sicily), Metaponto (Basilicata), Syracuse (Sicily), and the island of Ischia off the coast of Naples provide clues about the roles of ancient Southern women as housekeepers.[6] Daily life for the women of Magna Grecia was consumed with the preparation and storage of food around a *focolare*, hearth in a central room. For untold generations, ingenious women of the lower classes nurtured and fed large families of agricultural workers with limited resources. From time-honored recipes passed down from mother to daughter, women created the cuisine of the humble Southern peasant known in modern times as *le cucine dei poveri*, the kitchens of the poor. Though historically overlooked as guardians against the constant threat of hunger, the Italian mothers' ability to feed families often meant the difference between starvation and survival. Incorporating foods introduced by Lombard, Arabic, and Byzantine invaders, Campanian women created simple yet nutritious dishes they transported to American tables, which in recent times have attained the status of haute cuisine in upscale Italian restaurants. In America, the Italian woman's domain became known as "domus," the center of family activity where members not only found sustenance from mother's home cooked meals, but also learned moral principles grounded in the Southern Italian code of righteous behavior.[7]

Homes unearthed in southern Italy shed light on another important aspect of women's lives in Magna Grecia. Special rooms designated for spinning and weaving fabric acted as female workshops in which sewing skills were passed to the next generation. At Paestum in 1934, archeologists discovered the original temple dedicated to the female cult of the goddess Hera in the sixth century BC that incorporated a separate space within the building reserved for *vergini tessitrici*, virgin weavers.

Millennia later, in 1897, Salvatore Salomone-Marino, a noted Sicilian physician, observed the continuation of the ancient sewing tradition in a study of Sicilian peasants. He found a space in many homes reserved for the loom where "the housewife or daughters sit alternately and produce the *rigatino* (striped cloth) for their own clothing, or the *faustian* for the men, or more frequently the *tela,* homespun linen for ordinary sheets and skirts and underclothing for daily use, or that fine linen called *alessandrina,* which compares to the finest in Holland today."[8] In the twentieth century, Italian women transported centuries-old sewing skills to Connecticut's burgeoning textile industry as expert dressmakers and seamstresses. In 1938, Phyllis H. Williams wrote *Southern Folkways,* a handbook for social workers that surveyed the cultural traits of the large population of New Haven's Southern Italians. She observed that Italian women had descended from a culture where "young girls learned sewing and, in country places, weaving and spinning even before their small hands could properly handle the necessary tools."[9] Williams's book was written during the Depression when many men had lost their jobs, creating a desperate need for alternative sources of income for struggling immigrant families. Italian women and their American-born children put their sewing skills to use, finding jobs in Connecticut's needle trades. Because of economic need at home, many girls left school at fourteen, sacrificing careers as nurses, bookkeepers, and schoolteachers to work in sweatshops.

Women in southern Italy's patriarchal society were subject to the will of their fathers and husbands, and grew up under strict parental supervision that guaranteed an unmarried woman's chastity in the name of protecting family honor. The women of Magna Grecia had their mates chosen by parents, and ceded their rights to their dowry at marriage, but were given the responsibility to raise children and run the household.[10] Senofante, a fourth-century BC Greek historian whose writings were known in Magna Grecia, recorded in *Economics* the statement of a married man who described the division of responsibility between husbands and wives in the Greek world, "I'm never at home at all because my wife is very capable of running all the business of the household."[11]

Magna Grecia produced an important woman Pythagorean philosopher whose works survive. In the fourth century BC, Aesara of Lucania (Basilicata) wrote *Book on Human Nature,* a treatise that reflected the ideal role of women in southern Italy. Aesara envisioned women's work as focused not only on raising children based on the moral principle of "becoming just, harmonious individuals," but also on "how a Pythagorean woman analyzed the ways in which the principle of *armonia* could be applied in the living of

everyday life."[12] Pythagorean philosophers in southern Italy believed a man's responsibility was to create harmony and justice in the city while women applied the same principles to their children in the home. Men received recognition in the outside world as workers, hunters, and warriors; women's sphere of influence was the home where they found self-expression in household arts. Men built coliseums and temples; women's daily work was invisible. Men created historical events and wrote histories; women told stories and kept family history alive. This dichotomy is reflected in the burial customs of the ancient Samnites who marked the graves of men with spears rather than inscriptions, women with their well-worn spindles.[13]

Women in Southern society were valued not only for their homemaking skills, but also their adherence to a strict code of morality based on familial loyalty, deference to male authority, and the ability to work tirelessly from dawn to dusk. These qualities formed the basis of the ethos southern Italian women transported to Connecticut and transmitted to their American-born children. Connecticut's second and third generation Italian American women eventually found emancipation from the closed society of limited opportunity their mothers and grandmothers experienced in Italy. In the 1920s and '30s, when husbands faced work reductions, seasonal employment, and factory closings, women entered the workforce as breadwinners, a change that began to alter the dynamics of male authority in marriage. Many found empowerment in the union movement as industrial feminists. Some with prior experience in Italy became entrepreneurs and started their own businesses. Others lent money from their corner grocery stores, offering their customers loans at reasonable rates. Still others recognized the financial opportunities of owning property and invested in real estate, owning multiple apartment buildings with rented street-level storefronts.

In 1928, as Italian immigrant women were helping families climb out of poverty and into Connecticut's working class, the anthropologist Charlotte Gower traveled to Milocca in rural southwest Sicily. Living among the townspeople, she observed women still living in a society where men enjoyed a wider range of possibilities of self-expression as "natural protectors" and "masters" of women.[14] By the turn of the twentieth century, social conditions for wives and daughters of *viddani*, tenant farmers in Sicily, and *mezzadri*, sharecroppers in Campania, had changed little since the eighth century BC. Having lived by a script they had not written, poor women in southern Italy faced three possible futures: arranged marriages established through chaperoned courtships, life in the convent, or a life of maidenhood dedicated to the care of family members.

In 1898, the Sicilian sociologist Alfredo Niceforo observed the social status of women in Sicilian society, noting men still practiced what he called "Arabic"

oppression of women.[15] In *How Fascism Ruled Women*, Victoria DeGrazia referenced the lingering traces of Arabic culture at the turn of the twentieth century, referring to the "Islamicized" society of the island's west where "women lived in cloistered domesticity."[16] In stark contrast to northern Italy, which absorbed Celtic and Germanic influences through the ages, the South remained Greek and Arabic in origin, part of a larger Mediterranean culture whose imprints lasted into the late nineteenth century. Greek temples in southern Italy stand in majestic testimony not only to the cultural brilliance of Magna Grecia, which once rivaled Athens, but also as holy shrines to venerate the supernatural powers of goddesses to protect and nurture. Millennia after the temple at Paestum was dedicated to Hera, the Greek goddess of childbirth and marriage, her image reappeared in the Christian iconography of the Madonna of Granato (Saint Mary of the Pomegranate) who holds Hera's pomegranate, the ancient symbol of fertility, and bears her classical facial expression of quiet nobility.[17] In 1935, the Turinese writer Cesare Pavese was exiled to Brancoleone in Calabria for his anti-Fascist politics. There he observed women who still spoke with Hellenic cadence and a people whose hospitality and kindness to strangers he attributed to *qui, una volta la civilta Greca* (here there was once the civilization of the Greeks).[18] Sicilian women carried the name of their ancestral town to Middletown, which reflected their Arabic roots: Melilli was originally "Malillah," named after the North African tribe of conquering Berbers who lived there from the ninth to eleventh century when Arabic culture in Sicily had reached its zenith, with Palermo as the crown jewel of the Islamic world.[19] In the great migration, when women uprooted themselves to follow husbands to the New World, they severed deep familial ties to ancestral villages, yet they carried a rich cultural memory of southern Italy that reached back millennia. Once in the new world, Southern Italian women lived by the dictates of their ancient culture and transmitted those values to their American-born children.

"The Horse Stopped"

Antoinette Tommasi Mazzotta said her father Tommasi's wine was well known in the area of Pachino in Sicily. People often recited this rhyme: "*Ó vino di Pachino/È sempre fino*, The wine of Pachino is always fine."

My parents were newlyweds in November nineteen-oh-eight. They were married in Melilli, Sicily, and then they went to their home in Pachino. It was their first Christmas and they were going back to Melilli to celebrate the holiday with her family. There were no cars in those days and they were traveling by

horse and buggy. The horse stopped. And he wouldn't move. They were hitting him and he wouldn't move. They stayed there for a while. My mother kept saying, "But why isn't he going?" So they just had to wait until he felt like moving. When they got to Melilli, the people were saying, *"C'é stato un terramoto a Messina! È distrutto completamente!* There was the earthquake in Messina and the city is completely destroyed!" It was the earthquake of nineteen-oh-eight in Messina. Thousands and thousands of people were killed; they had to build a new Messina because the whole city was destroyed. That's when that horse felt the ground shaking under his feet, and he wouldn't budge. They couldn't feel it. They didn't know why he stopped.

"The Dowry"

During our interview, ninety-three-year-old Francesca Grillo paused for a moment to recall one of her mother's sayings, *"Non ti sgomentare/Che Dio vede e pervade,* Don't despair/God sees and provides." At times, she spoke in her Pugliese dialect.

In Italy in the nineteen twenties, when my aunt was ready to get married, like here we have showers, over there the bride's family and the groom's family got together. And they'd say, "What are you going to give your daughter?" And the family of the bride would say, "We'll give her six sheets, pillowcases, tablecloths, towels, handkerchiefs." Then they asked the husband's side, "And what are you going to give?" "Well, we're going to give him this piece of land, that piece of land," whatever they had. But the bride had to have linens for the house. So I remember when my aunt was getting married. They had a wall in the house or they put it on a table, what they promised to give when they got married. That was called *u currète,* the dowry.

The families had a special somebody [*u aggestàtore*] to make sure everything was legal. So now they have all this stuff on the wall, and everybody gets together because it's a small town and everybody knows everybody and they want to know what's going on, so they all gather. So this man or woman the families picked to make sure everything goes well says, *"Va bene, cominciamo,* Okay, let's begin." And with a pencil and paper, *"Sei lenzuoli,* six sheets," and they count one, two, three, four, five, six, *"Eh, va bene,* that's good." Then six towels, *"Uno, due, tre, quattro, cinque e sei, eh, va bene."* So now there's only five tablecloths, one, two three, four, five, *va*

bene, okay. If the paper said you were giving six tablecloths, you counted one, two, three, four, five, and then they go, "Five? *Alda volde!* Let's count that again! [laughing] *Uno, due, tre, quattro, cinque, e basta!* One, two, three, four, five, and that's it, no more! You're trying to cheat, where's the sixth one? *Spiegami che succèsso,* Explain to me what happened here." And so one looked at the other one and said, "Eh." And the other one looked at the other one and said, "Eh." That was it, "*Va bene, il matrimonio non essiste piu!* All right, the wedding is off!" There were a lot of marriages that didn't take place, and they'd stop people from getting married in Terlizzi [Puglia] even for a handkerchief sometimes.

"The Dream of Cosimo and Damiano"

Francesca Grillo recalled celebrating Christmas in nearby Ruvo in Puglia, with a Nativity scene cast with real people and animals. She said, "It made you feel warm and accepted in God's way."

I was born in nineteen seventeen in Terlizzi, in Puglia. When I was ten years old I had a cold, my father called the doctor, and he came and gave me medicine. After about a week, I was getting worse. I lost my voice, and I was losing my hair and had sores all over my body. I was getting high fevers. So my father went to the city to call the specialist. He came and my father told him, "The regular doctor says she's gonna die. I want a consultation." The specialist said, "Where's that jackass doctor? She hasn't got a cold, she's got typhoid!" He told the family to put me in isolation because it was very catchy.

My uncle Joe, he was the only one that had the nerve whenever there was a bubble on my body, and the skin broke from the medicine I was taking, he pressed it to get all the poison out. It went up from my body to my eyes. So the specialist said to call my father. "She's gonna die anyway, so let's try something. Go get me a keg of ice, put it next to her bed and get some hot water and put it in a tub. Take her, put her in hot water, then take her out of the hot water and put her on the ice. If it's meant for her to live, she'll live, but I wouldn't . . ." So in the meantime while they were saying I was going to die and that it was just a matter of time, they called the carpenter to take the measurements for the coffin. People used to come by and ask, "Did she die yet?" The doctor came by too; "Is she gone yet?" They did all this in the afternoon and my father used to lie down on the floor in

the *salotto*, the living room next to me, so he could help me. My mother was with the kids on the other side of the house because they didn't want to come near me. So my uncle would come and take care of me.

So all of a sudden one day when Zi' Peppin, Uncle Joe, came and it [the infection] started to go up on my body, he told my father, "I see red marks on her face and pretty soon it's gonna go up to her and it will be goodbye." That very night they thought I was going to die, and they were waiting for me to die. That night I had a dream about *I Santi Medici*, The Holy Doctors, and we always went to our church named for Cosimo and Damiano. I dreamt of these saints, Cosimo and Damiano, who were doctors. I felt it, one on one side and one on the other side of me. And they rubbed my face with their hands. One had a pen with long feathers. And one said to the other, "Put her name in the book." And they wrote my name in this book. And up to that time I couldn't talk and I yelled, "Ma!" And my mother and father came running in the room because it was the first time I talked. I called my mother and right away she ran in, and my father called my mother, "Marietta! Marietta! She's okay! She's gonna be all right."

The next morning my uncle came to take care of my things and he said to my father, "My God, what happened to her face?" because he was expecting to press the sores on my face. I started to get better. So my father said, "*Un miracolo, un miracolo!* It's a miracle!" After that I don't know what my father promised them every year, what he gave or what he did. He was a fanatical Catholic.

"We Were Carbonai and Boscaioli"

Michelina Venditti chuckled when she compared her first job in New Haven as a cigar maker in the early 1970s to the hard physical labor as a lumberman in the Campania region of Italy.

From the day I was born I grew up in the woods. We were considered *boscaioli*, woodsmen, the name for the life we led in the mountains.

During the six warm months, we went up to the mountains to work and we lived in a one-room shanty made of *legno e terra*, wood and earth. My parents and eight children lived there. There was no school for us. I learned how to read and write those nights after we finished eating when my parents taught only

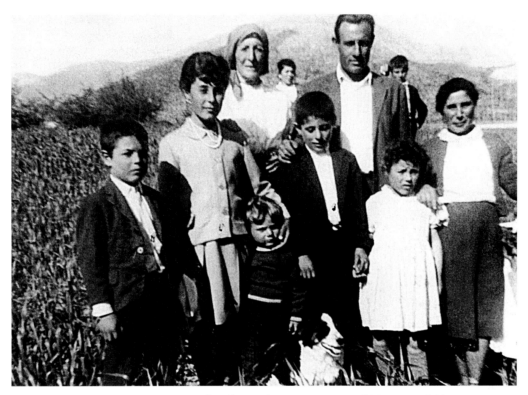

Figure 1.1. Montuori family in the mountains of Matese, 1940s.

the boys. I learned myself without any schooling by just watching my father teach the boys. My father never wanted the girls to learn. He said, "*Scrivi ai fidanzati quando facete grande,* You'll learn how to write to your boyfriends when you get older."

The girls had to wash the clothes, get water, and do the shopping. To get our water to cook our food and to wash ourselves, we had to walk about two hours to get spring water and then carry it back in wooden barrels, balancing them on our heads without using our hands. It took us three, four hours on foot with baskets on our heads to get to the store to buy macaroni, wine, and everything we needed. Luckily we had a donkey to help us carry things, though a lot of the other families didn't have one. To wash our clothes we had

to go to a small river where the freezing water ran under a big cliff, and as we washed the clothes in that freezing water our hands froze. Then we had to carry the clothes on our heads back to our shanty.

My *mestiere*, my job, from when I was fifteen years old in the 1930s until I was twenty-three, was a *taglialegna*, a lumberman. My father taught me everything about tree cutting. We cut down the biggest trees in the mountainous area around Gallo Matesa! After we cut them down we had to carry them on our shoulders to the *spazziale*, a small clearing in the forest we made with our rakes and *á vanga*, a spade. We called it our *l'aria per carbone*, the coal area, where we built *ó catuózzo*, which looked like a miniature Mount Vesuvius in Naples. It was this big cage-like form that looked just like a volcano with a hole on top of it where the smoke came out, about the size of a garage, with logs piled up about eight or nine feet high. We used ladders to build it up and then we covered the whole thing with dirt and leaves. Then we used twigs and leaves to start a fire inside and we burned the logs for eight or nine straight days to make coal. It had *fucarol*, little holes all around it, where we put the small logs in day and night to keep the fire burning. After that time, we pulled out all the *carbone di legno*, wood charcoal, and our faces were covered with so much soot that we looked blacker than black people, like chimney cleaners.

At the end of nine days, we cooled the fire down by throwing water on it, then we filled up sacks with the coal, and brought it by *i sommari*, mules, to the *magazzino*, warehouse, where we sold it to the owner who in turn sold to people who had *fornacelle*, wood stoves. The bigger the sack, the more money. But the wood there wasn't always good. Sometimes we'd find good, other times not, because we cut them down every five years. Up in Matese, it was every twenty-five years.

We used our wood charcoal in our *braciere*, a round pot framed with a wooden footrest so we could sit around it, put our feet around it, and stay warm. At night we'd leave the coals burning, but you had to be careful of carbon monoxide, so we'd put orange skins on the coal. This coal was different than *carbone fossile*, which they used to power trains.

For six months we stayed in mountains until the snows came. In September, when the snow started to fall, we came down from the mountains to our home in Piedimonte Matese in the region of Campania for a month and we worked in the forest and on the plains where

it was warmer. The girls washed, ironed, and repaired all the clothes for when we returned to work in the mountains. Compared to living in the mountains, when we came down to our home we lived like *i signori,* rich people. We went to mass, to the cemetery every night. But no movies and no enjoyments! On Sundays my mother took one of the daughters to mass, but never did we all go at once. When Christmas and Easter came around, my father took us to mass on Christmas Eve and Easter. Later my parents went to the first mass and we *signorine,* young ladies, went at eleven in the morning. At home, when our boyfriends came to visit, my father and mother sat on either side of the boyfriend. I sat across from him. (Translated from Italian)

"We Lived *Oggi per Domani*"

Marietta Scalzo Notaro recited a well-known saying of the farmers of Calabria: "*Se non si fa á campagna, che fa á mangiá?* If there are no farms then there is nothing to eat."

My father came to America at fifteen, and was a track boss on the Rio Grande Railroad. In nineteen twenty, he went back to his village of Decollatura in the province of Catanzaro in Calabria to marry my mother. Her parents were millers in the town and they made flour. They owned land, so they didn't want their daughter to marry my father and leave to go to America.

My sister was born in nineteen twenty-one, and my father sent for them. I was born in Green River, Utah. We lived in the mountains, and it used to get very cold. My father had to be away for work, and my two sisters and mother and I were left alone a lot. After a few years my father developed serious heart problems and decided the best thing to do was to return to Italy. He said, "At least if I die in Italy my wife can be with her family." When he died in nineteen thirty-four, my mother was left with nothing because my father had loaned a lot of money, and after he died the people refused to pay her the money they owed my father. So we returned to working on my mother's family farm in the town of Decollatura in Calabria.

When I was ten years old, I started working alongside my mother growing beans, potatoes, wheat and tomatoes. I only went to school up to the fourth grade, and because I was an American citizen I couldn't attend school. Sometimes, when a lot of farmers needed help during the summer, my mother hired me out

as a day worker, a sharecropper. This was in nineteen thirty-nine, nineteen forty. In September, from morning from six until eight at night, I dug potatoes, hoeing all day for about ten, twenty lira a day, maybe a hundred lira a month. Ooh, how my back hurt after hoeing all day long! With what I earned I bought high-cut leather shoes with iron nails in the soles for walking on rough terrain in the hills gathering chestnuts. We'd pick for more than a month, and they'd protect you from the *spini*, the thorns and thistles, as you picked chestnuts. We put three leather *ditali*, thimbles, on our fingers to protect us. After they stuck you, how those thorns burned! At noon the owners of the farm brought us *pasta e fagioli*, macaroni and beans, *pasta e piseddi*, macaroni and peas, meat and sausage, bread and fruits. In July, my mother and I used to help in the fields cutting down the wheat. How hot it was, mama mia! I drank a lot of spring water, I had breakfast and lunch, and rarely ate a night.

I remember how many times there was nothing to eat after a day of working, and I'd fall asleep exhausted and hungry. The water came from underground springs, and it was so good to drink, and it had a lot of minerals to help with digestion. In my whole life I never

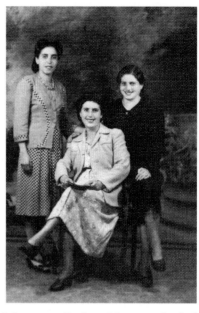

Figure 1.2. Marietta Scalzo Notaro (right) with sister Rosina (standing left) and Marietta Gentile, Soveria, Calabria, 1949.

drank a soda! It didn't exist! On our farm we had chestnut and walnut trees, which saved us during winters. Sometimes I'd eat chestnuts for breakfast as I did my housework. In October when the *noci*, the walnuts, dried up on the trees we'd hit the branches with a stick to make them fall to the ground, and we used to eat fresh walnuts with bread. Everything we ate was natural.

In October, from seven in the morning until sundown, we picked chestnuts with

baskets. We placed them in the *castagnaru*, a storage building made of stone the size of a garage where everyone in the fields stored and sold their chestnuts. People from Naples used to come and buy them, and sometimes a truck would come and take them to northern Italy. Sometimes we boiled them and they were sweet-tasting! We roasted them, put them in burlap sacks, and with one person on each end, banged them together to take the peels off. Then we put them in wicker baskets, shook them to get the rest of the peels off, and later sold them to buy bread and macaroni.

Sometimes we made bread from *farina di castagne*, chestnut flour, mixed it with a little *farina bianca*, white flour, added *il levito*, the yeast when the bread rose, and put it in *il forno*, the wood oven, to bake. It was delicious bread! We used to say, "*Pane per una sera, salute per sempre*," Bread for an evening, health for life. What it really meant, though, was that if there was health, bread will follow. As long as you have health, everything is okay. If you're sick, you can't work, but if you're healthy, you can always make bread.

We made macaroni with the chestnut flour, too. Some chestnuts we gave to the pigs to fatten them up before they were slaughtered. During summers, my mother and I went into the woods to cut as much wood as we could to put away for winter. I remember carrying it on our heads many times in the pouring rain. Sometimes we ran out of wood by January. Then we would have to go back out into the woods to cut down trees and carry them back on our heads.

It snowed in the winter where we lived in Calabria, and we needed wood to cook our food in our *focolaio*, the hearth. We lived *oggi per domani*, day to day. My mother cried a lot because she had four children to feed, and there was no help. Things got so bad my mother sent my oldest sister to *la maestra di ricamo*, the embroidery teacher, to learn how to become a tailor. She earned a little money at home as a tailor sewing suits and clothes, and I used to help her. During the winter I used to sit around the *braciere*, a round copper pot that held the burning coal with a wooden edge around it where you put your feet to stay warm. I used to sew shirts and pants until around ten at night until there was no more light. Many people paid her for her work, but a lot didn't. Sometimes people bartered. Right after my daughter Pina was born

in Decollatura, Calabria, in the nineteen fifties, my friend had a boy and couldn't breastfeed him.

There was no milk for children in those days, no such thing as going to *la farmacia*, the pharmacy, to buy milk. In Calabria in those days you had to travel too far to find milk. So many newborns died in Calabria in the early nineteen fifties because mothers couldn't find milk for their babies in the first few days of childbirth. Sometimes they used *ó latte ru cuccio*, donkey milk, because it was *dolce*, sweet, but many times it was hard to find. Cow milk was a little too heavy and difficult to digest and the children still died.

Figure 1.3. Marietta Scalzo Notaro and her daughter Pina.

Sometimes they gave the babies *camomidda*, chamomile tea they grew, but it wasn't nutritious like milk. So my friend's husband said, "*Per favore, viene e mi da un po' di latte a mia figlia, perche se no, mia figlia muore, á mamma non avia latte*, Please come and give my daughter milk because she'll die, her mother has no milk." I went there for a month to give the daughter my milk and they were so grateful to me for saving their daughter's life. At the same time a lawyer from Catanzaro had a little boy and his wife had no milk to give him. He asked me to come and give him milk for two months. He paid me as a *levatrice*, a midwife. At the same time I was also feeding my daughter and he became *un fratello di latte*, a nursing brother, with my daughter Pina. There were few doctors around. Once, when I went back to Italy, I saw the little girl I had breastfed years ago, who was now a grown woman. When she saw me she said, "*Mama, mi ha salvato!* Mama, you saved me!" (Translated from Calabrian dialect)

"Hard Labor"

Giuseppina Naclerio was ninety-five at the time of our interview. One of her favorite sayings was, "*Quando*

fa una giornata buona, pigliatela, che domani non ci sta, When it's a good day, take it because you don't know what tomorrow brings."

When I was a young girl of five in Agerola in the region of Campania in the nineteen twenties, my father died and I had to go work. I was the fifth born of three girls and two boys.

When I was fourteen I went with my older sister to work the land as laborers to make a little money. It was hard labor, clearing the land of the rocks and large stones. The builders used these rocks for their foundations for houses and retaining walls. Sometimes they used the rocks for making stalls for the animals. Then I worked for the local farmers picking crops and weeding. We used to go to the hillside to cut fire wood and tall grass to feed to the farm animals. This was my life until I was twenty-two when a young man named

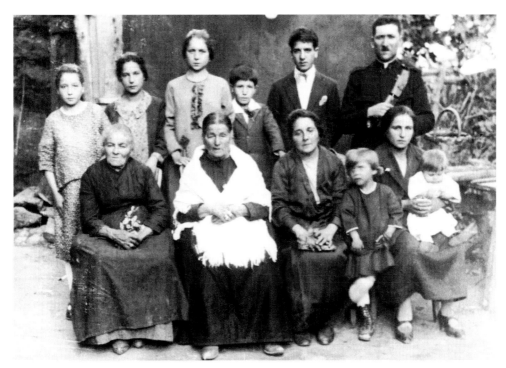

Figure 1.4. Giuseppina Brancati Naclerio in Agerola, standing third from left, 1920s.

Nicola came along and asked my mother for permission to court me. I got married and did a lot of the same work on my own farm.

"Life in Castellabate"

Anna Fasano explained how good jobs in her area of Italy were always controlled by politically connected families, "*Ó padre lascia, ó figlio piglia,* when the father leaves the job, the son takes it."

When I was a young girl in Castellabate in Campania in the nineteen twenties, we had the best food to eat. The rich people bought the seconds. What were the rich people thinking the way they carried themselves, as if they were better than us? They weren't better than us! We had the best of everything, the best food.

One day I walked past the house of this rich woman. She stopped me and said, "Young girl, the next time you walk past my house and see me there, you have to say, '*Buona sera, Excellenza,*' Good evening Your Excellence." I looked at her and said, "The next time I pass by here, I'm not saying good evening or *Excellenza*! Arrivederci!" She called my mother and said, "Your daughter is a *scostumata, senza edu-*

cazione, rude and has no manners, and she's ignorant. So my mother, knowing what kind of person she was, said to her, "What do you want me to do, kill her?"

When my mother got home I said, "So mom, how many beatings are you going to give me?" She said to me, "That's just the way that woman is." I said, Mom, "That's the way I want it and that's it." My mother said, "But she said you were a *scostumata,* a person with no manners." I said, "I don't care. When I walk by her the next time I'm not saying anything to her, even if you beat me, you kill me, I'm not saying anything to her." My mother said, "All right, now just stop it, or today I really will kill you." But from that day on I never greeted that woman again. (Translated from Italian)

"Making Cheese with My Father"

Antonette Becce Padula spoke about her mother's life in Tolve as her nieces Lucia Becce Mudd and Joanna Becce Herman listened. She recited her bedtime lullaby: "*Ninna, nonna, ti voglio riposar/ Ninna, nonna, ti voglio cantar/ Ninna, nonna, ti voglio suonar,* Ninna, nonna, I want you to rest/ Ninna, nonna, I want to sing to you/ Ninna, nonna, I want you to sleep."

Her father wanted her to go to school, but instead of going in the morning she'd go to the *massaria*, the dairy farm, with the cows right there to make cheese with her father and uncle. She was very attached to her father and didn't care about school. She'd rather be out in the fields.

Her father was in the dairy business, exported cheese all over. She learned how to make *monte ca,* cheese with butter in the middle, *la treccia,* braided mozzarella cheese, and provolone. They made it all from scratch, they milked their own cows. They went out to the pastures, sometimes for a week at a time. My mother Lucia Santorsa was privileged because she was the oldest child.

They had olive and almond trees. Her father hired all the women from the city of Tolve in the province of Potenza to pick them when they were ripe. Then they made their own oil from it. They raised their own wheat, threshed it, and took it to the mill to have their flour made for bread. All she talked about was her father, she never mentioned her mother. It was always her father; she was very close to him.

They made the cheese right out there on the *massaria* and her uncle, Zi' Gerardo, took the little cheese and made it into little birds with feathers and wings and horses and little figure toys for the children. They were masters of art. In Italy, her uncle, Zi' Gerardo, made her a regular doll. She said, "It was so beautiful," but then it got *tuost,* hard, fell on the ground and broke. She said, "I cried and I cried." So then her mother took the doll and put it in the *minestra,* the soup! She cried, "I want my doll back." Her uncle said, "All right, Lucia, all right," and he would make more cheese toys for her.

When I had my daughter, my mother Lucia made little rings of cheese as teething rings for her grandchildren. She dried them out until they got hard and gave it to them to bite and suck on when they were teething. It was nourishing.

"La Festa Maggiore"

Francesca Grillo's eyes lit up as she described the religious festivals she experienced as a young girl in Italy.

The fifteenth of August is La Festa Maggiore. The men of Terlizzi in the region of Puglia used to start way before the summer, and they used to build a *carro,* a float, like an altar. They

put benches where the kids would sit and on the top, and then they put La Madonna di Sovereto. She was the patron saint of a little town of Sovereto next to Terlizzi and they used to bring it into that church until the festa. Then they took the Madonna from Sovereto to Terlizzi and put her on this altar. And then the kids would get dressed up, my mother used to make us our dresses.

My dress for the feast was a black velvet dress with a white lace collar and a big ribbon. And you'd sit on these seats that these men built on this altar with the Madonna up there. And the procession, you'd go get the Madonna with respect [tapping table] and to bring it to Terlizzi. You'd have a long thick candle for everyone who wanted to be in *la processione*, the procession, and you'd light these candles and walk with the lit candles with the Madonna from Sovereto to Terlizzi to bring the Madonna there. Mostly everybody in town—big ones, small ones, old ones, and young ones—would light their candles and bring the Madonna.

When they built this *carro* they built it up high because you didn't have horses pulling them those years. Honest, when I think of it,

what I wouldn't give for another day! There were a lot of men carrying the Madonna and carrying these kids on the altar. The men had pads on their shoulders, and boy those men walked slowly. Who knows how many men, carrying this thing! And as you go along, it's like a parade, and people are watching, and once in a while, they'd come up and put money on the Madonna's dress. The money went to the church. It was a wonderful thing when my mother and my grandfather would say, "You're going *sopra al carro*, up on the float." And then my mother would be busy making my dress.

Then at night at the Festa Maggiore, that's when my grandfather would take me by the hand and say, "Don't tell your father that we're going to see the fireworks." Because my father was always giving him hell because he'd go under the fireworks. He'd go too near and he was so afraid that my grandfather was going to get hurt. But I used to love it! The town used to shake it used to be so strong. My grandfather would be right next to it. He used to take his jacket and put it over my head and squeeze me. Oh God bless his heart, honest to God!

"I Was His Son"

Francesca Grillo spoke about sitting around a *braciere* during the cold months, keeping warm by burning dried-out almond shells. Her mother also put woolen shawls over the backs of her children.

My father had the business and we had to help him.

We used to get on the team of horse and wagon in the morning. It was always me because my father wanted me to be a boy. You know how it is, the Italian people? They want a son. I was born a daughter, but my father always thought that I was his son! So I had to be the head one. I had to set an example for the other ones.

It was always an argument between him and my grandfather. Because my grandfather always said, "*Ma Pasqualino, che fai? È giovane, è piccola, la ragazza*. But Pasqualino, what are you doing? What do you want from her? She's just a kid!" I was his team driver. We used to go on with horse and the wagon with the

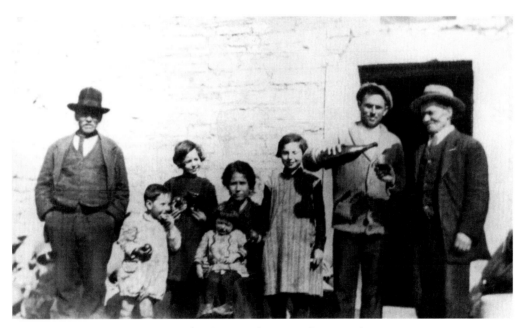

Figure 1.5. Amodeo family in Terlizzi, Puglia, 1920s.

wood high on one side. And he had property in a place where the mountains were made out of clay. And so there would be men there breaking the clay and fill up the team, to bring it to the *stabilimento*, the factory, and there was a manmade pool of water where they dropped these pieces of clay until it got soft. Then they used to take it out, and you had to knead, work the clay. It was me, together with the men for crying out loud; he used to put me to knead. You kneaded the clay, you'd have a mound of soft clay, broken up in pieces, and you knead it with your feet. and knead and knead until it becomes paste. Then they'd pick it up and put all in one tub.

My father had about a dozen of these pottery wheels. Then they took the clay by the clump and formed things on the wheel. They would put it on a slab of wood, and put it outside in the sun to dry. And after it dried, they'd put it into the *forno*, a big, big oven to bake them. My father would be there throwing in the olive branches to make the fire to bake. I was there all the time.

He expected me to be his bookkeeper. I was only seven, eight years old! He said to me, "You, I want you everyday to put in the book how many vases Francesco made, how many Petruccio made." Because my father had to make the payroll at the end of the week. So all the workers worked and my father, the *padrone*, the boss, would sit at a desk. And I was right there by his side, with the book! I opened my book and my father would say. "*Eh, va bene Petruccio. Quanti vasi hai fatto Lunedi?* Okay, Peter, and how many vases did you make on Monday." And Petruccio answered, "Sixty." My father said to me, "Embeh, so how much do you have in your book that he made Monday?" I'd say, fifteen, sixteen, seventy-five. It never was the right number, but what the hell did I know? I was so young. I always had to check with the workers, but I never had the right figure according to them. Then my father checked my book, and found the first mistake, and look at me, and "Hummp, *va bene*, all right." Turn another page, "Petruccio, how many vases did you make on Tuesday?" And he'd say the number. Then my father looked back at me and said, "Meh, what do you have in your book?" My heart started to pound. After the third or fourth mistake, he'd take all pencils and the book and I'd run away [laughing]. I'd be quiet and the workers, my brother and sister would be standing there, watching it all

and laughing because I caught hell. At that time, that's the way it was.

"Making Bread in Terlizzi"

Francesca Grillo lived on Franklin Street in Norwich amid many immigrants from the city of Bari in the region of Puglia.

My job was to grow up in the house and do things that kids do in the house. I used to help my mother make the bread. My sister Joanne was fourteen months younger, and we had to make bread once a week to last the whole week.

We got up at one o'clock in the morning, "Get up, you gotta make the bread!" and we finished about when it began to be daylight. We went into the shed off the kitchen where they dried things and we had to get the *frascidde,* kindling wood, to make warm water to make the bread. Now, in the meantime I'd get the big board, make a well, put in the yeast cake. Then I had to melt the rock salt, turning and turning it.

My sister Giovanna was making the warm water. Then you put fifteen, twenty pounds of flour on a piece of board and we mixed it. How big and how much strength does an eight, nine-year-old girl have? We only had one knife and my sister kneaded the dough on this side and I kneaded the dough on the other side. All the time we both needed the knife because sometimes the dough stuck to the board and we had to keep cleaning it so we could work it in. And yet, there was a big bread board.

My sister and I used to make seven, eight loaves of bread. Imagine, with our little hands to mix the flour, mix the dough, knead it, and braid it. We even had to braid it! And then cover it and put it away. And each loaf, you wrap it with a *moppine,* a dishtowel, and separate it. And put seven, eight on this board. And when it's all risen, you bring it to the *forno,* the communal oven in town. The men used to put that board on their shoulders and just carry it to the *forno.*

Every town like Terlizzi had three or four of these bakeries. The ladies of the house used to bring everything, a casserole with potatoes and peppers and rabbits, all fixed with the tomatoes and everything else to *al forno,* to bake. And us kids, we used to take a walk by there once in a while and that smell used to make us hungry.

On a rainy day, my mother would say to us, "All right, *andiamo a prendere le lumache*, let's go and get some snails." She used to take a handkerchief and make a knot in each corner, and it formed a little basket. Take this basket across the street where there was a stone wall where after it rains all the stones got wet. She'd give us a candle, and we lit the candle and went by the stone. And all of a sudden you'd see a snail come out. You take that snail and put it in your basket. Take it home. My mother would put them in warm water and you look. And we'd have a pin. The minute you'd see a little bit of horns come out from the snail, you pick that snail, take that pin and take it out of the shell and put it aside. When you get them all clean, my mother would have the sauce made, she'd throw it in the sauce, and we'd have spaghetti with *cimarouc*, snails in Pugliese dialect. And that snail sauce was good! That's how we lived ninety years ago.

"My Grandfather and the Cauliflower Plants"

Francesca Grillo:

My poor mother, she worked hard. Ninety years ago in Italy, the woman wasn't worth nothing. It was all the man. Because I was named after my *nònonne*, my grandmother, and I think that was the reason why I was special to my grandfather. And so every morning he used to take his shovel, because he had an *orto*, a garden. He used to say, "Come on, Checchèlle," which means little Francesca in Pugliese dialect! *Alzati! Dobbiamo andare*, Francesca, get up, we have to go." It wasn't even daylight yet.

We'd leave early and he'd take me by the hand. And we'd go. He'd take his *spada*, spade, and put it on his shoulder. By the time we got up to his garden, he'd get twigs and build a fire underneath the tree. We had a big olive tree in his garden. He'd shake and shake the big branches. And when the olives were ripe, they would fall. And when they fell, I'd help him pick them up; he'd pick them up, "Come on, Checchèlle!" And he used to put these olives on the fire and when they'd blow up, that means they were done. He'd pick them up, take the handkerchief out of his pocket, wash the ash off the olives, one for him, one for me, one for him, one for me. He'd have some bread in a bag and that's how we had breakfast.

And then we'd start to weed the garden. And he taught me, "*Checchèlle, io vado avanti e tu vieni indietro*, I'll go ahead and you follow behind me." And there was a row of cauli-

flower. And he used to tell me, "A cauliflower is supposed to be big and it's supposed to be white, *come la neve,* white like snow. And in order to do that, you gotta do this. When the cauliflower starts to come out, it's a small bud. There are little leaves on the side, and they get big as the cauliflower grows. But the leaves are thick and you gotta bend the middle of the leaf and bring it over the cauliflower. You gotta turn it over, and then as they grow, the other leaves come. And if it's a little bit longer, turn it over. Now I go first." He used to go first and take all the weeds out, and I used to go right behind him and turn the leaves. And once in a while he'd go like this, "*Hey Checchèlle, vai in dietro,* Hey, go back, that one isn't covered good enough."

And I used to see him, when he got tired, he'd put *la spada in terra,* the spade into the ground. And then he used to lie down right in between the rows of the vegetables. And I used to run around and see all the other things he used to grow. And then when he had enough, he'd get up, "*Eh, va bene, andiamo,* Okay let's go." And we'd walk home.

"Going To School and Learning Values"

Francesca Grillo:

As I was growing up, my father started to put us in public school in Terlizzi, but we couldn't go because we weren't born there. So they wouldn't accept us at that time in the nineteen twenties. So we had to go to private school.

We had a young woman as a teacher. There were two rooms with no chairs around. In this one room was the schoolroom where we had to learn. In that room, there was a big high chair. The teacher lived with an uncle and two aunts. The two aunts, Matilda and Carolina—they were old people and bedridden. Her uncle was a dentist and in this room where we were learning our A B C's, how to read and write, how to sew, learn how to crochet, you learned everything! She was a good teacher. But if somebody had a toothache and came in, the uncle had to treat the patient. And like it was yesterday, the people, they yelled and screamed their head off.

If any one of us kids disobeyed the teacher, or made a mistake or something, we learned you have to pay consequences. And so the doctor, Paoluccio, or the teacher, would pick one of us kids who didn't do so good in school. And for punishment, we had to hold the pan under the patient's face where they spit after they had a tooth that was pulled. Don't laugh, that's how you learn values! That's how I

learned my values. It taught me I better be good, I better not skip a stitch when I sew. Or, if you were really bad, which I had been a few times, and I had this happen to me. This teacher had a rock about that big, and it had a hole through it. And through that hole they put a rope. And if you were really bad, that rope was tied around your neck like a necklace and the stone hangs. You go on the balcony. You kneel with that rock. And the reason why they put you on the balcony is that everybody walks in the street, they pass by the jackass, and they see you, "Hi, you're being punished!"

You'd look around to see if anyone was coming. If no one was coming, you put your head down so the rock wouldn't land on the stone, but if the teacher was coming around to see, you pick up your head and that was heavy when you're a kid, seven, eight years old. But that was the punishment. Or, we had to go in the other room where the aunts were in separate beds. You'd wash their face, you combed their hair. That to me was a value that you learned—you have to care for people. That's how you learned—really learned—the values.

"Graduation Day"

Francesca Grillo:

I knit and purl it, you knit one side, then you turn it around and you work it the other way, you purl it. When I finished it, it was black as an ace of spades, because sometimes your hands would sweat and you'd have to keep on working because the teacher would say you had to make it before you go home. They were strict. The rules were strict, but thank God! We hated it then but we learned from it. When we were kids, we wanted to go out and do other things, but we learned from that. When you finished this thing, that was the day you graduated and the teacher would wash it, make it come out clean. The she'd crochet it herself with colored thread all around. She'd put a little ribbon and made a little pocket on each end. And when it was all put together with pink and blue ribbon and everything, she'd put it across your arm, and in the pockets she'd put a little candy or a confetti with a nice linen piece of cloth over it. And you'd go home. You're so happy. You graduated and you're done. It was like having a diploma here in the U.S. You're so happy. You

walk the streets smiling from ear to ear. Oh my God, I graduated from school! You go home and when your mother and father see you they're so happy. They hug, they kiss, and it's such a big deal! And that was graduation when I was eight.

"Can I Lean On Your Wall?"

Antoinette Becce Padula and Vittoria Becce Semprini visited their hundred-and-one-year-old cousin, Domenica Becce, in Tolve. She and her husband Pasquale had been partners in the Becce farm in Waterbury. Though blind and homebound, she recited this poem to her beloved Vittoria and Antoinette, and her visiting great nieces and great great nephew: "*Se il cielo/Fosse una foglia/E tutto il mare/Tutto inchiostro/Non mi basta scrivere/Il bene che ti voglio,* If the sky were one sheet of paper/And the ocean, an ocean of ink/It would not be enough to write/How much I love you."

My mother came from Tolve in the province of Basilicata, down on the ankle of Italy. Things were bad there, and money was very scarce even though they had olive groves and almond trees. Where they lived, they had to borrow money from the church to buy the seed to plant wheat, and if the crops failed you went into debt, and the church confiscated your land. They had two years of crop failure. And there was no money coming in. He was in debt and came here to make money and go back to Italy.

So my father went to New York and he worked in the bowling alleys putting up pins. He also worked in the coal mines in Pennsylvania. Then somebody told him about Waterbury, that there were a lot of factories, so he came here alone to work around 1908. With her father's help, and with the money my father was sending her from America, my mother built a house and waited for him to come back. She had given birth to my sister Arcangela. They built houses as an *appoggio,* a lean-to. They would say to the adjoining neighbor, "*Puozz appogg a u muro mio alla casa tóia?* Can I lean my wall on your house?" So they only had to put up three walls instead of four. That's how they built their houses in those days, around the turn of the century.

"Washing Clothes, Washing Floors"

Marietta Scalzo Notaro worked in the New England Shirt Factory in Danbury for sixty-five cents an hour in 1955.

In Decollatura, going to wash clothes at the river, the water was cold. I used to wash white clothes by taking the ashes from the fireplace. I used a white linen cloth to filter out just the white ashes and get rid of the impurities. Then I put them in water so they would dissolve, and boiled them in a large pot. The ash liquid became bleach, and it also acted as a disinfectant, which I used to wash linens. I used to put the clothes in a wicker basket, layered them, and put it outside on the balcony. Then I poured the liquid into it—it would pass slowly through the clothes—and I let it sit for a day. The next day I'd take them down to the river to wash them and they came out perfectly white. Then I'd put them on the wheat stalks to dry in the sun. Sometimes to wash the floors, I'd mix a batch of the same thing, only thicker, to wash the tiles around the fireplace and all the wooden floors in the house on my hands and knees. (Translated from Calabrian dialect)

"Vesuvius Rumbled"

Joe Criscuolo:

My mother came from a small town under Mount Vesuvius, Scafati, and she would tell how at times when the mountain started to rumble—it wasn't exactly an eruption—but the mountain rumbled and smoke would come out and it threw a little bit of ash and clouds of dust. And her mother was afraid it would erupt, and she would put pillows on the kids' heads and towels across their faces so they wouldn't breathe in the dust and the little pieces of pebble that fell down from the mountain. They'd run to the church just because it was the strongest place in the village. The lava didn't flow. But in nineteen-oh-six it erupted, and it destroyed Boscotrecase nearby. And that's where her mother came from. It was a huge eruption, and it destroyed quite a few towns at the base of the mountain. They were carrying San Gennaro in a procession because he was the patron saint they prayed to for protection against the eruption of Mount Vesuvius. The lava started coming down the mountain and supposedly the statue extended its hand and stopped the flow of the lava. Even to this day in Naples they have a ceremony where they take the blood of San Gennaro, and if it liquefies, that means everything is going to be all right, that there won't be any eruption that year. If it doesn't, supposedly there's going to be an eruption. A lot of times in the old days,

they would swear at the saint. They used to call him *faccia gialliat*, yellow face; if the vial didn't turn into blood, they'd say, "Make that turn! Make it change!"

"My Mother the Shepherd"

Mary Pesce worked as a young girl during summers in the late teens and nineteen-twenties for fifteen cents a day on the local Farina Farm in East Haven. She connected the old proverb, *"Chi lascia á via vècchia,* Whoever leaves the old road for the new," to a passage in the Bible, "He who takes the wrong road, stumbles."

My mother's mother died when she was four years old in southern Italy. She had a mean stepmother when my grandfather remarried. My mother tried to make bread in Italy, but they used to give her all the hard flour. And her sister would say to the father, "See, your daughter wants to make bread!" But she used to give her all the bad, the hard flour. Then they used to go tend *le pecore*, the sheep, with her sister-in-law. My mother was younger and she was there watching the family flock. But my uncle would go off petting, and my mother used to get blamed if one of the sheep got lost. And her mother would hit my mother but not my aunt.

"All He Wanted to Do Was Good"

Mary DeNittis was ninety-nine and in a nursing home at the time of interview. Though blind and bedbound she held my hand during the conversation, smiling and speaking enthusiastically about her long life.

I came here with my mother in nineteen-oh-nine. I was almost two years old, a little tot walking around with my brother and sister who was fourteen. My mother was a widow, and then she remarried, and had me and my brother. She was learning to be a nun in a convent. Her name was Nunziata.

One holiday they sent her home. Usually when you become a nun they send you home for the holidays. That's how she met her first husband in eighteen ninety-nine. She went to church with her mother and father. All of a sudden she saw a *carabinieri*, a uniformed policeman, with a hat, and he was a tall, good-looking man. Evidently they must have fallen in love in the church. When they came out of church he followed them to the house.

He talked to her, and he wanted to become her *fidanzato*, what we call going steady.

She had never gone with anyone because she was in the convent, but because it was the holidays they went to church, and somehow or other they must have fallen in love. They told her she couldn't still be a nun. He kept going after her every chance he could get, and finally they consented, and they got married. Their first child was a little girl. When he was a *carabinieri*, a policeman, he learned how to be a shoemaker. But once you get married, they didn't want you any more, and you had to resign as a *carabinieri*. So he resigned. They were married, and had the baby, and were happy as happy could be.

So he was in his shoemaker shop in Campobasso. All of a sudden, he saw two men fighting. Sometimes it doesn't pay to do good. He says, "Oh my God! I gotta go separate those two." Well, he did. But the man killed him with a knife. I don't know if he did it purposely to kill him, or whether he wanted to kill that other guy, and it hit him. And my mother said, "How come my husband is not home yet? He's not here and it's getting late." So she told the neighbor, "Take care of the baby, I'm going over to see," and when she went there she found him killed outside. Well, that shocked her, and I don't know how she didn't die.

She took it very, very bad. And you know in Italy, they don't kill people. I think he got ten years in jail. And they put her in an asylum for a while because she had taken it too hard, and she had a nervous breakdown. Just never a better man, loves her man, and he gets killed for no reason at all. And why? That poor man wanted to do good. He wanted to separate them, you know? She was there for a year with her baby, and when she came out she lived with her mother and father. She tried to do a little sewing, a little embroidering, crocheting, and things like that to help out living. But she took it very hard. She never got over it.

"You Should Wash Her Feet"

Michelina Venditti was eighty-two at the time of our interview. After her husband died, she worked two factory jobs to support and raise her five children.

I was twenty-one years old in the nineteen forties, and I went to work one day in the mountains of Matese, in the woods in the

small town of Mignano Montelungo. Four or five of us young girls were unloading wood from a cart into a house. All the boys were watching us work, and an elderly man who was driving a wagon up the hill stopped and said to me, "*Signorina, chest anno, non te ne vai da chest ó paese, qualcheduno sposa a te,* Young lady, you're not leaving this place. Someone is going to marry you this year." I said, "*Come? A me no piace a ccà, chist e nu paese brutt! I' voglio ghì' proprio mo'. Dopo sei mese ccà mi pare mille anni, me ne voglio ghì',* What? I don't even like it here, it's an awful place and I want to leave right now! Being here six months feels like a thousand years, I want to get out of here." He insisted, "*Tu sposa ccà! Tu rimane ccà!* You're getting married here! You're staying here!"

So what happened? One night in our *barraca,* shanty, in the mountains, about the size of a large garage, we used to have a brick oven where we made loaves of bread every day. The three girls, the five boys, and my parents slept in little rooms separated by wooden dividers strung with linen sheets, like little tents. We had a space for our dances. All my five brothers knew how to play the *organetto,* an accordion, and another type of accordion, the only instruments we had in the mountains at the

time. How much fun we used to have at night there! We had two *scanni,* long farm benches, like church pews, where everyone could sit, and we danced folk dances—the tarantella, vorca, and mazurka.

When work finished on Saturday night, all the young men and our friends used to come by. Sometimes cousins and a bunch of brother and sister-in-laws came, and sometimes they'd bring a *compagno,* a close friend, to meet a young girl, or a young man. They were small dances, though, maybe a few couples.

That's how I met my husband. One night I was at one of our little dances, and this young guy came with his older married brother, and usually no one said too much when we were dancing. He came up to me and said, "*Ó fratello mio vuole sposa a te,* My brother wants to marry you." I said, "*Ma vattenn, tu e isso! Tu tieni a proprietà, e i' non tengo niénte, ma vuoi sfott a me? Ti donc una mazàtta in capo! Si ó padre mio sapé chest, ti uccide,* Get out of here, you and him. You own property, and I don't have anything. Are you trying to screw around with me? I'll whack you over the head! And if my father ever finds out about this, he'll kill you."

Later his mother told me, "*No, no, chillo ti vo sposa á te veramente perche i' mi serve una*

figliuola per stare accorta a me, teng' una malattia e cuore, No, it's true, my son wants to marry you and I need someone to help me along because I have a bad heart." I said, "*Si é vero, okay, pero si isso sta sfuttendo a me, i' uccide a chill,* If it's true, then okay, but if he's trying to take advantage of me, I'll kill him" [laughing].

So I got married at twenty-three to this *contadino,* this farmer. I thought things would get better for me but after I married things got worse. I had to learn how to take care of all the animals on his farm by myself—buffalo, sheep, goats, pigs, chicken, and cows. My husband didn't explain anything, how to feed them, take care of them. He used to buy animals that were *sicche, sicche,* very undernourished, and then he'd feed them and fatten them up to make more money.

The land was full of rocks. And the black buffalo—we had seven of them—with those turned-up horns. They scared the hell out of me because if they saw red they'd come after you and trample you. I used to have to milk them with big pails and then put the *ó quaglio,* the small intestine of a baby lamb that turned the milk from the buffalo into mozzarella. I had to make cheese and ricotta from the cows.

But I could never get used to the smell of the manure. I had to carry it out to the fields to fertilize the *scarola,* tomatoes, and salad. And then *vanga e vanga e vanga,* with your foot on the *vanga,* the spade, to turn over the soil. That was the toughest work of all.

I even planted grapes to make wine. I had my five children working and sleeping out there with me. Then my mother-in-law took care of my kids until her death. *E meno male che era brava, chella voleva bene a me. Se ó marito mio alluccàva a me, chella vatteva ó figlio, chella stev accorto a me, era nice. Che si steva un àuto che appicciava ó fuoco, perche stanno certi suoceri appicciàno solo ó fuoco e fanno male a muglière. Si ó marito mio qualche volta alluccàva a me, chella alluccàva e diceva a isso, "Tu stai zitto, che tu non merita chista ccà, tu tiene un muglière e oro, tu adda lavà i piedi,* And it's a good thing she was a good person, that she loved me. There are some mother-in-laws who cause trouble for their daughter-in-laws. If my husband ever raised his voice to me, she'd yell at him, "You shut your mouth, you don't deserve this one here. You have a wife of gold. You should wash her feet." (Translated from Neapolitan dialect)

"A Hèra di Cuccùza"

Marietta Scalzo Notaro talked about emigration after WWII: "Many went to Argentina. In Canada they wanted immigrants with a trade—housebuilders and tailors. In Australia, it was for people who wanted to work the land, like Argentina. But America was always number one."

In Decollatura, Calabria, the farmers who grew wheat used to have a saying during planting season, "*Sotto la neve, pane/E sotto l'accuia, fame,*" which meant If the snow falls on the wheat it's good because it covers the wheat,

but if a heavy rain came in early spring, it washes all the wheat away. And if you lost your wheat, you'd have no bread for your family and starve. The farmers used to have another saying, "*Chi avia huòcu, campau/E chi appe pane pe un jòrnu, mòriu,* Who has fire, survives, and who has bread for a day, dies."

At the end of the growing season around the third weekend of September, we had a big farmers fair, "The Pumpkin Fair." Vendors came from the nearby towns—Nicastro, Adami, and Soveria Manelli—selling sheep, goats, and pigs. If we had a good crop that year, I sold *cuccuzze* for feed for the pigs. It was the only crop we didn't need, so I could sell it. Most of the trading and selling was for farm animals, especially pigs and piglets because in winter people would fatten them up, and they became a staple for families.

Vendors sold shoes, cheese, lard, *zibibbo*, big white grapes, and *fighi indiani*, figs. They made *mustazzola* for special occasions—weddings, bridal showers, baptisms, and first communions. It was baked and made with flour and honey; it was more like a biscuit than a cookie. It was unique in our area. They came in all kinds of decorative shapes—round with

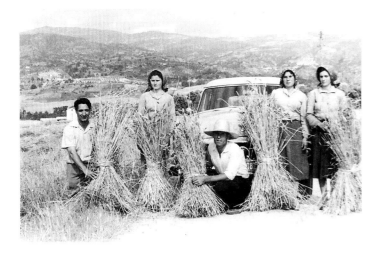

Figure 1.6. *La Mietitura* (The Harvest). Rose, Province of Cosenza, Calabria, late 1940s. Covello family archives.

all sorts of designs, some in the shape of grape bunches, some diamond-shaped with a design in the middle, some were in the shape of stars with ribbons around them, others in the shape of triangles or ring-shaped. They sold *grispelle*, a Calabrian version of fried potato dough. They sold pumpkins to animal owners, and *ù giddu*, the roots of potatoes, for planting. Vendors and farmers bartered their wares with each other. Some vendors camped out in the fields, and others rented rooms from local families. We used to rent a room every year. There were no hotels in those days. (Translated from Calabrian dialect)

Italian Women Journey to America

Women's stories that describe daily life aboard transatlantic ships provide missing pieces to the immigrant journey mosaic. Their testimonies from the female perspective illustrate why and when women chose to leave Italy. Although men comprised 78 percent of migrants in the early days of migration, wives played important roles as decision makers who gave their blessing to husbands leaving in search of jobs.[1] Women often viewed migration as a strategy to improve the economic status of the family, planning with husbands to repatriate with enough money to buy farmland.[2] In Sicily, more than three-quarters of Sicilians who migrated to the Americas between 1880 and 1914 were male.[3] In towns such as Sutera in Sicily, nearly 75 percent of the men returned.[4] With family ties that stretched across an ocean, wives in Italy, known as *vedove bianche*, white widows, received remittances from husbands in America as they waited for their return. Many married men found America a better place to live, triggering a delayed exodus of women who planted new roots in Connecticut with their husbands.[5] One woman who had stayed behind in Puglia later joined her husband in

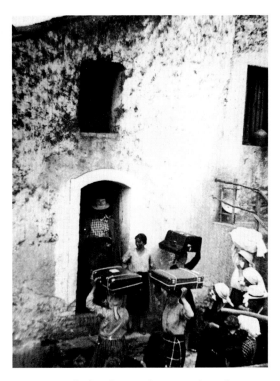

Figure 2.1. Michele Smeriglio in the doorway of his home in Rose, Calabria (province of Cosenza) leaving on June 25, 1955 with his sons Mario and Luigi for Stamford, Connecticut. Ida (daughter) on the step, Melina Perri (sister-in-law) carries their accordion. Iolanda Iuso Smeriglio (daughter-in-law facing Michele), and Iolanda Ceci (black-and-white striped skirt) carrying their suitcases on their heads. The women crying with hankies drawn are neighbors. Smeriglio family archives.

Connecticut with plans to return to Italy together. On the day of her departure, she left her prized gold necklace on the bedroom bureau expecting to repatriate within the year, but did not return for three decades. Other young married women—many of whom had never set foot outside their isolated villages—departed alone to join husbands, often caring for several small children during the harrowing oceanic journey that could take up to a month.

Young women emigrated not only to join their husbands. Some young women were dispatched to Connecticut as negotiators in family matters. In one case, a mother in Sicily sent her daughter across the ocean to Middletown to forbid her son from marrying without her approval. To uphold the honor of the family, fathers sometimes sent daughters to live with relatives in America. For the varied reasons they made the difficult journey, the voyage across the Atlantic changed the lives of Italian women and the identity of their families.

"The Adoption"

As the sun set in the Campanian village of Faiecchio, Giuseppe Cinquino, a young tenant farmer, wiped his brow after cutting wheat all day on the large estate of Don Francesco. October was the busiest time for farmers in southern Italy, the season known as *la vedemmia,* winemaking, and *la mietatura,* the harvest. On his way home, Giuseppe noticed a large crowd gathering in the piazza. An animated shipping line agent was telling townspeople of his company's affordable ticket prices and comfortable steam ships that guaranteed arrival times to New York within fourteen days. The agent told the curious crowd about well-paying jobs in America for any venturesome young man willing to take the chance.

Guiseppe's wife of five years, Celestina, whose family name appeared in town baptismal records from the seventeenth century, had also listened to women at the communal fountain talk of leaving to join husbands who had found good paying jobs in America. Some said they were sending home monthly remittances, enough to buy land, or enlarge their homes. With round trip transatlantic passage affordable, Celestina realized they could make the voyage to America, and repatriate with enough American money to buy their own farm.[6] As landowners they could forever be free of the hated Don Francesco, who owned the best farmlands in the area and charged tenant farmers exorbitant fees for tools, seeds, and rental of his land. Facing a gloomy future trapped in a cycle of constant debt to the Don, Celestina and Giuseppe decided to journey to America.

On a chilly December morning in 1902, with the mood of "American fever" hanging in the air,

Giuseppe and Celestina left for the harbor of Naples by horse and wagon on the familiar winding dirt road down the mountainside. At the port they boarded a German ship that made its final stop to pick up passengers on the coast of Ireland before heading out into the cold darkness of the North Atlantic. At the Irish pier Celestina spotted scores of families such as Emily and Michael O'Brien's, hurrying their three small children to the gangplank amid the confusion of boarding passengers. Once on the ship, the O'Briens descended down a poorly lit stairway to the steerage section where they would live at close quarters with other travelers on their way to America. In the dim netherworld below water level, the O'Briens and Cinquinos began a friendship that lasted the entire trip. Celestina quickly took to the three red-haired children with bright smiles and fair complexions. Conversing in improvised sign language and sharing meals together in the ship's cramped dining room, the journey passed quickly for the two families who shared the same dream of a better life in America. Families often shared the same contaminated drinking water and contracted diseases, infecting other passengers crammed into tight living spaces. Suddenly one night, Emily and Michael came down with high fevers and uncontrollable coughs. The two died the next morning, a few days before the ship arrived in New York.

On a frigid afternoon in open sea, with howling winds blowing across the deck, Celestina and Giuseppe attended the memorial service for the O'Briens. They listened to a young, studious-looking chaplain read from a prayer book to a small gathering of sympathetic passengers. When the final amen was uttered, two deckhands appeared, and buried the O'Briens at sea amid sprays of rising and falling gray-capped waves. During the service, Celestina's mind focused on the three orphaned children. Knowing she could never bear children, Celestina turned to her husband and said she wanted to become their surrogate mother. On the last day of the journey, Celestina gave the three Irish children new names. Under the watchful eyes of immigration officials at Ellis Island, she declared the children as hers, making Celestina and Giuseppe parents of three adopted children.

The young couple settled the family in New Haven's Hill neighborhood, a part of town where Irish prejudice against Italians often boiled over into name calling, beatings, and street fights, posing a potential threat to the safety of the Cinquino children. Celestina wisely kept her children's identity a secret, knowing if her Italian neighbors found out their Irish ethnicity, they would be ostracized from the Italian community. She also knew if her Irish neighbors discovered Italians raising Irish children, the three would face permanent exclusion from the Irish community.

"Maddalena's Decision"

On June 7, 1903, Filippo Susi, one of countless illiterate laborers, made a plan with his wife to work in the United States alone, and repatriate with enough money to buy a farm.[7] Traveling back and forth to Italy many times, he decided to settle in the United States, and sent money to his wife for passage of his two oldest sons, who joined him in 1905. According to their plan, his wife Maddalena and youngest son, Rocco, were to leave Sulmona in September 1906, permanently settling the Susi family in Connecticut.

On the night before her departure, Maddalena packed her steamer trunk, then went house to house visiting neighbors and relatives to bid them farewell. When she returned home to the solitude of her bedroom, surrounded by images of patron saints and the statue of the sorrowful Madonna looking toward the heavens, she decided she could not leave her beloved village. Maddalena wrote her husband of her decision and remained in Italy with her son Rocco. She never again saw her husband Filippo, a victim of the Spanish Flu Pandemic in 1917.

"You Were Born In America and You're Going to Die There"

Francesca Grillo recalled Italian society in her native Terlizzi in Puglia. "There wasn't rich and poor in my town. We knew a rich person by the name 'Don.' Once I heard them call my father 'Don,' and I said, 'Oh, we're rich.'"

As I was growing up in the nineteen twenties in Terlizzi, going to school, and working in our *stabilimento*, factory, and we had two balconies. Not too far away was another *stabilimento* where they made shingles for the roofs. They had a boy, and his name was Luigi, and he was the same age as me. So in the morning, he'd go by the house with the bicycle. And a couple of times I'd be on the balcony, shaking the sheets for making the bed, and he'd go by. And I'd wave, he'd wave. And before you know it, he'd go by more than once sometimes. My father caught me once waving at him. "*Hey, che fai? Vatene a jinde. Va a fa u ljitte!* What are you doing? Go inside and make the bed!" So at dinnertime, he said, "*Jì te autà a scì all'America!* You are going to America and I'll help!" He was so mad, honest to God. Because he saw me talking to this boy Luigi, and he wanted to keep me away from him, you know. And I started, "*Pa, e percè m' jì asci all'America?* Why do I have to go to America?" And he said, "*Si nata in America, e devi morire all'America,* You were born in America and you're going to die in America."

I came to America in nineteen thirty-three because I was born here, and my father figured, you were born there, and that's where you're gonna go, and that was a good excuse for him to push me to come over here. We were just kids for crying out loud! Parents of boys wanted their sons to marry certain family girls. In their eyes [parents], if the girls got married to the people they wanted, that was all right. It was "Hey, my compare's got a nice daughter," and they told a son, "When you get ready, you marry her," and that was it. I have a cousin in Bari who married her husband—she didn't even love him—but her parents said "You're going to marry him," and that's what she did. And she spent her whole life miserable. Come to find out, it was because Luigi and I were looking at each other. Son of a gun, my father! If it wasn't that he sent me over here I would have been married to Luigi in the old country. He became a priest. That's the way it was in Italy, and it wasn't only my father. I guess he didn't want me to get involved. They were very protective of the daughters.

Everybody that I know of, my cousins, or whoever it was in Italy, that's how we grew up. There's no questions. You just do what you were told. My father did the same thing to my sister because she got a letter, kid stuff, from

a boy in town, and he sent her to America with a friend of the family. So one morning I was behind the wall looking for the *gelato,* ice cream, and Luigi went by on the bicycle and he stopped. And I said, "Hey, Luigi, my father says that I'm gonna go to America." He turned around, and he said, "*Te uto a vi all'America e jì aie a me faccio ò prjìvete,* If you go to America, I'm going to become a priest." As God is my judge, I often think, I wonder whatever happened to him, where is he? Somebody told me not long ago that his name was Luigi Cataldi, the priest at Saint Joseph's in Norwich.

So my father made the papers and took me to Naples. I came alone. They made up all the papers. I was fifteen—what the hell did I know? I was doing what my father told me to do. My mother was really upset. The name of the ship was *Saturnia.* Big, big ship. My mother was crying all the time. And the night before I left, my father had a big party. Everybody was there drinking and saying goodbye to me, all the people who worked for him, and my little brothers were saying goodbye. I was looking for my grandfather, and I couldn't see him. He was so short that between all the people I couldn't find him. Finally I went over the corner where we had a closet where my mother kept all the cheeses and stuff. I said

to myself, maybe he's getting something. So I went over there, and he was shaking his head, saying, "I don't know what to give you, I'm looking for something for you." I just hugged him, and held his hand. He reached into the closet and took his umbrella, one of those big Italian umbrellas, like a beach umbrella, and said, "Take this with you." My mother couldn't talk. That umbrella was my life for many years.

Before my father brought me on the ship in Naples, in a building on the dock, they examined you to see if you had any diseases, and there was a big room. You started from one end, and finished on the other end. You undressed, took all the clothes off, and they had a stick to see if you had lice. You put your clothes on that stick, and they put it through a steamer room to clean all your clothes. While that was done you stayed there, and they took your hair to examine if you had bugs. Then you went into another room and took a shower. Then into another room, and by that time the clothes are nice and hot, but they're dried. Then you got dressed, go in another room, and a nurse examined me.

So my father was waiting for me there when I got out and he said, "All right, *man-giamo prima che andiamo sopra*, let's eat something before we go up." There was a market there and they were selling containers of razor clams. I said to my father, "Gee I'd like to have a couple of those." I had one and it was good! I said, "Ooh, I'll have another one," and I guess I had two or three and my father said, "That's enough because you can get sick if you have too many." We went a little further and there were bananas. I had never seen bananas from where I came from in Puglia, there weren't any bananas. He bought two, one half for him, and half for me. The other one, I says, "What are you gonna do with other one, Pa?" "The other one, when I go home, there's five people, I'm gonna take it home and cut it into five pieces, and they can all have a piece each" [laughing]. Honest to God!

So he put me on the boat, and looked at the numbers, and he showed me where my place was, "*Numero quattro, va bene*, Number four, that's good." When I left Naples—now you fly in six or seven hours and you're there, it's no big deal—but getting on that ship . . . just imagine, the band is playing, and there's a lot of noise, and everybody's got red, yellow, and white handkerchiefs, balloons. When they closed that gate, my father said

goodbye and left. And the band is playing, and on the ship you're trying to see where your sister is, where is your father, where is your cousin, and if you happen to know they had a red balloon, you could probably see them. And the band is playing, and you don't feel anything. I swear to God, you don't feel like you're moving [away from the dock] but that ship is moving so slow that now you see the band playing, you see all the people. All of sudden, they disappear, and you don't realize— how can they disappear when I'm moving? It's like a dream. It's like a fog, I can't explain it.

There was a little room with two bunk beds on either side. In that room I was with a woman with two little girls. So she took a bottom, I took a bottom, and the two kids took the top. But I got seasick the whole ten days. The water and sky, the water and the sky, that's all you see. We reached a point where there was a lot of noise on deck, a lot people running around. And everybody was shouting, "*La Statua di Libertà! La Statua di Libertà!*" Then everybody, "*Oh, grazie a Dio!* Oh, thank God!" There was a woman who came from another part of Italy, and I couldn't understand her at all. She couldn't understand me at all. But at least we had company. So we

went upstairs, and the rich people, the "Don" Smith this and "Don" this and that, had binoculars, and they were saying, "Yeah, yeah, I can see it!" I was saying, What the hell do they see? Everybody's going crazy. So little by little, little by little [soft voice], you started to see this little black spot, and you started to get a funny feeling. And that spot started getting bigger and bigger and bigger [crying]. She [the statue] got nearer. We started seeing all the seagulls, and they're getting bigger and bigger. Until you saw the Statue of Liberty. And you say to yourself, thank God, thank God.

When I found out my sister Joanna was coming to America, I told my uncle who I was living with that I didn't want my sister coming here without me there. I wanted to be there in New York, right when you come down that plank because I wanted Joanna to see me and she'd feel safe. Because when I came all I had was grandfather's umbrella, and that was my family. Everybody had somebody there in the family waiting for them. And everybody was shouting out names. And then everybody was gone, and I was left there sitting on my suitcase and the umbrella.

I was looking out, and it was getting darker and darker. I had the green coat my mother

made for me with two pleats on each side and big white number tag. So when you got off the boat when people were looking for you, you had to have that number. Maybe they put that number on me because there was nobody there to get me. I was left on the docks alone. There were two old ladies left, and an old man. I was so hungry and scared. I said, Gee, how can I get back home swimming in ten days?

Here I am fifteen years old. I remember my mother putting fried chick peas in a towel in a corner of my suitcase and saying to me, "If you should get hungry, I'm putting these here in the corner of your suitcase, take them and eat." I was waiting and waiting, so finally I didn't know what was going to happen to me, and I see these three people waiting for their family. I opened the suitcase to eat some chick peas. When I opened it, wouldn't you know, it was all moldy after ten days. I couldn't eat them.

So finally this man came over, and there was an opening in the wall where cars came in and out to pick up the suitcases and trunks. This man, a cabbie, came over, and I couldn't understand him, I didn't understand English. Then he motioned to me for money, and I had American money, but I didn't know how much because my father told me how to exchange for American money on the ship. He took all my money and said, "Come on, come on." So the old man and the two old ladies got in the cab.

We got through New York, the lights and everything, and I was all eyes. He told us to get off, and I went into this room with benches all around, and you sat there. And I didn't know what was going on, and I was doing what I was told to do. So pretty soon there was a place that had a telephone booth, and once in a while it rang, the guy answered it, and the guy called out a name. One by one all those people left. That's what they do. If the family doesn't find you at the dock they went to this place. So I was left by myself, and sat on a bench with my grandfather's umbrella, and I says, Oh God Almighty, I don't know what is gonna happen.

So a guy came over to me, and said in English, but then in broken Italian I understood him to say, "You wait here, we close at nine o'clock, and you come with me. You go to bed, you rest, tomorrow I come and pick you up, and you stay here until your family comes and gets you." I said, "My family? They should be here."

What happened was that they were already there, but because I was sitting they couldn't see

me between all the people. But they told me that they were there. So I waited and waited and it's almost nine o'clock, and I said God knows where I go from here. I remembered my mother telling me, "Write the name and address of your aunt," and she made me put it underneath my stocking in my shoe to never lose it. I knew that I had it but who was I going to tell? Now the telephone rings, and he talked in English, and whatever he said, and then he said, "Amodeo!" Amodeo! That was my name. I got up and started jumping all over the place because I knew somebody was asking for me. The guy came over and said to me, "It's okay, I'm going to wait here; I don't care what time, how long it takes, I'll wait here with you."

I stayed there until my aunt, my mother's sister, Zi' Filomena, came. There was a rap at the door, and when the guy opened the door and I saw my aunt, Oh my God! It was like, Oh God, thank you God. I was so scared. Ellis Island was already closed a month before I got here in 1933.

"He Looked Like a Famous Gangster"

Michael Mele was 105 at the time of our interview. He recalled that when children in the neighborhood saw *a mammàna*, the midwife, coming, "They used to say, 'She's carrying a baby to somebody.'"

They came in steerage. My father resembled a famous gangster at the time. But he was no gangster at all. So one day, when one of the stewards came to wait on these pilgrims in steerage down below, he said something my mother didn't like. And they said, "Hey! Do you know who she is? She's the gangster's wife!" Oh, when he heard that, from then on he treated my mother great, gave her things the other women weren't getting. She got more sauce on her macaroni, he was a real friend.

"They Fell In Love"

The last of sixteen children, Assunta Celotto Sirico learned from her mother how to cook for a large family and later started her own successful catering business.

My father and mother came from Castallamare di Stabia in the region of Campania. They were on the same boat. My great-grandfather and her father [my grandfather] were sailors in the Italian navy. At the time there was a law in Italy that if a man is out to sea as a sailor, and

has daughters, they have to go into a convent because they have to be disciplined like a father while he was away. That was the law of the land. There had to be a man in the house. So while she was in the convent my mother became intrigued, and wanted to be a nun. So she took her first and second vow to become a nun. She was going on her third vow to become a novice, but when she heard her family was leaving for America she stopped and didn't become a nun. So all these years we kidded her, "Hey, mom, you didn't become a nun, but you got sixteen kids. You became nun at all!"

We had a lot of jokesters in the house. My six brothers were comedians. They used to pinch her cheeks and kiss her. My parents met on the boat. She was hungry so my father gave her a banana and she was eating it with skin on it. She didn't know to peel them, and he told her how to peel it. During the trip to Ellis Island he told her he liked her, and they fell in love. They got married at Saint Michael's on May second, nineteen hundred. They had a horse and buggy. My mother gets out of the buggy to go into the church and the horse got wild and ran off with my father. Every time they had an argument, "That horse should have run away and never come back." [laughing] But we were taught by our moth-

er to be good people because she was in the convent, and we learned from her. We were brought up to be very religious and kind, and to always be good to people, and help people who needed help.

"They Came to Negotiate"

Antoinette Tommasi Mazzotta was ninety-six at the time of our interview. She recalled her mother insisting the family spoke *Meliddisia*, the Sicilian dialect of Melilli, at home in Middletown.

My mother came from Melilli, Sicily, from a family of four brothers and two sisters. She came to America when she was fifteeen with her brother Gaetano because she had to see her brother in Middletown. He was going to marry a girl in Middletown who my grandmother in Sicily did not favor. My grandmother sent them here to negotiate and persuade their brother that *nanna*, grandmother, wanted him to go back to Melilli with them. But when they got here, they were already married. It was too late, and once they were here, they stayed for three years.

My mother knew my father from Melilli. My father came from Pachino in province of Siracusa where they made and sold wine. After

he got out of the Italian military he delivered wine from Pachino to Melilli that took overnight to deliver. The whole village knew him. My grandfather Tommasi took care of the prince's grape orchard. My grandfather Falbo, my mother's father, took care of fruit trees and he knew how to graft two or three fruits on a single tree. So the Falbos and Tommasis got very friendly in Sicily because they worked for the same prince. And that's how my mother met my father; the two families got close and that's how she met him.

In Middletown, the Tommasi family baptized a Falbo and a Falbo baptized a member of the Tommasi family in Saint John's Church, before San Sebastian was built. They were so close in their work that they became good friends, and they baptized each other's children. The Sicilians had a name for that connection. You became a *San Giuanne per sette generazioni*, a Saint John for seven generations, which meant that you were as close as a relative for the next seven generations once you exchanged baptisms. When my mother was here during those three years she was anxious to go back. In those times, other fellas used to ask for her, but she didn't want anybody. If she went out with a man it was understood you married that man. If she dated another man, then that third or fourth man wouldn't want anything to do with her. She said she wanted Michele. So my uncle and mother went back to Italy. And my mother married him.

"They Were on the Same Boat"

Rose Serio met her husband square dancing at the Dew Drop Inn in North Stonington. She recalled her immigrant father being impressed with her future husband he called the *soldato marinaio,* the sailor.

My father was from Cefalù in Sicily. He came to Pawcatuck in Connecticut when he was very young. My mother was fifteen when she came from Pettineo in the mountains of Sicily. He stated on registry at Ellis Island that he was staying in New York and she stated she was staying in Pawcatuck. They came to America on the same boat. Her mother sent her because she could have a better life in America. My mother's family owned a small olive grove, and she picked olives, and raised goats to make cheese. That was her life, helping her parents. She had no schooling. My mother came with her cousins Angelo and Anthony Sanquedolce. She went to live on Downer Street, and lived in Ballato's rooming

house for two dollars a month, and she stayed with relatives, the Ballatos, the Gandolfis.

My mother met my father here in Pawcatuck because he knew she was staying at the rooming house. My mother didn't care for him at first, but then they ended up getting married. They never realized that they were on the same boat coming to America. My mother remembered how all the streets in Pawcatuck down to Church Street and beyond was all Italian, and the other side of town was all Irish and Scottish. She used to tell us the story of how people sat in Saint Michael the Archangel Church. One side was all the Italians, the other side was all the Irish and Scots.

"You're Going to America"

Rose Pagano Onofrio recalled her mother's house having a well and no water or toilets in the house. Dead animals were often left in the streets and children could not "wander around." Rose said her mother couldn't believe how clean New Haven was.

My mother, Rose Fanello, came from Favara, Sicily in nineteen ten, when she was twenty years old. Her mother, my grandmother, was nursing her under a tree in Italy, and saw a snake, and was very stressed out because it looked like it was coming toward her. She blamed that on her lameness. She used to throw that leg out, but she walked all over, and didn't sit still. And later on I took her to New Haven Hospital at the time and the doctor said, "That wasn't a snake. That was polio, and you're lucky to be alive."

She sewed all her life, and she was really good at it. She sewed making men's suits. She had a Singer sewing machine. That was her only pleasure. She grew up doing what her parents wanted her to do.

Her father wouldn't let his children out to experience anything. If the girls went out for a walk at night, he sent one of the brothers to walk with them, no matter what they did. They were always looked after, and not really on their own. In the meantime all her sisters were getting married and her father thought, she's hitting twenty, and she's not married yet, and she's not the best looking woman in the world, and she's lame.

So my father found a groom for her. He was a farmer, and came all dressed up, or so he thought he was dressed up, with a rope for a belt and rope holding his shoes together, and he stuttered. So my mother said, "I'm not marrying him no how!" And her father said, "Yes you are," and he bossed her into going

into the city hall where they had to sign their marriage papers. But she told her father, "I'm not going to marry Pasquale, I don't care." He said, "He's bringing you a dowry tomorrow." She said, "That's all I need, a dowry! I'm not marrying him."

Her father got so mad that he took the sewing machine and threw it out in the road next to a goat. My father was embarrassed. Everybody in town was talking about it, that she wasn't going to marry this good guy who was supposed to really take care of her. My father was ashamed. He told her, "You're going to America and that's all there is to it, you're going to stay with your two brothers in America." He packed her up and sent her off to the United States to live with her sister and two brothers on Fair Street in New Haven. He put twenty-five dollars in her suitcase, but somebody stole it when they were inspecting her bags at Ellis Island.

The trip in took forty days in steerage, and it was terrible, and everybody threw up as the boat rocked back and forth. She was really sick from it. The only time they came up from below was to eat at tables because there weren't enough tables below. There were more people than tables. When they put the food on the table it fell off. And being on deck was worse because she saw the waves at her face.

Her brothers weren't much better to live with than her father. She walked home one day from the shirt factory off Wooster Street in New Haven, and some guy whistled at her. And she bragged about it. Her brother said, "Why did you let him do that?" She said, "I didn't, but wasn't that nice of somebody thought I" . . . and her brother took a beer pitcher and broke it over her head. He was just like his father. He got tired of supporting her and found a widower to marry her, which was the best thing he did. She liked him a lot.

"They Buried Them at Sea"

Norma Barbieri received her name after her father saw the opera *Norma* in New York. He told his wife, "Filomena, *scurdatelo* [forget the name] Angelina, Giuseppina, o Catarina—it's gonna be Norma because I just saw the opera *Norma*, and it was magnificent! Filomena answered, "How do you know if it's a boy or a girl? He said, "*No è femina, si, Norma,* no it's a girl, Norma."

My mother was born in Buenos Aires, and she spoke Spanish and Italian. Her mother and sisters lived there. The economy was so poor

in Italy at that point that when my grandfather married my grandmother, they moved to Buenos Aires, and had seven children. Foolishly my grandfather had signed them up at the *municipio*, the town hall, and the sons automatically became citizens of Italy. The war broke out, and my grandmother never forgave my grandfather for having done that because they never would have touched her sons. Two of them were drafted, and her first child was killed at nineteen. She was never well after that. So consequently that was a very sad time for my mother; she loved her brother. He was very handsome; all of them were.

In 1911, they went back to Italy. My mother told me how horrific the voyage was: they were in steerage with close to a hundred women down below on one side, all the men on the other side. They got sick, and their babies got sick and died. One woman in steerage with them lost her baby, and they threw the baby overboard because that's how they buried anyone who got sick and died at sea. It took twenty-eight days to get to Italy. And then my mother came to America with her two brothers and parents. When they got to Ellis Island after leaving Italy she said they were so frightened that they would find something wrong with them and send them back.

"I Wanted My Shoes"

Rita Restituta Ruggiero was born in the town of Isola Del Liri in the region of Frosinone in 1912. She left for the United States when she was two years old.

My mother and I came over in steerage in nineteen twenty-three. When we came over in steerage there were no private cabins or anything, and my mother put me to sleep one night. Luckily my mother and I were on the lower level. I insisted on getting out of bed because my shoes were on the floor. My mother said, "*Addo vai?* Where are you going?" I said, "*I' voglio le scarpette*, I want my shoes." She said, "Oh." To think that I was so frightened because everything was so strange. And I just picked the shoes up and put them under my pillow because I was afraid. I was a frightened child. I thought they were going to take my shoes away from me.

We were so poor. The visualization that I have is always being below deck in steerage. My mother talked with the ladies on board ship. But we were children, and we just got together, and we played. A child can pick up anything and play with it sitting on the floor in steerage. We watched a story about Ellis

Island on television, and I had it all in my mind. It was like I was just coming to America all over again. I could remember where I sat, the room. Also how I cried because my mother Antonia loved long hair, and I had a lot of hair. And when I got to Ellis Island . . . in those days you could not get off the boat if there was something wrong with you, minor things. They went through your hair with those combs to see if you had any bugs. and I had so much hair, and all I could remember was them tugging at my hair, and my mother's sad face looking at me because I was crying as they were tugging my hair. My poor mother was shaking her head, and her poor Rita was having a problem with them tugging at my hair. They didn't cut it, but she was really scared because if you had a physical problem, if you limped, they could send you back.

"I Almost Had No Country"

Mary Ruggiero was ninety-six at the time of our interview. She recalled her father's special mare that could get him from the farm in North Haven to the market in New Haven in fifteen to twenty minutes. She remembered a time when Pepe's pizzeria had no seats for customers, "They sat on flour bags, often having to brush the flour off their suits."

My grandmother said it was a cattle ship, it was horrible. My mother was a little girl. She was so frightened with the ocean. It took them quite a while, a month to cross. That's why they never wanted to go back anymore. My mother got sick. She got pretty good care later, though, because she went back with my father in 1913. She was pregnant with me on the way back to America. She got here just eleven days before I was born. I could have been born on the ocean. I would have had no country! [laughing] and she got the best care because she was pregnant. The captain gave her the best food, she was so pregnant. She never said too much to me about Italy. She would never go back. They loved it here in North Haven.

"I'll Never See You Again"

Joe Carbone, Mary Carbone, and Kathy Bozzi recounted the story of their shepherd father from Castello Pagano in the region of Campania. Tending sheep one hot day, he drank too much wine, and his donkey had to show him the way home.

My father was a shepherd. The night he left from Naples for America, his mother was fixing his tie, and she gave him a hug and a kiss. And she said, "I'll never see you again." He never

went back to see them again. He never saw his mother and father again. I remember when he got the letter that his mother passed away. He was reading it at the kitchen table, crying.

"You're Going to America"

Anna Aiello said her father was known as "Black Andrew" because of his dark olive complexion. He made "eggs in purgatory" on meatless Fridays, a marinara sauce with whole eggs.

My mother Adeline didn't like Italy, and she never went back. They were poor. She very seldom talked about the past. Of course she worked hard in Amalfi. She used to crochet socks, sweaters, and bedspreads, and she would go and sell them. She had no patterns. Her grandmother made her work, and she used to wake her up at five o'clock in the morning to finish up her work. She'd look at it and make whatever just by looking at it.

She had a boyfriend. He loved her. And they [people in town] told her mother that he had a woman's disease. But it wasn't true that he had a disease. So she was forbidden to see him again, and she couldn't marry him. He tried to come over and convince the fam-

ily, but her father told her, "You're going to America. There's a guy there named Andrea who wants to meet you. You're going with your brother to marry him."

There was a storm on the ship, and she threw up all the way to America. She took the *Richard Peck* from New York, and it landed in New Haven harbor. And when they were about to get married my father said to her, "What's the use, we're getting married tomorrow. Let's sleep together." And my mother said, "That's it! Until we get married, I'm staying with my aunt! I'm not coming back to our apartment until we get married."

"From Melilli to Middletown"

Pat Damiata Bourne described Middletown's thriving industry, with a big Goodyear factory, Walter's Belting, which manufactured belts for parachutes, and the Russell Company, which made ties. She remembered elderly Italian women making tomato sauce in big black cauldrons outdoors on open fires, and porches hung with tomatoes and peppers, often with wooden boards for making *strato*, tomato paste.

The connection between Melilli in Sicily and Middletown began when Angelo Magnaro, a

stowaway from Melilli, tried to avoid going into the Italian army. He boarded a train from New York to Boston and got off in Middletown, in eighteen eighty-six, because it seemed like a nice place to stay. This immigrant got settled without knowing anybody, and eventually began sending for people in Melilli telling them, "I'm here, and I can help find a job," because there were a lot of jobs available for unskilled laborers. There were a lot of stonemasons from Melilli who could work at building Wesleyan University and the Connecticut State Hospital.

My grandfather was one of five boys. He was the youngest, and they came before World War One. He came over but his mother missed him, so they sent him back, and he got drafted in World War One, and ended up serving in the Italian army. When the war was over, he came to Middletown in 1919 because his brothers were here. By that time my grandmother in Melilli had an older sister who had settled here. She was about eighteen or so in nineteen twenty, both her parents were dead, and all she had was a piece a cloth clipped to her that said "Middletown Connecticut." So she came over with another family and the Imme family here helped her to get here.

They took the ferry from Messina to Brindisi, and there they were given medical examinations. When they got on the boat to leave Italy, the woman she was traveling with wasn't allowed to make the trip because of an eye infection, and they knew they wouldn't be able to get through. So at eighteen she had to make this decision. Either she had to stay with the woman, who was the mother of the group, or go on by herself, and trust that she would make it okay. And she just got on the boat with this group from Melilli, but alone really, with no immediate family, and came to America with this cloth attached to her.

When she got here she was really scared to pass through Ellis Island and be inspected for anything wrong medically. If there was any suspicion, they sent you back and there was always that fear of going through. She was coached, and people told her, "Make sure you know your name. Practice. Make sure you know where you're going." But that fear of, now I got here, am I going to be allowed to stay? Then someone put her on a train. She had a trunk with her name with "Middletown Connecticut" written on it. When she got off the train and met this man here at the railroad tracks at the bottom of Ferry Street in

Middletown, it was her brother-in-law, but she had never met him, and she didn't know who he was. But this man said, "Are you Rose Morello?"

I can't imagine this eighteen year old, coming out of this little town, and embarking on this adventure, and going through all that, and then being able to get here. The courage and the strength of those early people.

"She Lost Her Children"

Teresa Grazio recalled bringing lunch to her father at Sargent where he worked as a buffer.

My mother, Maddalèna, went back to Amalfi, Italy, with two little children in the late eighteen hundreds. And when my mother went, my father didn't want her to go, and he said, "Well you could go, but you're not taking my children." But anyway, my mother won out. She went with Michael, who was seven years old, and my sister Teresa who was five years old. On the way my brother got some kind of a disease on the boat, and had to be buried at sea. And of course that was a big tragedy to my mother. She got to Italy to see her mother, and while she was there my little sister—they didn't inoculate children at that time—they didn't have the vaccine. So my little sister died in Italy with a tropical disease, and my mother was left with no children. And she didn't want to come back to America. She was afraid my father was going to kill her. Because he didn't want her to take his children. So these things happen, and she came back to America. And she started another family. She had me, another Teresa, and another Michael, which was my oldest brother. We were eight in my family. She had a very unhappy life, but yet she was a happy lady. She buried three of her older children. Very sad, plus the other two children she lost from the trip.

Pioneer Italian Women

A New Life in Connecticut

In the late nineteenth century, Costanza Berretto, a diminutive dark-haired, round-faced woman left Scafati, a few miles from the ancient city of Pompeii in the region of Campania. She joined legions of vibrant women of southern Italy whose life trajectories in America would challenge many stereotypes about Italian women. Costanza settled in New Haven's Wooster Square neighborhood on Green Street amid the heavy concentration of newly arrived immigrants from villages along the Amalfi coast—Castellmare di Stabia, Scafati, Atrani, Amalfi, Ravello, Maiori, Minori, Positano, and Sorrento. Within a few months of her arrival, a matchmaking cousin introduced her to Dominic Berretto, a railroad laborer, who became her future husband.

In the 1920s and '30s, many Italian men employed in low-paying factory, building trades, and laborer jobs faced Connecticut's harsh economic conditions. Fortunately, the women of Costanza's generation carried more than dowries in their steam trunks. Many transported a wealth of work experience from Italy as small proprietors of stores, seamstresses, and midwives.[1] As many Italian women like Costanza entered the workforce in Connecticut's thriving industries—rubber plants, corset factories, shirt and dress factories, and brass manufacturing—they became breadwinners, helping to provide basic necessities for their families. With the strong work ethic they inherited from southern Italy, wage-earning women worked tirelessly at their jobs, with enough stamina left at the end of the day to cook dinner for their families. Their expanded roles as working mothers altered the Southern Italian code of female deference to patriarchal authority. Once in Connecticut, economic need overcame male opposition to women working outside the home. Some opened boarding houses, offering single men home-cooked meals and laundry services for weekly cash payments. Others with prior experience in Italy as shopkeepers converted street-level rooms into neighborhood grocery stores or millinery shops. Some became midwives providing medical advice, filing birth records at City Hall, and delivering children

for substantially lower prices than local doctors.

With three children, Costanza used her premigration experience as a seamstress to find a job as a sewing operator making pajamas at May Undergarment. When a neighbor told her of higher wages at Gottsagen and Kaufman, a factory closer to home on Franklin Street, she took a better-paying job as seamstress. Costanza became a part of a growing female workforce in the 1920s at the epicenter of New Haven's garment industry. She earned five dollars for a fifty to sixty–hour work week sewing and assembling men's pants.

Italian women played critical roles planning long-term economic strategies that would guarantee the survival of the family. As soon as Costanza's first daughter Josephine turned fourteen in 1933, she left grammar school to work with her mother. A few years later the next oldest sisters followed Josephine's path to the factory. Young working girls followed Italian family custom in the 1930s, handing their weekly pay envelopes to their mothers. Costanza wisely managed the family economy, collecting five dollars from each envelope to pay bills, setting aside an equal amount for the dowry of each daughter. She told her daughters they could keep any change left over in the envelope. Unfortunately for young Josephine, her weekly earnings always amounted to an even five dollars, with a few pennies left over. After months of penny allowances, Josephine stopped at the factory office, and asked the secretary to change the five dollar bill into four singles with a dollar's worth of change. When Costanza opened Josephine's envelope, she mildly questioned why there was so much change. Josephine told her, "Oh, well, that's the way they gave it to me." Costanza, a working woman who understood the misery of toiling long hours under sweatshop conditions, let Josephine keep the change.

Like many Italian women, Costanza had deep faith in the miraculous healing power of saints. She contributed to the social, religious, and cultural milieu of New Haven's Wooster Square neighborhood by organizing the yearly procession of the Society of the Santissima Maria delle Vergini, the patron saint of Scafati, her hometown in Italy. Costanza encouraged society members to invite everyone in the neighborhood to march in the procession following the special mass at Saint Michael's church, where Nick Caruso played his soulful trumpet from the choir loft and choirgirls sang songs in honor of Santa Maria. Society members dressed their children in white to replicate the color of angels. Holding hands with their proud parents, they marched through the streets of the Wooster Square community, crowded with the neighborhood faithful. In one of the most vibrant Italian American communities in Connecticut, with over

eighty mutual benefit societies and many religious feasts, people in New Haven considered Costanza's "the best procession in the whole neighborhood."

By the 1940s, Costanza decided to stay home to raise her eight girls, minding the eldest who were approaching marriageable age. Italian American factory girls worked in a network of women who formed relationships based on ancestral villages. Young working women often met husbands through trusted female intermediaries, usually a close friend who wanted to match a brother to the right girl. In 1944, at the summer feast of Saint Andrew in the streets of the Wooster Square neighborhood, Josephine's work partner, Millie Gargano, brought her brother Andrew, a fisherman who plied the waters of the Connecticut Sound, to meet Josephine. The two married on April 12, 1945. At their wedding reception that afternoon, a moment of silence was observed for the death of President Franklin Roosevelt.

Josephine inherited her mother's legacy as a pillar of her community. An ardent follower of Saint Anne, she kept Costanza's tradition alive. On July 26, the feast day of Saint Anne, Josephine held a religious ceremony in her backyard on Green Street, the culmination of the nine-day novena of devotional services to the saint. At the end of the service, a little girl chosen from the neighborhood, dressed in white, walked down the red carpet to the makeshift wooden altar decorated with fresh flowers, and placed a crown of white roses on the statue of the saint. After the ceremony, Josephine opened her home to neighbors and friends, including the parish priest who presided over the novena at Saint Michael's church, and twelve Sisters of the Apostles of the Sacred Heart who lived nearby. Toward the end of her life, Josephine often expressed her undying loyalty to her church, family, and many friends of her beloved Wooster Square neighborhood, telling her children on many occasions, "As long as I can wake up and see the dome of Saint Michael's, I'm happy."

"She Was the Daring One"

Theresa Grego was ninety at the time of our interview. Her uncle Luigi from Amalfi opened "Buonocore's," the first Italian-owned sewing factory.

Maria Louise Nastri, my grandmother, came here first in nineteen oh-six. She was the daring one. She came to make sure before the rest of the family came here so that they could get settled. She was the pioneer. She had no one here. She heard this was the land of opportunity. Things were bad in Europe. From Italy

they went to France and lived there. Then she decided to come here.

"They Were Pioneers"

Angelina Baldino began working right after grammar school in 1930 as an examiner in a dress shop in Bridgeport. She earned thirty-five cents an hour working from eight to five.

My grandmother had to go to South America before she came to Connecticut because her husband left her with two kids. She told us about working in the fields, and how a snake was going after her daughter while she was drinking milk. I felt so sorry for her. She had a spinning wheel, and she knew how to weave and spin the fleece from the sheep into yarn. She had teachers who taught them how to sew, tat, to crochet, and sew on a machine with a foot pedal. She made patterns out of newspaper. They had a tough life.

When I was young I got so disgusted with my mother and grandmother because I had to be the interpreter. When I was ten years old they used to take me by the hand to the bank, and I had to talk to the teller. I had to put the bank book in front of the teller. And I used to go home and say to myself, Why can't they be like all the other people? I always have to come and talk for them. My grandmother had a way of going to Mister Leventhal, the Jewish man who owned the furniture store. She'd say, "*Dici che voglio dare quindici pezz,* Tell him I'll give him fifteen dollars cash for that!" And I had to tell him, my grandmother says she'll give you fifteen dollars for that. He said, "Oh no, you're crazy." Then she'd say to me, "Okay, come on," and she'd take me by the hand and we'd go out towards the door. He used to call us back, "Tell her I'll give it to her for sixteen." So I'd say, to her, "*Isso ha ditt che vuole seidici pezz,* He says he wants sixteen dollars." She'd say, "Alright," and take the money out and give it to him. Now that's embarrassing! Imagine bringing your daughter to negotiate.

Now I could kick myself. Now I realize these people were pioneers. They came to a strange country, couldn't speak the language, never went on welfare, never had any help, and they built their own houses. My grandfather even built his own store, and they did whatever they could. It's amazing what they did! I could never do it, me the smart one who thought they were so backwards. And I still feel so guilty about that, even more so now. I

can visualize it now, and say to myself, How could you be so mean? I used to do it because they made me do it, not that I wanted to do it. My grandmother used to say to us, "When you don't owe anybody any money, you can look at them straight in the eye."

And we had all these Irish people around us. A lot of people had to change their last name, even though they spoke English. Like Baldino was changed to Baldwin, Missus Lattanzi changed her name because they couldn't get a rent. Some people cut their names short so they could hide their Italian identity. She used to say, "Don't worry about them, you don't owe them anything. Walk right by, if they speak to you, fine. If they don't, fine. You don't need them. So they gave you a little boost, you know.

"Why Should I Go Back There?"

Betty and Angie Paul's father worked on the Brooklyn Bridge and couldn't take his "gators" off because they were frozen to his feet. The family moved from Brooklyn to Bridgeport in 1919.

My mother Saveria came from San Biase in Calabria around the turn of the century. She told us about her life there. It was hard work. She left in the morning when it was dark and she had to walk for two hours to get to the owner's property where they picked and filled up bushels of olives. Then it took them two hours to walk back home. So she left when it was dark and got home when it was dark. Years later I'd say, "Mamma, don't you miss the old country?" She said, "Are you crazy? I live like a queen here in this country. This is the most wonderful country that you could live in. Why should I go back there?"

"Why Couldn't You Mind Your Own Damned Business?"

Vincenza Parise told the story of her son Joe being scared watching a horror movie on televison. Her mother comforted her young grandson, saying, "*Mette paura alla gente vive, non mette paura a chilli morti*, Be afraid of the living, not the dead."

My grandmother didn't like it here in New Haven. My mother called for her. She liked her *paese*, town, in Italy. The church was right there, all her *paisans*, friends, were around, and she wanted it like you open the door and you go to a friend's house. She couldn't get used

to it here. When we were small my brother and I weren't going to school yet. We were living on Collis Street, and my grandmother and her *cumare*, her close friend, we were going to church. The *cumare* had her two grandchildren, and my grandmother had my brother and me. I was four, and my brother was five. So when we got out of Saint Michael's Church, we go to see the statue of Columbus on the Columbus Green in the park near the church. We didn't know, we thought it was a saint! [laughing] So, I told my mother, "Ma, why did we go near Columbus?" She said my grandmother and this other *cumare* used to go there and say, "Ah, *Columbo, perche non ne ha fatt í cazzi suoie? Tu ha sbattut mamme e figli!* Hey, Columbus, why couldn't you mind your own damned business? You broke up so many mothers and children!"

"We All Became Protestants"

Florence Fusco was ninety-three at the time of our interview and had worked until eighty-eight as a seamstress at J. Press in New Haven. Her uncle Luigi Fusco had been trained as an artist in Italy and painted the magnificent ceiling of Saint Anthony's church in New Haven.

My mother took care of the house and went to church because it was right in back of her. She cooked, cleaned the house. She had a garden she took care of. That's all she used to do. My father in Vitulano, near Benevento in Campania, used to say to her, "*Perche tu vai a chiesa sempre, e non esce. L'ommo vanno al bar e parlano a tutti quand. Tu fai nient, vai a casa e a chiesa, a casa e a chiesa,* Why do you always go to church and stay home? You're not like a man who goes to the bar and talks about everyone. You don't do anything but go back and forth to church." She was happy. She even belonged to the Children of Mary Society for the children.

But then when she came to New Haven in the eighteen nineties, it changed all together. The first Sunday she was here, she went to Saint Michael's church. At the door, you have to put the money in. So she didn't know, and she just walked into the church. She sat down, and so when the priest walked in, the church was crowded, and everybody was sitting down. The usher came down to her, tapped her on the shoulder, and said in Italian, "You can't have that seat because you didn't put the quarter in at the door." So my mother left and she said, "Gee, he embarrassed me." She was

embarrassed because there were people from the neighborhood she knew personally. So she got up and she said, "*I' non sapeva che stev a rienn a nu teatro, I' credeva stev a rienn a casa di Jesu Crist!* I didn't know I was going to a theatre, I thought I was entering the house of Jesus Christ!" Then she did the black sign of the cross, and she said, "*Croce nera!* A black cross." No more Catholic church. And she never went back. They got married in the Church of the Redeemer on Whitney Avenue. And we all became Protestants. So I don't know the first thing about the Catholic religion.

"She Was the Matriarch"

Betty Panza:

One time my mother sent my sister Jenny to Saint Michael's church to get her baptism certificate. The priest said, "You have to pay a quarter." And my sister said, "I don't have a quarter." He wouldn't give it to her. So my mother went down there. He said to my mother, "*Graziel, tutti adda paga venticinque soldi,* Everybody has to pay twenty-five cents." She said, "*I' manco teng venticinque soldi, teng sei figli,* I don't have twenty-five cents, I've got six kids." She took the umbrella and hit him, "*Chest è venticinque soldi!* Here's your twenty-five cents!" Boy he gave her that certificate pretty good. That's the truth. She came home and told my father, "*Dat a nu' gazz e paliàta,* I gave him a good beating." My father was so mad. They had their quirks and everything and they had their hard times, but they made the best of things, they made things work. My mother was really the matriarch in the family. My father had sclerosis of the liver and died young. Here's the kind of woman she was. My mother used to go to Doctor D'Amico's office on James and Grand and help the doctor tap his stomach to remove the fluids because she didn't have the money for him to go to the hospital. Doctor D'Amico said that he was happy if, "Graziel, just make a *nu piatt í stok e patan,* a dish of dried cod and potatoes," and he wouldn't charge her. Because she didn't have the money.

"Salome"

Michael Mele told me of his conversation he had in the late teens with his friend, Pat Apuzzo. On the way home from school one day, Pat told Michael he

was going home to work on his radio. Astonished, Michael said, "What's a radio?"

When we bought our house on Hamilton Street we didn't have any electricity. Every hallway had a kerosene lamp. Now my mother didn't want me to waste the kerosene, and she didn't want me to read at night. Then we put in electricity. And she didn't want us to waste electricity, but I still used to read at night. When I used to hear her come upstairs, I'd shut it off. And my mother said, "I heard it!" So the next time I heard my mother coming up. I turned the bulb. But she fooled me. She touched the bulb! One time she didn't want us to go swimming. She was afraid. So she asked me, "Did you go swimming?" And I said, no. She said, "Come here!" She licked my arm. It was salty. She used to chase me with the broom.

I was about fourteen when I started doing my own theatrical shows in the backyard. We had a woodshed and I wanted to put on shows. So I got permission from my stepfather. He said, "Yeah, as long as you leave the wood because we need it for the furnace." So I made a floor over the wooden floor and I made a curtain and painted a scene, rolled it up, put wheels under the ceiling, and ran the wheels to back of the shed, and a guy operated it for me. I put on the play *Salome*. I cut a hole, and I got under the table, the audience could only see my head. I had straps holding me. My mother was sitting in the audience. So she yells out loud, "Aye, *si tu cadde malat, ti mando al ospitale!* If you get hurt, I'll send you to the hospital!"

"The Flood of 1938 in Hartford"

Natalina DiPietro graduated from Hartford Public high school in 1922. She played guard on the basketball team at a time when the rules stated that "guards couldn't throw the ball in the basket."

The water went over the first floor window up to the second floor. I saw a refrigerator, chairs, and a couch come by because the furniture store's window broke and all the furniture came out. They came with the boats. We had to get in the boat, and my mother was screaming because this fella was trying to get her out of the window to put her on the boat. By the time we got on my mother was scared. We got to Temple Street and got off. From there we walked way down to my aunt's house on Franklin Avenue and stayed there.

"Garlic and the Spanish Flu in Waterbury"

Vittoria Becce Semprini:

My father used to deliver milk in Waterbury during the Spanish Flu in nineteen seventeen, nineteen eighteen. People used to say that garlic wouldn't let you catch the Spanish Flu. But I realized that nobody's gonna go near you if you're wearing garlic! Nobody in our family got it [laughing]. I guess the garlic worked.

"She Put Him through Yale"

Marion Sperandeo DeNegre often paused during our interview to reflect on her mother's many accomplishments.

My mother decided she had to help her family. They had one son, and my grandfather insisted that he go to college. She said she didn't want to work in the dress factories with everybody else, and she wanted to be independent. My uncle, Doctor Anthony Sperandeo, was the first Italian doctor to graduate from Yale Medical School. So my mother worked at Strouse Adler to put him through Yale. He was appreciative of my mother because they couldn't afford Yale. We have fond memories of our uncle. She actually handed the money over to my grandfather and he paid for his education. After he graduated, and after my mother got married, and she had us children, he had his office in our house. We had a flat. The first two rooms, one was a waiting room, and one was his office. We had the rest, the dining room, and the two bedrooms, and the kitchen. So, from one to three, you don't say a word, because Uncle To' has office hours. So what did we do? We opened the door for every patient that came in, and we'd tell them to sit down in the living room, and they'd wait until the doctor would see them. And from seven to eight at night in the house we couldn't say boo because he had office hours, and then he'd go out to make house calls after that.

"Poor Italian Women"

When Mary Ruggiero's grandfather Anthony died, a team of horses was used to pull the hearse from Pool Road in North Haven to the cemetary in New Haven. Harriet Culver watched his procession, saying she had never seen such a big funeral with "carriages and carriages of people," many of whom he had helped.

Before the Depression, when the market in New Haven closed at the end of the day, poor women would come looking for whatever was left, vegetables that fell on the pavement. Whatever my grandfather had left over, he gave to these women. These women had just come from Italy. What did they have, trying to make a start? They came to a strange land. They had to start from scratch. My father and grandfather were warmhearted and giving.

"We Lived by Sicilian Sayings"

At age ninety-four, Antoinette Mazzotta had a unique way of telling stories, weaving old Sicilian proverbs into her life experiences.

All these sayings, they passed them down from one generation to another. My mother couldn't even sign her name, she didn't go to school, but she taught me more than any teacher. You know what they believed in those days? Grammar school is enough. Now learn how to sew, learn how to keep a house in order, and get yourself a man, and that's it.

I was the only girl, and my mother loved all her children of course, but she was always with me, always telling me different things.

She always made sure to keep me busy all the time. She had an old saying for everything. And we lived by them. When she had to say no to me she'd recite this old proverb, "*Cu ti fa ridere/Ti fa chiànciri/E cu ti fa chiànciri/Ti fa ridiri.*" It meant I didn't have to say yes, yes, yes all the time to you. There's a time when I have to say no, because it could end up that when I said yes, I should have said no because you're in trouble. In other words, if my mother made me laugh all the time, saying yes to everything I wanted, then I might be crying later. I was invited to a party when I was twenty-three, and this friend of mine received a nursing degree, and they gave her a party, and I was invited. And she wanted to know if there were going to be boys there, and I said yes. My mother said, "*No a mammà*, we'll go to the store to buy her a nice gift, and we'll send it to her with one of your friends." Oh, I cried all night, I felt so bad that I missed that party.

When I got up the next morning, she looked at me and said, "*Ma che! Nun pari bedda ma figlia, pari na japanesedda,*" because I had cried all night, I looked to her like a little Japanese girl. But what happened at that party? They decided to go to Savin Rock, an

amusement park in West Haven. They got into a very bad accident, and three were badly injured. In fact, one was lame for the rest of her life. I didn't say anything to my mother. I didn't want to give her the satisfaction. But I thought, my mother's right. She said no, she made me cry, but had she said yes, I would have been in trouble . . . so I was grateful I didn't go to the party.

She'd say, "*Non son li biddizzi/Che ti fanno amari/Si è buoni caratteri/E duci parole,* People don't love you for your beauty, they'll love you for your good character and sweet words." Isn't that the truth? She'd say, "*Sai a mammà? Se trasisse una picciotta, bedda, longu, di facci bedda. Si gràpiri à vucca. D'unni vèni chistu?* You know, say a young girl walks into your house, pretty and tall, with a pretty face. Just beautiful. Then as soon as she opens her mouth, you say, O my God! Where did she come from?" It's true. Sometimes she'd say to me, "*Pinza la cosa/quannu la fai/che una cosa pinzata/È bedda, sai/perché ù primu nun pinza/l'ultimu suspiru,*" and she was telling me think before you say something because if you don't think, you'll end up sighing, why did I do that? Why did I say that? "*À lingua non ha ossu, e rùmpe ossa,* the tongue has no bones but it can break

them. You can say something to me that's so bad that it's like breaking a bone!"

We lived by word of mouth. And I used to tell my daughter, if you're doing something, and it doesn't look right, even if you're not doing anything wrong, don't do it. In Sicilian we say, "*L'occhi lu munno/Né vogghianu na parti,* The eyes of the world want to know what you're doing or saying," so make sure it's good. If [your actions] don't look good, don't do it because people will always find that one little piece that doesn't sound or look good. People "*circarino u pelu nell'ovu,* try to find the hair in the egg." Because a person will always find something bad in something that's good. It might be right, but it doesn't sound right. Don't say it. My daughter and other teachers sometimes went out after school, and had a few drinks, and sit around, and I'd say I didn't think that looked good. My daughter would say, "But we're not doing anything wrong, Ma, we're just talking and laughing." I'd say that doesn't look good, you shouldn't be doing it. No one will ever say "*Nudu ti dice lava la facci che pare chiù bedda di mia,* Wash your face so you can look better than me." People always observed the kind of people you congregated with. The Sicilian version of birds of a feather

flock together went *"Dimmi cu chi pratichi/Ti dico chi cosa sei,* Tell me who you hang around with and I'll tell what you are." And if you didn't keep the right friends, *"Cui pratica cu zoppu, impara a zuppica,* Whoever associates with the lame becomes lame himself." And my mother always used to tell me, and it's true, *"Cu parra mali a tia, in facci non ti talia,* Whoever talks against you, won't look at you in the face."

"Open House"

As a young girl, Josephine Parlato Bonfiglio once swam across the dangerous currents of the Quinnipiac River in New Haven thinking that her brother had tied a safety rope to her.

Mothers in my mother's generation didn't work. If a mother who just had a baby had to go shopping, she'd give you the baby to nurse, and come back at two o'clock. They'd nurse each other's children. They never worked, and they had one kid after the other. And they were all poor, and not getting any aid, let me tell you. We were called *"I Quattrocento,* The Four Hundred," because we never went for stamps or anything.

Not that we were rich. We struggled, but we always had meat on the table, and we never wanted. My mother at Easter made fifteen pies, it was nothing and each aunt on my father's side got a pie or *ó casatiéllo,* the Italian Easter bread. She'd make so many *zeppole* she had to put paper in the laundry bag and fill it. She bought flour by the sack, crates of eggs came in. We always had a dollar to do this, not that we were rich.

When my father died, he left eight broken hearts and a mortgage on the house. My parents never had a word between them. They never discussed anything. They'd just look at each other. There was that love, that understanding. I never saw my father kiss my mother, they didn't do that. What went on afterward, I don't know. My father would sit down at the table with ten of us around, and never touched his dish until everybody got theirs. And he'd look around. If he didn't think you had enough in your dish, he took some out of his dish and put it yours. He never touched his dish until everybody got their share.

We always had open house. We had a big long table, and having fourteen, fifteen people was nothing. Holidays, the party was at our house. My mother played the guitar, my father

played mandolin, and my sister Phyllis took lessons, and played the violin. They played Italian songs, "Torna a Surriento," and "Wey Marie." They'd clap their hands, stamped their feet, and danced around. Sometimes we had a band come in, and the drummer played "the broom dance," and you danced with a broom. We had a wine cellar downstairs. After the wine fermented, we helped him grind it, put it in the barrels to ferment. Then you put the rubber tube in and sucked it out. Then we filled the bottles. And who had to go and draw the wine? I think that's why I hate wine today.

"The Dream"

Rose Pagano Onofrio spoke lovingly about her Sicilian mother's *minestra cu macho,* a thick soup started with split peas for thickness with added vegetables, beans, and pasta.

My mother had a dream during this one night. She was really scared about something but she didn't know what. She had a dream that there was a cop at the door, and she was saying, "My *picciriddú,* my little one." She asked herself, did Vossia, My Lord tell me such a thing before? Two days after the dream my uncle Carmelo

took my two-year-old sister around with him, as he often did. She had a starched dress on, and they went to Olive Street. They were standing on the corner, and he was talking, and she was talking, and her dress got stuck in the pulley of the knife sharpening machine, and it crushed her to death. They buried the little girl, and my mother was stressed. She had a son Jim after a year or so, and almost ignored him because he wasn't a girl, wouldn't nurse him, and spent her days with her daughter in Saint Lawrence cemetery. In fact some nights they locked her in when they closed the gates.

"Werewolves, Witches, and Holy Bread"

Betty Panza and her sister Fannie Panza Buonome laughed about the days when, if anyone heard someone screaming in the old neighborhood, "they all thought it was just Fannie getting another beating."

When we were kids, and we'd sit around the old coal stove, and my mother and father told us all kinds of stories. We were just kids, and we'd say, "*Ma, dici un àuto vòta,* Ma, tell us the story again." In fact, she even told the same story to her grandchildren, and they used to say, "Nonny, tell me another story," and she'd

tell it to them in broken English. They told us about a road in Italy where my grandfather was sitting on a wall in a village, talking with his *cumpare*, his friend. All of a sudden they saw this man running down the road, a man no one really liked. They said he was a warlock. And all of sudden he went up into the air, and turned to smoke, and went away. My father said his heels hit his ass because he ran so fast. They used to say, "A *verament'*! It's really true!" My parents used to tell us the story, and we believed it.

There was a saying my mother had, "*Mette a scopa 'ncoppa a loggia e nisciuna venne, le streghe adda conta tutte le brisk in della scopa*, Put the broom outside your door, and no one will come because by the time witches count all the bristles on the broom, it will be morning, it will be light, and they can't do anything when it's quiet." And we were kids, we were afraid, and they used to put the broom out there to keep the witches away. They put it out on a day in the spring, and one day in the fall. My mother had holy bread, it was little hard *taralli*, biscuits, and when there was a storm, she put it on the windowsill, and we'd all pray, and she used to say "The Litany" for

the weather. We didn't know what she was saying. That sonofabitchin' broom, every time we went out, it was in the hall.

"A Woman's Journey from Melilli to Middletown"

Anna Ruffino Foreman, Tina Ruffino, and Filomena Ruffino said women in Melilli always used their maiden name instead of their married name.

We left Sicily on the *Andrea Doria* in the nineteen fifties because there was no way to better yourself in Melilli. Women still tended gardens, the chickens, and spent all day washing, cleaning, and cooking. There were no phones until nineteen sixty-five. Every family was known by what they did as occupations. Ruffino is my maiden name, but we're known as *i pisusali*, or *pisusaio*, the salt weighers because they once went door to door with pedal wagons selling salt. My mother's family was known as *i calamari*, because they must have fished or sold calamari. Missus Faino, her husband's family were called *lu nasu* because they had big, long noses. My father wasn't Angelo Ruffino, but Angelo *scuparu*, because he was a

shoemaker. Our mother was a seamstress and her trunk was filled with material to make us our clothes.

Women did not work in Melilli—it was a no-no. It was considered a privilege to work and they wanted to work. They always stayed at home, so it was big thing when they came to Middletown and had to work. When the women left Melilli they knew life was going to be different, they were going to work. To own property was to have security and they were denied that possibility in Sicily. It was a caste system. They came for that opportunity, to better themselves financially. So many people who came here did what they had to do to be able to say, "I own a house."

There was a greenhouse operation in Cromwell called Piersons where they sold roses wholesale and they were recruited to work there. The women called it "*a shop e sciuri*, the flower shop." Other women worked at Carmellina's, a coat factory. It was all piecework and no union. Some didn't like it here and went back to Melilli after six months because they felt they were in the middle of the woods with no one to talk with, no one to have coffee with. When we came here in 1956, the first thing our cousins did was to make us take our earrings off because we were "just off the boat." They did it to protect us so we wouldn't be ridiculed or made fun of in Middletown. When we got older and started dating we heard the story of a non-Italian boyfriend who met his Italian girlfriend's mother at the house. He sat down on the couch and noticed something written on the ashtray in Italian. He asked what it meant. And the girl's mother said to him, "It means 'Any one who comes into this house with bad intentions should immediately drop dead.'"

"A Biancheria"

Nick Aiello and Natalie Aiello Adamczyk:

In the old days this old guy used come on a bike, a Jewish man from New York, and sold bedspreads, towels, sheets, and pillowcases. He came every week on the train with a big package and sell. Your mother used to put *a biancheria*, the hope chest, the cedar chest, and stack it with sheets and towels, and so when you got married, you got your share. He used to come from New York and make the rounds.

My mother used to give the guy two dollars a week.

"They Found Them Jobs"

Theresa Argento recalled Chapel Street in New Haven as "an arbor of elm trees."

Between my father and mother, we had a mini employment office at our store. My father knew the Sargent boys who owned Sargent. My father spoke English, and my mother spoke Italian. So these girls would come from Amalfi, and wherever they needed jobs they'd say, "Antonette, my daughter needs a job, try to find her one." So when Sal DiBenedetto, the owner of Planeta Shirt, used to come in, my mother used to say to him, "*Sally, è venuta questa figliuola d' Amalfi, e si serva lavora,* Sally, this young girl from Amalfi just got here and she needs a job." And Sal would say, "Antonette! Every time I come in here, you're looking for a job! How many jobs do you think I have?" So my mother was a smart cookie, she would say in a calm voice, "Sally, tomorrow I'm making *pasta e fasule.* Come and have lunch and pick out the job." And my father was the same way with the Sargent boys who owned Sargent.

"Don't Dress Me in White"

Theresa Argento:

My maternal grandmother was special, and I was very close to her. I can't remember how many years she was a widow, but she never took off black, with the black "mules," the slip ons. We called them *i chianiel.* She walked with the black apron, and there was always a surprise in her pocket, either a cookie from Lucibello's Pastry, or a couple of candies from my father's store. After my grandfather died when I was eighteen I stayed with her in her four room apartment. I had a little bedroom, she had a bedroom. She used to help my mother in our store, and she learned how to say the cigarettes to the people buying them who worked in the factories. She knew enough how to say Chesterfields and "Lookey Strika." She made the change, a little bit of a thing. And she always used to say to me, "*Figlia mi, quando i' muore nun mi mette in dei panni ianc,* My dear daughter, don't dress me in light clothes when I die." The morticians had shrouds downstairs, but they were light pink and light blue, and she knew that, and she didn't want that. So I drove my Uncle Andrew and Uncle Tony

crazy looking for a black dress. The undertakers didn't have black shrouds. She wanted to meet her husband and God in mourning. We found a beautiful black velvet dress for her. She had everything ready to be buried, the box with all her underclothes, her shoes, a set of moonstone rosary beads that I gave her. I said to her, "À *nonna* [grandmother], what about the rosary beads?" When I opened up that box, I found the rosary beads I bought her years ago.

"My Mother's Kitchen"

Edward Morrone was the last of eight children. He recalled sitting in his mother's busy kitchen as a young boy in the 1930s.

My mother had a wooden rod, like the handle you'd have on a shovel or hoe, only not nearly as long, maybe two and a half, three feet long, and two and a half inches in diameter. It was something my father cut from somewhere; it could have been an old broken shovel, thicker than a broom stick handle. And it was used as a rolling pin because they made their own dough for everything, for bread, pasta. You had to roll it, and she used what she called a *lainatura,* a rolling pin, to roll out the dough.

She needed the whole table to go back and forth. When she made macaroni, they didn't make it just for Sunday dinner, they made it for three Sundays because there were ten of us in the family. She'd dry all the noodles on a makeshift clothesline rope where they'd hang clothes tied between the pillars on the porch. She made polenta with corn meal from scratch. And she'd stand over the stove and use the *lainatura,* the rolling pin, to make polenta the old way, stirring it around and around all day. On occasion if I did something out of the way, it was also something she chased me with, saying "*Ti mette á mazza in cap*', I'm gonna hit you in the head with this thing." So it was used as a *mazza,* kind of a stick as well as for all those cooking needs.

On the south wall of the kitchen was the sink with some rough cabinets over it. On the sink was a pump that pumped up water from an open well outside. The water was great, but every once in a while you'd catch a night crawler coming out of the pump, and into the sink. But the water was good! None of us died from it.

On the west side was the doorway that went to two bedrooms, and on that same wall was an icebox. The iceman used to come. On

the east wall facing the yard there were two windows, and our kitchen table was against the wall between the windows with a little shelf above the table. On Sundays my mother used to make sauce on the stove. My brothers and I kept taking pieces of bread, and sneaking some sauce on the bread. Seeing me do it, she occasionally let out a yell. She'd shout out, "*Eh, mangia! E poi mette ó cazz' ncopp i' macherun'*, Go ahead and keep eating! Then you'll have nothing to put on the macaroni!" But it didn't stop us from doing it. We'd just quickly get out of the house before she grabbed that *lainatura* and come at you! She was pretty good at it, swinging that thing. She'd swing it at your legs because she didn't want to leave any marks. She figured she'd catch you in the legs and get away with it. She was a wonderful, kind lady, and good to everybody. It was just a bit of her upbringing that would come out once in a while.

My father gave our house number forty-two. The Italian National Lottery had a ticket that used to come out; it was called *Biglietto*. Letters represented different cities in Italy, like V for Venice and R for Rome. And then across there's numbers on each of those lines corresponding to each of those letters. For Rome, for instance, there were six numbers going across. And you could make bets on three numbers or for the whole sheet, any city with those three numbers or you bet on a particular city, say Venice, three forty-two and if you named the station and the three numbers you'd get forty-two dollars for a penny. Of course you had to name the three numbers out of six on that station in order to get that. Anyway, there were seven cities down on the left side represented by a letter, then across six numbers. So there were forty-two possible numbers, the total number in the pool was forty-two. And that's how he came up with number forty-two! To this day, if you go down there to Milton Street in New Haven, you'll see five houses, and it's two, four, six, eight, and then forty-two. We didn't even get mail on Milton Street in New Haven. The mailman didn't come down there. We got our mail on Burwell Street, at the Melillo's house, who we knew, and we could go through their back lot to their house. Sometimes we didn't get the mail for three or four days—not that there was much mail coming to us. And the mailman goes there now.

"They Were the Heart, the Center"

Ralph Marcarelli:

When you consider the excellence of these women, the human fineness of them, and the capacity to be self-effacing, is an extraordinary gift, it's truly a gift of humility. They weren't confrontational. If the husband was wrong, they would seek to, in a very political and diplomatic manner, bring about a rightness. But they certainly were not people who insisted on confrontation because of the assertion of their own individuality.

Their individuality was definitely there. These were not women who were under subjection and consequently timorous. They were not timorous at all. Their attitudes in general flowed from their concept of their role. And their role was not an inferior one, not at all. It was a complementary one. They realized just what dignity they had. The expression of that dignity was not an adversarial expression. It wasn't asserted in controversy, it was asserted in quiet everyday attention to what they considered their duty, and the fulfillment of their role, which they fully conceptualized and fully understood and fully practiced.

The women were not visible in the sense that they were publicly visible, that they were few and far between to achieve any positions of prominence primarily because their position of prominence, as far as they were concerned, was their home and family. There too, in the psychology that most women today could never conceivably emulate, they were quite content to play the patriarchal game whereby they allowed their husbands to think in fact they were the real bosses of the house. The women were smart enough to know they were the real bosses of the house. They never said that or demonstrated that. Any intelligent man knew perfectly well he was not, and that she was ceding to him the place of honor. That in fact the mother was the center, the house, the glue, and there was no doubt about that at all. But again it was a society wherein a man had his place, and his place was head of the house. They didn't dispute that, it was a cultural phenomenon, and it was certainly a religious phenomenon.

So that was the role the women played, and almost inevitably they played it willingly. As a result of that you didn't get women prominent in public affairs. You would have to

search few and far between. They were happy with that kind of a situation. If the men were intelligent they recognized the kind of game it was. I use the word *game* loosely. It was far more than that, and it was a modus vivendi. It was a profound philosophy, which came from the culture, which in turn came from the faith and religion. The relationship between the faith and that philosophy lies largely in Saint Paul's Epistles wherein he lays out the role of the husband and the wife. He's pilloried by today's feminists because he tells women to be subject to their husbands. He also tells men to love and take good care of their wives, to treat them very well. Behind that, there are various passages from the Old Testament that describe how marvelous it is to find the virtuous woman, the good wife.

And obviously Saint Paul was an heir of that orthodox Jewish tradition. In his Epistles he outlined precisely what the various roles of husband and wife should be. He does that not merely because there's some arbitrary tradition that says that's the role of the man and woman, but he does it because the husband, the father of the family, is compared for all practical purposes, to God the Father and that's the role model. And the father has those duties

of sustenance, support, and love. The woman is then subject to the father, the husband as head of the household. The Italian women took that very seriously, it was part of the warp and woof of their being, they wouldn't do anything differently, would see no reason to do anything differently. And on the rare occasions where anecdotally you find some holy terror of a woman who did not behave that way, she was clearly the exception and not the rule.

So we find that philosophy deeply ingrained, but the wife was smart enough to allow the husband the world, to think that he ran the entire household. And again, if the husband was intelligent, he certainly would have great peace in the family, understanding that in fact she was allowing him to do precisely that. In the main, the husband gave enormous deference to their wives because they recognized that even if they didn't articulate it, that the wife, the mother, was the center, the heart of the household at least in Italian families, and many other families.

Anyone who has lived long enough knows that the kind of unity which you find in intact families, certainly Italian families, and the family home was a headquarters. And that head-

quarters continued even after the marriage of the children who left and set up their own households. The famous Sunday dinners where everyone came back every single Sunday with the patriarch and the matriarch. I think it's a matter of common experience, certainly mine, that when the mother dies, slowly but surely that unity dissolves.

"Sunday Mass in Southington"

Alphonse D'Angelo said one of his chores as a boy was to bring fresh figs to all the Italian women in Southington.

We lived on the end of Bristol Street in Southington, and our church was nearby. Any given Sunday morning there were anywhere from twenty to twenty-five people that stopped at my mother's house. My mother would make dinner, but she always had a huge pan with sauce and sausage and meatballs, a big loaf of bread, a big urn of coffee. And people stopped in after church. They didn't knock, they'd come in, cut the bread, make a sandwich, they would chat, and then leave. Next mass, same thing. They talked about everything, but what stands out in my mind was World War Two

when I was a little boy. My aunts hated Roosevelt because they used to say he sent their sons to die. They didn't think in terms of the New Deal. All they knew was that their sons had to go to World War Two.

"Baking Bread in Southington"

Alphonse D'Angelo listened as Florence DeFeo recited her mother's saying for daily housecleaning, "*Fatt ò liet/scopa a casa/che nun sa/chi trase,* Make the bed, sweep the house, because one never knows who may come in."

My Uncle Antonio D'Angelo had a big brick oven in the backyard on Beecher Street in Southington. Once a week all the women from up the hill came down to bake bread, with a big wooden board on their heads, a hand on their hip. Missus D'Agostino, Missus Perrillo, Missus DeSorbo, the Galliettes, they'd take a dishtowel, and put it on their heads like a turban, and then they'd cover the dough, come down the hill to bake their bread. They brought their own wood, and they would chat and gossip. My Aunt Fortunata used to love to tell dirty jokes in Italian dialect. Whenever they said, "All right, you kids, go over there!"

And the kids would say to me, "How do you know that?" I'd say, because they don't want us to hear. And the women would talk and laugh. We kids used to love it. We played, and the women said, "Well, here you can have a little piece of bread."

"No One Will Tell You to Wash Your Face"

Ralph Marcarelli:

They were magnificent women. I'll be grateful to God till the day I die, and really for all eternity because if I get to heaven it's going to be a result of the women more than anything else in my family. They were guides, they were supports, they were comforters, they were encouragers, and they gave you cautionary words as well.

My great aunt whom I called "Zi'-Zi'," she and my grandmother were sister-in-laws, and they lived in the same house for forty-five years with not so much as a cross look, much less a cross word. And I loved her enormously, and I happened to be the first of my generation and male, so you can imagine as far as they were concerned the sun shone on me. I'd come back from Hillhouse High School, and I'd go to my grandfather's house every day coming back from school, and I was always in the thick of everything. So I'd come in, and I'd say of a particular day, you know, "Zi'-Zi', today I got elected president of the class or chairman of this club and so on," and of course my aunt was delighted but she'd say to me, "That's a nice, *pero nun ti scurdà, nisciùno ti dice lavata à faccia che pare chiù bella e me*, Don't forget that no one is going to tell you to wash your face so you can look better than me."

As I got older I understood the immense wisdom of that because she wasn't talking about the open and obvious envy that people might have, stabbing you in the chest. She was talking about that kind of passive envy, which if a person sees you having finished dinner with spinach in your teeth, won't tell you that there's spinach in your teeth. And not certainly for any sense of delicacy, but with the notion of why should I tell him something to make look better than I do? And that was a proverb. They understood the malice of the world if you had precocious talents, and they wanted to protect you. Italians are people of enormous talents and virtues, and some enormous vices, and the worst of that is mutual envy. That's rather typical of human nature;

however, it seems among the Italians to be foremost.

So there were things like that they would give you because they were schooled in millennial wisdom which expressed itself in aphorisms and in maxims. And they would caution you, having lived. They led an entire life, and raised entire families on the basis of that wisdom and those maxims. I say again that if, God willing, I get to heaven, it is because of them, that immense love and marvelous example of kindness and charity unlike I've ever seen.

I was with that same great aunt when I could not have been more than four years old. The doorbell rang at two or so in the afternoon on a summer's day. And I tried to go along behind her as she went to answer the door. I instantly hid behind her skirt because this fearful looking man was standing there, and we'd call him a bum, all dirty and disheveled. And he said to her in Italian, and it was a great rarity to see something like that, "I am hungry." Without a moment's hesitation she said, "Come in." She brought him first to the kitchen, and she handed him a towel, and said, "Go into the bathroom and wash your hands." And she proceeded to cook for him. Sat him at the table. She didn't know him

from a hole in the head. I could never forget it because he scared me being a little kid. He was a frightening sight. My aunt was alone. She wasn't in the least bit frightened. She didn't just hand him a dollar bill, she cooked for him! So you know those things stay with you always. And that comes from the notion often repeated that this is the way you treat some stranger at your door because that stranger could be Christ.

My aunt "Zi'-Zi'" used to read the New Haven *Register* every day as best she could. She could read well enough but when she had problems, if I were there, she'd say to me, "*Zi'-Zi', viene ccà, spiegami stu fatt*, Come here and explain this to me." And I would do that. And one day she asked me to do that, and I went over to her. There had been a crash of an Israeli airline, and forty-two people were killed. As soon as I told her she said, "*Oh, poveri Cristiani*, Oh, the poor Christians." And glibly I said to her, "*Ma Zi-Zi', chisti non son Cristiani, chisti son Judea*, But aunt, these people aren't Christians, they're Jews. She said, "*Sempre Cristiani sono*, Oh, but they're always Christians," meaning in the same sense that Christ said, "Whatever you do to the least of my brethren, you do unto me." "*Sempre*

Cristiani sono," they're human beings worthy of compassion and everything else under the sun.

"Italian Women"

Alphonse D'Angelo, Florence DeFeo, Jean Simone recalled the Depression and the local Protestant church sponsoring parades through Southington to attract converts. They offered Italian families food if they joined their church.

The most powerful person on God's earth is *una nonna Italiana,* an Italian grandmother. Italian women are very smart. They make their men think that they're the boss, but every Italian family I've ever known, it's always *la mama* and *la nonna,* the mother and the grandmother. She could tell you who your twenty-fourth cousin six times removed is, which family married who, and what they did eighty-five years ago. And you better not cross her. I've seen that all my life. My father was blah, blah, blah, but my mother, very quietly, made the decisions, where the money was going to be spent. You can make any Italian man on earth cry by playing the song "Mama." Every man in the room will start crying. Italians are mama's boys, they really are. It's always *figlio a mammá,* mother's son. I can remember my father, when he was dying, and who did he call but his mother, "Ma, ma, come and get me!" My husband too. That's what he said until he died, "Help me! Help me! Only you can help me!"

"Pass on Our Good Traits"

Diana Avino:

My mother would always say, "Teach your children our good traits." Because she was a very smart woman. Not everything about family is good, and you needed to weed through that. What were the good traits? She said that to my daughters when she was dying. They wanted us to keep going with the good traits and leave the rest behind. They knew nobody was perfect, and they knew what they came from, that they were not educated when they came from Italy, and they knew they were doing all kinds of things to make money. Family life wasn't easy. Obviously for somebody like my mother who didn't even know her father for the first five years of her life. Think about that today. You'd think, oh my goodness, it's going to be a dysfunctional family not knowing their

father. You had people moving from Italy, and being uprooted from their families, and they came here to try to regroup themselves. Not everything was going to be good. And it wasn't like, Oh you're Italian, welcome to the city of New Haven. It was hard. And that's why she'd always say, "Pass on our good traits."

"Make Believe You're Crying"

Anna Calabrese Sagnella was eighty-nine at the time of our interview.

We would always do things that in my mother's eyes were wrong. And all she would do is promise us, "*Quando venne patèta stasera, aggia vedé che paliàta che l'hai,* When your father gets home you're gonna see the beating you're gonna get!" I was a little alert, and I'd meet my father coming in, and tell him, "*Mama sta'nu poc imbustiliat. Abad! Chella vo'che ci mette à mazz,* Mom is in a bad mood, you better watch out! She wants you to get the stick and give us a beating!" And he would say to me, "*Nun ci pensa, mo' veg i',* Don't worry about it, I'll take care of it." Then we would go inside, and my mother would have the stick for him to hit us. And my father, especially because I used

to have the big mouth, he would say to me, "*Fa vede che chiagne, che cheste nun a finisce,* Make believe you're crying, or else it's never going to end." So I would go like this, [crying voice] Ahh! Ehh! And my father made out with the stick [like he was hitting me] so she was satisfied. And then he used to tell me, "*Va, vatene a liétto va, vatene 'ncòppa, che se no chella nun a finisce,* Get upstairs, and go to bed, or else she'll never end it." And she was happy because I got a beating. I didn't get one! [laughing]. I have to say I was my father's pet. Because my father knew that my mother used to pick on me because I would be the one—I don't know why—to take her and another older sister and direct them. I was the director.

"I Don't Need Charity"

Andrew Calabrese Sr. and Anna Calabrese Sagnella:

Our mother would never accept charity. She was too proud. My father joined the Eagles, an organization like the Knights of Columbus. My father died in 1940, and I never forgot this. We were kids. The Eagles organization came over after my father died, and brought a basket full of fruit, candy, all kinds of stuff.

And of course, we didn't get those luxuries like chocolate bars. It was a great thing when papa brought us a little chocolate because we never had it. And I went over on my crutches, and I looked at the chocolate bar, and I wanted it so bad; I was dying for that guy to go away so I could open it up. My mother said, "*Va, vatene a ccà, nun aggiu bisogno!* Get out of here, I don't need this." Now here's a woman just got left with nine children, a widow. And she chased him out of the house, says, "We do not accept charity," and that guy had to go back with that big basket, and all the stuff I wanted to eat. They had my father [laid out] in the house in our living room for three days with the white ribbon on the door. And the sisters wore black dresses, everything black, stockings, shoes, for a year. And every time I went out—I was a little kid—I had to wear a black band around my arm for a year. And my mother dies wearing black out of respect for my father, all those years after. One time the girls bought her a Christmas present, a navy blue sweater. She told them, "*Esce a ccà!* Get out of here!" Chased them right out and said, "Bring it back to the store." This was their custom, and that was their way of healing.

"The Mouse Game"

Betty Panza:

My mother came from San Martino, provincia of Avellino. She was a farmer, and they had a prosperous farm. When we were kids, we used to say "*Pazziamo alla lamba.*" My mother put your hand on hers, and she used to say a rhyme in Italian, *Alla Lamba, alla Lamba/Chi ci muore e chi ci campa/E si campa al lavaiola, e ò mast' in da scuol/È rimast é ò maest/Chi ò pan a chest?/A acchiappata chest! Abbad a mano, quotidian/Pare badessa/ Acchiappà di chest!* And when she'd say "*Acchiappà di chest!* Grab this!" you had to move your hand away so she wouldn't grab it. And the kids used to go crazy! Sometimes my mother used to make a little mouse with a handerchief. And she'd put it on her thumb, and it had two ears, just like a mouse, and said to the kids "*Mo' venne ò sòriciello,* Now here comes the little mouse," and she'd make it jump! She thought it was such a good thing. Those were our toys. The kids, when they first saw it, they used to run. Then they used to say, "Nonny, do the mouse! Nonny, do the mouse!" My mother Graziella Santacqua had

all those kind of little games, and the kids loved her. My daughter Phyllis in Washington caters some parties, and a couple of senators couldn't believe it. They used to call her and say, "Do that for us."

"I'm Going to Pray for You"

Anna Aiello described the relationship between Italian seamstresses and Jewish factory owners in the 1920s and 1930s in New Haven. We had nothing to do with the Jewish people. They ran the businesses, and the Italians were the slaves that worked on the machines. She was ninety at the time of our interview.

My mother went to church every day. She had a dog Freddie, and he used to follow her to Saint Rose church. He used to wait for her on the corner while she went into church. And one time he couldn't find her—I don't know how he got away from her—he went to everybody's house. Everyone said, "No, she's not here, we don't know where she is." And the dog would leave one house, and go to the next. She used to go out more after *ò nonno*, my grandfather, died because she had no head-aches at home. Know where she was? She was at her girlfriend's house. She said, *stu pizz e strunz*, this little shit, he came following me, going house to house, and he made everybody know I wasn't home! She was tough, but she was good. I always say my mother's words. I remember what she used to say. When she was dying, she had cancer. We all had turns taking care of her. I used to go on Sunday morning, and I used to wash her up. I used to work in the restaurant. She used to hold my hands and say, "*Cheste mani!* These hands! Look! I grew you up so good, look at you now! You're getting all wrinkled up." But I enjoyed it, I said to her. My mother said to me, "*Quando mamma muore, quando vedo Jesu Crist,* When I die and I see Jesus, I'm gonna pray for you, *perche tu si na bella figlia,* because you are a good daughter." We were all good, all of us. I think she is praying for me. But I often wonder if she still prays for me.

"The Dream"

Mary Pesce recalled the Feast of the Madonna d'Assunta on Main Street in East Haven, and the Italian women dressed in white and blue weeping the

same way the Blessed Mother did when she lost her son on the Cross.

My father died when he was thirty-two years old. He used to shovel coal into the furnaces at Sargent to keep the fires going. He came back and forth on his bicycle to New Haven, and got pneumonia. When he was sick in the hospital, he used to say to the nurse, "Nurse, I got four children. Make me better." He used to say to my mother, "If anything happens, sell the house, the horse, and wagon. Keep the cow because you need the milk for the kids." He died four days before Christmas. My mother had nothing, and she didn't want to live here in East Haven all alone. She brought my brother Chappie, the baby, to stay with my uncle Joe Pesce in Momauguin in East Haven, then she brought my brother Pat to my aunt they used to call *L'American*, and my sister Vera to another relative. I was a baby so I stayed with my mother at my Uncle John's. She was afraid to stay alone. The lady next door, Missus Carbo, went up to my aunt's house, and said, "*Maria mi! I' m'aggiu sunnato a marito tuoia! E comme steva 'ngazzata! Isso steva dirett a yard vicino a fence e diceva, 'Guarda questa casa mia, è vacant, e i figli mi stanno sprugliat,'* Mother of God! Last night I had a dream about your husband. He was standing in the back yard near the fence. He was really angry, and he was saying, 'Look at my house all empty and my children are all over the place!'" My mother was scared too because my father was so mad in the dream. So they all said, "You know what you better do? *Tu vai casa e pigliate tutt i figli e nuie tre fratte ci damm na pezza a uno a settimana,* Go back home, get your children, and we'll each give you a dollar a week." So her brothers used to give her five dollars. So she took all the kids back home, but she was still afraid. So the lady across the street made her daughter stay with my mother a few nights until my mother got used to staying alone here again.

"My Mother and Billy Doyle"

Andrew Calabrese Sr. and Anna Calabrese Sagnella:

I had a friend, Billy Doyle, and his family was an Irish family living on Brown Place in the Annex in New Haven. And he was always at my house playing with us kids. Nice kid, you know. And one day he got the shakes.

They didn't know what it was in those days. So he went home, and his mother took him to the doctor. The doctor gave him all kinds of things. He couldn't get better. So he came to the house, and he got the shakes. And my mother says to me, "Go to his mother, and ask her if I can cure him. I can cure him." So I went over his house and told his mother and she said, "Tell your mother to do whatever she has to do to cure my Billy."

My mother, you wouldn't believe this, made a sandwich with Italian bread, and filled it with garlic, just raw garlic, put it in his sandwich, and she made that kid eat the garlic. She said, "You gotta eat it!" And the poor kid, he was eating the garlic. He was cringing. He had garlic in the soup before, but not like that! And the kid, he ate the garlic, he ate the whole sandwich! You know what? It cured him. Later on in years, you know what he had? He had the "Saint Vitus dance" we used to call it in those days. He had the shakes, but all he had, *a verminara*, was worms in his stomach, and *a mamma mia ha dato a nu sandwich e aglio, isso ha mangiato,* my mother gave him that garlic sandwich, he ate it, and the garlic killed all the worms, and the kid was better. And his mother came to my house on her knees and

thanked my mother for curing her son. Us kids translated what she said to my mother. They used to do that in Italy. She brought that old remedy from Italy.

"The Women Helped Each Other"

Annunziata and Florence Adriani told me that during the the long voyage to America their mother, Maria Lucia, told stories to her children so they wouldn't worry about the ship sinking.

In our neighborhood in Bridgeport we had Jews, Swedes, Irish, and a lot of Italians. We were like one family, we all got together, and our neighbors were so nice. Everyone used to come to our house on New Year's Eve. We were the only house with a telephone and no one else had one. My father would get all the news, especially when someone died. He'd bring the families the news, sometimes at three in the morning. When my mother had a baby the Italian women used to come over and help. They helped each other. When my mother had her babies they'd help her with the baby till she was able to do it herself. They did housework or whatever she needed done for her.

"I Didn't Need a Dowry"

Sister Bridget Esposito was ninety-three at the time of our interview. She recalled bringing lunch to her father at the Gloria Macaroni factory on Wooster Street in New Haven. She watched as workers put the dough in a big machine, and the long strands of spaghetti and linguine coming out the other end. Then they placed the fresh macaroni on long racks to dry.

I went to Columbus School on Green Street right next to the convent. I went to school there, and when we had recess we looked through the fence that separated the convent from the public school. We didn't have a Catholic school until they built Saint Michael's. We'd look through, and on winter days watch the nuns hanging up the clothes. We called them *baccalà*, because they got so cold and stiff. My mother belonged to the Sacred Heart League, right in the convent on two-nine-five Green Street. My mother was very friendly with them, and she did them a lot of favors. They didn't have a car in those days, and depended on people, and my mother didn't either, but she did all the shopping for them on foot. One day they asked my mother for

twelve potties for the children to train them. So my mother went down and carried them back.

One day when I was fourteen, right after I finished grammar school, Sister Theresa Pappacoda asked me, "Would you like to teach the little ones on Sunday morning after mass?" It was an Italian tradition that after church everyone stopped at one another's house to have coffee and pastry. They enjoyed family life, big macaroni dinners, and having a good time. I said oh sure. So my friends on the street heard I was teaching the little children, and one lady said, "Could you take my little boy with you on Sunday morning because I can't come, I have a baby to take care of." I said, sure, okay. Before you know all the neighbors heard about it so they asked me take their children, and before I knew it, I had a line of children. I had to cross them on Chapel Street, and though I was a little scared there were some good people who helped us cross. After five or six weeks, the provincial superior Mother Celestine tapped me on the shoulder in church, and said to me, "After mass, will you take them to the convent? I want to give them something. I said okay, and marched the little kids to the convent and

she gave them a little medal and a holy card. They were happy.

One day after, Sister Giaconda and Everista were downtown, and they ran into my mother. They said, "Does your daughter have a vocation?" because they saw me in church. She said, "Well, she never talks about it." They said, "Maybe you could talk to her about becoming a nun." My mother said, "I'll ask her when I get home." At home my mother asked me, and I said, do you think I'm crazy like them, hide myself behind those bars? I used to see them always quiet, so stiff, and you'd get a funny feeling inside the convent. When I said that to my mother I don't know how she didn't slap me because she was very friendly with them, and she thought they were great.

My mother was from Minori, and we spoke, her in broken Italian, and my English. After a few weeks I started to work. We had five kids, and my father had lost all his money because his partner at the macaroni factory stole it and ran to New York. I went to high school but I said, I have to help my family. I went to work at the Par-Ex shirt factory in nineteen thirty-five on Wooster Street near East Street. I put the collars and the cuffs on for three dollars and fifty cents a week, imagine that!

I helped the family for a while. One Sunday, when I brought the children to the convent after class, I asked the provincial superior, how much do you need to become a sister? Because I was thinking of the money, you had to have a dowry. She said, "Oh don't worry, we'll talk it over with your mother." I found out my mother was going to pay a little at a time, and that's when I entered in October, nineteen thirty-eight. My mother was okay, but my father cried. My father didn't want me to go. Not that he didn't want me to go, but it just touched him.

"I Was a Lively Nun"

Sister Cecilia Adorni was 103 years old at the time of our interview. She often entertained patients at the adult day care center during holidays at the Mount Sacred Manor, dressing up as Saint Joseph, Saint Patrick, and The Little Drummer Boy. She told me how much she loved making infirm people happy. With eyes sparkling, she said, "The more I see them laugh, the crazier I act."

My father came from Lucca in Tuscany, and my mother came from Alessandria in Piedmont in the north of Italy. My mother got sick, and she

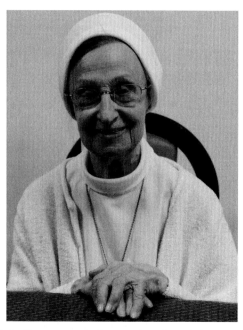

Figure 3.1. Portrait of Sister Cecilia Adorni, age 103. Convent of the Sacred Heart. Anthony V. Riccio photo, 2010.

needed a marine type of climate, so she decided to come to Connecticut when I was five, and we lived on Clay Street in New Haven. I was born in nineteen oh-eight in Monroe County in Rochester, New York [laughing]. After my mother died of a stroke, my father worked at a laundry, and we were three girls and one boy. He didn't know what to do with us. He was very friendly with Missus Poli, who owned the Poli Theatre. I was lucky. She used to give me tickets to see live shows on stage in the nineteen twenties. She was a nice lady, very friendly with the family. She belonged to the Sacred Heart Sisters on two-ninety-five Green Street near Saint Michael's Church, and they had a club, and my mother had joined.

Missus Poli told my father about the Sisters of the Sacred Heart, and how they took girls, and had a school to educate them. So my father went to speak with Sister Emerinciana Lodi. My father came home, and said to me, since I was the oldest of the three girls, "Now Mary, she's going to be your mother, and you have to listen to her, and do what she tells you. And you, Mary, you take care of your sisters." So I said, okay, papa. So in nineteen thirteen, we moved in with the sisters. It was like a boarding school, and they took care of us, and educated us until we graduated when I was twelve. We went to regular classes, and my teacher was Sister Theresa Pappacoda. My piano teacher was Sister Aida, and we all took music lessons. We went home on weekends.

We were very friendly with the other children, Julia Conte, Rose Fazzone. We used to get together real nice. They all had lost somebody, a mother, a father. I missed the sisters and my friends, so I used to say to my father, you know, I don't like it here, it used to be nice with the

sisters. With a lot of the orphans, they couldn't pay tuition, so Sister Giaconda and Sister Agatha went out to beg on foot every day, to Long Wharf, to the market to get produce, and they'd load us up, and never charged us. And that went on for years. The Acquarulo family on Chapel Street gave us fish every holiday, loads and loads of the best fish. Monday was crackers and bread, Tuesday was eggs, Wednesday was chickens, and Saturday was meat. We have lots of good friends. The Lord said, "Those who leave father and mother for my sake, I will reward them a hundred fold." And that's the hundred fold we get. People are so kind and generous and they help us in every way.

I went out a few times with a fella named Caesar Rossini, and we went out for a few years. When he started talking about getting married I said, you know Caesar, I've decided to be a sister, and I don't think I want to get married. He was stunned. But it was the saddest moment of my life when I left my father. I went to kiss him goodbye, and he gave me a slap in the face. He said, *"Figlia ingrata! Mi avevi promesso e adesso mi lascia ancora,* Ungrateful daughter! You told me you were going to take care of me and now you're leaving me!" Because I always used to tell him

when I was little, don't worry, I'll take care of you. That's why he called me an ungrateful daugher because I promised to take care of him and I didn't.

In the convent I was a wild gal. I loved to have good times. I wanted to be free, and I didn't want to take all those orders that they gave me. I used to say, I obey the commandments of God, don't give me any more. Ten are enough! We had to keep quiet at a certain time, and I used to sing. Even when I became a sister, and we had to be quiet I used to sing. They made me kiss the floor. It's a wonder I didn't get tuberculosis because I was always kissing the floor [laughing].

I was a lively person, and the other nuns didn't understand me. We were right across from Wooster Square, and Saint Michael's church used to have an orchestra and they had the procession of Santa Filomena. Then they had a party and the band stayed all night, and people danced. I used to get up, go to the window, and hear the music. And I'd sing the lines to [singing] the song *"Wey Marie/Quanto suónno aggiu perso per te/Fammi durmì'* . . . Hey Mary, how much sleep I lost because of you, let me go to sleep." So one night I hear a tap on my shoulder, and I said,

oh my God, what now? And she said, "Sister, what are you doing?" I said, I'm listening to the music. She said, "Don't you know you're breaking silence?" I said, sorry. So I went to bed. The next morning, she called me and said, "You know you broke silence last night?" I said, but they were playing such nice music, I couldn't resist. It was some of the music I used to play, "Ó Sole Mio" and "Wey Marie" they were playing, and I enjoyed it.

But then I got common sense, and grew up. I decided the best thing to do was follow the crowd [laughing]. Even when I became the Mother Superior I'd get in trouble because we weren't supposed to go to movies, to restaurants in the nineteen seventies and nineteen eighties. And the sisters used to work so hard. So I used to say [to Mother Superior], they work so hard. Once they gave us tickets to see *The Sound of Music*, live when it first came out. So I said, Gee this is a nice present for my community for Christmas. I said, Sisters, I have a nice present for you. We're going to see *The Sound of Music* at Radio City. We went and I said, now who is going to go home and cook? I said, let's go to Patricia Murphy's for dinner, and we weren't allowed to go to restaurants or movies either. So we went to both! I told the Mother Superior,

Mother they work so hard, how can I please them? The lady gave us the tickets. When she made me Mother Superior later, she said, "Use your head." So I used my head. I had the vow of poverty. I had the tickets. I wasn't going to throw them out, I was gonna use them. I had the vow of poverty, so I took it that way. In front of God I wasn't guilty [laughing].

I was always in trouble. I was ahead of my time. I used to say they don't understand me. Wake up! I used to say. Change! When I went on my first mission to teach fifth grade in Saint Louis in nineteen twenty-five, I told my students, if you listen to me and do your work every day, there will be no homework on weekends. That's how I got good results. Finally [the order] they changed, changed our habits, and everything.

"Becoming a Citizen"

Betty Panza:

My mother loved this country. I went to all the immigration classes with my mother. There were Italians, and other nationalities. There were ten in the class, five Italians, two Polish, two Lithuanians, and a Jewish person.

My mother was the only Italian woman there and she looked forward to going to school. We went to Woolsey School in New Haven to get her citizenship papers.

My mother couldn't read or write, my mother never went to school. So she used to take me to the class. And I was so proud of her. And the questions they used to ask them. They used to say, "Mary, write your name." The M, you'd see how difficult it was. I was little, and she used to take me. I used to erase the blackboard. In those days, you at least had to know how to write your name to become a citizen so you weren't considered illiterate. And my mother used to cry, because she was no illiterate. She practiced every night. And my father, he had beautiful handwriting, and he'd say, "No Graziel, you gotta do it like this." She finally got it down. So one day the teacher said, "Mary, Mister Tondolo, Mister DiToro, and the Gedrem family from Lithuania are ready to go get your citizenship papers."

So my sister Jenny, being the oldest, we took them to city hall in downtown New Haven. Now we're sitting there, and they're calling all the people up, and they said "Maria Grazia Santacqua." My mother got up. And he said, "Who is the president of the United States?" She said, "President Roosevelt." She wasn't nervous. She answered him just like that. And they said, "Who was the sixteenth president?" And she said, "A president o Lincoln. And he freed the slaves!" She even said that. I can never forget that. And he said to her, "When you came from Italy where did you land?" And she said, "A New York, but first I had to go to an island," but she didn't know the name, which was Ellis Island. "And then to New York, and then I came here." "Oh," they said, "Where do you live?" She said, "I live forty-six Main Street, New Haven, Connecticut." She said all this in Italian, in broken English, the best she could do. It was so cute.

They asked her why she wanted to become a citizen. And she said, "Because I love a this country." The judge said, "You got your citizenship papers." She got it. They made her write her name, and she got her citizenship papers. She was crying. She was proud because she did something. And my mother worshipped that paper. She never, ever wanted to go back to Italy. She said, "It was my country, I loved it, but I love this country because they send people to school." She never went to school at all in Italy, and neither did her sisters and brothers. They all worked on the farm, and

they had to learn to make pasta, cook, and take care of things. She was the one in the middle, so you took care of each other. And it broke her heart later that my brothers had to leave school and go to work, but that's what it was. I was the only one that graduated from high school, being the youngest.

The only thing she was sorry for was that she never knew how to read or write. And she used to say it all the time. She said, "I don't know why." If my mother could have read or learned how to write, she could have been a wonderful teacher because she was really dedicated to anything that she did. And that's why a lot of people honored Mussolini. He did bad things, but he brought education for women and men, and you had to go to school. I think of everything that was the proudest day of her life, and she was so proud to be a citizen, she really was. But she laughed because her good friend Mister Tondolo went before the judge. And they said to him, "When you came from Italy, where did you land?" He said, "A thirty-seven a Castle Street!" And my mother, it was like she got hit by lightning. He didn't understand. If anybody's ever gone to night school in those days, and it was your parent or a friend, you could really be proud of them because, for some of them, it was very difficult.

"The Big Handkerchief"

Natalina DiPietro spoke lovingly about her old Italian neighborhood in Hartford, known as Front Street, before it was torn down by urban renewal and Constitution Plaza. She noted that "most people moved to Franklin Street in the south end, and the wealthier moved to Wethersfield."

My mother bought her first house in Hartford. The Jewish people lived in the north end. The French lived on Park Street. The Polish people lived on State, Grove, and Sheldon Street. She saved all her twenty dollar bills. She had to come up with a deposit, and she had a big handkerchief full of twenty dollar bills. So I counted it, and it was over nine thousand dollars that paid for the house. The house was a three family, and was worth nine thousand five hundred, and she bought it with those twenty dollar bills. She was putting the money aside. My father didn't know she was putting it away. She managed the money. She had her little trunk with all her linens. Take one layer out, two layers out, three, and in the little corner was the big handkerchief full. My father didn't care because he knew she was doing everything. My friends are all like that too, the wives take care of the money;

the husbands don't. They trust us. If there was something I wanted I asked him first.

"She Bought the House"

Before our interview, ninety-nine-year-old Carmella Raffone Polio D'Onofrio played the piano and sang a few Italian songs to her daughter, Norine Polio. Carmella's husband worked at Sargent as a welder and created a lot of the iron gates on the Yale campus.

My mother Anna was an orphan, and lived with her aunt in Naples who was a seamstress for wealthy people. She went to a private convent school in Naples run by the French nuns. Her last name was Mas, a Spanish name because of the Kingdom of Naples and Spain, and her grandparents had been sent to Spain by the King of Naples. My father and mother were matched to be married, but since he was in the Italian navy they had to wait five years until he was released.

After she got to America, she came to New Haven. She handled all the household expenses, and my father handed her his pay every week and she took care of everything. She also raised six children. On Sundays on Greene Street, the family took long walks around the streets of the neighborhood, and her favorite street was William Street, and she had a favorite house, number fifty-four. Maybe she liked it so much because it was Italianate style.

One Sunday, as they were walking by, she saw a "For Sale" sign in front of it. So she asked my father if they should buy a house. He said, "What? You need money to buy a house." She had been saving part of his salary every week, and arranged a loan from some close friends, the Ferrantes. All the while she'd been putting money in the local Esposito Bank. A friend of the family told her the bank was about to fail, and she should get her money out immediately. She withdrew her savings the next day, and the bank closed soon after. This was before the F.D.I.C., and many people lost money. But she had enough money to buy the house on William Street.

"I Always Dreamed of Home"

Theresa Laudano said that only the men were allowed to stomp the grapes with their feet during the *vendemmia,* wine-making season in Sorrento.

I grew up on our family farm in the hills over the town of Sorrento on the Amalfi coast. I had a cousin who was the local priest. My oldest brother Raffaele used to be the altar boy, and

my sister took care of putting the flowers and decorating the altar of the church of San Biase. We were always there for the mass. My aunt in America had no children, and she wanted a child. This priest in our town was my aunt's first cousin, and when he got back to Italy, he said to my mother, *"Tua sorella va trovando a na' figlia tuoia, tu la vuoi manda in America?* Your sister in America is looking for one of your daughters, would you like to send her one? She can't have any kids, and she wants somebody to take care of her." My mother said, *"Si, teng a piccerélla, dice che I' á manda chella la,* Well, I have seven kids here, and I have the little one, she's fifteen, and she can go."

My parents thought I was going to a better place, where everybody had their hair done like *i signori*, like the rich people. None of my older sisters wanted to come here. They were smart. They had boyfriends! I was the baby in the family. I didn't know nothing. I thought I would be able to come right back home, like when I used to stay with my uncle in Sorrento, they'd take me home once a month. I didn't know my aunt or my uncle Zi' Michele in New Haven. I didn't know I was coming over the ocean, and could never come back. My father fought with my mother and told her, "You're not sending my daughter away!"

She signed all the papers, did it all. He didn't want to sign the papers because I used to help him trim the grapevines and pick the olives. I helped him and my brother a lot on the farm. My brothers and sisters were very upset that I had to leave. All my mother said to me was "Buon viaggio," because she thought I would have a better life in America, and that I'd be coming back home.

My father cried taking me to the boat in Naples. He kept saying, *"Chella mamma ti ha mandato, non ti voglio mandare,* That mother of yours is sending you. I don't want to send you."* My brother Salvatore always blamed my mother for taking me away from the family, *"È stata una infame che ha mandato lontano,* It's a terrible thing sending her far away from us."* My parents bought me gloves and a hat, and they got me all dressed up really nice. But the priest led my mother to believe that things were much better in America, that I would live like a *signore*, a well-off person. And that's what my parents believed would happen.

It didn't turn out that way. No *signore*! I was better off on our farm. We weren't poor in Italy. I ate better in Italy, ate fresh figs, grapes, oranges, and we had the best olive oil. We made our own wine, my mother made fresh bread and pizza in the oven. We grew, we

planted, and we had the best. We always had fresh olives, artichokes, apples, lemons, potatoes, beans, and peas. The grapefruits were so big that we played bocce with them. I used to go with my mother to milk the cow, put the milk in the pail—ding-ding-ding—all fresh. Sometimes she used to squirt me in the face with the milk. It was all warm and foamy on top. Healthy! I didn't like the milk when I came to New Haven. My aunt gave it to me, but I didn't drink it. That wasn't milk. It was funny. I couldn't understand the food.

When my mother signed the papers to send me, the lawyer gave me a chaperone. I wore a red carnation during the trip for the chaperone, so when I got to New York my aunt could identify me since I never met her. I was scared stiff in nineteen thirty-seven, seven days on the *Rex*, especially when we passed by Gibraltar, and there was a big storm—and the ship—*brrrmm*! But I didn't cry on the boat because I thought I was coming back home. Here I was, a fifteen-year-old who never left the house back home. I never traveled in Italy. I was always taking care of the elders in the family. I still have nightmares about it. I dream that I'm walking and walking and I'm lost, and can't find my way, I can't find my house, and I can't find my church. I see the mountains,

I see the water of Sorrento, but I can't find home. Sometimes I dream I'm lost and I'm asking people, and it's getting dark, and what am I gonna do, who's going to take me home?

I used to cry and watch the fire on the kerosene stove. I was petrified because I saw a big fire on a nearby street. We didn't have a stove like that at home. My mother and I wrote back and forth, but I never told her how bad it was. I wrote that everything was fine even though I was very unhappy. My first two weeks I cried so much that I wanted to go back home, and my aunt said, "*Tu non puoi ghì a casa, ci hanno voluto due anni prima che tu hai potuto arrivare, e mi ha costato moneta. Quando vai a faticá e busca í soldi, tanno puoi ritornare a casa*, You can't go back home because it took two years to get you here and it cost me money. When you get a job and earn money, then you can go back home." I got sick, and started to lose weight because I wanted to go home. I couldn't go home. So then, I was stuck here.

My aunt wasn't the type to hug and kiss you. My mother was that way too. My father was a lovable man. But the women believed that hugging and kissing was a sign of weakness. They were tough. I was a kid—you didn't have to be old—and I went to work at Goodyear working on the production line making

rubber hot water bottles. The man working on the press next to me lost a hand, another fell and got hurt, it was awful work. Then I used to take a bus, and then go by truck to the Dunbar farm in Hamden to pick strawberries, clean all the shovels rain or shine. I never told my mother all this. She would have died. How could I tell her what happened to me?

My aunt was strict, and in the end, she was good. I loved my uncle, and he loved me. My aunt asked me to plant the garden, clean the chicken coops. I had to kill the chickens, the roosters to make soup. She didn't know how. I knew from working on the farm. I wasn't afraid. We had the Hurricane of nineteen thirty-eight, and all the big trees came down in the backyard. I sawed and chopped them, brought them to the basement, and piled it all up for the wood stove. My uncle used to ask me if I finished my work on Sunday, and if I did he'd sneak me twenty-five cents to see a movie. But he got sick in nineteen thirty-nine, and I had to take care of him. He died in my arms. They had the wake in the house, and I had to sleep in the same room as him for three days.

When I left Italy, I thought I could come right back home. I didn't go home for thirty years. When I found my mother she didn't recognize me. I said, "*Mamma, tu mi ha mannàt a quest' America, e ti credevi che stevo in grazie come nu re, e i' aggiu fatto una mala vita la, aggiu chiagnuto sempre che i' volevo torna dirett ma non teneva i soldi*, Mom, you sent me to America, and you thought I was living the life of a king, but I had a bad life, and I always cried to come home, but I didn't have the money." She hugged and kissed me, begged me for forgiveness, "*Ma figlia mia! Mi dispiace, figlia mi! I' mi credevo che tu stevi buon*, I'm so sorry, I thought you were good in America." She told me that had she known my life was going to be that tough, she never would have sent me. She said, "Why didn't you tell me that you weren't happy, you could have come back." But how could I have ever told her? How could I leave my aunt? She didn't have a husband because he died two years after I got there, and she didn't have any kids. How could she have survived? My aunt never told my mother anything. My mother begged me to come back and live with them, that we would never have to work again, and to bring my three children who were grown. I said, "Mom, my life is in America now."

"Life in Middletown in 1915"

Antoinette Tommasi Mazzotta's mother came to Middletown from Melilli in the early 1900s when she was fifteen. Antoinette recited her proverbs with great reverence.

It was all horses and wagons, and no trolleys or buses. No phone, no television, no refrigerators. We had an icebox, and a man delivered ice to the house, and if you forgot, you'd have water all over your floor [laughing]. When people came from Melilli in those days, they knew each other, and were very friendly, and there was a woman that had five, six rooms, usually with four bedrooms. Every bedroom had a full family. "Á *bossa*," they used to call the lady that owned the apartment house, and her real name was Cumare Peppina Perruccio. So we were three children, and there were two big beds, and that was our little apartment on the second floor, one of five apartments where other families lived. The "*bossa*" was the only one with a kitchen. She had one of those big black heavy pot belly stoves, and she did all the cooking.

The families planned the meals for the week. And most of the time they ate pasta, pasta with garlic and oil, or with tomato sauce. Every night we went to her kitchen "*Cumare Peppina, preperate a na pinàta e acqua bolliuta!* Cumare Peppina, start the water boiling in the pot!" and then they knew we were having spaghetti that night. We sat at a long table with other family members who lived on the second floor. That's how it was in nineteen fifteen, nineteen sixteen.

Then gradually each family got a little apartment of their own. My mother taught the boys how to help. We had a double tub in those days, and I'd wash the clothes that weren't so bad, my brother Sal washed the heavy underwear, the winter longies, and hang them out, and bring them in standing up, frozen. We had to be careful—the towels had to be all together, the blouses—don't dare put a blouse and pants together—oh, everything had to be just in order. I had five brothers and my father, six men that I had to iron white shirts for. No radiators, no furnace, just one big stove in the kitchen.

At night we had blankets, and we'd wear our winter coats to school, and have them for covers too because the rooms were never warm as should be. We went through it all right. She used to have a saying that meant to be

economical while you had things, and don't wait till you're at the end because then it was too late to be economical: "*E vidi cu finu/Ma mentri che chinu/Ma quanno funno pari/Nun pa nenti a evitare,*" she explained it. "If you have a bushel of apples, and eat three, four a day. Why? Have just half. Or one a day, this way it'll last longer." Don't wait until you see the bottom, and then start eating just a half or a piece. Do it when it's full. Be economical while you have. Like all these people all out of work now. If they saved when they were getting it, they wouldn't be suffering now like they are.

My husband worked hard, and I had to think of a way to save because I wasn't working, and we educated my children, so I always tried to save. When I could do it, I'd save a week's pay out of a month, and live on the three pays. We'd manage it somehow. I never worked, but I was able to help my children. I could have never done it if I would have done what some of these kids do today. Everything is always, big, big, big. I believed in having that little extra just in case you needed it, but keep it simple. You don't need five, six, seven of something like pocketbooks, or shoes, or whatever.

"They Shot Geno Raymondo"

Francesca Grillo:

In the early nineteen thirties, when I came from Italy and lived in Norwich with my cousins, we'd go see a movie. I remember the actor Gene Raymond. The first time I went to the movies, I couldn't understand English, so whenever I saw my cousins laugh, I'd laugh. Whenever I saw them cry, oh, well, it must something sad, so I cried. I said to my cousin Nancy, hey, Nancy, that fella, what's his name? She said, "They call him Gene Raymond, he's an actor." Yeah, boy, what a nice looking man! We went together every week, oh, and every time his picture came on the screen, oh my god, it was heaven. One week, the movie was playing, and all of a sudden, somebody shot him. I didn't know what the story was or anything, but somebody shot him, and he was dead. I went home, and I was crying. My aunt Mary said to me, "What's the matter with you?" I was crying, "They killed Geno Raymondo! He's dead!" And she was trying to tell me in Italian, "He's not really dead." "Yes he is," I said, "they shot him!" So two weeks later, another movie comes and there he is, alive. Madonna!

Mamma Mia! I went home, "Hey Zi' Maria, Gene Raymond, you're right! He's alive, he didn't die! He came back alive!" [laughing]

"The Women Made Wine"

Laura DeGregorio recalled the story of her father who worked on a merchant ship that sailed to Spain and Portugal delivering olives. Stopping at the port of New York, a man recognized him as "Giuseppe Maresca's son from Sorrento" because "all the Marescas looked alike." The man took him home, and eventually to New Haven. He never returned to Italy.

We used to have nice parties at my grandmother's. We always had a big party on Hamilton Street in New Haven on the Fourth of July. And all kinds of fireworks. The fire trucks were there every two minutes putting out the bonfires. And my grandmother used to buy this extract, and put alcohol in it, and made all different flavors, like orange, coffee, and lemon. She lined up all the bottles on the table. They used to make their own hooch, you know? I remember being small, and looking over, and once I tried every one of them, they were so tasty. And all the wine my aunts, my mother's sisters, used to drink.

My grandfather used to make wine, and that was another party. He ordered all these cases of grapes, all in the backyard. Then he called the family over, and on the Sunday all the daughters got together, put the grapes in this big vat, and squeezed the grapes with the squeezer until all the juice came out. And some of them didn't even wait until it fermented, they drank it. The girls, oh yeah! They did most of the work, they worked hard. They wanted the wine, that's why [laughing]. They put it in the barrels, did all the bottling. The women made the wine. My grandmother didn't help. She was too busy in the house. When she died they found her dress hanging on the door, and inside were all these little packets she sewed in, all full of money. Thousands, all the way down the dress. She was afraid of banks.

"We Didn't Have Emergency Rooms in Pawcatuck"

Surrounded by the family during her backyard picnic, Rose Serio wove stories of Pawcatuck's social history. Rose and her family, like many other Sicilian families, were celebrating the yearly procession of The Madonna d'Assunta through the streets of Pawcatuck.

My mother used to do *ú suli*, the sun, with the glass of water if you had sunstroke. It was done in the morning, and a second time before the sun goes down. They took a bath towel, squared it, and put the glass of water on your head. It bubbled, and drew the sunstroke out of your head. It took the heat out of your head. The Calabrese called it the evil eye, *ú fàscino*, and we Sicilians called it *ú malocchiu*. With *ú fàscino* you take a dish of water, and put nine pinches of salt in it. Then you wash your face nine times with your left hand. If you still have the evil eye, you do it again. With us, we put three dishes, and you put salt in the water, then three drops of oil, and if you had *ú malocchiu*, the oil would split. And the last dish you threw outside, and say the prayers. Sometimes they called a couple of Italian ladies to come and say a series of prayers. You could only learn these prayers on Christmas Eve. Once my mother said our neighbor Missus Cash was giving her the evil eye. So when she did *ú malocchiu*, she threw the water out the door that faced her house! If you were suspicious of someone giving you the evil eye, you put salt in your left shoe. Left-handedness in the old days was considered evil, so maybe it was to drive the evil away.

My mother used potatoes for severe headache or sinus. You sliced the potatoes, get the blue bandana handkerchief, tie it around your head, and it used to draw it out. If someone had a bad cut and it got infected, they used a "polar sleeve," the furry part of the leaf on the wound. When babies got colic, we'd get a pan of water, boil parsley, strain it, put it into the baby bottle, and have the baby drink it to calm the colic. They knew all of that from Sicily. If your palate dropped, the epiglottis in the middle, they take a piece of your hair, give you a piece of bread to chew, and they told you to swallow exactly when they pulled that hair, and it pulled that epiglottis back into position so you could breathe.

We had this woman in the neighborhood, Natalise, who did *a sfilatura*, for sprains. She'd rub it with oil, take the egg white, beat it until it got foamy, and put it on the sprain, and wrap it around. The egg made the cotton and any white cloth bind together like a homemade bandage. We didn't have any emergency rooms! Very first day of the month, you take a box of salt, and put them in the corners, and in the doorways, and say the old prayers. Then you sweep that salt out, and when you get to the door they used to say, "*Chi fa male ccà,va*

ci di ritorno, Whoever wishes harm here, make it go back to them."

"Picking Blueberries in Pawcatuck"

Epiphany "Epifania" and Josephine Faulise described the Sicilian community in Pawcatuck hailing from the town of Tusa and the colony of Calabrians across the border in Westerly, Rhode Island.

Growing up we helped to raise the family. We worked hard. My mother had eleven children. We were all born at home. She was a serious woman, and all she did was work hard to keep the family going. We picked wild blueberries as part of our living. One summer we picked a hundred quarts of blueberries to sell to the bakery in town. When you went blueberry picking with my mother, you didn't get a drink of water. It was work! And everybody, the older brothers and sisters, had to pick ten quarts of blueberries. No drinking, no lunch, no nothing. We'd be in the woods from seven in the morning until my dad picked us up at three in the afternoon.

We had a little farm with a few cows and he had a little house to house milk route. We sold vegetables from when we were five years old. When I was ten years old I felt like I'd been minding kids since I was born. I was born in the middle of the family. It was weed, plant, put seeds in, go pick the beans, go do this—di-di-di—mind the kid, the kid was crying, wash the dishes, pick the berries—that was life. Of course! In those days there were no cars, and my father was the only one who had a vehicle on the street.

We didn't have a bathroom until 1938, we had a backhouse. We called it *ó backhousa.* My mother had a two-family house and my cousins and aunts lived upstairs, and in the summertime we'd all sit out on the front steps. Thompson Street was all Italians. The kids played out in the street, and the adults sat on the steps, light a little fire, and that was our life. It was a beautiful life. Who had a car? When we had corn my mother piled dozens of ears in that wagon. It had the sides that went up, and she'd pile as much as she could in there. And we'd go peddling corn to all the Sicilians, the Tusani from Tusa lived in this part of town, and the Calabrese lived just across the border in Westerly, Rhode Island. We knew our customers, who was going to buy, and who wasn't, it was always the same ones. In those days they were willing to buy. A lot of them couldn't get to the store. My brother

Jack and I were the biggest sellers, and we'd go through all the streets in town with our wagon.

"She Taught Me How to Cook"

Angie Paul and Elizabeth Paul:

My mother-in-law Saveria Paola came from Calabria, a town called San Biase. She came through New York to live with her sister and her aunt in Brooklyn until they got on their feet. She taught me how to cook. She was a good cook, Calabrese style of course. They didn't have the meat the Northerners [in Italy] had, the milk and butter. Everything was cooked with olive oil. Meat was maybe once a week. It was mostly fruit and vegetables, all the good stuff they tell you to eat today. They were doing that years before.

"Be Independent"

During our interview, Antoinette Tommasi Mazzotta recited the saying, *"L'omu avvisatu/è menzu salvatu,* A man warned is a man half-saved." She said it meant that when you warn somebody who is going to a place they've never been before, and you know there's dan-

ger ahead, you tell that person and he's half-saved because he's prepared.

My mother Sebastiana came from Melilli, and went right to work during World War One at the Russell Company in Middletown. Most of the Sicilian women worked in the factories in my mother's generation. It was the grandmother's generation that passed it down from one generation to the other. They didn't know how to read or write, but they knew right from wrong.

In Middletown there was *á shop i sita,* the silk factory, and for many years, Remington Rand Typewriter, and Goodyear. Some worked in the stores. My mother made belts for the uniforms, and ran a machine. She was a very proud, hard working, and independent woman. She didn't ask anyone for anything. Lots of people just rented, but she wanted her own home. They were all from Melilli, the foreladies and foremen, and they could speak Meliddese [the dialect of Melilli] with each other. They all knew each other. She didn't want me working in the factory. She would get home around suppertime, and she never complained. We lived with four or five other families, and we lived in an apartment where each family

had a bedroom. She left the four of us to someone who was like a grandmother to us, Cumare Peppina [Giuseppina]—she was a lovely person—and Cumpari Buddu [Giuseppe]. They were the landlords of our apartment. They had an only daughter Angie who was older than us, and she took us to school, and brought us home to her mother. My mother went to work, and she had peace of mind because who we were with was like a grandmother to us. Of course she was from Melilli. We loved Angie like our older sister, and she loved us all.

One day my mother and I were going downtown, and she saw this girl, running across the street barefoot to a store. She probably didn't wash her face or comb her hair. My mother stopped. My mother wasn't well, and she had a bad heart. "*A vista chista? Did you see her?*" I said, yeah. She said, "*Ora iu vogghio che tu a sèntiri chiddu che ti dico iu a mamma. Si chiùdi l'occhiu iu pi sempri, vogghio che tu tènniti forti a jobededda, e cussì si hai bisognu e paru di cosetti, e li soldi tenni. Iu vogghio che tu si ndipinnenti e nun c'e bisognu a jiri a to patri e mancu a to frati. Nun vogghio che divinti una sugghiarda mala pagata come una carusa,* Now, I want you to listen to what I'm telling you, mom loves you. When my eyes close forever,

I want you to hold on tight to your job so if you need a pair of socks you'll have your own money. I want you to be independent. I don't want you to become a low-paid servant, like a child. I don't want you going to your father or your brothers for anything."

I got a job at J. C. Penny in nineteen twenty-six as a saleslady. I used to enjoy working, approach people and satisfy people and I handled all the old Sicilian women. They were always so happy because I could understand them. And I'd always sell. Mister Larson, the manager of the store, used to say, "My God, do all you Italian people talk so fast?" One elderly woman where I used to sell dresses came to me and she wanted a dress. I made sure it looked good on her. Then she looked at me and she said, "*Si sita, tu?* Are you married?" I says, No. She said, "*Vi, figghia mi, sai che ti dico. U bon cavaddu, nun c'e manca la sella,* A good horse lacks no saddle." Which meant I would get married. Then she said to me, "*Mi stai credendo, mi stai capendo a me?* Do you understand me?" [laughing] Maybe she had a son, I don't know!

My first Christmas I was working at J. C. Penny in nineteen twenty-six, and they gave us a bonus. I was making eighteen dollars a week for a full week, and Saturdays. My brothers

never had pajamas, and they went to bed in their shorts. I bought them all pajamas with my bonus. I said, "Ma, I bought . . ." She said, "*Eee! E pi tia nun ti haju pinzato?* And you didn't think of yourself first?" She was happy that I did it, but she said, "*Primu si paga ù boss, e poi si paga li lavuranti,* First you pay the boss, then you pay the workers." My brothers still talk about it, they couldn't get over it. When she died, I wanted to die. I was very close to my mother. And I didn't want to go to work. My brother Sal said to me, "What are you doing? She told you to hold onto your job, and to be independent, and now you're doing this? You're going against mom's wishes!"

"We're in America Now"

Mae Dell'Amura:

My father didn't want to be a tailor in Italy, in Minori on the Amalfi coast. He studied how to make pastries and lemon ice in England. When he got married they opened up Libby's, short for Liberato, in nineteen twenty-two. It's been going for four generations now. My mother was a lawyer's daughter. She thought she was God's gift to the universe because her father was one of the few lawyers in Italy. Oh yeah! Until she got into business, and she started to meet different people, and she got in with these people. But this is a lousy thing to say. One day she met a family, and my aunt happened to be here from Italy. So my aunt said to her, "Gee, who are those people?" So my mother said to her, "Those are the people who used to clean our house [in Italy]." So my aunt turned around and said, "And you got the nerve to talk to those people?" So my mother said to her, "We're in America now, we're not in Italy anymore!"

"She Knew How to Handle Money"

Antoinette Becce Padula, Lucia Becce Mudd, and Joanna Becce Clapps Herman:

My father taught himself how to read English. My mother never knew how to read or write. She wouldn't go to school in Italy. She always wanted to work on the *masseria*, the farm, with her father. We taught her how to write her name. We used to take her hand, and let her write "Lucia Sortorso Becce." Then we let her trace over it until she learned to write her name.

In the beginning my mother made all our clothes. We learned to make our clothes with patterns, and we took sewing in school. My mother had her own patterns. She "smocked" it by stitching them with cross stitches, the yoke, and she added more material, and then made the whole dress. She spun on a spinning wheel in Italy. She had a crude wooden spindle, with a hand-wrought metal thing with a hook. They made their own material. They used to grow linen plants, flax, and they'd put them into a stream, weighed it down with stones, and let them stay to break them down. Then they beat them, and wove them together.

She used to fix our shoes. My father had a saw to cut wood with thick belts that went around the saw. When they wore out, she had a shoe form in the shape of a foot, and she cut the leather around it with a knife and sewed soles onto our shoes. On the inside we used cardboard to cover the holes.

My father and his cousin, Uncle Pat, had originally bought our family farm. Then they split up, and one had to buy out the other. Uncle Pat, [clapping her hands] said, "I want the cash right now, and if you want to buy me out, whoever has the cash." He figured he'd

put my father out. My grandmother wore a corset, and she had an undershirt—they didn't wear bras—and then the corset went over that. When she put money in there it wasn't going anywhere because the corset held it in. And they never thought my mother had it. So my mother pulled the money out and she said, "*I' teng í soldi ccà, ho tirato fuori, e a pagat*, I've got the money right here, I took it out, and it's paid for." Then she said, "Here's your money, now go!" We all earned that money but she took care of it. I worked in Scovill's from 1933 to 1939, and handed in my pay every week.

"No More Promises"

Nick Mulé, Lucia Mulé, and Annamarie Mulé Berry recalled Italian women in Thompsonville making their own tomato puree, filling pillowcases of ripened tomatoes and hanging them on clotheslines to drain the excess water.

We lived in a four-family house in Thompsonville, and it was all family. We had aunts living above and below us. We lived upstairs, and if you wanted to ask my aunt something who lived upstairs next door to us, we went into the pantry, banged on the wall, and then

opened the window. Look out the window, and "Aunt Jo, you got a cup of sugar?" And they'd pass it from the window over to us.

Saint Calogero was our Sicilian saint. He was a dark-skinned saint, and some people thought he was black when they saw the statue of him. The Sicilians blocked off the streets for their procession in the old section of Thompsonville once called "Frenchtown." Once my aunt Mary was sick with a kidney stone, and they vowed that they'd make macaroni for the Saint Calogero parade if she got well, and it was supposed to be a couple of pounds for a couple of years. By the time they were done, they were cooking ten pounds for twenty years! She got well, but everybody came in droves in front of our house to watch the parade because they knew they were going to get fed.

Then my son got sick with a kidney disease. So my sister-in-law Lil, she lived with us, and worked as a setter at the local carpet factory, Bigelow Sanford. She vowed, "If Michael gets better, I'll cook macaroni, and Michael will go door to door, feeding everybody." So he got better, and he dreaded it, going knocking on doors. He only did a couple of houses, just to satisfy her. A few years later he was in a motor scooter accident, and fractured his skull. And one of the first things he said when he came out of his delirium was, "Tell Aunt Lil not to make any promises." And the answer was, "Too late." She already made another promise. So he said, "Fine, but I'm not going door to door." So my aunt made the macaroni, and invited some people, and my brother served the macaroni at the house.

"Could We Buy Some Bread?"

When Antoinette Becce Padula suffered a heart attack in her late eighties, she called her next-door neighbor who always told her, "If you ever need a ride, call me." When Antoinette called and said, "Anne, I'm having chest pains, can you take me to the hospital?" her neighbor answered, "Antoinette, you know I only drive as far as Stop and Shop, but I'll go with you if you drive." Antoinette answered, "Okay, let's go!" and drove herself to the hospital.

We graduated into our responsibilities. When I went to work at Scovill, my sister Vittoria took over making the bread. The older one did them before, and the next one took over. Every Saturday we made bread. All the girls took turns helping my mother. We had *a cong,* a big aluminum pot, about thirty inches

across for the twenty-five pounds of flour. We didn't really have a recipe. We put *a cong* on a stool with no back on it. She made a well in the center of the flour, and poured tepid water in. She had already heated the water, and it couldn't be too hot or too cold. Then she slowly crumbled the one yeast cake into the water until it dissolved, and that's all she needed because we left it overnight. In the morning the bread had raised. Then she'd put a little flour in the well of water a little bit at a time, slowly incorporating the flour until it was all mixed together. Sometimes she supervised one of us girls mixing all by hand, and we all had our turns. Meanwhile she added whatever was needed to the dough, a handful of salt, or maybe a little semolina. If the dough was dry she added more tepid water. Whoever was working the dough pulled up a bit of dough at a time, and kneaded it into the pan. Then you'd go all around this pot, and walk around and around the outside of the pan to get the flour mixed into the well of water, and knead the dough, pulling it more, until mama was pleased with the consistency. And then my mother covered it up with a big *moppine,* a dishrag, then a blanket or a coat, and it stayed overnight. The stove was right there, and then

in the morning we'd loaf it. We had these pans. Two of these loaves would fit on one of those pans. Then we'd cover them, and let them rise again. We'd have the brick oven ready while the bread was resting.

Once the bread was all raised my mother twirled a little dish towel, made it round, and put it on her head. Then she put one of the big pans with the two loaves in it on her head, and she'd carry another one in her hands. To this day I don't know how she did it. She walked straight down those stairs and down the hill to the oven. Our job was to work on the oven. We had to go into the woods, and get little branches to get it started before you could put the heavy logs on it. First you made a little crisscross with the branches, you build it up high. Then in the middle, you put your kindling wood in, and newspaper, and start it. After that burned all down into an ash, my mother swept it into a corner, and left it there, making sure it wasn't too hot. She took a handful of flour and threw it in. If it burned too fast, the oven was too hot, and we had to wait. That was her thermometer. Then she waited a while. But if browned nice and easy, then the oven was on time, and we could put the bread in.

The pizza went in first. My mother made the "double layer" pizza because we had all this fresh basket cheese that we put in the middle.

Then we'd put another layer of dough on top, and then put the tomatoes. It was a double decker, it was so good! We had a lot of cheese, so anywhere she could put cheese in, we'd used it. We even used to cook macaroni in milk. It was delicious! We used to boil macaroni in milk. You talk about macaroni and cheese! This was delicious because it'd stick to the macaroni. You drained it, and you put some pepper, and a lot of grated cheese on top. We had a lot of milk. We used to do seven loaves in one baking, and that lasted us a whole week. As she took them out she took the knife, and made a cross. People walked by and said, "Could we buy a bread?" My mother would say "No," but she gave them a slice so they could taste it. It was really nice that way, she felt bad refusing them. And sometimes she had homemade butter to put on it for them. She was so good.

"The Old Wakes and the Community Mourner"

Anna Perrotti Caccavalle was still climbing a flight of stairs to her office at ninety-five, handling bookkeeping and income taxes for the property she owned in New Haven.

As far back as the nineteen twenties, Margarita Mastromarino used to be in the back of the room at the wakes in Woodbridge. She lived next door to us on the farm. In those days, when you went to a wake, you sat down at the house, and stayed there for a while. The wake lasted three days, and they stayed up all night. Everybody dressed in black. If somebody close in the family died you wore black for a year. They used to stop the clock for three days, and put a wreath around the door with black ribbon. You weren't allowed

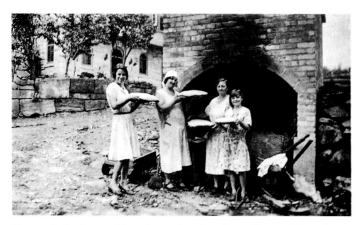

Figure 3.2. Becce Family at the Outdoor Oven, Waterbury, 1930s, Becce family archives.

to put the radio on, or listen to music for a year. Now they go to wakes with shorts and sneakers! All of a sudden in the middle of a wake, from the back of the room, you'd hear her shout and cry out in Italian. It wasn't a speech. It was a cry. "Oh, remember the day when she used to do this or do that!" Or, "Oh, her life was so short!" Then it would be quiet again. Then ten minutes later she broke out in another cry. Still seated, she'd talk about the dead person's life to remind the people of what went on with them in their lives. She would say, remember this or remember that about the person. She wasn't paid, and she wasn't a professional. It wasn't her job, and she just felt sorry for the person who had passed away. She was the traditional accepted mourner. She would give the dead a blessing. As years went by, that faded away.

"We Made Up Our Own Language in Seymour"

Joe and Marie Criscuolo told the story of Marie's father. As a young boy in Italy he once posed as a priest, going into the confessional with his cousin. Opening the slide, they listened to a young girl confess her sins. Marie grinned and said, "Both of them got a good beating afterwards."

Figure 3.3. Joe and Marie Criscuolo at their home, 2008.

Marie Falbo Criscuolo:

My grandfather left Italy because he was so poor, and came over to get a job here. It took him sixteen years before he sent for his wife and his son. My grandfather didn't see my father as a baby because he left my grandmother over there in Parenti in the mountains of Calabria, near Cosenza. They didn't write because my grandmother couldn't write or read Italian. Her life was miserable over there during those sixteen years while she waited to come here. In order to eat in Italy—I don't think my grandfather sent money because

he was saving everything to buy a place for them—they used to have to go to people's gardens to dig for potatoes. Sometimes they went without eating.

My grandfather shoveled snow on the streets of New York City, and one of his cousins vouched for him, and he worked street maintenance. They used to take the horses out, and load the snow in the carts, and then dump it in the river. When it was bitter cold, my grandfather told me that they would keep the horses in the stable, put blankets on them to keep them warm, but they sent the Italian men out. He said they used to say, "A horse was worth fifty dollars, a guinea we can always get."

When my grandfather finally got enough money he went to Seymour, and that's where he settled, and he bought a house and a farm. It was a mixed neighborhood, and there were Russians, Polish, and Italians. He had quite a bit of land. We had a pond up in back, and the blueberry bushes, and a barn with cows and chickens. He worked in Waterman Bic Pen. My grandmother took care of cows and chickens. They would grow vegetables and he would take the cart on Saturday, and go to downtown Seymour, and sell fresh fruits and vegetables.

Once my grandmother Maria got here, she never, ever left her home. She never went anywhere. One time they were taking a ride to Naugatuck, and she got so carsick that she had to walk back home. After that time she never went any place at all. She was afraid to get carsick again, and never went in a car again. She stayed in her house her entire life. She never left the farm or the house to do shopping. An Italian guy from New Haven used to come with a truck with the salami and the pasta and all that stuff. That's how she did her shopping.

Phil Rizzuto's mother and my grandmother were first cousins. My grandfather would take us without my grandmother, and we used to visit them at Thanksgiving in Brooklyn when he had just started playing ball for the Yankees. She wasn't that impressed. It was baseball. She was an old Italian woman who lived in one of these railroad flats, it was like everybody else's. It was just a regular Brooklyn railroad flat, it wasn't anything exceptional. She didn't have anything great in there. He had just started playing ball at the time, and that was his job, and this is what he did. She probably would have been much happier if he'd been a carpenter or something like that. What did she

know? What were the New York Yankees to her? But my grandmother was the happiest, most pleasant and wonderful person you ever wanted to be around. Nothing perturbed her.

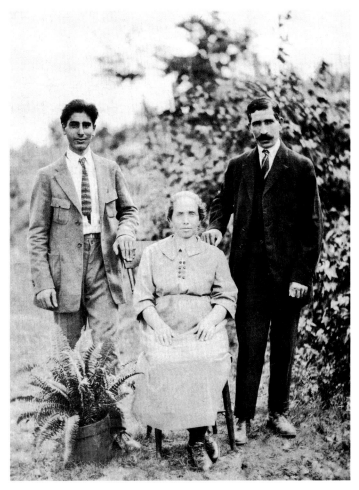

Figure 3.4. Grandmother Maria Falbo with her son Ralph and husband Peter on the family farm in Seymour, Connecticut, 1930s. Criscuolo family archives.

She wanted nothing. She never asked for anything. She dressed with the skirts and a babushka, even in the summertime, and never had her hair cut. She died at ninety-six and her hair was still down to her waist. She cooked, did all the baking, took care of the chickens, milked the cows, worked in the garden, and she had three other kids after that. We used to spend a lot of time with her, and my mother worked as a dressmaker in Ansonia, Derby, and Bridgeport, so in order to communicate—I didn't speak Italian and she didn't speak English—we made up our own language. No one could understand us. Little bit of Italian, a little bit of English that she would learn from me. No one else understood what we were saying, but we understood each other. I loved her.

"Everyone Became My Mother"

Rita Restituta Ruggiero:

Women here in Naugatuck were from different areas in Italy and had different dialects and we congregated in the same area. All the Casertani from Caserta, all the Sicilians, the Ruotese from Avellino, all the Marchigiani,

and they all congregated and mixed in a lot. They had nothing else. It was just nice knowing all these people. And after my mother died at thirty-seven, and you have to realize that I was only ten years old. I had no family in this country, no aunts, no uncles. It was all of the Italian people that lived on "The Hill," on High and South Main Streets, and it was known as "Little Italy" in Naugatuck. Everyone became my mother. This is the old Italian way. If something happened in your family, they were there to take care of you. One of the best things about living on High Street, I had a lot of love from everyone. Started with my mother and father who were very loving parents. My mother would talk to you. She never, ever raised a hand. Now I know it's not unusual when some people lose their patience with a child. My mother never did.

I can picture my mother at the sink, washing dishes. and if I was doing something that I shouldn't have been doing, my mother would come over, wipe her hands on the towel, sit down, and call me over and she'd say to me, "*Hai fatto male. Tu mi vuoi bene?* You did wrong. Do you love me?" And I'd say, "Oh, of course Mama!" Then she'd say, "*Se tu mi*

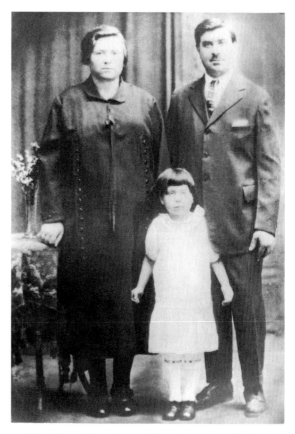

Figure 3.5. Rita Restituta Ruggiero and her mother Pasqua Antonia and father, Pietro, 1920s, Ruggiero family archives.

vuoi bene, non fa male, ma hai fatto male, If you love me, then don't do the wrong thing, but you did wrong." If the floor had a crack in it, I could have fallen right through! That was worse than a spanking.

As her bouts of illness became more acute, I knew she was going to die. I always had lunch with her every afternoon from school, and she would say to me, "*Non piangi, Rita, se tu piangi, non mi senti*, Don't cry Rita, if you do, you won't hear me." Then she'd say, "*Io, ti preparo per quello che succede, la saluta tua è buona, allora mi fai un piacere, mama ti stai a di che stai accorto a Barbarina*, I'm preparing you for what is going to happen, you are in good health. Now do me a favor and take care of your little sister Barbara." Then she said, "*Se tu fai la buona sempre la gente ti vogliono bene, se tu non fai la buona, nisciuna ti vuole bene*, If you are always good, people will love you, but if you are not, no one will love you." See, this is what I latched on to. That's why I never sassed anybody back. I would always say, What would my mother think if I answered back? And my father was just as loving. Even the teachers, even though they were Irish or English, I have to say that the best thing that I remember about the Italians on High Street and the teachers in school, I had all the love in the world. Especially after my mother died, the teachers were so concerned. The principal, Missus McAvoy, volunteered to send me to Normal School, the Teacher's College in New Britain.

"They Were the Glue"

Rosa DeLauro was the United States Representative for Connecticut's Third Congressional District since 1991. She earned a solid reputation as a voice for the voiceless and a lawmaker who always remembered the forgotten.

It is quite remarkable, my mother's generation. These were women who did it all. They carried a family. They worked. They raised children. They were oftentimes the backbone of the family. They did it under the radar screen, and they did it without having the benefits that Italian women today like me and my generation have. So, for us, it's the fruits of their labor. We are the realization of their dreams.

They coped with whatever life threw at them. With good husbands, with bad husbands, with kids, good or bad, with illness, with wars, they sent their sons to war, they lost their sons, and they continued on. They worked in the factories when their husbands went off to war. It is that generation of women, and

Italian women, who really were extraordinary. I don't know if they recognize it as a sense of self-identity. They don't. It was just what they were supposed to do. And they did it! Unassuming, no glory, nothing, they did what they felt was their responsibility. Amazing! They kept families together—they were the glue that kept the family together. The quiet inner strength is nowhere more pronounced than in that generation of Italian American women. I saw it in my grandmother. I see it in my mother, still today.

"Love Each Other"

Ralph Marcarelli:

We had a friend of the family, Adelina Lenzi, from Saint John Street in New Haven, who had thirteen children, and she was left a very young widow to raise those children. I got to know her in her old age, and I loved the lady. I called her "The General" because she was a commanding general with thirteen kids and all the progeny of those and on and on. She had an army at her disposal! I remember her going for breast cancer at seventy-five, and she came out of that hospital with both breasts removed.

And not five weeks after that, which was Easter time, she proceeded to bake forty-five huge *pastiere*, Easter pies, and *pizze e grano*, wheat pies, and all the Easter pastries. She was kneading that *pasta frolla*, pastry dough, for the pies, just amazing!

Nothing held them down. Nothing defeated them. God knows how many of these women I could remember and relate with no complaint. It is absolutely quiet heroism. Saints are canonized officially by popes when it's proven that they lived lives of heroic virtue. There are other requirements like miracles attributed to

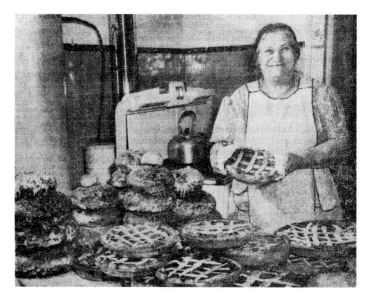

Figure 3.6. Natalina Aiello making Easter pies on Wallace Street, March, 1951, Aiello family archives.

them certified by Rome and so forth. But by that definition of sanctity, that heroic virtue, heaven must be populated with so many hundreds and thousands of Italian women! To the point, and I've seen this many times within my own family.

Men are known to moan and groan and complain if dreadfully ill. The mothers in the family—not on your life! They did everything possible to spare the family the sorrow and grief over their suffering. They wouldn't show you how horribly they felt, how much pain they were in. It was amazing. And my great aunt, dying of cancer, in that sweet way that she had would say to us all the time, "*Vuleteva bene,* Love each other." I don't know anything greater than that. I know an awful lot of prominent people in the world, heads of state. To me, no one reaches the caliber of those women. You may have learned this, you may have learned that, you may have learned chemistry, you may have learned astrophysics, and you may have learned philosophy. But there is one thing, and only one thing that has to be learned. And I learned it at the knees of my relatives as a small child. And the question posed was this: Why did God make you? And the answer is: God made me to know Him, to love Him, to serve Him in this world, and to be happy with Him forever in the next. If all of you have learned everything else but not that, you haven't learned a thing.

"She Had a Steady Job"

Gennaro "Jerry" Santore's eyes glistened as he spoke of his mother's life and how much she loved her children.

My mother Angela Maria was born in Amalfi and my father, Victor, in Atrani. They got married in Saint Michael's church, nineteen thirteen. She worked in the Ideal Shirt Company on Chapel and Hamilton Street in New Haven. Philip DiBenedetto owned it. There wasn't too much work for my father in the teens. He worked on and off at Sperry and Barnes, a slaughterhouse on Water Street. Then he got laid off, and he'd go back again. But my mother had a steady job, and she worked steadily, even though she had a bad heart. I had to quit school because my mother's heart got worse. I said to her, "If you don't go to work anymore then you can stay home and watch the kids."

I got a job at the Ideal Shirt for ten cents an hour as a floor man delivering clothes to the

girls on the sewing machines in the early nine-teen thirties. I worked till six at night with no overtime, worked on Saturdays. So we shared the housework to make her life more comfort-able. My mother had four girls and four boys. I have no picture of her because she would say, as mostly the Italian women used to believe, "*Se tu fai ó fotografie, i' mi muore,* If you take my picture, I'll die." That's why today we have no pictures of her. She was a beautiful woman with wavy hair. We always used to sit around the stove in wintertime trying to keep warm, and she would talk and sing to us. At Christ-mas she used to sing "Tu Scendi Dalle Stelle."

"So Where's the Piecework?"

Betty Panza told the story of her older sister Jennie being so strong she could lift a manhole cover to retrieve a lost ball, a feat the local fighter Al Oliver could not match.

That's all they knew. Where were they gonna go to work? A lot of them didn't go to school. My sister Jennie went to work in Whalen shirt shop when she was a kid to help the family. And you know she was a fox. She'd be on piecework, and she'd get two separate enve-lopes, one that she did for piecework, and one that she did for day work. And she thought she was gonna fool my mother, you know? She said to mother, "*Ma, guard a pag che ti paga,* Ma, look at the pay I'm giving you." My mother said, "*Figlia mi! That alla che si fatt?* My daugh-ter! Is that all you made?" She said, "Oh ma, that's *alla che si fatt,* Oh, ma, that's all I made." And my mother said, "*Addo sta ò piecework?* Then where's the piecework?" She didn't go to school. My mother couldn't read or write. But she knew what was going on.

"One Francesca Is Born and Another Is Dying"

Francesca Grillo was ninety-one at the time of our interview. She still tended her vegetable garden out-side her kitchen door in Niantic.

My mother and father met in Norwich. When I was born, I was small and fragile. And the doctor suggested to my family to "Hurry up and take her to church, have her blessed because she's not going to live." So they put me in a shoebox as the story goes, hurried me to church to have me blessed before I died. And they took me back home. And my father quickly got somebody to take a picture of me

because my father was the oldest son in the family, and I was the oldest grandchild. So my father wanted to hurry and have a picture taken of me to send to Italy because my father had gotten a letter that my grandmother was dying.

And so, the story goes, my grandmother was bedridden because she was sick, and so when my grandfather got the picture through the mail, he hurried to my grandmother. I owe all of this to my grandfather. My grandfather went into the bedroom and said, "Oh, Francesca, Francesca! Look at your first grandchild is born!" My grandmother took the picture, and she was looking at it, and she said, "One Francesca is born and another Francesca is dying." And she closed her eyes and she died. And so my picture is in her hand somewhere.

"They Carried Her in Milford Like in Sicily"

Rose D'Auria told the story of the women in the family to her sister, Christina Marino, nephew Tony Chipello, and friend Rose Vinci.

West Main Street in Milford was ninety percent Sicilian, and they all lived on West Main Street. A lot came from Canicattì in Sicily, and many of the men worked on the railroad between New Haven and New York. My mother died at thirty-eight when I was two years old so I didn't really know my mother at all. We had a grandmother, Angela Vella, who raised us nine kids. My grandmother was sixty-two, and raised nine kids with my father. She was so spry when she took over the family. She was from Campobello in the province of Agrigento in Sicily.

On the stairway, my mother, before she went to the hospital, said to us, "Goodbye, I won't see you anymore." She knew she was going to die. It was in childbirth. When she died, they had a procession from the house just like they do in Italy. They carried the casket from the house on West Main Street to the church. Everybody from West Main Street came out, and they all walked, following the casket. And all the little kids followed behind it. She was laid out in the dining room, and the coffin was on the side wall. They buried her at Saint Mary's cemetery.

"Growing Up In the Convent"

Grace Pompano graduated from the Green Street orphanage in New Haven at age eleven.

My mother died when I was about two and a half from the Spanish Flu Influenza [1918], and I was brought up in Sacred Heart Convent on Green Street until I was eight. They used to have the wakes in the house. My grandmother told me, "She's sleeping." Then from there they shipped me to the convent.

I remember going up the steps to the convent, and there was a big, big door. I looked up, oh my God! And the nun opened the door. I could picture it today, saying, gee what a big door! Every morning we walked to Saint Michael's Church. I used to sit in church, and pass out very easy. I was weak, I don't know why. Maybe I didn't get enough to eat. But I remember the cook. She was a big woman, the nun. She used to come around with a pot and a scoop. Standing in long lines for cod liver oil, we used to get a spoonful with a cracker.

The dining room table was a big long wooden table. There was a hole, and the dish would fit right into the hole. We had a lot of chores. We had to wash piles of dishes, oh the work! We got on our hands and knees to polish the floors, the stairs. Seven, eight years old, they made us work, boy! We had to make our own beds. We did a lot of embroidery work, and they used to sell them. I remember a lot of hand sewing. We even had a little schoolwork. The nuns taught us how to crochet.

What I remember—the best of all—out of the whole group, the nun picked me to sing in the choir, and I was the lead singer. And the chorus would all join in with me! We ate moldy, stale bread. I remember one of the nuns took me to the bakery. We used to go begging, and the bakers would give us big bags of buns and bread and cakes and things. And we would bring them home.

My father came to visit once a week. My grandmother used to come. I still remember at Christmas time, a group of men from a service club used to bring us used toys that they repaired. I still remember my father, every time he'd come and visit, I'd get a big bag of oranges. But the nuns would take them [laughing]. When we graduated in nineteen twenty-seven, one of my aunts gave me a twenty dollar gold piece. And my sister's mother asked my father for it, and he gave it to her. Up until this day, that was mine!

"She Wanted to Read and Learn"

Betty and Angie Paul recalled their mother's ability to recite entire novels she had memorized in Italy.

My mother used to sit by the window and read. Our neighbor used to go to the library in Bridgeport, and he'd get all the classics in Italian. And she'd sit by the window reading those books, and when I came home from school for lunch, she'd be at the window and I'd say, How far did you get? And she'd tell me the chapter. She would read to me and explain what was going on in Italian and all those classics were so sad. Tears would come to her eyes. She knew "The Crucifixion of Our Lord" in Italian, from the beginning with Pontius Pilate, and the ending with his death on Friday, and the words the Blessed Mother said. She told us the whole story into a prayer in Italian. She made expressions to keep you interested. And we understood every word in Italian she said. She was in a world of her own while she was doing it. When she was in Italy, she was going to school, and my grandmother took her out of school to work in the fields, and she cried because she was doing really well in school. She had that yearning to read and learn.

4

From Italy to Connecticut

The Sewing Tradition

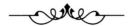

For girls in southern Italy, the ability to sew, spin, and weave represented an important rite of passage from adolescence to womanhood. Under strict supervision of mothers, young girls were occupied from dawn to dusk with house chores, feeding livestock, tending gardens, supervising children, preparing meals for men returning from the fields, and learning to become embroiderers, seamstresses, and weavers. Some learned sewing skills studying under *maestre* of the *scuole di taglio*, teachers at trade schools, or from nuns who taught classes in convents. Young women often could be found working diligently at their looms where they displayed weaving skills that attracted the attention of matchmaking mothers with eligible sons. A Sicilian proverb captured the suffocating nature of small village life, where the gossip of watchful neighbors often established permanent reputations, "Your mother dowers you, but your neighbor marries you."[1] Women often sang at their looms, creating a rich anthology of women's folk poetry. One weaver's song captured the physical attraction of a young man stricken by the beauty of a young woman busily working her loom:

> What a lovely daughter this peasant has,
> She is like a golden banner!
> When she takes a needle in hand, it seems
> she sews with thread of gold;
> Then, she sits at her loom,
> She lets fly so easily the shuttle;
> And I, poor wretch! Look from afar,
> I hear the beats and die of pain![2]

In Homer's *Odyssey*, the female weaver appears in the character of Penelope who shrewdly uses her sewing skills to outwit her suitors, establishing herself as the archetype of the faithful wife. Promising to choose a new husband at the completion of weaving a burial shawl, she waits until evening to unravel her work, buying time to remain loyal to her wayward husband Odysseus. The image of dutiful weaver woman reappears in Giovanni Verga's late-nineteenth-century novel *I Malavoglia*, which takes place in the poor

fishing village of Aci Trezza on the eastern coast of Sicily. Filomena is given the nickname Saint Agatha, the patron saint of weavers. As a woman who knows her place, obediently attending to household chores in all seasons, she embodies the southern Italian ideal of the faithful woman. She is poetically described as a "*donna di telaio, gallina di pollaio, e triglia di gennaio,* a woman of the loom, hen in the coop, and mullet (fish) in January."[3]

At the time of the great migration, seamstresses in southern Italy were considered skilled workers. Italian women held other occupations as storekeepers, teachers, midwives, and agricultural workers who labored seasonally during planting and harvesting periods. Among these occupations seamstresses earned the highest salaries, and half of working Sicilian women were employed in the cottage textile industry.[4] By the 1880s, the negative effects of the Unification's industrialization of the North changed the lives of sewing women in the South. When the new government opened markets to foreign competition for manufactured goods, it made working on looms in the home obsolete and unprofitable. Textile factories employing women all over the South closed, fueling more decisions to migrate to America.

Connecticut's booming textile industry, with labor-hungry manufacturing plants in many of its cities—silk factories in New Haven, Middletown, and Rocky Hill, pants factories in Norwich and New London, pajama, embroidery, and tie factories in New Haven, blouse factories in Stamford, shirt and dress factories in Bridgeport, thread mills in Pawcatuck and Willimantic, a velvet factory in Stonington, and coat factories in Middletown—provided job opportunities to immigrant women with sewing skills. Women who had never seen a factory floor in Italy took jobs in filthy, hazardous sweatshops where they had to adapt to the demands of the American wholesale market, with fast production of garment pieces rather than the time-consuming craft of sewing entire dresses or custom suits for individual clients.[5] With their meager earnings, women in the needle trades paid loans to relatives in Italy for their passage to America. In some cases they sent money to Italy for aged or infirm parents. Many American-born workers handed their paychecks to mothers who used the money for the upkeep of the family, saving a portion for their dowries. No longer able to sew at age ninety-eight, Lucia Fulin, a Sicilian immigrant from the town of Mellili, wrote a poem in homage to her hands, and her long, productive career as a *sarta*, a fine tailor.

Le Mie Mani (My Hands)

Le mie mani scarnite
e un po' deformi,

con qualche machioline
qua e la, segni indelebil
della tarda etá!
Messe a riposo da parecchi anni,
guardandole mi duole
nel pensare che, al par di me,
dovettero invechiare!
Quanti lavori insieme,
abbiamo creato, negli anni belli,
verdi e produttivi, adesso
il nostro compito è finito!
E, nelle reminiscenze del passato
che, spesso destano al cor
malinconia, un unico
pensiero mi conforta:
"Essere non si puo
piu d'una volta!!!"

My hands, emaciated and a little disfigured,
With some little spots here and there,
Indelible signs of old age!
Put to rest for quite a few years now,
Looking at them hurts me to think that,
Just like me, they too must grow old!
How much we created together in the beautiful
Years that were verdant and productive
Now our work is finished!
And in the reminiscences of the past that often
Stir feelings of melancholy in the heart,
Only one thought comforts me:
"To exist more than once is not possible!!!"

"I Had My Own Business"

Lucia Falbo Fulin was 102 years old at the time of our interview. Her father hailed from San Vendemiano in Veneto and had been a policeman stationed in Sicily. Lucia made her own wedding gown when she was married at fifteen.

When I was only three months old my parents went back to Sicily. I grew up in Melilli, I went to school there. I got married there.

Melilli was *pittoresco*, picturesque, the houses built up the mountain, a very pretty and very calm place of about eleven thousand people [in the teens and 1920s]. People were either too poor or they were too rich. The poor, the *i viddaneddi* and they took the *sceccuriddu*, the mule, to go to work, to *zappari*, to work the land on the farms. They seeded the wheat, they took care of the almond and olive trees, the grapevines. They sold *u must*, the first cut of the wine. They made a big platform and threw the grapes from a window, and men with special shoes would crush them

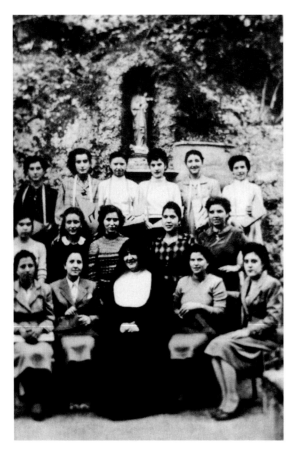

Figure 4.1. Sewing class taught by nuns in Melilli, Sicily, 1950s. Foreman family archives.

landowners, they were called the "Don" and they owned the *fèudu* and rented the land. These lands were so large they had to sell it or rent it. I used to go to *scuola elementare,* grammar school, at eight, and come home at noon, and I got *la licenza di scuola elimentare,* my diploma, in nineteen eighteen. In the afternoon, I used to go to another school where three old maids taught me how to *ricamare,* embroider, until I was eleven. I learned by just watching them. Nobody really showed me how to do it. After eleven, I went to learn to sew and make dresses from a dressmaker. I was an apprentice. I was so young, but I could make one good dress out of two small ones of less quality. The teacher was impressed. I had a born talent to sew, to create things. And the teachers wanted me to continue learning because I was smart (I shouldn't say it), and they thought I could be a teacher. But for some reason in the family, that couldn't be done.

I was an only child. My mother decided to send me to *la scuola di taglio e disegno,* a trade school of sewing and design, only for girls in Catania. I stayed there from February to August with a family my stepfather knew, with Francesco and Magherita Sessa, and they had a daughter my age. Signora Margherita was my

with their feet, and the liquid would fall into a big trough below. And below there was a press. One day when I was eight, the *u chiàuru du must,* the smell of the first wine, was so strong, I almost passed out drunk!

The *massari* were farmers who owned cows and rented the land. The *fèudutari,* the big

teacher, and she was from Genoa. She used to put the material on the table, and explain the basic pattern and design. And then we found our own inspiration to make things. There was no pattern. You had to know how many inches for the shoulder, and all the parts. I used to listen and absorb.

I used to sew on my own. I was fourteen, and went back to Melilli, and decided to become a dressmaker at home for everybody in town. I was a *sarta*, and I was more than a *sarta*. A lot of people worked in the shop and they would do just one thing—*drrr-drrr-drrr*—I had to do everything by myself. Take measurements, make the design. In those days the style was almost like today. The drapery, how the garment hung on a person, was done on the person. I wasn't interested in men's clothes.

Because I came from the big city, Catania, the people thought I was special, like I came from Paris. And I made dresses, coats, drapes, and wedding gowns. The rich people used to come in to my business in my house, the doctor's wife, the lawyer's wife, or somebody wealthy. They made appointments for me to go to their house. I used to work for satisfaction, not for money. I used to think, Well, I'm home, I don't go out, and whatever I make, that's okay.

"*Una Sarta* in Middletown"

Lucia Falbo Fulin:

In America, even if it's the president's wife, she comes to you. In Sicily, it was the opposite. Sometimes I had to have the dress ready for a fitting, and then it was finished in a week or two weeks. They'd try it on the last time to make sure it fit right.

When I came to America I sewed for Missus Gildersleeve from Portland and they owned a boatyard. She came with a corset on. A beautiful woman, and she brought her corset [to fix], and I said, "You could wash it before you bring it." The next time she did.

The Lymans, the Hubbards, all the hifa-lutin' people used to come to the house and I would sew for them. They brought a design or she would create a design for them. I had a lot of professors from Wesleyan, and they would talk to me like I had the same level of education. And I said, well, if they think that way that means that I'm doing okay.

Missus Lee's daughter was going to get married and she wanted to wear a dress that her aunt once wore. It was laced, very delicate, and it was coming apart. Someone else would have thrown it away. So she brought it to me,

and said, "Do you think you could fix it?" I said, "Yeah," because of the way it looks. It was a beautiful lace. And a little bit here, a little bit there . . . when she asked me how much I wanted I said, "Well, I did it because I liked it. It was some work and a little love." She laughed. And she got married in that dress I fixed for her. If it wasn't for me, she wouldn't have anyone to do that work.

Once this old lady came to my house with a dress and she wanted me to fix it. The front of the dress was all dirty! When she came to get the dress, she asked me how much I wanted. I said, "Nothing." And she said "Why?" I didn't know what to say because I didn't want her to come back. So I said, "Oh, I don't know, you remind me of my mother-in-law!" [laughing]. She looked at me. She didn't know if I meant something good or something bad. But she didn't come back.

My daughter Elizabeth, in the nineteen fifties, went to G. Fox in Hartford, to the boutique, a special department with very expensive clothes. It was Easter, and there

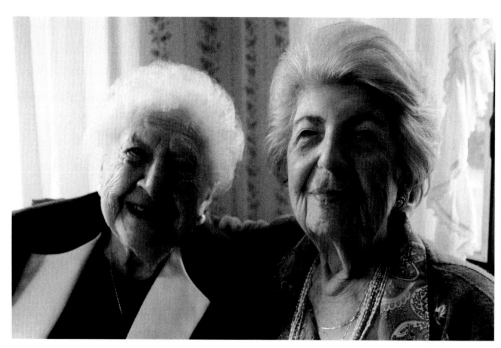

Figure 4.2. Antoinette Tommasi Mazzotta and Lucia Falbo Fulin, 2011.

was a mannequin with a beautiful coat. My daughter made a drawing of the coat, bought the fabric, and brought it to me. I duplicated it perfectly. There was a beautiful cotton laced dress in Vogue magazine with a jacket, pure white with a bottom on the side, and underneath it had a blue chiffon blouse. My daughter showed it to me, bought the fabric, and I did the same thing. It cost about five hundred dollars in those days.

"My Mother's Sewing Proverbs"

Antoinette Tommasi Mazzotta recalled baking Sicilian sweets at Christmas. One was *giuggiulena,* a candy made with sesame seeds, almonds, sugar, and honey. They also made heart and wreath-shaped *bagnucata,* a dough made with eggs and flour, rolled into little balls, deep-fried in oil, and drizzled with sesame seeds and honey.

She couldn't even go to school in those days in Pachino, Sicily. She couldn't write her name, put down a cross if there were papers to sign. She taught me how to crochet, how to knit, to mend, how to reverse collars on shirts. Sometimes a shirt was in excellent condition, but the collar was worn off a little bit, so when I

was about thirteen my mother showed me how to reverse the collar, and I'd sew the collar, "*Vidi a mamma, guarda á cammisa pari nova!* Look how new the shirt looks!"

My mother didn't make clothes, but she knew how to mend clothes, and she used to have a saying in Sicilian, "*Cu sapiri arripizzari/ Mai poviru pari,* The person who knows how to mend never looks poor." She'd tell me, "If you have a dress and the hem is falling down or a button is missing, you know how to sew it back on." And the dresses looked good. They used to say, "How could she know how to do this when she had no education?" She taught me so much, oh, she really did! "*Stai attenta a mamma, stai attenta,* Listen to your mother. *Í cosi che ti onurano, adda onurari,* The things that bring you honor, you must honor."

I was maybe six, seven years old, and we went to visit Angie Ballacino's family. My mother was always very particular with my dresses. She always made sure they were neat and ironed. There was a man that boarded with Angie's mother. When he saw me he said, "*Ma vi! Che vèni chista picciridda,* Oh what a beautiful dress! What a beautiful color!" And he was bragging about how cute I looked in that pretty dress. So my mother said, "*Vìd á*

*mamma. Á vestina è stata onurata, ed ora tu
onuratu á vestina,* Admire that dress because
that dress has made you proud." She always
said, "*Í cosi che ti onurano,'a devi onurari,* The
things that bring you honor, you must honor."

"She Had a Photogenic Mind"

Michael Mele often waited for the horse and wagon
from Hulls Brewery to pass by his home on James
Street. He jumped on board and got a ride to Green
Street School on Chestnut Street in New Haven,
graduating in 1921.

My mother was very artistic. She had to go
to school. Her father was a very proud man
and his last name was Proto. She could see
something, go home, and make it. There was
a woman in her village of Atrani who used
to design mantillas for the women who wore
them to church. And when my mother sat near
her, the woman kept shaking her head so my
mother couldn't see the intricate designs of her
mantilla. So my mother went home that day,
and made the shawl exactly like hers. She had
a photogenic mind. So my mother walked into
church the next Sunday. And the woman said,
"Hey! Where did you get that shawl?" And my
mother said, "From you!" My niece still has it.

"I Kept Sewing"

Gaetana DeLaura was ninety-four at the time of our
interview. She recalled her mother and cousin sharing
the same wedding dress.

I had already learned to sew on a sewing
machine at home, the kind with the pedal.
My mother Angelina taught me.

Her older sisters didn't go to school, and
they weren't working, but they were mostly
in the kitchen learning how to cook. They
believed the girls didn't need school. You

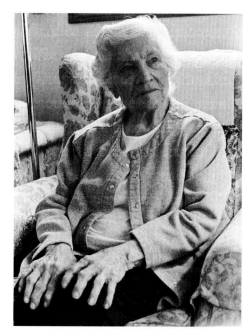

Figure 4.3. Gaetana DeLaura at the her home, 2008.

From Italy to Connecticut　～　123

couldn't fight it because that's the way it was. It wasn't just in Sicily, it was here too.

She learned how to sew her own clothes at home in Caltavulturo, Sicily. She even made men's shirts. She could do everything, and she taught us. I was really young, and I couldn't wait to try the sewing machine. So one day when she wasn't around—I could reach the pedal—and I hopped on. I got my finger caught in the needle, and it went right through. I didn't want her to know about it because I'd get hollered at, and this and that. So I pulled it out, and I still have the scar. Of course it tore the end of my finger, but she never said anything. I don't know whether she found out or not. I never told her. She was always afraid we'd get our fingers caught, which I did. But I still kept sewing. One of girls in the neighborhood was a baton twirler, and I made her uniform from scratch. I just borrowed one of their blouses, and the skirt had to be just a short skirt, and I copied it from one of their skirts, and just made it shorter.

"Á Principessa"

Theresa Grego was ninety years old at the time of our interview. Her parents hailed from Amalfi, and her father was a sailor in the Italian navy.

I came from a family of thirteen children. Being the first girl after my parents had six boys, my father called me *á principessa,* the princess, and sometimes *á check e bank,* the bank check, because he felt he hit the jackpot when they had their first daughter after so many boys. My mother had twelve kids, and couldn't do any sewing. My father wasn't strict because we all behaved. My mother, with all those kids, never raised her voice, never gave anyone a beating. We all helped one another. My mother had a lot of patience with all her kids, and even the cousins who came to eat with us—all the kids eating her meatballs while she was cooking.

The dress factories sent out work to women who couldn't get out of the house and wanted to do work at home. They did all the finishing, putting on buttons, snaps, hooks and eyes, loops for belts, sewing everything by hand. I used to go back and forth to the Buonocore factory with a bundle on my shoulders, or under my arm. I used to help out my grandmother who lived with us from time to time living with each of her three children, and she did most of the work. I didn't get any money for it, but I was helping out, being good. My grandmother used to sneak me a few dollars at a time from the pay she made from the factory. My uncle

used to give it her, and she passed it on to me. She used to say, "Put it aside, and when your husband Angelo comes home, buy yourself a sewing machine." We all had our sewing machines with the foot pedal, my aunt and my mother had their own. Everybody made clothes for their family. I bought my first machine at Singer's on Orange Street in New Haven. I used to make underwear for my husband from brand new cotton feed bags he bought from the farmers for ten cents a bag. I made a pattern from an old pair of shorts. I made shirts, curtains.

"They Taught Each Other on Williams Street"

Marie Santore told the story of her sister Rosie who gave her father only fifty cents from her weekly paycheck. Marie chuckled, saying, "She kept the rest to buy dresses for herself and buttered my father up telling him he looked like the Pope even though he was bald."

Everybody who came over from Italy, they were all peasants, really. One of my grandmother's *paisans* was so heavy she couldn't find clothes, and my grandmother used to sew for her. They used to go buy material in bulk, and wash the wood floors, scrub the floors. No linoleum. Anybody having a baby, and they'd make a big pot of soup and bring it over. Even when my mother had us, people came up with chicken soup and stuff. You never had to worry, it was really something.

There were three buildings in one backyard on fourteen Williams Street in New Haven. So the women got together, and they bought a whole bolt of this material from a dry goods store on Grand Avenue. One woman had a sewing machine, and they carried it down from the third floor into the backyard. Everybody had a lot of kids. There were the Lucarellis, the Paradises, the Fiskos, and the DiGioias. They put the sewing machine outside in the backyard. Somebody had a pattern, and we all wore the same dresses! [laughing]. Cute as buttons. Everybody sewed, my mother made ours. She was talented. Maybe her mother must have taught her. She crocheted beautifully. Everyone took a turn. They taught each other. Some of them worked in the dress shops like the Fiskos who worked in Kramer's. Somebody got a hold of a pattern and they taught each other the different steps. We all looked like orphans.

"Silkworms and the Procession"

Marietta Scalzo Notaro:

Women bought silkworm eggs from the local agricultural store in Decollatura [Calabria], and they looked like little seeds. The women put them in a warm place in the home, and as they hatched, they needed to be fed, so they collected *cielso*, mulberry leaves. In the country, they got them from the bushes and they called them *ciuzú*, and brought them home to feed and crawl. Because the house was sometimes cold and damp, some women used to keep them in their bosom to keep them warm so they hatched quickly into caterpillars. As they finished their life cycle, they left behind white strands that grew into a *ciacu*, a web, which they put in a cauldron of hot water, and pulled it apart by hand placed around a *fuso*, a spindle to dry.

Sometimes they combined *lino*, linen, made from the flax plant—one thread line of silk and then one thread line of lino—to make bedspreads, towels, and doilies. With the silk, it was used to make bedspreads, or sold in the market. Since there was only one woman—

Matilda Falvo—who owned a *telaio*, loom, and she was the town *tessitrice*, weaver of silk. She wove silk for a lot of people who asked her to weave whatever they needed, especially linens for a young girl's *corredu*, or dowry. They brought pillows, table linens, sheets, bedcovers, and towels, and everything had to be in twelves. The silk bedspread was woven and richly embroidered. Three days before a wedding in our town, unmarried girls organized a procession to help the bride fill the drawers of her *corredu*. They walked from the bride's home to her new home, and as they walked they would carry the most beautiful piece over their arms, or even on their heads to let everyone see she had the most beautiful dowry. (Translated from Calabrian dialect)

"I Brought These Needles from Italy"

Anna Sagnella:

My mother would get flour bags because she made her own bread, and she'd buy it by the hundred pounds. She would bleach those flour bags and make clothing for us. She made little slips, panties that I always helped her sew.

She was very talented in her own way. They didn't know the language, but they had a lot of talent. She learned in Amalfi. She said as soon as she could walk by herself, there was a knitting crochet needle in her hand. That was the main thing that her mother did. As they grew up, the more they were taught to sew, crochet, and knit and of course, it was carried on to us.

My mother used to say, "*I' m'aggia fa í calzètte*, I have to make stockings." She wanted to teach us how to make our own stockings. She said, "*Mo' aggiu portata í ferr, aggiu portata dall'Italia, e mo' i' mette in mano e fa accussì*, Now I brought these knitting needles from Italy, I put them in my hand and do it like this." The knitting needles, they were just wires, sort of edged off on each end. Not like we have now, with one end with a nice little knob on it. And then, she was very careful. Because we would have an argument we'd have the needles in our hand. Kids, you know. She said, "*Oh, mette, mette ccà! Mette í ferr ccà! Nun toccate!* Put the needles here! And don't touch them!" Her mother was a very strict woman. And no matter how much we wanted to speak English in the home, she would not allow it,

"*Í parole American nun si parla in chesta casa! Quando iat fuor, parlata American, ccà si parla Italian!* We don't speak American words in this house. When you go out, talk American, but here we speak Italian!" She said we had to learn her language. Oh, she was very strict about that, she didn't want the English language in the house. See, she had a method to her madness. She wanted us to learn the language. We didn't believe so at that time, but when you think about it in later years, I know the language well, and I can speak it well.

"Sewing for the Dead"

Betty Paul went to grade school in Bridgeport with the actor Robert Mitchum and said, "He always stuck up for me, and he used to give me olive and cream cheese sandwiches."

My mother Saveria's father, my grandfather, was a tailor and he taught her how to sew in the town of San Biase, in Campania. He went to school in Naples before he married. He was pretty educated for those days. When somebody passed away in Italy, he'd have to go and take the measurements of the suit or whatever. He

wouldn't go and he used to send my grandmother, Caterina Funaro. She had to do it all.

"The Curredo in New Haven"

Ralph Marcarelli:

Part of what was happening in the city of New Haven was that the dress manufacturers had ancillary manufacturers like Mister Goglia who had a beading concern. And the women all over the city had these devices, a rack setup on which you put the fabric, and the women were in their houses beading. I remember my mother doing that.

The domestication of women in those days, the nineteen twenties and nineteen thirties, was extraordinary. They knew how to knit, sew, crochet, tat, embroider, bead, and on and on. This was part of that climate, the ambiance in which they all lived. The Italian women born in this country learned those skills in this country. My mother learned because every woman in her family knew how to do it and taught her children. And sometimes they were sent to Provincial House of the Zealotries of the Sacred Heart on Green Street in New Haven and they were taught by the nuns. During the summer, the little girls were sent to the nuns by their parents for a dime a day to learn how to sew.

It was a whole system of domesticity, and it wasn't a haphazard thing. It wasn't merely an academic exercise when they taught how to tat and embroider and crochet. These were also practical things, because they made their own trousseaus frequently. Somebody in the family was delegated to get linen, and to crochet, and embroider to prepare this hope chest, just like the *curredo,* the dowry, in Italy, which had to be furnished by the bride's family. The bride brought her *curredo* to her new home. There was a system. The bride brought her *curredo,* and at the time of the marriage they had people called *il compare d'anello,* the ring *compare,* a person different than the best man, who bought the engagement diamond ring. My *zio* Giulio, my uncle, had that role. Somehow it came about that instead of the diamond, he gave my mother the entire dining room set to furnish the house at her request. What my mother ultimately wore—she didn't care about diamonds—was a wedding band with small emeralds in it.

"The Sewing Tradition"

Diana Avino:

My grandmother's name was Giacinta Cristina Ferrara Storlazzi. They called her "Giacin'." She was born in Ripacondida in the region of Campania. She was a sewing teacher in a sewing school in the town. They had sewing machines, and she taught the girls how to sew. She was an expert tailor, so when she came to America that's the job she took early on.

My grandfather used to go through the towns fixing sewing machines. And he went to this school to fix their sewing machines, and that's how my grandparents met. My grandmother taught my mother how to sew. My mother came with her brother and sister and mother in nineteen sixteen. My grandfather had already been here for three years working as a fine carpenter. They hadn't seen him for three years. My mother had no recollection of her father until she met him at five years old.

They lived on Wallace Street in New Haven, and they realized right away my grandmother was a fabulous tailor. "John the Miser" owned the local Fazio's Dry Goods Store and gave my grandmother all the work, anybody who came in and needed their clothes fixed. She didn't just take in clothes that had to be fixed, but she also did fine work. She would make bridal sets. She would make the pillows, and crocheted the ends of the pillows, and she made the bedspread with the crocheted piece. And then she'd make the bridal gown, all by hand. She sold them to everyone. And through her side business she started to make a lot of money for the family.

My mother was so good at sewing because her mother had taught her, and my mother started to work with her doing the same kind of sewing. That's why my mother was such a good tailor, because her mother had taught her everything. So where does this go with the next generation? And, of course, my mother taught me everything her mother taught her. Right now my daughter Jennine is getting married, and I'm in the middle of beading the ends of her bridal veil. And we went to New York City to buy some of the netting. My daughter told the woman, "My mom is going to make my bridal veil, and she's going to do the beading." And the woman said to

her, "Your mother must be Italian!" and we both laughed. It's part of the family, part of the tradition, and it never goes away. You own all the good traits of your family, and they always go through to the next generation. And the sewing has.

Midwives and Giving Birth

At the turn of the century, midwives played critical roles in the lives of women in southern Italy and in the United States. As late as the 1930s, 93 percent of births still took place in the home in Italy.[1] Midwives trained at universities in Palermo, Turin, and Naples married well, and were considered highly skilled. In a culture where married and single women seldom appeared alone in the public square, midwives traveled freely from house to house, often on their way to give medical advice or to deliver children. In Sicily, the midwife was given the respectful title of *Za,* aunt. The midwife in Italy had the right to baptize children, and they provided legal testimony in the case of illegitimate children.[2] In Sicily, she not only delivered the child surrounded by the mother's female relatives, but introduced the newborn into society by carrying it in the baptismal procession.[3] At the church she carried the child to the baptismal font, placing it in the arms of the godfather, and stood by through the ceremony to aid the priest.[4] In cases where the

baby's life was in danger, the midwife could perform emergency baptisms.[5]

On both sides of the Atlantic, midwives tended to be close confidants of women, knowing their medical condition as they neared childbirth. Outside of the female kinship network, they shared intimate relationships with women, offering medical advice before and after the birth. Midwives often performed abortions and gave advice on contraception methods. In American cities with large Italian American populations, the midwife's stature grew in importance. In Milwaukee, the demand for midwives (115) was so high they numbered nearly as many as doctors (171).[6] In Connecticut, midwives provided Italian American women the comfort of speaking the same provincial dialect, and understood Southern cultural norms surrounding the birth of a child. Midwives often colluded with parents to keep the physical aspect of childbirth hidden from young children, who were told tales of how babies entered the world. In the town of

Milocca in Sicily, children believed—as they did in Middletown—that the midwife brought the baby in her little black case.[7] In a society where men determined women's destinies, childbirth and labor represented one of the few settings where women were in total control. In Pietro DiDonato's *Christ in Concrete*, the character Luigi tries to enter the bedroom where his sister has just given birth. He is scolded by the midwife, "Away-away! This is not territory for men!"[8]

In 1933, Professor G.Chiodi Barberio wrote *Il Progresso degl'Italiani nel Connecticut*, a survey of mostly Italian American men who had achieved economic success in Connecticut. Scant attention is paid to Italian American women, which reflected their limited opportunities to achieve professional careers at the time. Two midwives are profiled in the predominantly male world of Italian American success stories. Maria Pezzella, the first known *levatrice*, or midwife, of Bridgeport, arrived from Naples in 1903, where she had graduated with high honors and delivered a record 311 births in one year.[9] During her career, Maria had the reputation of saving many lives during difficult childbirths. Giovannina Garamella, who established a midwife practice in Bridgeport immediately upon her arrival, won the admiration of the Italian American community. On her first day from Campobasso, Italy, with a degree from the University of Naples, she saved the life of a patient needing emergency surgery during a complex procedure normally reserved for a doctor.

Midwives in Connecticut's Italian enclaves faithfully served the women of their neighborhoods, often returning to the same address to deliver a new baby. For struggling immigrants with large families, the midwife's charge for deliveries was considerably lower than the doctor's, who was called only if there were complications. When the newborn was cleaned and placed in swaddling clothes for all to see, proud parents in Italian American neighborhoods were heard saying to friends and family "*Abbiamo abbuscato a nu baby*, We have a new baby."

"I Wanted a Sister"

Antoinette Tommasi Mazzotta:

I was very disappointed when my kid brother Gaetano was born. I wanted a sister. I already had four brothers, and didn't want another brother. When the midwife came out of the room, in those days, I never noticed my mother was pregnant. I was six years old. So she comes out from the room, and tells me I have another brother. I said, "Oh no, I want a sister! I have four brothers!" So then she

brought him out. She put him on my lap. Oh what a beautiful baby, round faced. So cute! In those days they didn't weigh them. They just held them in their arms, and say, "Oh, about eight pounds." I kissed him, I thought he was so cute. He's ninety-two now, and he's always been an angel of a brother.

"Is It a Boy or a Girl?"

Assunta Celotto Sirico was eighty-nine at the time of our interview.

My grandmother's name was Lillian, and my mother wanted to name me Lillian. She came from Castellamare di Stabia in Campania. But I was born on August fifteenth, so all her friends and neighbors said, "Oh you can't do that! You gotta name her Assunta because it's the day of the Ascension, and you know it's a big deal in our religion." So she named me Assunta, but she always called me Lillian. I grew up being called Lillian, and when I'd run into friends years later with my daughter they'd say, "Hey, Lil, how are you?" And my daughter looked at me and said, "Ma, your name is Sue." So I told her the story.

Everybody from Wooster Street to Wallace Street got together, and they were all in that parade in nineteen twenty two. They carried the Madonna d'Assunta, and everybody put dollar bills on it, they had a band, and people followed, just like in New York. So my father was out walking in the procession of the Madonna d'Assunta, and he had so many kids already. We had sixteen in my family, and I'm the youngest. He was forty-seven, and my mother was forty-three. So when I was born he was out there in the street, and he yelled up to the midwife who delivered me and was taking care of my mother on Wallace Street, "What is it? A boy or a girl?" The midwife, her last name was Sangiovanni, yelled down from the window to my father, "It's a girl." And then boom! Boom! Boom! Back to the parade. He [laughing] witnessed the parade even though my mother was giving birth. He was very into all that stuff.

"Bootleggers and Midwives"

Angelina Paul spoke about her mother Josephine Rea, a short, strong woman who volunteered to make bandages, gave blood, and took care of the sick during WWII while her two sons fought in the war.

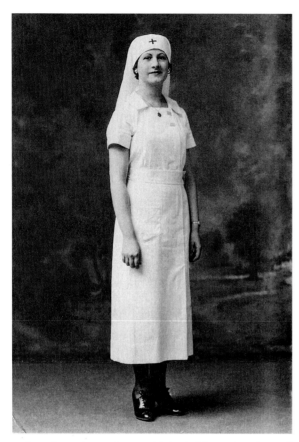

Figure 5.1. Josephine Rea, 1936. Baldino family archives.

I had six brothers and sisters and I was the oldest. We lived above a saloon on the third floor on Railroad Avenue in Bridgeport in the nineteen twenties. The landlord on the first floor was a bootlegger, and he used our back hall to store his liquor. He'd come up the back stairs, go into that little closet, get the liquor, and bring it down to the saloon. One day I saw what he was doing, and he said to me, "Don't you say anything," and I said, "Oh no, I won't."

One day there was a knock on my door, and I had to let the man in. He wanted to see my back hall. I said, "I can't let you see it." He said, "Why not?" I told him, "I don't let nobody in the back hall." He said, "Well, I just want to look." I said okay, but I went in after him, and I opened the door, and he said, "What's behind that door?" I said, "Oh, my mother keeps different things in there for us kids." He was a plain dressed man, must have been a cop. So he took my word for it. So that night, when I did that good thing, the landlord came up, and gave my poor grandmother—she had osteoporosis, walked with a cane, and used to enjoy to drink a glass of whiskey—a whole gallon! The landlord said to my mother, "Here, this is for what your daughter did."

One of the first things I remember was when my brothers were born. My mother had midwives. I never went into the bedroom, only after [the baby was born] we did that. Every child that was born, the midwife used to put the baby in my lap, and I would show it to all

the kids. As I grew older I got to hold quite a few of my brothers and sisters because I was the oldest. As much as my mother had babies in the house, we never heard my mother scream or cry. Nothing, very quietly. We were always in the kitchen waiting, and all the kids would come around me. My father was at work.

"Call Doctor Conte"

Rose Pagano Onofrio's mother went to the New York World's Fair in 1938, making the long, torturous ride on Route 1 in her son's Essex road car. Along the way, the hungry family stopped to eat one of her famous homemade lunches she had carefully packed into shoeboxes. Instead of lunch, they found shoes.

My mother didn't believe in midwives, and she thought they were terrible. They had midwives in her village in Sicily, people who knew something about delivering babies. But she wanted the doctor, so she got Doctor Conte. Imagine the old doctor. He came for me and my brother Ben. He was short, and the house was up on a walkway, and he all but sunk in when he came to deliver us right in the house.

"My Mother Delivered a Baby"

Betty Panza and Fannie Panza Buonome spoke in respectful tones about their mother's ability to always rise to the occasion.

My mother Graziel delivered a baby. Dorothy was an African American woman who lived in the back of us in Fair Haven, and she was related to Mister Clark. We used to wait for him to come home because he made the best homemade ice cream, right on his back porch. And the best biscuits! She was in labor. You couldn't help it, my mother must have heard all the screaming. From my brother's bedroom door, you could have gone right into their apartment. It was all up and down, and they lived in the back. My mother couldn't speak English, but no matter what you told her, she was there. Missus Santacroce, who was our downstairs neighbor, was kind of timid about things, so my mother went over there and delivered the baby. She didn't have any training. There was none of that Lamaze stuff, and all that breathing, *whuf! whuf!* In and out! She also delivered Andrew Calabrese, the band leader of "The Top Hatters." She used to nurse children as a wet nurse. She

nursed Doctor Scialabba the dentist because they didn't have enough milk. My mother was pregnant at the same time.

"A Mammàna Rossa"

Sal Garibaldi recalled the seven Sansone sisters walking home at lunch from the Py-Rex factory dressed in black because their father had died. He remembered men in mourning wearing black ties and black armbands on their jackets. He described a funeral where a friend almost pulled his dead uncle out of the coffin, saying *Sus! Pietro!* Get up, Peter!

The midwives in those days were called *'a mammàna rossa*, the red midwife, who were like Red Cross workers. The mothers made their own choices. There were midwives all along Chapel Street. For example, your mother might prefer Donna Sofia, a midwife who lived right around the corner from us on Grand Avenue, and was well respected in the neighborhood. She was from Sorrento like my mother, and was considered a *paisan*. And you as a kid didn't know anything about her. They were very secretive in the nineteen twenties, and you didn't know what she was doing.

Since there were no phones your mother would say, "Go to Donna Sofia's house, and tell her to come tonight. And don't say anything to anybody!" So you went there, and said, "My mother says she wants to see you tonight." And she'd say, "Alright a boy." And you left, you were just like a little messenger. You didn't know why she was coming to see your mother. Your mother discussed women things with her, but you didn't know. Mothers had a lady friend who came to visit, and when there was small talk—not like today that these boys and girls at a young age know what's going on from day one. In those days, we were denied hearing what they were saying.

As soon as your mother and my mother started talking, they'd say, "You! You go in the other room." They didn't want you to hear what was going on. It was quite comical, but that's how all the families lived. The first visit was the first step, when a woman missed her period. Then the next month she had little conditions, and depending on how things were running, my mother might say, "Tell her I want to see her." In the meantime the *mammàna* became more friendly, and she came more often. She was like the doctor, had

a lot of experience. She advised my mother what to do, how to conduct herself, don't get scared, not to drink, or things of that nature.

The women in that field were hepped up, they knew what was going on. If the mother was having problems, she called Doctor Conte for more medical attention. Doctor Conte came between the two, and they decided who was going to bring the child into the world. The *mammàna* was available every hour of the day, but the doctor was all over the neighborhood taking care of everybody. The *mammàna* was reliable when she had a doctor, with her knowing, the doctor knew what to do medically. She knew she couldn't order prescriptions, or touch her. All she could do was bring the child into birth. There were quite a few of them in the neighborhood.

When it came time for childbirth, especially the boys, you didn't know what the hell was going on. All they did was push you into another room, "Get out! Get out, no looking!" And your mother was in the bedroom with the midwife. Not even my father. The man never saw a child born. It wasn't a thing for a man to see in those days. Today they take pictures of it.

In those days, there were no restrictions on the men with the women. Some had ten, twelve kids, and they made sure they kept their wives pregnant. That was their lifestyle, not that they necessarily wanted big families. Wives carried children for twelve, fourteen years. And that was common. I'm not a racist, but the Irish and Italians were noted for having large families. That's how the man lived, not like today where we plan children. Like today, if a guy has four or five kids, he's ridiculed by his friends, more or less, what are you doing? Jesus Christ!

There was a woman, Angelina Caggiano, who came from Sorrento, and she knew the mothers of the women in my generation from Sorrento. She'd tell the women, *"Chiud í còscie,* Close your legs!" And they'd answer, *"Sì, ma chill piace a pazzià,* Yes, but my husband likes to play." Now we as little boys and girls, we didn't know what was going on. You'd go to school, and when you got home there was a baby. I was born on Christmas Day, about two in the morning. The next day my brother Joe, who was about seven years older, he's in front of the house after coming home from mass at Saint Michael's Church, he's telling

people, "Santa Claus brought two babies!" My mother had twins.

"The Black Bag"

Mary Pesce smiled, happily recounting the times when her mother and family gathered *sótta à prèula,* under the grape arbor, outside her kitchen door to process and can tomatoes from their garden. She chuckled remembering her father's saying when her brothers misbehaved, "*È cchiù meglio crescere i porci, magari te mangi ropo un anno,* It's better to raise pigs, at least you eat them after a year."

They all had midwives in the neighborhood, but my mother had Doctor Boardman from the Annex. He used to come in here with the black bag, and then he used to say, "Boil the water," this and that. We didn't know. In fact me and my brother Clement, we were sitting there, and all of a sudden the doctor came in with the black bag. He went upstairs, you know. All of a sudden we heard a baby cry. I said, "It's a baby!" The doctor told us he brought us the baby but he didn't tell us where it came from. And we used to believe the baby came out of the black bag.

6

Going to School

———⟨⟩———

Luisa Canestri DeLauro's life trajectory reflected the experiences of many second-generation women in Connecticut during the 1920s and '30s. Like many American-born daughters, Luisa stood at the crossroads between the backward school system her mother had experienced in southern Italy and the chance for career advancement that Connecticut's educational meritocracy offered those who could afford tuition. Luisella (Luisa's mother) emigrated from Amalfi in the aftermath of Italy's Unification, whose new seat of government in Turin disproportionately increased taxes on the South while channeling revenues to upgrade school systems in the North. In 1901, 77 percent of Sicilian females were illiterate.[1] The same year, the illiteracy rate was 94.7 percent in the region of Basilicata. In a survey taken of Basilicata, 122 of the 126 communal schools, often inaccessible unless a student walked five to six miles, had no drinking water, and ninety-eight had no latrines.[2] In an agricultural society that required even the youngest hands to help during planting and harvesting season, young girls seldom went beyond a few grades of grammar school.

Luisa was enrolled in the Columbus Day school in the heart of New Haven's most densely populated Italian neighborhood, Wooster Square. In a family of four girls and two boys, she was fortunate to complete grammar school, and attended three years of high school at night, working during the day in the family business, the Canestri Pastry Shop. Like many young women who aspired to achieve the American dream, Luisa set her sights on continuing her education to become an attorney. One night after dinner, while her sisters cleaned the table and washed dishes, Luisa took her mother aside, and revealed her career plans. Luisella had grown up in the patriarchal society of southern Italy that bred girls as nurturers, giving first preference to males. She gave her daughter a withering response, "Luisa, someday you're going to meet someone and get married and raise a family. Then your husband will support you. The boys are the ones that need the education."[3]

Though she disagreed, Luisa dutifully accepted the Old World belief that reserved higher education for boys instead of girls. As Luisa stated, "I accepted it because during the Depression all the girls had to go to the factory to work, but I always regretted it. It was something everybody did in those days." [4] Although some second-generation Italian American women in Connecticut completed high school, they nevertheless followed the Old World patriarchal dictates of their parents who believed the father was the head of the household and that sons should be favored over daughters. Ironically, Luisa's brothers, as in other immigrant families, had no desire to go to college. With resignation in her voice, Luisa said, "I guess Italian parents felt girls didn't need education as much as boys did."[5] Like many Italian American women of her time, Luisa realized her dreams could never come true, but the yearning for education remained with her the rest of her life. The realization of her dream would have to wait until her daughter's generation, when the booming postwar economy in the 1950s and '60s, and a greater belief in the importance of the American meritocracy, allowed more women to complete high school, and attain college degrees. Many Italian American women like Luisa were determined that their daughters would never have to work in sweatshops, and wisely put aside money for their education.

One day, making up an excuse to walk home together, Luisa asked her teenage daughter Rosa to stop at the dress shop after school. In reality, Luisa wanted her to experience the inside of a sweatshop, to witness the effort that sewing a complete dress demanded, and to weigh the value of the paltry fifty cents she was paid for it. She wanted Rosa to see the frenetic pace of the factory floor packed with workers in constant motion in the sweltering heat of summer without air conditioning, to hear the deafening roar of two hundred power machines whose intense heat poured over the backs of dressmakers hunched over their stations. She wanted young Rosa to observe open windows that served as air conditioning, admitting more oppressive heat into the stifling factory, and to see women reaching into brown bags, taking bites of their lunch so they could keep working without losing time. She wanted to show Rosa how male bosses forbade workers to speak to one another, often screaming at anyone leaving their work station for a drink of water, and how they intimidated women spending too much time in the bathroom with loud knocks on the door. After a few visits, Rosa admitted the sweatshop gave her a headache, suggesting she could be home doing her homework.

Luisa never told Rosa the real reason why she wanted to meet her at the factory; Rosa never told her mother she knew all along why she was bringing

her there. Images of the sweatshop were etched into Rosa's consciousness, and she graduated from Mount Holyoke College, and then earned a master's degree in International Politics from Columbia University. When Rosa DeLauro was elected to the U.S. Congress, representing Connecticut's Thirty-Third District in 1991, she carried the collective pride of an earlier generation of Italian American women whose sacrifices for their children's future had come to fruition. As a lawmaker, Rosa recalled the men and women laboring in her mother's dress factory, and became a voice in Congress for the rights of working people and the less fortunate. Luisa spoke volumes describing the changes between her generation and Italian American women of Rosa's generation, saying "[In my generation], we were satisfied with very little—we didn't have many opportunities. But we wanted our children to have what we didn't have. It's us. Maybe we spoiled them? It isn't that we spoiled them. We just wanted them to have what we didn't have."[6]

"The Pork Sandwich"

Anna Calabrese Sagnella's story illustrates the intersection of the American school system's beliefs on proper nutrition and the peasant food brought by the immigrants.

We used to call it cigola bread. My mother used to call it *pane che è cigola* [laughing]. And don't waste anything! My mother made sandwiches, and put all the fat on it. My teacher's name was Miss Gilitz, and I wanted to throw it at her. She wouldn't let the kids eat it. My mother made the sandwiches with the pork fat. And Miss Gilitz, I'll never forget it, took it out of my hand. She said, "You're not eating that!" I said, "Yes I am, my mother made it." She said, "No you're not," and she took it away from me. I wanted to throw it at her. I ran home, and I told my mother she took the sandwich away. My mother came down, I can still picture her. She ran there, *comme nu'diavolo*, like a devil, she wanted to pull the teacher's hair out. She didn't speak English, and she said to the teacher, "*Si fa accussì con ó sandwich, i' ti tiro tutti i cappelli!* If you do that with the sandwich again, I'll pull all your hair out!" She was vulgar, too, and she continued, "*E chelle 'ncòppa e chelle sott!* And not just the hair on top of your head, but the hair down below too!" My mother was tough.

"From Gaetana to Thelma"

Gaetana DeLaura's mother, Angelina Moscarella, came from Caltavuturo near Palermo in Sicily when

she was eighteen, in 1914. She sewed men's clothes she took in from the factory in New York.

We lived on Shaw Street in New London where a lot of Italians lived, some next door, some across the street, but not everybody was Italian. My grandmother raised all her kids there, and my great-uncle had a meat store where all his *paisans* came to hang around. Then my father bought a house on Jefferson Avenue. It was mixed, Irish, Polish, and Italians, from different parts of Italy. They mostly congregated close, they didn't run to each other's house much, but they just wanted to be near somebody Italian, or the Irish wanted to be near the Irish. The old Marchigiani families from Fano lived in Fort Trumbull. They used to think that Sicilians were below them. The Sicilians and Marchigiani didn't get along. One thought one was better than the other. Shaw Street had a football team and they played the Marchigians on Thanksgiving morning. They were all ex football players and it was like watching the Super Bowl. They played for pride and nobody got paid.

I went to kindergarten at the Nameaug School, and that's when they changed my name. They didn't know anything about us.

As long as it was foreign, they didn't believe in those names because they didn't recognize the names. So they changed them. So my sister Giuseppina became Josephine, my sister Serena became Sadie. The Jewish and Irish teachers changed my name from Gaetana to Thelma. I don't know how they got to that! [laughing] They did that to everybody. They said they didn't know how to say it, never heard of it before, so they changed it. I liked school. I played third base for our girl's baseball team. I finished the eigth grade, and went to work sewing in a factory. In those days, they believed girls didn't need to go to high school because they didn't need to be educated. I wanted to be a nurse, but in those days they didn't have places to get ready, and have classes, and things like that. Today they have so many places that help out. But in those days, we couldn't afford uniforms, so I didn't even ask. It was the Depression, and I went to work sewing in a factory. My husband and I were very big on education.

"They Called Me Bessie"

Betty Paul's mother Josephine worked for Oscar Keane in the teens, making dough for ice cream cones at

the Acme Cone Company on 192 Railroad Street in Bridgeport.

I had a *mammànella,* a midwife, who brought me into the world. She wrote my birth certificate in Italian because she didn't understand English, and she only spoke Italian. It got me into a lot of trouble when I went to school because they couldn't translate my name, Battistina Paola. When I went to school in nineteen thirty, it was bad. My sister Helen came with me to tell the teacher who we were, and enroll us in kindergarten. The teacher asked, "What's her name?" And my sister said, "Battistina Paola," and the teacher couldn't pronounce it. I was American, and I was born here. We were in America, and people laughed at it, or they couldn't pronounce Battistina.

In the first grade, the teacher asked me a question that I didn't understand because of the language barrier. She came over, and gave me a whack on the behind, and said, "Sit down, dummy!" It wasn't that I was stupid, I just didn't understand. I was shy to begin with, and that made me more introverted as a child. They were mostly Irish teachers at the time, and the Irish didn't sit well with the Italians, and vice versa. When you went to school, and you heard all the other kids so fluent in English, yet we had to learn the meanings of the words the teachers told us because we didn't speak it at home. I cried my eyes out about the old names. They called me "Bessie Payola," and I hated that. I'm not Bessie Payola, I'm Betty Paul! Then my father had my name legally changed to Elizabeth Paul. When he went for his citizenship paper, our last name was changed to Paul because it was too hard to pronounce it. It wasn't easy when we were kids. We got along pretty well with other nationalities.

"All They Had Was Their Virginity"

Norma Barbieri always sang as a child despite the fact that "there was always someone dying in my tenement house in New Haven, *È morto ó zi',* the uncle died." Oblivious to what was going on, she continued singing lighthearted songs like "Wey Marie" that reverberated the hallways until one day when her mother grabbed her "by my skinny neck," and said, "*Figlia mi,* my daughter, what am I going to do with you?"

I didn't speak English when I started school. I walked out of Columbus School in kindergarten, all of four years old mind you, walked

all the way down Chapel Street to our pastry store. My father said, "*Che fai ccà? What are you doing here?*" I said, "*Papa, chilli soncono cretini, non mi capiscono,* They're stupid in that school, they don't understand me." He said, "*Non ti capiscono? È tu che sei cretina perche tu devi ritornare, devi imparare due lingue, figlia mia, Italiano in casa, Inglese nella scuola,* They don't understand you? My dear daughter, you are the stupid one. You have to learn two languages, Italian at home and English in school." He picked me up, and took me back to school.

So many girls at Columbus were just incredible, very bright. But they never spoke of college because the family was strapped during the Depression, and those aspirations never occurred to these girls. I was fortunate. My father had a business, and he was extremely bright in Italy. I got to go to school. His father was a fisherman in Amalfi, but he and his wife wanted their boys educated. They insisted. His mother and father must have had some bright aspects in their life that told them if we have children we're going to have to educate them. It was a public school in Amalfi, from first grade to fifth.

My father was very excited about education. During World War One, my father was in the Italian infantry, and the captain's secretary got shot, and there was no one to write things down. So the captain said to his men, "Which one of you dummies know how to write?" So Salvatore went up, and "Oh, *stupido!*" Giovanni was next in line, "*Si, eccomi,* Yes, here I am." "*Ma che fai? Giovanni, sei cretino, non sai scrivere!* What are you doing? John, you are stupid, you can't write!" Then my father stepped up. Francesco! And he told me that while the others went ahead and fought, he stayed behind with the captain. A percentage either were killed or hurt. But he survived because he could write.

And when we came to the United States, he couldn't go to school because he was working, and began to look for a trade for himself. Then he became a baker and it appealed to him. When I graduated from Columbus School, I had had a very good friend, Ann Cretella. She was two years older than me, valedictorian of her class. She lived upstairs from us, and was very inspirational to me. She loved learning, she was very bright, and I had no older sister, so I'd run to her whenever I had a problem with school, and she was right there with me. And she made me feel as though I should go to school because I had a brain. My sister and I loved Ann.

When it came time for high school, I thought about a Catholic girl's school, Saint

Mary's. My father said, "What! A Catholic school! You'll be absolutely tunneled with your education, and you'll only go one way." He said, "With *la scuola pubblica, ci sta l'educazione per tutte le persone in America specialmente. Non siamo solo Italiani! Devi imparare.* With public schools in America especially, education is for everybody. And there's more than just Italians in this country. You have to learn." He was tough! When he said Commercial High School, I went, and I was very happy because it was a smaller school than Hillhouse, and I found wonderful friends there.

My mother had worked in a shirt factory, and thought it was great because she didn't want me to work in a factory like a slave woman, all those women she knew, a lot of the boss's hands were very active at times. And so she and my aunts walked out to look for another job. They were very dignified ladies, and thought it was terrible. They were frightened because the only thing a woman had was her virginity in those days. If you were going to give it away you became a tramp.

"Jimmy Milotti's Report Card"

Sal Garibaldi:

To be honest, a lot of us were ashamed of our parents. My mother knew how to speak English and everything. They had no such things as PTAs in the nineteen thirties and forties. Mothers used to go to the nuns once a month to meet and talk about how their kids were doing. Some of the Italian-speaking women never knew what the nuns were saying, so my mother used to be the spokesperson. Jimmy Milotti, nice kid. Son of gun, he was no dummy, but he played hooky a lot. Naturally, report cards come out, and he's got a couple of sisters, and when he came home with the report card he already knew what was on it. So his mother doesn't know what's going on, so she's asking her daughters. He told his sisters, "Don't tell Mom what they mean, tell her that P means perfect." They said in Italian, "Mom, he got all Ps." Now, the grades in those days were E for excellent, G for good, F for fair, and P was poor. To protect him, his sisters told the mother they were all perfect. The sisters said to Jimmy, "You better tell mommy." Now, he gets a note from the nun. She wanted to see Jimmy's mother. He brought the report card to his mother. Now, his mother talks to my mother, and says, "*'Jiuline, á monica . . .* Julia, the nun wants to see me." Naturally my mother sees the report card, and

tells the nun she doesn't understand English. The nun said, "He's poor." So his mother said in Italian, "Yeah, yeah, he's poor on the card." So my mother said to her in Italian, "Yeah, but that doesn't mean good, that means he failed." She thought poor meant perfect. So what happens? The next day Jimmy beats me up in the school yard, saying, "Your mother's a stool pigeon!"

"Send Me Three Working Men"

Anna Perrotti Caccavalle's uncle Francesco was the first Italian farmer in "The Flats" of Woodbridge.

When we went to school we had to eat our lunch on the way to school because in the morning we had to get up very early to pick a hundred bunches of radishes before we went to school. We didn't have time for breakfast. In the afternoon, we went home for lunch, and it was only a little way. We had to work on the farm during lunch hour, and my mother used to give us a sandwich. We had to eat on the way back to school. When we used to get back to the school, we used to throw it over the fence on the neighbor's yard because we

couldn't finish eating it. Our neighbor, Missus Paluzzi, used to find a lot of sandwiches, half-eaten! [laughing]. She must have said, "Who's throwing these sandwiches in here?" Every day, we couldn't finish.

If we had a headache in school we'd go home, we had to go work on the farm. So the teacher said, "Don't go home, go in the office and rest," because she didn't want to send us home. She knew we were tired. My brothers and sisters had to quit school when they were in the fourth, fifth grade. My father sent the teacher a wristwatch because they let them stay home. Years ago, there were no laws, do what you want. When I graduated from grammar school in nineteen twenty-nine, from the eighth grade, my father wouldn't send me to high school. The three teachers went and asked my father why he didn't want to send me to high school. He said, "Send me three working men, and I'll send my daughter to school" because he needed me on the farm to work. So the teachers went to Hartford, and they passed a law the year after. After that, the law came out they had to go to school until sixteen years old. I was fifteen, so I missed it by one year. All the students in my class went to Hillhouse

High School, but my father said, "You don't have to." My father used to talk to people, his friends used to advise him what to do. They said, "You don't have to send your daughter to high school, she can stay in the same school for the eighth grade." And the teacher, Miz Bassett, taught me all by myself in the eighth grade.

"On the Backs of Their Sisters"

Ralph Marcarelli:

The women sought and succeeded in educating their sons to postgraduate education, to professional careers as doctors and lawyers, and so forth. Frequently those sons were educated, in a certain sense, on the backs of their sisters. Their sisters went to work in the garment factories, and turned in all their money, which in turn helped to pay off the loans their parents had incurred in order to send their sons to college, and to medical school. This caused imbalances in families because the boys went on to a degree of sophistication, often marrying in accordance with others who were more or less in the same categories, and they moved up the social ladder. The sisters did not.

"The Truant Officer"

Erminia Ruggerio told stories with the conviction of a woman who had learned many difficult life lessons from working on the family farm.

Saturday was always housecleaning day. Everybody had a job. This house was so clean! Every little thing had to be polished, it was unbelievable. We had a school official from our school come to our house. They wanted to come and see the environment in our house. They were concerned. We were skinny. Because of our clothes. I remember going out to work on the farm, and at lunchtime coming back and laying on the floor because I was so exhausted. The bread man would leave about twenty loaves of bread a day. We'd just cut them in half, and I'd eat a whole loaf of bread. We were starving because we worked so hard.

They knew how much we worked on the farm. Our school work didn't necessarily get done on time because by the time you went to sleep, you fell into bed. They realized we had so many kids we didn't have the best clothes. Mom used to make our clothes from the flour sacks and feedbags. She [truant officer]

said, "Oh you must have known I was coming because I don't know how you could live on a farm and this house is so clean!" Well I got news for you, because I went into some of these other friends' houses where the mother was lying on the couch. I couldn't believe that a mother could be lying on a couch during the day because I never saw that. I never laid down and my mother never did either. She [truant officer] went back with her tail between her legs because I don't think her house was ever that clean.

"Go Back To the Sweatshops"

Catherine Possidente:

My father believed very much in education for girls and boys. On our street, and even the other streets around the Oak Street neighborhood, a lot of places in New Haven, girls didn't go to high school. When they graduated from grammar school—some of them didn't even graduate from grammar school—they had to go to work. But we didn't. My father said, "No, girls and boys go to high school and possibly college." Being that he was close to the owners and executives of the company where he worked, they gave him good instruction.

While we were going to high school we worked in the sweatshops in the summers to make a dollar. Now when we wanted to go to work, my mother was the one who said to us, "*Chella che vuie buscate, vuie stipata vuie stessa,* Whatever you earn, you keep." My father used to say, "*Nun é necessaria che vuie iata a fatìca, i' venga a fatìca per vuie, i' faccio abbastanza moneta,* I go to work for you, I make enough money so you don't have to go work." And my mother said to us, "*Eh, iata a fatiga, e vide che si tratta, e vide che staci la fuor' ru munno, si stata a casa, non imparata niénte, ma quando iata fòre vi vidi che si tratta,* Go to work and find out what's going on in the world. If you stay home, you won't learn anything, so go out and find out what it's all about." So we did.

In nineteen thirty-four, after I graduated from Commercial High School, we wanted a job, and we went to the telephone company, United Illuminating, the gas company, the water company, and the banks too. In those days you got dressed with a hat and gloves, a pocketbook. Well dressed. You didn't go the way we go today. My sister Vera and I went together. So when we went to these places they said, "Are you Italian?" So we said, "Yes,

we're Italians." They said, "Well, you Italian girls, you better go look in the sweatshops. You don't belong here in these companies." So we didn't know what to say, we just turned around and went. So we went to the Eastern Machine Screw Company where my father was working. They accepted us because my father was a big chief there.

"It Was Hard for Me to Catch Up"

Josephine DiGiuseppe:

Only one of my sisters went to high school. I was the oldest. I only went up to the ninth grade. My father didn't say I had to go to work, but I just didn't want to go to school anymore, I just didn't care to go. As children we were brought up on Italian. My father was born in Santa Maria a Vico, near Caserta. He never knew his parents. They gave him up for adoption when he was a child. They put him on a doorstep of a church. Even though my mother was American-born, she spoke a lot of Italian with my father. Her parents were all from around Caserta in the region of Campania. So we were brought up in Italian. When I went to school I didn't know much English at all.

It was hard for me to catch up with the other children. When I went to school I wasn't reading any books at home, and it was hard for me to catch on. They weren't advanced like today with special programs. I felt as if I was behind, and I didn't want to go much after that.

"You Don't Look Italian"

Rita Restituta Ruggiero and Catherine Cuccuru had been childhood friends, and worked together for many years at U.S. Rubber in Naugatuck. They recalled Irish, Polish, Russians, and Italians, with more than five thousand people working at the factory during WWII.

When we went to school in Naugatuck, I could remember not knowing how to speak English. A brother and a sister walked me to school. They didn't know what to tell the teacher my name was because of the difficulty in pronouncing the names. My first name is not Rita, that's my middle name. My first name, nobody knows it. It's Restituta, and she was the patron saint of Sora, Italy, which is the next town to where I was born. She was so revered. And here I come to the United States, and the brother and sister don't know what to tell the

teacher my name is because they're not going to understand. So it ended up with my middle name, Rita. Made it simple.

There was a lot of discrimination from the Irish. Those who could speak English, and this is where we had a problem. Going to school when you couldn't speak English, and those that could speak English made us feel very inferior. We felt inferior to the English-speaking community. And our parents did not speak English. They didn't want to bother to learn. They heard stories that people here kidnapped children, and they were not enthusiastic about wanting to learn the English language. People frightened them in certain ways. You'd find that difficult to understand, but those of us who went to school had to put up with listening to name calling. When we talk discrimination now, we went through it in our own way. I'm eighty-eight, and my friend Catherine here is eighty-six, so we went through an era that was very bad. We finally overcame a lot of things.

It wasn't until I was about twenty-one years old, always felt inferior. I happened to go to New York to see one of our lady friends who worked there as a hairdresser. I was walking down Fifth Avenue with her and I heard all these beautifully dressed women speaking different languages. I was so used to "Little Italy" and either English or Italian, and that was it. And I said to my friend, What is this? And she said, "This is cosmopolitan, everyone speaks their own language." When I came back to Connecticut and Naugatuck, I was very proud to be Italian. People thought I wasn't Italian because I have light hair and blue eyes. In fact, my mother was a redhead with green eyes. They would speak to her in any language but the Italian language, and the only thing she understood was Italian. So when they would say, "You don't look Italian," well, then I would hasten to say, "I sure am, and I was born there." I had to add that. And they'd say, "Well, you don't look Italian." Was that supposed to be a compliment? I don't know. As far as I was concerned, now that I learned our background, our heritage, our culture, as you grow older and go to school and learn different things, I thought to myself I have nothing to be ashamed of, really.

These are some of the experiences we have had in this country, but basically, I want to tell you, I am so proud to be an American, and as much as I love having been born in Italy and being of Italian descent, I would never

exchange it for the United States. But I am so sad to see what's happening in the United States at this time. The power struggles. And people not loving people. That to me is such a bad thing.

"She Was a Storyteller"

Mary Carbone and Kathy Bozzi:

After my grandfather dynamited all the trees, cleared the land, and made it into a farm in Hamden, my mother and her mother worked with him too. She really wanted to go to school. She would have been a great student. She was very intelligent. She started to go to school, and then my grandfather went to the truant officer. He wanted to keep her home. The truant officer told him he had to leave her in the school. And my father said, "I have crops that have to be picked. What do you want? All that stuff to go bad?" So they let her out of school. She was in the sixth grade. This was in the early nineteen hundreds He convinced them that she had to be there to pick his crops because they were going to go bad. And she never graduated from grammar school. But she was an avid reader. She loved

to read. She loved to talk with people, and hear stories, and loved people being around her. She was a storyteller because as a kid she had a lot of thoughts going through her head when they used to be on the wagon going to the farm. We always said that if she could have gone to college she would have taken this world by storm.

"The Scholarship"

Though Grace Serio had suffered a stroke, she spoke eloquently about her life experiences. She recalled her parents singing while they cooked Sunday dinner.

I had a scholarship. I graduated and I was supposed to go to collegiate prep. I was good in math. I changed some of the books because the answers were wrong. Miss Moran, my teacher, became a nun. She wanted me to study, to go into insurance because I was good in math. I wanted to be a bookkeeper, and I liked figures. I always thought I'd become a bookkeeper. I was fourteen when my mother told me I couldn't take it because I had to go to work. I went to the attic and hid. I cried and cried for a couple of days. I was the oldest of eleven children. Mister Marks [at City Hall], he said,

"These damn immigrants, they have children just to make money. They don't know that an education comes first." All I wanted to do was read, but there were always too many household chores. I used to go down the basement to hide in the coal bin to read the newspaper. But instead, I became a dressmaker, and my younger sister Rita worked with me making buttonholes from seven-thirty to four-thirty a half-day on Saturday. I brought in a dress, I sewed it, and that's how I got the job. The owner examined it, inside and outside, and he said, "Did you make this?" He didn't believe it. I said, "Yes, I cut it out." We had to bring in our own toilet paper. It was work, work, and work. They gave us nothing. It was hot in the summer, and cold in the winter. The bosses used to pay too much attention to the young girls, and the older women would say horrible things to the young girls.

"We Want Babe Ruth"

Florence Fusco recalled Orchard Street in New Haven as a place where African Americans, Jews, Irish, and Germans played ball together without anyone being called a "Jew" or a "Black."

I played baseball with the boys in the early nineteen twenties.

When we were in school they all wanted to pick me to play on their team, "We want her. We want Babe Ruth!" In the eighth grade, you know how big the windows are in the

Figure 6.1. Florence Fusco, 2007.

school? The gym teacher said spring was coming, and she said, "I'm gonna teach you how to play baseball." I said to myself, she doesn't have to teach me, but I'll go along with her. So everybody gets up, and she hands me the bat, and she says, "This is how you do it." I hit the ball—it's a good thing the window was open, because the ball went flying out the window. She says, "Well, I guess that's the end here, we'll have to go outside." All the while I knew how to play because my brother was a second baseman, and they wanted to send him to Georgetown on a scholarship.

I quit high school in my second year because a teacher didn't like me. She was Irish. She just didn't like me for nothing. She used to pick on me all the time. She used to sit in front there and she'd go, "You get up and recite," and she would give us things to memorize. I would know them, but the moment I'd go in her room and just look at her, I'd forget. I could not remember what I memorized. So when she did that to me, my homeroom teacher said,

"Before you go into her room, I want you to recite them to me." And that's what I used to do. But it didn't do any good. She was so mean. My homeroom teacher, he got after her. He went to the dean, and told her about it. He was going to change my room, but by that time he was called back into the service.

One day she had me—it was a cold winter day—and my lips were chapped and red. She said I had lipstick on, and sent me to the dean's office. And the dean took a washcloth, and was rubbing and rubbing. Nothing came off. I had no lipstick on. I was only in my first year of high school. I was crying because it hurt. And when I went to Dean Lockhart, my homeroom teacher, I was crying. And he said, "What's the matter?" So I told him, and he went right in there and bawled her out. They used to call him Captain Lockhart because he was a captain in the service. But that's why I quit school because he was called into the service again, and when he went, I said I'm going too. And that's when I quit school.

7

Betrothal and Marriage

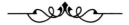

On a bright spring day in 1935, Anna Perrotti Caccavalle arrived for her wedding at the little country Church of The Assumption in Woodbridge, Connecticut. Wearing the white veil her mother had sewed, she walked down the aisle locked arm and arm with her proud father, nodding respectfully to the large congregation gazing at her from dark brown pews. The sparsely decorated altar and peeling paint in the vaulted ceiling of the church's nave reflected the hardscrabble times of a state mired in the Depression. In the Woodbridge "Flats," money was a scarce commodity among farming families, and people bartered services for fruits and vegetables instead of exchanging cash.

After hugs and kisses from the long line of well-wishers at the reception, Anna waited until the money from the wedding envelopes was counted. She hoped there would be enough to pay the Waverly restaurant for the dollar and seventy-five cent dinners prepared for her three hundred guests. Anna's concern was well-founded since her in-laws lived in Italy, and the

customary contribution from the husband's side to help pay for the wedding would never materialize. Luckily, her mother had come to her rescue, donating fifty dollars to buy the all-important *dolci*, Italian pastries served at the end of the meal with espresso in porcelain cups with gold handles. Her father supplied his best aged wine as his wedding gift. With the little money she managed to save despite many years of hard labor on the family farm, Anna scraped together enough to buy a wedding ring for her husband. Unfortunately for the women of Anna's generation, Italian custom dictated that parents buy wedding rings for sons to give wives, but not for daughters to give husbands.

Anna's wedding reflected some of the marriage rituals transported from southern Italy, and the new ways of Italian Americans in the New World. Young Ernest Caccavalle, whose parents came from the same farming area as the Perrottis, Santa Maria a Vico in Campania, had negotiated the terms of marriage with his father-in-law. On a cold March day, Ernest had walked to the Perrotti farm, and knocked on the door

of the clapboard homestead. Speaking the same dia-
lect as Signore Perrotti, he stated his intention to "go
steady with Annie." An argument ensued between
the two. Signore Perrotti did not question the young
man's boldness, his character, or family reputation, but
challenged his choice of daughters. He insisted Ernest
marry his oldest daughter Rose, but lost the argument.
Like many immigrant parents who distrusted new
American ways, the marriage of his second daughter
Anna posed a threat to Signore Perrotti's way of life
as a farmer. Anna's marriage meant the permanent
loss of an unpaid farmhand he had always depended
on. She had been the hardest and most productive
worker of his twelve children on the family farm.

Had Ernest been in Italy, he would have followed
Italian custom, enlisting the help of the *agghiusta-
tore*, a respected man in town who would approach
the girl's parents, assuring them of the young man's
serious intentions, praising his good virtues, and his
unquestioned ability to be a good provider. In Sicily,
Ernest's mother would have found a suitable match
for her son based on being a good worker, virtuous,
well endowed materially, and of the proper station in
life.[1] In Connecticut during the 1920s and 1930s, it
was customary to favor sons over daughters in Italian
families. As Anna stated, "That's why the daughters
worked so hard. Even when it came to the inheritance
it went first to the boys."

An omen of the hard life Anna and many women
of her generation would face in the Depression, and
the need for self-reliance women would have to draw
upon, came at the end of the reception. Starting their
new life together barely paying for their wedding with
the gifts of money from their guests, Ernest told Anna
his bank account totaled five dollars, the result of
sending his weekly earnings to his aged parents in
Sant Angelo in Formis in southern Italy.

"It Was Serious"

In the 1920s, during Carnevale in Melilli, Lucia Falbo
Fulin dressed as Epica the Muse of Poetry, and her
husband as Astronomia. Their costumes won them
a prize.

> I got married when I was fifteen in Melilli.
> People didn't believe I was fifteen because I
> looked older. My husband was twenty-seven.
> I didn't even know him. The first time I saw
> him from far away, he was passing by on the
> road. He came from San Vendemiano in the
> foothills of the Alps in Veneto. This friend of
> the family talked to my mother, and stated his
> [my husband's] intentions. We knew the fam-
> ily. Then he came to the house with the man
> who had spoken to my mother. It was serious.

We just looked at each other. In August we got engaged. I made my own wedding gown. The mother was supposed to make sure, but I made my own trousseau too. I made thirty pieces of everything, thirty towels, and sheets. *A Melilli, se un ragazzo non aveva una casa non si poteva sposare, e i poveri genitori affitava una casa, e dava sua casa al figlio. Era una cosa terribile, una cosa brutta quando sentivano che non aveva una casa,* If the boy didn't have a house [as part of the wedding agreement] he couldn't get married, and it was a terrible thing because it happened a lot in Melilli. Oftentimes the parents rented a house, and gave the son theirs.

"Megghiu Schetta Che Mala Maritata"

Antoinette Tommasi Mazzotta arrived on her first birthday with her mother at Ellis Island on December 3, 1913. She marveled at being able to see her great-grandchildren in other states on Skype, and compared it to her parents who left Sicily at the turn of the century, never to see or hear from their parents again.

The boys sent their parents to the parents of the girl they were interested in, to ask for her hand. That's how the Sicilians from Melilli used to do it in Middletown [in the teens and the twenties]. The reason they did that was because they knew each other so well. They all came practically from the same town. Melilli was a very small village. So when they came to America they did the same thing. On Ferry Street they were all from Melilli, and they all knew each other—four or five girlfriends of mine from Ferry Street married fellas from that street. Some of the marriages, though, should have never been, and the husbands treated their wives like slaves.

If anybody married out of their nationality they wouldn't have anything to do with the son. I remember the Marino family in the nineteen twenties, and they owned a bakery. Their oldest son, "Mack" they called him, Marino, and he married a beautiful Polish girl he had met in school. Oh my God! *"Una pollacca si ha pigghliatu!* He picked a Polish one!" They didn't want anything to do with him, and they probably got back together in time, but she was a lovely girl, pretty. The Polish people are very religious, very clean. Now the time has come. You don't mind if they come from another nationality.

In those days they married from Center Street, Court Street, and Union Street and

these were all the people who came from Melilli. They all knew each other, who was good, who was bad. And so they would match. They picked a son for the daughter. Not unless you didn't like the person, but you knew who they were because they were on the same street. So if one of their sons was interested in a girl, you'd tell your mother and father about her. And they went to talk to her parents, and they would sit and talk. They told them of all the values of this fella, that he'd make an ideal husband, "'*Lu figghiu è spijatu a tò figghia*, Our son is interested in your daughter." And then of course they'd brag about their son, "'*Lu figghiu è buono, un travagghiaturi, e poi educatu, e ci piace arrispittari*, He's a good son, he's a good worker, he has good manners, and he likes to respect people." The girl wasn't there. Her parents would say, "Well, we'll talk to her and *vediamo che decide*, see what she decides." The boy's parents wanted a yes or no after they talked to the girl. Then the mother told the daughter what transpired, and how she felt about the family.

My mother never forced me when my time came. I had five brothers, and they'd be out playing in the same streets with different boys, and who they liked and didn't like. I had a good idea of who was good and who was bad.

When I went out to the movies, I couldn't go out alone, or even with other girls. I had to go out with my brothers. My mother used to give me her opinion of how she felt about a boy's family, "'*A famiglia e chistu non mi piace*, I don't like his family." She said, "*Tu a mamma, pinzari si è un giùvini travagghiaturi, beddu, se beddu macari, e fai una bona coppia*, Mother loves you, but if you think this young man is a good worker, maybe even handsome, you can make a good couple." She'd say, "*Pari un bel giùvini*, He seems like a good young man." But we liked to find out more about this boy. And then I'd say, "Mom, I don't think I like him." And she'd say, "Okay, *basta!*" My mother used to say, "*Megghiu schettu che mala maritata*, Better off single than a bad marriage." Then she used to say, "*Cu si nnamura dei capeddi e di denti, nun si nnamura di nenti*, If you fall in love with someone for their hair and their teeth [their good looks], you fall in love with nothing because eventually they are going to lose their hair and their teeth."

"My *Curredu* in Middletown"

Antoinette Tommasi Mazzotta's grandchildren carried the same prayer book down the aisle at their weddings that she had carried in 1941.

In Middletown—not Melilli—they would send their parents. There would be a fella that liked a girl. So he tells his parents. His parents come to call at the house of the girl that he wants. And for me it was always no, but when it was yes, that's yes. That's it! If the girl said yes, the boy was all ready to say yes. The night before my mother died she said to me, I was single when she died, "*Figghia e mamma, si chiùdi occhi me pi sempri, me ne vai con u dolore d'u cori che ti sto lassando sulu a mamma, pirchì che no calast a testa pi Pietro Mazzotta? E un bel giùvini, un travagghiaturi, hèju un bonu misteri,* My daughter, if I close my eyes forever, I'll leave with a pain in my heart because I'll leave you all alone. Why don't you nod your head toward Peter Mazzotta? He's a handsome young man, he's a worker and he has a good trade."

When I got married [to Peter] in Middletown, my mother-in-law gave my husband six brand new shirts, ties, stockings. She even gave me a dozen handkerchiefs. And my mother gave me "*á biancharia*" of sheets, pillows, and tablecloths. That's what they did. Two weeks before the wedding day the invited guests came to the house to see the bedroom, and bring gifts. They didn't give gifts right at the wedding day, I don't know why. In those days,

satin drapes, and satin bedspreads, everything was just so and pretty. Most of them used to bring money, and pinned it to the bedspread, and wished us well. The most was ten dollars. It was a tradition from Sicily. No one bought gifts. It was five dollar, ten dollar bills.

"Fifty-Fifty"

Gennaro "Jerry" Ruocco came from a family of fourteen, and worked in the Plating Department of Sargent in 1922, making coffin handles ten hours a day for twenty cents an hour. Both parents hailed from the small town of Minori on the Amalfi coast. He was ninety-seven at the time of our interview.

I was born in nineteen oh-eight. The fishermen used to come over with their pushcarts on Hamilton Street in New Haven, "*Ó pesce! Ó pesce! Piglia in man, e chilla cresce!* Fish! Fish! Put it in your hand, and then it grows!" And the women upstairs, they'd stick their head out the window to hear it, and they used to love that!

I used to go to the Minorese club when I was growing up, and they were all married men. We had our own cooks, we didn't hire anybody. Our meetings were in Italian, but if they spoke real Italian I'd ask them to speak

the Minorese dialect because I didn't understand Italian, it was different. I was fourteen, fifteen when I joined the Minorese club. And they used to teach you a lot of things, and they were right. They'd say, like if you were going out with women, they'd say, *"Guaglione, sta accort! Boy, be careful!"* Whatever they wouldn't do, they'd tell you not to do it. And believe me, I listened to them.

When I was fourteen, I had to quit school, and I went to work at Sargent. I met my wife while we were working in the department that made locks. We went together for five years, but we couldn't get married because we didn't have any money. We got married on September twentieth, nineteen thirty-four, when I was twenty-eight. And I had nice kids, healthy and everything, a good family. That's the way it used to be. They used to say a little rhyme, *"Che si dice?/Í sard mangiano alìce/Si tenn á muglièra buon/Campa una vita felice.* What do you say?/Sardines eat the anchovies/If you have a good wife/You'll live a happy life." And that's true.

I believe marriage is fifty-fifty, and we got along beautiful. We always discussed everything. We didn't do anything without talking things over. No arguments. Hey! She works,

you work. Why shouldn't it be fifty-fifty? I had a cousin, and he says to me [loud voice], *"L'òmmo è bosso!* The man is the boss!" So I told him, "Oh, it can't be." Because your wife works—it should be fifty-fifty. And he argued with me in Italian. But I got that guy down to sixty-five percent [laughing]! But I couldn't get him down any more than that. He was thick. Oh yeah.

"The Americano Is Coming"

Lena Corvo was ninety-seven at the time of our interview.

My parents came from Palazzolo Acreide in Sicily. My father came to Hartford alone as a laborer at Edward Balf Construction and after two years went back to Sicily to get married. It was a very patriarchal society, and they rounded up all the girls, brought them all to a house, and they were all together saying to one of the girls, "The Americano is coming, he's going to be your husband." One of the women said, *"Ó sposo,* the husband is coming to marry you," and naturally all her girlfriends went to see this American. When my father saw this girl the family had picked out for him,

he said, "I'm not marrying her. I want this one with the baby sister." My mother was good-looking [laughing]. So he married my mother in Sicily, and this other girl was left without a husband. Then he came back to Hartford, and about a year later he sent for my mother, and she came here pregnant on the boat.

"You Keep Them"

Grace Loglisci's parents hailed from Gravino di Puglia, near Bari, in the region of Puglia. She recalled going to the Italian Institute in Stamford to learn model Italian, which was vastly different than the dialect spoken at home. She described growing up on Steven Street in Stamford's West Side amid six families from Gravino di Puglia, a place where "it was nice because everyone was able to speak to each other."

Stamford had a blouse factory, a dress factory, a pocketbook factory where a lot of the Italian women worked.

We had the Genovese Pants factory. I worked in Henry's pocketbook factory from

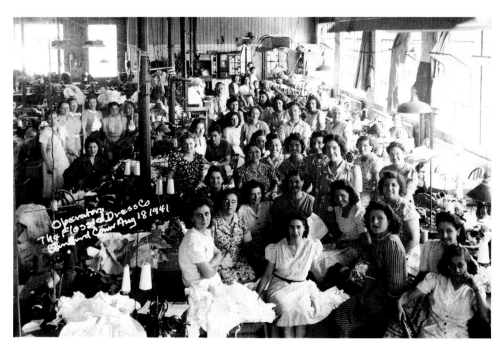

Figure 7.1. Flossie Dress Company, Stamford, Connecticut, August 18, 1941. Carcusa family archives.

nineteen forty to nineteen forty-two as a finisher, trimming the strings and polishing cowhide and patent leather bags. There was no union there. It was big factory and the men did all the cutting and piecing of the bags, the women did all the stitching and finishing. I made between twelve and fourteen dollars a week. Then my husband said he wanted me to stay home.

A lot of the women stayed home too. My father was one of the *paisans* who founded the Gravinese mutual aid society because there were no societies at the time to help the immigrants in Stamford. The women wanted to start their own society but the men said, "*Nah, non bisogna li fimmine*, we don't need women." My father was a shoemaker in Italy and made shoes for *le contesse*, the countesses in town, and for the rich people. My mother lost her father when she was a little girl. She had two brothers so her mother had to go out, and work in the fields. When my grandmother got through with work, she would come and pick up my mother, and they came home together. So my mother was raised by nuns in a convent in Italy, and she became a very religious lady. They taught her how to sing all the Catholic songs, and she sang all the popular songs, "O Sole Mio," and she had a beautiful voice. She taught us how to sing in Italian, and we always had music playing on the radio and opera in the house. If you weren't reading, you were singing religious songs.

One day he made a special pair of shoes, and he said to my mother, "Try them on, these are for the woman I'm making shoes for." So she tried them on and she said, "Oh, these fit beautifully!" And he said, "Well, they're yours, now you keep them." When he got here to Stamford there was a mixture of northern and southern Italians, and he opened the first business on Cove Road in the nineteen twenties repairing shoes. My parents lived into their nineties here in Stamford.

"Why Don't We Get Married?"

Marilyn Faulise and Anna Sammataro:

The town of Pawcatuck was half Irish, half Sicilian. The Irish founded the church of Saint Michael the Archangel and thought the Italians were pagans—they didn't get it. The societies pushed it, the same men who never

went to church. The Irish and the Sicilians fought, but after thirty years, they intermarried and it didn't matter.

Pawcatuck was very rural with a lot of small houses, pretty much like it is now. Everybody had a garden, and we knew who had the best apples. The men did manual labor on the railroad fixing the railway ties. Women stayed home and their older children worked in the Cottrell Mills in Westerly or the velvet factory in Stonington. A lot of the Italians from Tusa in Pawcatuck worked in the American Thread Mill. A lot of the women worked at "The Rag Mill" where they got huge remnants from the other big mills in the area. The women went through the remnants, and if they were big enough pieces, they spread them out and folded them and the owner sold them as remnant pieces on bolts. People bought the good material for curtains and bedspreads. My mother and father, who were both from Tusa in Sicily, met at the factory. So my father talked to her on the way to work. He told her, "Your father wants to go back to Italy. Why don't we get married?" He talked it over with his sister—not his parents—and they got married. My mother was fourteen and he was nineteen.

"We Always Compromised"

Rose Nuzzo remained active into her eighties, helping her son Michael carry on the New Haven tradition of Grand Apizza in his pizzeria in Clinton, Connecticut.

We were afraid because we didn't know if we could make it. My husband had been working with his brother, and he knew the pizza business. One day we saw this place on Grand Avenue in New Haven, and there weren't any other pizza places nearby. So we thought, should we give it a try? I was all for it with him because that's what he wanted to do. He figured he wasn't getting anywhere working two jobs as a bookkeeper at Firestone, and working at Modern Apizza with his brother who was all for it. In those days, even though he was an accountant, and graduated from Stone College after World War Two, bookkeepers were making more than accountants.

So we rented the building, and opened Grand Apizza on March third, nineteen fifty-five, for sixty dollars a month, with heat and hot water. We were worried because we were taking a chance, so we borrowed a thousand dollars from his father, and another thousand

from the pinball and jukebox people. We painted the booths. At that time I was nine months pregnant, and we were cleaning up the place. When we were pregnant in our day and age, we didn't baby ourselves. I mean, the day I delivered my son David I scrubbed the front steps down. Girls don't realize it, the more you do—all right, you didn't go picking up furniture, or stuff like that to hurt the baby, but it didn't mean you had to stop and sit all friggin' day long, you know what I mean?

My father came up from Philadelphia to help us, he always gave us his hands, fixing things. At the time, Grand Avenue was very popular. We had Firestone's, an A and P, the post office, and we had a five-and-ten, the Pequot Theatre, two pharmacies, all kinds of businesses. You could buy anything on Grand Avenue at that time, it was a great place. We were nervous, but we figured we'd take the chance. What could we lose?

The first night we opened up, we were terrified. We didn't even have a cash register. I sat at the counter with a cigar box in my hand, and my husband Freddie made all the dough by hand, right from scratch, and mixed it by hand. Everything was heated on a gas range stove, and that's how we made our subs. The

traditional small plain pizzas with sauce and grated cheese was forty-five cents, the small mozzarella was sixty cents. There were none of these fancy pizzas like today. We were worried, but that night we opened up, and all the teenagers were waiting outside our door to open up. It was just unbelievable from that day on, we did so well.

The teenagers were the ones that started our business. They were good kids, not like teenagers today. From then, as they got older, their children's children kept coming. And we never advertised. All our business came from word of mouth. My husband had a great reputation. Up until we sold Grand Apizza [in New Haven], my husband was the only business that got thirty days to pay his bills because of the way he was. He checked every single bill that came in.

The kids loved Fred. If a kid came in and didn't have enough money he'd give them a soda, he was always giving stuff away, always. To this day, that's why they always remember him. That's why my kids have the reputation they have, because of their father. My husband was the most wonderful husband and father that any girl could wish for. I was one of the fortunate women of that day, not like today—I

was home with all my four children. I worked if somebody got sick, but I was home every day with my children, and I was there when they came home from school. As they got older, I started helping out more. Don't forget, he'd go in at ten in the morning, and not come home until after one o'clock in the morning. He was there day and night for years.

The business went good, and we bought a home. I was his bookkeeper. I helped my husband by taking care of the kids and the house. To this day I know every single sound and noise in the house, how to take care of things because he was never there when people came to fix things. I had a patio put in. My son Ricky had this Italian guy come over to work on the patio, and he spoke broken English. And he ran into some wires, which was from my lamppost. So he calls me over, he says, "What are these?" I said, "They're the wires to my lamppost." He said, "What a you want me to do?" and ba-ba-ba this and that. Then he said, "Oh, I talk a to you husband when he come a home." I said, "You talk to my husband! I'm here! You talk to me! My husband doesn't have time for this." He said, "No, no, no, you a woman, I no talka to you, I talka to your husband." I said, "Oh yeah?

See that gate over there? Get out! And don't come back, because here you do things the way I tell you, you don't have to wait for my husband!" He left right away. But he came back the next day.

We've been married fifty-eight years, and I always tell my kids, "That's from compromise, love, and respect." We always compromised on everything. It was never what I wanted, or what he wanted. Of course I always got what I wanted because he gave me anything I ever wanted. He never wanted anything but a nice car. That's all he ever asked for in all the years that he worked.

"One Year for Respect"

At fourteen years old, Josephine Parlato Bonfiglio's first job was at Fenischel's Pants Shop in New Haven. During WWII, she slipped little notes into pockets for soldiers but never received answers.

My husband worked with my father. I had two older sisters. So my father said, "Sal, you make such good money, why don't you settle down?" He said, "Aw, I can't find a girl." So my father said, "Well, I have a couple of daughters. Why don't you come over and meet them

and see what . . . we'll make a little *amasciat,* matchmaking." My sisters weren't going out with anybody, they were very old fashioned. He decided he would pick out one of my sisters. So he brought Sal over. I was fifteen, sixteen, and happy-go-lucky, come in from the beach with shorts. So my father got him in the boiler shop at work. He said, "Well, what do you think, Sal?" He said, "Yeah, I think I'll take one of your daughters." So my father thought, boy, I got it made now. He said, "I'll take the little one." My father said, "No, she's too young for you." He was nine years older than me. So he said, "Well, okay."

In the meantime, I was going with someone else. My mother loved Sal, though. He got into a barroom brawl on Ferry Street, and one of my aunts went back and told my mother. And that did it. And every time I'd go out with him, I'd come home, and my mother would be sick because she had a bad heart. So my father got a hold of me one day and said, "Listen, Jo, I can't say he's a bad person, but she's my wife, and you're my daughter. I can't make a choice." I said, "Okay Pa, she doesn't want me to go with him, okay, I'll wait." And he told my father the same thing.

My mother died in nineteen forty-two. My husband went to my father. They used to call him "Hook," because he had a big nose. He said "Okay, now, what's your problem now?" And my father said, "Listen! If you think you can keep your hands off my daughter, if you can respect one year for my wife, but if you don't think you can keep your hands off my daughter, one month!" He said, "No, I respect her." So I waited a year, and then I married Sal. We had our reception on the old barge on South Front Street on the Quinnipiac River in New Haven. Sal made a wonderful father, and he was a good husband for me.

"She Married a Widower"

Rose Pagano Onofrio told the story of her father carrying his dead daughter to a local priest in New York City. "After waiting quite a while for the priest to finish his lunch, he refused to sign death papers unless he received a two dollar fee, which my father did not have. My father, a true Sicilian, pulled a knife, and said to the priest, 'If you don't sign this, I'll kill you!'"

My mother's brother found a widower for my mother. She was embarrassed to admit it, but she liked him a lot. He was tall and good looking with blue eyes. He said it wasn't his fault that he had blue eyes. She married him, but he didn't tell her that he had two boys. His

wife died on board a ship on Easter Sunday on the way back from Italy. They wouldn't let her nine and eleven-year-old sons off the boat because they were afraid of diseases. Both were quarantined, and they gave them shots. They took care of them at Ellis Island, and were pronounced healthy, and he took them. They left her on board, and buried her later.

First he left the two boys with an aunt, and worked in New Jersey. When he went to visit them he noticed his kids were always sitting at the end of the table with very little to eat. He was paying for them, and the other kids were fed. So he put them in an orphanage, and they were treated better. After they were married, he told her about the two kids being in an orphanage, and she had a fit. But she took them out, and helped to raise them. And she put the picture of the kids' mother in the living room, so that they remembered her. She had a good heart.

"Tell Her I'll Marry Her"

Norma Barbieri's mother prepared a full menu of daily meals for the workers in Lucibello's, her husband's first-floor pastry shop in New Haven, which included fruit and wine. Once, after Norma dropped the whole lunch tray on the way downstairs, her father made sure to walk up and get the lunches himself.

In nineteen eleven, my mother had a boyfriend in Atrani. She was eleven, and she met this young man—they were kids—and she fell in love with him. And they grew up, and they declared that they were going to get married. My mother came to America with her family in nineteen twenty, and they wrote back and forth.

My father knew my mother in Italy, he knew her brothers. He knew she was engaged to another man, Giuseppe. But in nineteen twenty-one, when Giuseppe came here looking for her, his sister said to him, "You want to marry her? She doesn't have a dowry." He said to her, "What are you suggesting?" "Well, there are a lot of Italian girls here [in New Haven] who work in the factories, and they have a lot of money already. She works in a factory, but she doesn't have any money because she sends it back to her parents in Italy." Giuseppe became so unhappy and distraught that he finally said to his sister, "*Peppina, I' ti lo dico mo', I' me ne vaco un àuto vòta all' Italia, e non voglio sapere niente, perche se i' non mi sposo a Filomena, non voglio sposare a nisciun,* Peppina, I'm telling you right

now, if I can't marry Filomena I'm going back to Italy and I'm not going to marry anyone." And my mother was brokenhearted. So Filomena's brother Felice, who was the head of the family, said, "Well, you know, you girls have to go back to Italy because I can't be responsible for you now."

In those days, if the brother was married, the two sisters, *bizzòche*, the unmarried, had to live with the oldest brother. The two sisters, my mother and aunt, liked working and getting a paycheck although they gave it to their oldest brother. He'd give them a quarter or fifty cents a week. That's what my mother was facing. My father found out about it because his brother was living in the same building as my mother. And his brother wrote to my father, "*Francesco, é scumbinato ó matrimonio con Filomena perche chello Pippino non á voleva, e chillo Felice mo' á manda in Italia*, Frank, the wedding with Filomena fell apart, and Joe doesn't want her. Now her brother Felice wants to send her back to Italy."

My father was in New York, and used to come to visit all his cousins here. He wrote back to his brother here in New Haven, "*Manda in Italia? Oh no! No, diciel che me la sposo*, Send her back to Italy? Oh no! Tell him I'll marry her." She had no choice, her brother Felice told her, "Either you marry him or you go back." My father didn't care about the dowry. My mother knew who he was, but didn't know much about him. So when he came, he introduced himself again, had coffee or dinner, they set a date, and that was it. And her younger sister Elena was thrilled because she knew she could stay in America.

"Our Wedding"

Charlie and Theresa Cipriano had just celebrated their sixty-fifth anniversary with the same dinner they had provided their guests at their wedding in Waterbury in 1944.

My mother died when I was eighteen. We didn't have money for the wedding. My poor father, what few dollars he had working in the factory? And his mother and father, what did they have? My sister Louise and I made all the phone calls to invite the people for my wedding. We got it together in four days. A reception, the church, bought a gown. All in four days! Today they start a year ahead. And they still don't know what. Now look what they have now. They're trying to cut down on

weddings because they cost so much money to have a wedding today.

My mother-in-law lived on the top floor of a hall, and they called it the Russian Hall. So she was able to get the hall for our reception. We didn't have our reception dinner like they do now, my God! We had a banana, a ham sandwich, a bottle of soda, not even coffee to give to the guests. We had big wicker baskets loaded with the pizzelles, the little waffles coated with powdered sugar. The women worked for hours with those waffle irons to fill up those big baskets for dessert. We gave the guys in the wedding a bottle of vermouth and anisette. And that was it. No band or music. I had a band, but they were all in the service. This was nineteen forty-four.

"The Women Went to Church"

Ann Caccavalle Dickerson often marveled at her ninety-five-year-old mother Anna Perrotti Caccavalle's ability to recall names and events from the 1920s and 1930s.

For Italian farming women in "The Flats" section of Woodbridge, this is the way they perceived their religion: the men felt religious if they sent their wives to church. The men very rarely went to church, only the women went to church in the nineteen fifties. When women went to church they satisfied the family's responsibility to the religion. So when they had the Feast of the Assumption [Assunta] in Woodbridge, the women did a lot of the preparations. Women dressed the saint, they got the flowers, collected the money donations, and attached them to the ribbons on The Madonna. Her dress was embroidered in gold and it cost five hundred dollars. The women had a rotation schedule at the feast when the saint was sitting there while the procession went through town.

We young women had to carry the flowers. It was very embarrassing for us sometimes. We were carrying the flowers and the candles, and there's all our non-Catholic friends watching us on the side of the road. My cousin carried one of the flags, and you had to wear a belt with a leather pocket, and you put the flagpole in there. Boy, how she hated carrying that flag! [laughing]. All the little kids were dressed in white to march in the procession. This was not a tradition in this country. It was a tradition in Italy they brought over. Some of my friends weren't Italian, and I never asked them

what they thought. We always had this funny feeling about it. When they finished the procession, and they ended up at the feast, they would put the saint in this little niche. The women took their turn while people donated money and lit candles. Behind the saint was this recording that would replay over and over. That melody is still in my head today.

"Now I Saw the Whole World"

Catherine and Ben Possidente were the life of the party, telling stories and reminiscing with the family at their yearly Possidente Family Reunion in 2007.

They didn't have too much in San Carlo, in the region of Campania, but they had a pig. And of course, come January, they had the piglets. Now the biggest thing for any kind of income was when they got the piglets, they had to keep one piglet, slaughter the mother, the rest they brought to the market in Gaeta, up the road. They got the donkey ready, put the piglets on the side, and they left early in the morning. It was dark, so all the women

Figure 7.2. Catherine and Ben Possidente, Possidente Summer Picnic, 2007.

with their dark shawls made the sign of the cross, blessed the Blessed Mother, "O God, we hope they have a good trip." The women left after *a benedizione*, their little prayer, *"Si vo' Dio,* If God wills it," and he took off with the donkey, and the six or seven piglets on the side. He walked alongside the donkey.

By morning, they got to the market. As fate would have it, when they got there, by the time the day was over, he sold all the piglets, and he said, "Oh my God! I sold all of my piglets!" Certainly, per *buona fortuna,* for my good luck, I got to say a prayer to Saint Anthony. So he took the donkey, met some people, and they went into the cantina, a small tavern. He fed the donkey, tied the donkey up outside, and went into the cantina, and *"Saluta! Saluta! per Sant Antonio!* A toast for good health and to Saint Anthony!" for the good graces of selling all the piglets. And by the time he got through, it was nightfall.

He went outside. Eh, no donkey! *Bella Madonna e Dio!* Good God! What am I gonna do now? He started to walk down the street, going to one house after another. saying, *"Eh, avete visto ò ciuccio mio?* Did you see my donkey?" And the people answered, *"No, nun aggiu visto ò ciuccio tuio,* No I didn't see your

donkey." Go to another house. Nothing. He walked all night.

Finally, he came to a house. He knocked on the door. No response. Nobody home. So he walked inside, *"Hello, hello, signori, avete visto ò ciuccio mio?* Sirs, have you seen my donkey?" No response. Pretty soon, by the time he got into the bedroom, he heard somebody coming in the front door. They were laughing, and everything was going great. He said, "They're gonna think I'm a thief!" And he thought the best thing to do was to hide under the bed. Pretty soon, who should come into the bedroom, but *ò sposo and à sposa,* the bridegroom and the bride. And he hears the husband say, *"Ah, che bella sposa! Ma che bella cosa!* Oh, what a beautiful bride, how beautiful she is." And pretty soon, just as they were about to make love, *ò sposo says to à sposa,* the husband says out loud, *"Eh, mo' aggiu visto tutt ò munno!* And now I've seen the whole world!" So the guy under the bed figured if this husband saw the whole world, he must have seen his missing donkey. So from under the bed, the husband and wife heard a voice answer, *"Eh, avete visto ò ciuccio mio?* Did you see my donkey?" He escaped, ran out the door, and into the street. There he found his donkey. *"Ah, grazie Sant*

Antonio! Thank you Saint Anthony!" He took his donkey, and returned to Sessa Aurunca, and everything was fine.

"We're Getting Married Right Here"

Catherine Possidente spoke about Oak Street in New Haven as a melting pot neighbohood where businesses such as Lupi-Legna Bakery, Rosner's Grocery Store, and Marzullo's Pastry got their start. Her family learned horticulture and winemaking from the German family next door.

My mother came to this country from San Carlo in the Aurunci mountains near Sessa Aurunca in the region of Campania because my father was here. But when my father was in Italy, he wanted to go steady with my mother. But she didn't want my father because she had a boyfriend, and his name was Sabatine. He was in the Italian army, and he was engaged to my mother. He had two weeks left, and he was going to be discharged from the army, and my mother was supposed to marry him. A week before he was discharged he got pneumonia in the army and died. My mother was heartbroken. She wasn't getting married anymore, and she didn't want anybody else as a boyfriend.

But there weren't any men around because they were all in the Italian army.

Then my father started to write to her saying to come to America, I want to marry you. And she always refused. But then, after a while, there were no other guys there that she liked because they were either crippled, or they didn't get into the army in World War One. So finally she came to America with the consent of her brother Sam [Uncle Sabatino Mancini] who sent for her. Because you had to come with somebody's consent. He was her sponsor.

Now, when they got to New York, Uncle Sabatine was there with my father. My mother said, "Alright, let's go to Uncle Sabatine's house," in New Bedford because they worked in the mills. "We'll stay there for a while, and then we'll talk about getting married." And my father said, "No, we're not going anywhere. We're here in New York? We're getting married right here." And now they found the church, Saint Anthony's in New York. They went in there, and they got married. Uncle Sabatine was the sponsor.

In Italy my father got the nickname *ò pass 'nnanze,* a step ahead, because he always liked to get something better, like he wanted to get

a refrigerator when nobody had one. When he wanted to put oil in the stove when us kids used to go down to Coppola Coal Company, and spend the whole day putting knot coal, a half inch in diameter filling ten pound bags for a penny, which was used in all the coal stoves. My mother, said, "No, no, no!" She didn't want oil because she didn't want oil in the house. She was afraid for the children. And my father was the first one to have electricity in the house, the first telephone. He worked twelve hours a day, from six o'clock in the morning till six o'clock at night, three hundred sixty-four days a year. The only day he took off—the only time he answered his boss, saying, "You can fire me if you want"— was August fifteenth, the Madonna D'Assunta.

"Let Me See Your Hands"

Filomena "Phyllis" Consiglio recounted stories about her experiences on the family farm, while her husband Andrew worked on a drawing, listening to her from the next room.

I had a brother Pat. And every Sunday, he'd go, "Phil, come over and help me wash and wax my car," because he had a convertible. He was married. We'd go over to Uncle Joe's, and we washed the car by the brook. My father wouldn't let us go anywhere unless we went with my brothers. And our brothers never asked us to go anywhere because they were too busy running around.

In the meantime, his [my future husband's] mother and father would come to our house and play cards every Sunday. So his mother, she kept her eye out on me, said to my brother, "Gee, Andrew's coming home on leave, pretty soon he's going to be home for good, and I want him to meet her." So my brother said, "Oh, she's fussy, don't even mention it. I'll have to work out something." So my brother worked out that he was going to take me to the show. Then from the show he decided we'd go to Savin Rock, oh, that's even more fun. I said to him that I'd never been to Savin Rock. So we're going, and my sister-in-law [to be], says, "Wait a minute, I have to stop at my Aunt Theresa's to get something."

He [Andrew] comes walking out, and I said, uh oh, and I didn't say nothing. So the first thing I notice is, oh, this guy didn't grow up yet [chuckling]. He had his belt on sideways. I said, oh my God, I never saw anything like this, you know, it was funny. And we went

to Savin Rock. Well, he wouldn't leave me alone. Kept calling me every night at eight o'clock, and I had to hear it from my brothers and sisters, "You got a boyfriend somewhere?" "What boyfriend?" I said to them. "I haven't got no boyfriend." "Well who's this Andrew who calls every night?" Then my father started asking questions. So I said to my brother, "Pat, you started all this! Well you better put an end to it because you know how papa is."

Every time he used to go to the market, and was trying to match me up with the farmer's sons up the road. Well every time he got drinking wine he would preach to me, "You're too fussy. You're never gonna get married, you're never gonna find anybody." I says to him, "Don't worry about me, I'll find somebody."

I'll never forget this one time. It was melon season, and Mike Sansevero, the guy he's trying to make me meet, comes in with two bushels of melons with the excuse of the melons. It was my sister Rose's job to make the coffee, and she was the head of the house in place of my mother. So my father said, "Phil, make the coffee," because he had already told Rose, "Go upstairs, because I want Filomena to make it." He told them he was gonna make a

match with me. And he came with his older brother, and he figured I'd have my choice to pick either one! Well, he was yelling about this guy Andrew, and that I went out with him without him knowing about it, and he hadn't met him yet. So that night I said to my father, "Look, I'm gonna tell you now. You stop picking my husband! I'll pick my own husband when I'm good and ready." I said to him, "Did you ever get a good look at that guy? I couldn't look him in the face, let alone go to sleep with him! If you think I'm gonna marry him, you got another guess coming!" And I walked away.

The next weekend comes, and my brother Pat says, "Come on out, we gotta wash the car." We ended up going to the show. And he [Andrew] shows up. He was over there. So I didn't say nothing, I kept washing the car. He helped. We went to the show. And every night [sing-song voice] at eight o'clock, he would call. And my father said, "You went out with him again?" I said, "I didn't go out with him, Pat invited him out. I didn't invite him out." And he still kept calling, every night, eight o'clock. And I couldn't make up my mind, whether I wanted to go out with him, whether I liked him or not.

My father was pressuring me, and I figured he might be okay compared to the ones my father wanted me to marry! So finally my father said, "I want to meet this guy!" Well, anyway, he came up. Oh, I felt sorry for him, because he got the third degree. My father, the first thing he said to him was, "Let me see your hands. You think you're good enough for my daughter? Can you support my daughter?" This poor guy didn't know. He didn't even have a job because he just got out of the navy. He was collecting in the twenty-twenty club in those days. Twenty dollars a week from the government if you couldn't find a job. My father said, "You know what? Let me see if you could support my daughter. You come up to the farm, there's a lot of work over here!" He did the same thing my grandfather did to my father.

So every weekend he came to work. Every time we'd go out and hoe he'd make sure he had a row near me. And he didn't even know how to do anything. He was a city guy. You know my father was sneaky. He used to put us out to work and say, "I'll be back later." But he used to sneak up on us to see if we were fooling around, because if we horsed around he'd yell. We had to work, and couldn't even talk, couldn't sing, couldn't do nothing. So Andrew is there and oh my God my sisters and brothers are snickering because he couldn't do it right away, Papa's gonna. . . . So right away I'd go back, and tell him, look I'm gonna do it. When you get to where I did, come up near me—and be quick about it! Well, he learned, he picked it up. But I had to do double work because of him. My father came by, "Whoa, what a good a worker!" My brothers and sisters were snickering. They felt sorry for him too, so they didn't give away that I was helping.

He was handy when it came to taking the baskets of tomatoes out. He had to do a lot of bull work. I mean my brothers did it, so it wouldn't kill him. When I argued with my father I said, "Dad, if I gotta work on a farm for somebody I hate, isn't it better I stay home and take care of you and work for you for the rest of my life?" That cooled him. He never matched me again, never talked about me marrying somebody again!

"O.K., You Can Drive the Car"

Filomena "Phyllis" Consiglio:

We used to pick the lettuce early at four-thirty in the morning.

Figure 7.3. Filomena "Phyllis" Christoforo Consiglio on the Christoforo farm in North Haven with her brother Charlie, late1946. Consiglio family archives.

We were out in the fields because in April, May, it's daylight at that time. We picked three hundred crates. They were worth four dollars a box, which is only a dozen heads in the box. We "hit the market" that year. There was a demand at the market. There was no lettuce around, and we were the only ones that had it. You "hit the market" when it's scarce.

That was the year my husband was coming up to work with us. One field was all shot, and a then a new field was coming in. So my brothers brought the truck, and left it up on the hill because the sun wasn't out. They went out to plow the tomatoes because we were going to put tomatoes in the same land. Double crop. And my father came up, and he used to call my husband "Sonny Boy." "Sonny! Back the truck in the barn!" I looked at him, and I said, "No, you're not backing it in." The funny thing is, I had bought him a car, and he wouldn't let me drive it. So I says to him, "No, you're not backing that into the barn, because if you don't park it just right, and you put the brake on too fast, you're gonna make 'slaw' out of it!" "Slaw" meant that the load would tip, and it would chop off. So I took and I went because I watched my brothers do it so many times, what they did, how they pumped the brakes nice and easy, and just roll down very easy. I backed the truck in the barn. After, he said to me, "You know what? You can drive the car anytime you want" [laughing].

"Life with Graziel"

Betty Panza said when her sisters and brothers spoke up about something their father was doing wrong, her mother responded, "I take a care of my bisaneese."

He came from Tocco di Gaudio, provincia of Benevento. My father, as soon as he saw her, she was with the basket on her head, a real worker. He said, "Oh, I got to meet her." But her parents were not happy because he was illegitimate, so they sent my mother to America. They didn't want her to marry him. She came to New Haven to stay with her brother Ottavio. What does my father do, but he follows her here! And they got married at Saint Anthony's church. He knew what he was getting!

He was a happy-go-lucky man. He was only five foot five, and had a size five shoe. He was small. He had a wonderful singing voice, and he and my oldest brother used to sing all the time. He was a good-looking guy. My mother didn't look Italian. They thought she was German because she had blond hair, beautiful blue eyes, and she was five foot ten. She could have taken my father, that's how strong she was, take him and throw him off the porch.

My mother did—when I tell you—everything for him, even as far as holding his squillo cigar at night in his mouth, put it in his mouth, and take it out when he went to bed. One night the ashes went on him he almost killed her, "*Che gazz' steva facend?* What the hell are you doing?" "What are you talkin' about?" And they complain today! If it was raining, when they walked, she held the umbrella over his head. He walked in the front, she walked in the back! And if he fell, "*Graziel, addo stev?* Graziel, where were you?"

Make the wine? He didn't make the wine! He was the professor! He was the director! They'd go get the grapes down at the market in New Haven, and my mother picked out the grapes. My mother sat in the back of the truck while my father sat in the front! He didn't know nothing. My mother knew it all. My father stood there, *come ò signore*, like a big shot. "Get the *alecante,* the dark grape zinfandel, put it on the truck, deliver it to Main Street." He had the six of us carry the crates down in the cellar. He'd sit on the chair. And he'd go, "*Graziel, í nu pòc' í alecant, e nu pòc í zinfandel! Mette a box a la,* Graziel, a little alecant, and a little zinfandel. Put the boxes over there."

He made good wine, mixing the alecant, the darker grapes, with the zinfandel, which was a little lighter. And she cleaned fifty gallon barrels by hand in the backyard. She'd wash and wash them, shake them, get them

immaculate. My father would say, "*Graziel, abbadà luóco,* Graziel, watch out!" Then they'd go down the cellar. And there she was—strong as an ox—turning the *stringiatura,* wine press, by hand, and it wasn't electric. She turned it and turned it. Then, he'd say, "Ahh, now *á vinaccia,*" the last part where you make the grappa. And every night, he'd say, "Oh, that wine, what a smell!"

He made four barrels of red and a barrel of white wine every single year. He didn't even give it a chance to ferment! Then when he was feeling good [drunk], he used to sit on the porch, and all the Marianos and Sullos were outside, and he'd say, "*Graziel, venne ccà, Cunciett tenne due cap,* Graziel, come here, Cunciett has two heads!" He used to see two heads. He used to make it in September, and by January it was all gone. Then he used to say, "*Ma Graziel, addo sta ó vino?* But Graziel, where's all the wine?"

He used to drink a lot, but he never missed work, even though my mother had to get him up and dress him. He worked at U.S. Steel on Fairmont Avenue. He'd get up, walk from Fair Haven, bad weather, good weather, and he'd walk over the Ferry Street Bridge, and his dog

King followed him. Three o'clock, he'd leave work, and by three-thirty he was home. When he got home from work, my mother had a pan of hot water. He sat on a chair, his shoes and socks came off, and he soaked his feet. My mother wiped them, and rubbed them.

The old timers. My mother had to take the wine, chill it to a certain point, put it on the floor, and even if my mother was in another room, he called my mother, "*Graziel, damme a nu bicchiere í vin,* Graziel, give me a glass of wine." He wouldn't even pour it! She idolized him. She had to get up, and pour him a glass of wine! My father was a very happy man. My mother did everything but dress him. But you know, if you knew him, you'd love him. Sang all the time. Never lied. You know that was the way life was, but we used to say to my mother, "Why do you do this?" And she'd say, "*Chill è ò padrone della casa,* He's the boss of the house." That's all she would say. And if he ever said something, we'd yell at him. My mother would say, "Don't you ever! *State zitt, chill è pate!* Keep quiet, he's your father!" We used to say to her, "Ma, how do you do it?"

She washed clothes by hand until she was eighty-two years old, until she went to the

nursing home. My husband and I bought her a washing machine. We had to send it back. My sister Fannie lived on the third floor, my mother on the second. Fannie's washing machine went, and she had sheets in there, and they couldn't rinse the clothes. It took my sister Jennie, her husband Jimmy, Frankie, and Fannie—they couldn't wring out the sheets! They called my mother to wring out the sheets! She went up there and said to them, "*Pezz í stunad! Nun ò sai niend,* Why you stupid idiots! You don't know how to do anything." She threw them over her shoulder, and she wrung all the sheets out by hand! And her clothes on the line were as white as could be. I can't believe how hard she worked. She was a workhorse. She coulda taken that Mike Tyson and flipped him to another county!

"Crazy Mike"

Betty Panza and Jennie Panza:

Once she threw Crazy Mike down the stairs. He claimed my brother Koostie [Constantino] stole his brother Stinkfish's car. Somebody stole Stinkfish's car and the guys said,

"Oh that was Koostie." Crazy Mike—and he was crazy—came up the stairs looking for my brother Koost. He told my mother he stole Stinkfish's car. She said to Crazy Mike, "*Ma tu he vist che ha pigliat ò car?* But did you see him take your car?" He said, "No!" She said, "*Eh, e cómme ò sai?* So how do you know?" Crazy Mike said to her, "*Giuanne mi ha ditt,* John told me." She said to him, "*Manc é a vero,* It's not even true." He insisted, and said, "Yes, *é vero!* Yes, it's true!" She grabbed him, and said, "*Tu vatene a ccà!* You get outta here!" And she threw him right down the stairs. He took off, and he never came again. My brother Koostie was afraid of his own shadow. He wasn't going to take the car.

"I Wanted To Bowl"

Fannie Buonome recalled with sadness the story of a Marchigiano woman who married an African American man in the 1940s. Their mixed race children grew up in North Haven and were stoned by people who disapproved of their parents.

My mother and I lived in the same building in Fair Haven. She lived on the second floor, and

I lived on the third floor. I was the maverick of the family. I used to bowl. I figured if I'm able to go to work, why can't I go out? I couldn't go out. I had to meet guys on the corner with their cars—that was pathetic—then walk home. If I had a date, what was I going to say? Come and get me at the house? That would have been another one that got me thrown out! My father wasn't strict, but my mother was tough. She used say to me, "*Ma chistu sfacime e bowl, si maritata, tenne í figli! Stata casa!* But this damned bowling, you're a married woman, and you have kids. You stay home!" I said, "Ma, don't bother me," you know. So I used to go down the back porch, and go out into my car, and go bowling. I'd come home, and spot her out the window. I parked the car in front of Missus Perno's house, and I go back up the back way. We used to stop after bowling, have a coffee, and go for a drink. And my mother didn't like that, "You a no good." And I'd go back up, and the next day she said to me, "*Nun t'aggiu vist,* I didn't see you." I said, "Ma, I came home early. You were leanin' outta the window." She shot back, "*Ma tu vo'fa fess a me?* Are you trying to make a fool out of me?" We were like oil and vinegar, but we were the best of friends.

"Grandma's Wine and the Mayors of Bridgeport"

Angelina Baldino's grandmother came from Nicastro in Calabria, and her grandfather from the next town, Seratta. He built his establishment on 49 Sherman Street in Bridgeport.

All the mayors used to go into his store in Bridgeport on feast of San Pantaleone. They built these grandstands outside in front and the mayors spoke there. And so, before they went to speak, they'd meet in my grandfather's store. We had Mayor Burns there, Mayor Buckingham, and Mayor Jasper McLevy. They'd be there a couple of hours drinking wine, and talking, and then they'd go and make their speech, "Vote for us, we'll do this, we'll do that," like they're doing now, only in a different way. And my grandmother used to say, "*Eh, quando finscono questa gente?* When are these people gonna end it?" I used to say, "I don't know, grandma."

My grandfather used to talk to them always dressed in a shirt and tie with his pocket watch. And my grandfather glowed. He was the politician, and my grandmother was the worker. She'd get aggravated because instead

of working, he was talking. He was involved in everything. People came in, the mailman, people who needed help with their citizenship papers, people from church, and he'd give them a little wine, and my grandmother would make remarks behind their back. "And when are they gonna go home? And why doesn't he stop talking? And now this one's going to talk for an hour." She knew who was going to talk more than the other one.

We had to put up all the lights on the grandstand, and it was so much extra work. My grandmother made her own wine. My grandfather used to help, but she had the wine press. In September there always was a truckload of grapes in front of the house in nice wooden boxes, special zinfandel grapes. Underneath the store was a nice cellar, not beautiful, but usable. And he had this big wine press he had made. She'd say, "Let's go down and do the wine." And he'd say, "All right, I'll come down." Before you knew it my grandmother was there turning the press. They had to wash these big round barrels before they put the wine in them. She went all through that. It seemed like my grandmother was there more than him because she checked it as it fermented, and then she had these five gallon containers to put it in to keep. She had all her preserves of peppers and eggplants. They had just enough wine for the family, some for guests. The mayors came and took a gallon home.

"She'd Be a Gourmet Cook Now"

Betty Panza recalled the Lucchetti brothers, artists from New Haven, who painted scenes on the walls of the church of Saint Donato in Fair Haven.

My mother would be a gourmet cook today. She could prepare anything. My father went mushrooming, come home, throw the bag down and my mother Graziel would clean them, we would clean them! She'd cook mushrooms and sausage with little hot peppers. Homemade bread every single day, we had. She'd make my father's lunch. He'd give it everybody in U.S. Steel! They used to wait, "Hey, Serafin'!" They used to call him Jim. "Jim what a we got a for lunch today?" But see, he was "The Professor" at work because he was one of the few who knew how to read English and Italian, and he'd bring the Italian people the newspaper, *Il Progresso*. And you know what was funny? Every day he'd ask my

mother for a nickel to buy the paper. He had dollars in his wallet like this, but he'd ask my mother for the nickel every day. She used to say, "Okay, Serafin," and give him the nickel. He'd go to work, and he'd come back. He was never mean, he wasn't one to hit you. He'd get drunk and go to bed. But he got up in the morning, my mother used to dress him up, and he'd never miss work. So he went to work, he was only a sweeper, but they loved him there. And honest as could be. My mother never had a sewing machine, but everything she sewed was by hand. When she darned a sock, you wouldn't even feel it. My father thought he was a shoemaker—he was good for putting the cardboard in the shoes [laughing].

"Wait Till Winter to Get Married"

Mary Carbone and Joseph Fiore Jr. recalled their Maselli grandparents hailing from Castello Pagano near Benevento.

My grandparents weren't crazy about my father. My father wanted to marry my mother. I guess he wanted to get married in the spring or summer. My grandfather said, "Wait until winter and I'll give you a thousand dollars." To let his daughter still be a slave and work on the farm! She was the oldest. So my father agrees. The winter comes, they get married in January. No thousand dollars. They never got it. My father was a good-natured guy. There was conflict between my grandfather and my father. But my father was a good-hearted guy. He would do anything for anybody. He had the utmost respect for his in-laws. And as bad as my grandfather was to him, he used to go and hoe the farm, the strawberries and the beans in his spare time. He helped build the stone foundation of the barn. It's still there. I used to take my mother to see her parents. So I take her up to the farmhouse, and they had a big front porch. I would just sit out there while my mother and my grandparents sat inside, and they talked Italian. Well, one night the conversation sounded very heated. And all of a sudden I hear my mother say to her parents in English, "You are not gonna talk about my husband and treat him like a dishrag anymore!" And she came out on the porch and said, "Take me home!" I took her home, and the next day my father put her in the car and brought her back, and made her make peace with her parents. That's the kind of man my father was. He was just a good, good man.

"Smoke Signals"

Antonette DeAngelo recalled the custom of the people of Atrani during their feast of Santa Maria Maddalena. They prepared traditional *sarchiapone*, a long, thick squash, scooping the seeds out, stuffing it with olives and breadcrumbs, and then steaming it.

My mother was a hard-working woman. She always worked hard for us eight kids. She worked in dress shops. My father was Atranese, from Atrani, and she was from Calabria. He was always jealous of her. When my father started going with my mother, one night he went to visit at her house. So my father was

Figure 7.4. Antonette DeAngelo and her son Frank, 2009.

sitting there smoking a cigar, you know the guinea stinkers? My mother's father got up, got my father, and said, "Get out!" My father said, "What did I do?" He said, "You're sending smoke signals to my daughter!" That's how bad they were. That's a true story. He threw him out.

"What You Do to a Girl They'll Do to Your Sister"

Louise Aiello and Nick Aiello:

Oh, with my mother, it was all her sons! Oh yeah! "My sons, my sons!" She favored the boys. My father, it was all the daughters. When they got married, she used to say she treasured her daughter-in-laws. She always used to say, *"Figlio mi, quando vanno a durmì,"* which meant that at night, when her sons had to go to bed with them, she wanted them to take care of her sons. She thought if I fight with them, then they'll take it out on my sons, and then he doesn't have his fun. So she treated them very nice. She didn't want them to fight. All right? That was it.

Then, when we were bad, she used to tell my father. We had a room that went all

around, and he couldn't chase us. He had to run after us. He caught us when we were sleeping. And we'd get it. I wouldn't change our life, our times, with the times of today. It's a jungle out there. No.

My father never believed that women should go to school. They should stay home, they should cook, and they should have children. So he didn't favor the daughters. So they had to get out of school, and go to work to help the family. So they got to be sixteen years old. My father forbade, "No lipstick, no nail polish, no wearing slacks, and no tweezing eyebrows!" You couldn't have roller skates. You couldn't have a bike, or a sled, because those were all dangerous things. I used to hide my skates and my slacks at my girlfriend's house, and I used to dress there. Oh no! My sister was reading the newspaper, and she had nail polish on, and the light flicked on the nail polish. My father said, "What a you gotta there?" He threw her out. She had to go sleep over my aunt's house for a week before she could come back.

Another time my sister Mary was sick, and the girls from work at Brewsters came to see her, and they sat on the bed, and they lit a cigarette. My father said, "Hey, *chella è puttana,* She's a whore," and he threw them out. Now, people will say why was he so strict? He didn't want his daughters to be attractive to men because something might happen. He had seven daughters. When my sisters went out on dates, the guy had to come to the house. And my father made sure there were no long engagements. Six months, you had to get married. And by the way, you had to be Italian. My mother, she didn't believe in long engagements, three, five, six. Six months! If you didn't know your boyfriend by then, my father started to ask my mother, "*A catena lunga?* How long is this chain gonna go? What does this guy wanna do? What's his intention over here?" She'd say, "The fire would burn someday," if you stayed too long with a boy.

My father used to tell us, "You gotta respect women all the time because what you do to some women, they're [boys] gonna do the same to your sister." In other words, be a gentleman. You see a woman and you had to respect the woman because you expect them to respect your sisters. There was logic to that. In those days, the Italian immigrants, they were poor. They couldn't speak English.

"We Have to Live with My Mother"

Louise Aiello described her mother Natalina's kitchen where no one was allowed to touch her stove. She said, "I didn't cook on it until I was thirty-two." She recalled having to sleep on the couch around Easter because her mother had baked so many Easter pies.

I used to love to stay at home. I wasn't an out girl, go barring. I didn't drive until I was twenty-one. I didn't think of bars, I didn't think of nothing. But I liked to stay home. I took care of my mother, and my sister Suzanne who had heart trouble, and she was an epileptic. She used to take these fits, and I was the only one left home. The others were married, and they had their own children. I told my boyfriend, I says, "Look, you want to marry me?" He says, "Yeah." I said, "We gotta live with my mother. If not, we're not getting married." Yeah! [laughing]. He said, "Nah, that's all right." So we got married. But I had a choice between my mother and my sister, I couldn't do both of them, because I had my own problems and my daughter. My husband had problems with his back, he had surgery. Then he was put in a convalescent home.

"The Men and the Women"

Gene and Frances Calzetta's family hailed from the rural hill town of San Carlo in the Aurunci Mountains of Campania. Others from the same area were the Possidente, Coiro, Mancini, and Morrone families.

The women were with the men, but I don't think they were too hep with anything that was going on [in the teens and 1920s] because I don't think the men confided in most of them. The women weren't their friends. They were their wives, and they had duties, taking care of the house, but as far as what the men were doing, it was none of their business. They were never too keen about any discussions. Not that anything was ever wrong, but they never took them into their confidence. In other words, the women had nothing to do with their business. It was none of their business what was going on as long as the men provided, the home was provided for, and everything else was provided for. They had their duties, and the men had theirs, and that was the way it parted. No mingling too much. I don't think they took the women into their confidence too much about what was going on. They had

their own men's world. It was just as bad then as it is today with women. They had a lot of trouble between the women. They'd have all kind of arguments. The same as the men. I don't know how far it went, but I know this one wasn't talking to that one, the other one wasn't talking to this one. This other one doesn't want to do this. And try to plan a wedding! And the men never interfered. That was women's business. All the old folks were like that. East Haven, New Haven, because most of their lives and our lives were centered in East Haven, Forbes Avenue, Granniss Corner in the Annex. That was it. They didn't mingle with . . . that was their community. The only time they left was when they went to work.

"The Copper Pot"

Annunziata Adriani was the second daughter, the sixth of nine children born to Nicola and Filomena Adriani in Bridgeport.

My mother Lucia Caseria Adriana was born in Castelfranco in the region of Campania on December eighth, eighteen eighty-two. In nineteen oh_five, she came to America with her mother Filomena, and among the few possessions they carried was a large copper pot for cooking. After many decades of use, the pot developd a hole and Filomena asked her friend, the butcher on Washington Street in Bridgeport, Mister Tomasetti, whether he knew of anyone who could mend her copper pot. He gave her the name of a young man who worked for him, Nicola Adriani. He was born in Abruzzo, Italy and in eighteen eighty-four he came to America alone. Being a jack of all trades, he was happy to take the job of repairing Filomena's pot. When he arrived at her home, he and Maria Lucia caught a glimpse of each other, and there was an immediate spark of attraction. Though it was rumored she had other admirers, Maria Lucia had eyes for no one but Nicola from that moment.

On another occasion right after that, Maria's mother sent her to the store to buy garlic, and Nicola happened to be there. When the man behind the counter innocently handed her the bag of garlic, she dropped it. Nicola was there to pick it up, and when their bare hands chanced to brush against each other—bashful and unnerved—Maria Lucia dropped the bag again. Contact such as this was considered intimate in the early nineteen hundreds. Following a courtship of

months, Nicola and Lucia were married. They remained so for years until they were forced to part upon the death of Maria Lucia. They were still devoted to each other, still deeply in love and still with eyes for no one else.

"I'm Not Marrying Her Feet"

Filomena "Phyllis" Consiglio:

My father came over from Caserta, Italy, when he was fourteen years old in the early nineteen hundreds with a button in his pocket. He came as a stowaway with a couple. And the couple made out that he was their son. They got him as far as Hamilton Street in New Haven, and they got him a job as a stable boy. That's where my father started. He slept with the horses. The Italians in those days, they helped one another.

And then my father, right across the street was the stocking factory. And every day the guys would sit out there from the stable, eyeing the girls from the stocking factory across the street where they made cotton stockings that were held up with suspenders. One day the guys were, "Oh, I gotta date that girl." My father said, "See that redhead over there?

That's the girl I'm gonna marry." My father was only fifteen years old. So the kid said, "What the heck you wanna marry her for? She's crippled. There's so many other beautiful girls." My father said, "Look, I'm not marrying her feet, I'm marrying her heart."

My mother had polio from when she was a year old in Italy. When my grandmother, her mother, found out she was having twins, she took my mother to the nuns. She said to the nuns, "I can't take care of her with the twins coming. You gotta take her here. I don't want her anymore because she's crippled." My mother lived with the nuns for about ten years in Italy. And every time I'd ask my grandmother about it, she used to call me "Sassy, mind your own business," and go call my father. Right away to get me off her back. So my father goes, "Don't bother her, she doesn't like the truth."

My mother never talked about it. She came to America with her family after they took her from the nuns, and that's why she was so religious. She had about fifty pairs of rosary beads, and she used to say every one of them, every day.

So he didn't have guts enough to go up and talk to her for over a year, two years. When

he was sixteen, seventeen, he started getting a little gutsy. One day he went across the street, and talked to my mother, and they chummed it up. And she felt proud because nobody ever looked at her because she had polio. And she used to come from North Haven on the horse and buggy with her father in those blizzards to go to work for five dollars a week at the stocking factory.

Finally my father said, "I want to go out with you," but she said, "My father and mother won't let you, they need that five dollars every week, they want me to work, and they don't want me to get married." So my father said, "Well, I'm not going to marry you, I just want to go out with ya." See what did he used to do?

Every day when she used to take the trolley to go to the four corners in North Haven to meet her father, he would ride the trolley with her. So this one day my grandfather didn't show up. The trolley wasn't going to leave her off all alone, and there was a blizzard out there, it was snowing like anything. So my father said to the trolley guy, because he wanted to see what was going to happen with this [us], and he was kind of rooting for it. So he said, "Okay, Mike, you go ahead and take care of her, otherwise I'm gonna take her back on the trolley, but I can't keep the trolley here forever." So he took and he got off the trolley, and they waited a half an hour in that blizzard! Then all of a sudden my grandfather comes up the street. He had trouble with the horses in the snow, the buggy kept going off, so imagine how hard the women had it in those days! So my grandfather didn't even say to them, "I'm late," or anything. He said [harsh voice] "Who's this?" He's yelling, "Who's this guy?" My mother said, "Nothing, he was on the trolley, and he didn't want me to stay in the blizzard only because he was worried about my leg." So my [grand]father said, "All right," and he took them home for the night.

My grandfather said to him, "I don't want you going out with my daughter." My father said, "Well, I'm not going out with your daughter. I just thought I'd keep an eye out on her—there's a blizzard going and the trolley couldn't—and you were late!" So anyhow they fed him, and he stayed the whole weekend. But don't forget, my grandfather put him to work on his farm! He had to help him clean out the stable, go get the firewood. He didn't stay for nothing, he had to work.

So now, every weekend, when they used to get off the trolley, my mother didn't care,

but my father kept saying, "I'm coming to your house for the weekend." She said to him, "Oh, my father is gonna holler." "No, no, it'll be all right, I'll help him." So then my grandfather got used to him coming. So finally my father didn't say nothing, and he figured, aye, they accepted me, I'll do anything, as long as they accept me. He had no family here, nobody.

So every weekend, summer came, and he went to help on the farm. He helped cultivate because my father was a hustler, and his people had a farm in Italy when he was little. Finally, my father found a new job, and he says, "Ah, I gotta marry this girl, but I gotta get money together, and I'm gonna work two jobs." He said to my grandfather, "I know you've been good to me, and I'll still come and help you every night after work as long as you let me stay in the stable." He used to wash the buggies, groom the horses, and do all the errands for the stable man.

He got a job at the gas company cleaning out the stable. It was a dirty job, but it paid good money. He saved enough money to buy furniture, to get married, and he got himself a little apartment. So in the meantime, he didn't say nothing to my mother. He just got everything ready. So one day they were eating and laughing at the dinner table. He said to my grandfather—he used to call him Matthew. He didn't call him Pop or anything, he wasn't married. He said, "Matthew, I got something I gotta tell you. I want to marry your daughter." He didn't even propose to my mother, but my mother loved him. My grandfather said, "No, you can't get married, you're too young." My father said, "No, no, I have my own apartment. I got a job in the gas company, I got two jobs, I'm working good. Not only that but I got an apartment so that she don't have to come through this snow and everything. From my apartment I jump out to the gas company and to the stable, and she goes to the stocking factory. Isn't that better for her? This cold weather is not good for her." So they agreed. They got married around nineteen twelve. They were both nineteen. My mother had fifteen kids.

"A Vermonter in Middletown"

Patricia Damiata Bourne:

My mother was a "Rosie the Riveter," and a large group of women from Middletown worked in Pratt and Whitney during the war.

At that time it was expected for them to work, they didn't work until World War Two. She worked making airplane engines. After the war she went to work in Andover Kent, a factory here in Middletown.

After the war, my father left the farm in Vermont, and came down here because Connecticut was where the manufacturing was, where the jobs were. He was her boss. So when he started asking her out, she had a friend in Human Resources check him out to find out if he had a wife somewhere. So when they started dating, you couldn't bring just any man home. You had to be serious. And you weren't allowed to date, so how you were supposed to do it is a mystery.

So my mother would meet him in San Sabastiano church here in Middletown until some lady told on her. She told my grandmother, "Your daughter is meeting this man in church and going off afterwards." So then my grandfather said, "Bring the young man home." So the first time she brought him home on Ferry Street was the feast of San Sebastiano because she figured that was the safest environment, it was this great big party, total immersion. And here he is, a Vermonter from a farm, and these were very quiet people. And he came into this loud, festive party. They accepted him, and he fell in love with it. That's what he loved, and he became part of it.

Then when they married, we grew up on Ferry Street in my mother's multifamily apartment. It was this warren of apartments. So you'd go up the stairs, you'd be on somebody's porch. You go up another flight of stairs, and you're on somebody else's porch. Everyone was either related, or close in terms of connections. There was an incredible sense of family and people you were connected to. My father had gotten injured at work, and I had come home from San Sebastian School for lunch. My mother wasn't home. And there were three ladies in our building who all stuck their head out and said, "Patty, you have lunch with us today." There wasn't any sense of fear or anxiety or where are my parents? It was like, Oh, okay, no big deal. It's the original idea of "It Takes a Village."

Growing up on Ferry Street was like growing up in Melilli, Sicily. The whole North End of Middletown was mostly all people from Melilli. You never locked your doors.

Italian American Farming Women

In the summer of 1908, Vito Becce, an ambitious young tenant farmer from Tolve, immigrated to America. Like many young farmers of his day, Vito ventured to the new world alone, with plans to repatriate with enough American money to buy his own farm. The region of Basilicata he had left behind was southern Italy's poorest, its fieldworkers working more than ten hours a day, the longest among farmers in the South.[1] Entire agricultural families, including women, toiled in the fields as *giornalieri*, sharecroppers. They earned the pitiful sum of five cents a day, which included meals, for the backbreaking work of planting, weeding, plowing, and harvesting with archaic tools under the relentless Mediterranean sun. Workers had the option to earn twenty cents, but without meals.[2] Vito left the *massaria*, farm, in the hill country surrounding Tolve where he made cheese for the owner, Signore Santorsa. Lucia, the boss's beautiful young daughter, had caught Vito's eye early on, and he had fallen in love with her. Before leaving, he promised Lucia he would return to marry her. Vito

found his first job in the dangerous, unregulated mines of Pennsylvania. After a few months, he said to a fellow worker, "I didn't come to America to be buried alive in a black hole in the ground." The next day Vito headed for Waterbury where he had heard from *paesani* living there of good-paying jobs at Scovill Manufacturing, Chase Brass and Copper Company, American Brass, and Matatuck Manufacturing. He found a city built on hillsides surrounded by open tracts of farmland and wooded areas that reminded him of Tolve.

While waiting in Tolve for three years, Lucia remained faithful to Vito despite many marriage proposals from other young men in town. At twenty-one, Lucia, though attractive, was considered almost too old for marriage. One night at the supper table, her father asked, "I know you gave him your word, but are you going to keep it for a hundred years?" Friends in Tolve wrote Vito telling him to come home and marry Lucia, or lose her to one of many suitors. Vito wrote Lucia saying he was coming to marry her soon,

but that he had changed his mind about settling in Tolve. Waterbury, he wrote, was a busy manufacturing town which offered steady work in its many factories. Having noticed many tracts of open land surrounding the city, he assured Lucia he could someday make the dream of owning a farm come true. After their marriage in 1909, Vito returned to Waterbury alone. Soon after, Lucia bore her first daughter, Arcangela, and as time passed, found it increasingly difficult to uproot herself from her family. After two years apart from Vito, her mother and mother-in-law convinced Lucia to go to America, telling her, "Your husband isn't coming back here anymore. If you don't go, you're going to lose him."

After the long transatlantic trip to New York, Lucia found some comfort on the way to Waterbury, noticing wooden homes that reminded her of barns on the farms of Tolve. Growing up in a traditional southern Italian village, she had been used to homes constructed of brick, stone, and marble. As Lucia unpacked her *biancheria,* dowry, from her steamer trunks, she began her new life in Waterbury with Vito and Arcangela in a dilapidated two-story farmhouse with a view of Candlewood Lake in the distance. Vito had bought the twenty-eight acre property from Mrs. Piersall who recognized the young man's honesty and strong work ethic. She dictated the terms of the sales agreement, telling him, "When you have the

money, send it to me," and promptly left for Florida. On a quiet hillside tucked away from Waterbury's busy streets and gritty factories, daily life on the Becce farm replicated the same seasonal farming rhythms of Tolve.

In an Italian American farming family of four girls and two boys, the division of labor often fell most heavily on the shoulders of daughters, whose hands were always kept busy carrying water from the well, gathering wood, heating water to wash clothes by hand, bleaching white clothes, scrubbing and washing floors, tending gardens, and assisting with cooking in the kitchen. Lucia raised her daughters in the traditional ways of southern Italy, where girls grew up quickly, with little time for child's play. Little Becce sisters made dolls from discarded bricks, drew smiling faces on their rough red surfaces, and cut little dresses for them from old rags. Lucia once caught two of her daughters drawing pictures on a wall in the house using a plasticrete shard, which meant automatic punishment, to walk up the hill to wash the windows of the dreaded slaughterhouse. Aspirations to continue school and dreams to become teachers and nurses were never realized by daughters who had to work at Scovill Manufacturing to help support the family.

Lucia's skills reflected many household talents Italian women transported to Connecticut. As in

Italy, she wove clothing with a spindle, using her own patterns to make her children's clothes. She repaired shoes using worn-out leather belts from her husband's saws. Lucia quietly managed the family economy, depositing her children's weekly wages in the make-shift bank account she kept tucked under the long shirt beneath her corset. She taught her daughters how to make bread and pizza in the handmade brick oven in the front yard, and a variety of cheeses using the techniques she had learned in Italy. She lived by the ancient custom of welcoming friends and relatives to her home with open arms, part of southern Italian culture reaching back to Homer's *Odyssey*.[3] A farming woman who grew up in tune with nature's rhythms and the changing seasons, Lucia gazed at the moonlit sky one night as she was walking with her daughters, and recited a goodnight prayer she knew as a child in Tolve:

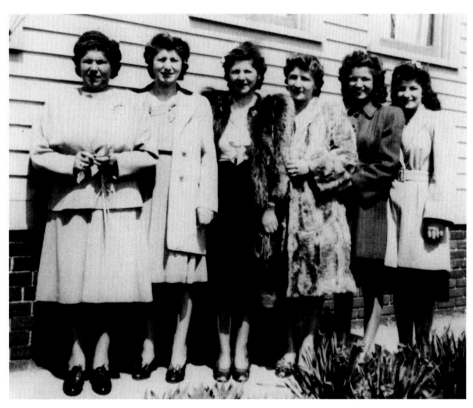

Figure 8.1. Perrotti sisters on Easter, late 1940s. Caccavalle family archives.

Buona sera Signora Luna,
Non ti ero vist,
Mo' che ti son vist,
Salutami a Jesu Crist!

Good Evening Signore Moon,
I didn't see you at first,
But now that I see you,
Say hello to Jesus Christ for me!

"The Women Never Went to Sleep"

Anna Perrotti Caccavalle and her daughter Anna Dickerson described "The Flats" in Woodbridge originally as a resting point for Quinnipiac Indians on their way to visiting relatives in Ansonia and Derby.

I said to my brother, when I get married, I hope God will never send me a boy, because my brothers were so darn tough, picking stones and everything. When I got married, I never got a boy! [laughing]. I had five daughters. I got my wish. We worked harder than the men.

My brothers hoed, they did a little work, and then they went to sleep during the day. They didn't do much work. My sisters and I? Oh no! We never went to sleep, you kiddin'?

I never slept in my life during the day! I never went to sleep. My husband had to sleep every afternoon. Even now, I never sleep in the afternoon, never take a nap. We were covering the hotbeds one night, and it was very cold. One of my brothers wanted to know where my sister was. She was on a date. He said, "Don't worry, when we get through covering the hotbeds we'll go looking for her." She was on a date, and they wanted to go look for my sister!

The girls did most of the work. My sister Rose and I, we did the most work on the farm. We were the older ones. The young ones, I don't even remember working with them. After I got married, I helped my father for six years. For nothing! My brother was sick because he had an operation and couldn't work. So I had to go there and help my father. For six years. And my father gave me fifty dollars one year. For the whole year. He said, "Ó bene sta in cuor, Love is in the heart," that he loved us, but he didn't have to pay us to do the work. So he only gave me fifty dollars; he said, "After, I'll give you some more." He never did, never gave me anything else. I helped six years and got fifty dollars for the whole six years. I was married then, and I had my daughter Rose very small in the carriage.

And I said to my sister that was working in the house, "Change my daughter's diapers, I don't want her to get a rash." She said, "No, you do it yourself," she didn't want to do it. She did get rashes. I loved my family, and I had my daughter, and I still went and helped him. And I did a lot of work for everybody. Nobody would help like I did. I took care of children, babies.

I used to help my mother on the farm until it was dark, the mosquitoes chewing me up. For nothing. One time I was washing clothes. And she said, "Ann, you want to come and help pick some broccoli rabe?" So I said okay. I pulled everything out of the washing machine, and I go help her. For nothing, not a dime. And she still charged me fifteen dollars for rent! In those days! Then she sold me a sausage machine for twenty dollars. I said, "Ma, do I have to pay you for this?" She said, "Oh, if you don't pay me your brothers will say I gave it to you for nothing, I can't do that." But when I worked on the farm, it was okay. But I wouldn't argue with my mother. I had to pay for the machine, and I worked for nothing. It was bad days, terrible. When I got through with my farm, I had a grocery store for five years. After the store, I quit. I was forty years

old. But then I used to go help my brothers and sister on their farms. For nothing.

"Shooting Tomatoes"

Rose Ruggiero remembered "Jake the Jew," a vendor who went house to house selling clothes wrapped in brown paper. She recalled jeans costing three dollars in the 1940s and wearing "like iron." She recalled being laughed at for wearing jeans on the farm and said, "We [the girls in my family] were the first to wear jeans when they were wearing skirts in high school."

We set a basketball hoop in the barn and shot hoops with tomatoes. We practiced all the time. When I was in high school I always played intramural basketball. I played whenever I could. When I graduated from high school they wanted me to play on the "Tel-Bells," the girl's basketball team from the telephone company. I couldn't play because I had to work on the farm.

"I Was Rebellious"

Erminia Ruggerio's mother made a "poor man's cake," using old coffee left in the pot, flour, lard, and raisins. She could not afford to use eggs.

We thought the only reason my father had us was so we could work on the farm. I thought we were slave labor. Even though we were second generation American—our parents weren't born in Italy, their parents were born in Italy. So you'd think it would just change, but it didn't. Maybe because they weren't bright. My father had a sixth grade education. My mother worked on the assembly line in Winchester in the nineteen twenties and thirties making guns.

My grandmother did *la spesa*, the shopping, for our family and hers. When my mother would say she wanted cookies for the kids, she'd say, "Oh they don't need them. They had them last week." She controlled everything. My poor mother. I don't know how my mother lived under those circumstances. She went through hell. When I was very young in the early nineteen thirties, she took me by the hand, and said she was running away. But she didn't know where she was running to. Then she thought, what for? I have no shelter, nothing. So she came back.

In those days, who ever knew about divorce? In those days the father was king supreme in Italian families. It was disgusting. You'd like to hit him over the head and say, where did you get off with that? I was always kind of rebelling against that, right from day one. That's why I still work, because no male is going to tell me what to do. Unfortunately, my poor husband could never tell me what to do. I was always very domineering because I got that from—I wasn't going to be like my mother—and there's no question about that.

My husband just recently passed away. I had no problem taking over everything. I miss him a lot. You know what I miss mostly? I miss taking care of him. As sick as he was at the end, I took care of everything. When I was working on the farm in North Haven, picking in the early nineteen forties, I was always the one who worked outside. I never did anything in the house except when I came in. And of course I'd have to help out after a day's work. But in my mind I was never thinking about what I was doing. I always fought with it in my head, that I didn't want to go back to farm life.

I was always thinking about what I could do. In school I memorized my lessons, or took a piece of paper with me, and I glanced at it while I was working [on the farm] to figure things out. I did all the shorthand in my head, and that's how I learned. I was always the best. Even as far as typing. While I was working I

tried to memorize what it was like to type, and where my fingers should go. All that was in my head. I couldn't think of what I was doing because it was rotten.

If you were old enough to walk you could work on the farm. Five or six years old you started carrying bushels of eggplants, cabbage. Then when you got older you did the picking, and somebody else carried the bushels. That was it. One day my brother was going to get out to lift up the boxes of cabbage onto the truck. My sister said, "No, you stay in the truck," and she lifted these eighty, hundred pound boxes of cabbage, and hoisted them up to Louie in the truck. When we got older, we could all fling an eighty, hundred pound box of cabbage like nothing.

From nineteen thirty-six into the forties, in the morning you got up, you went out, you tied radishes, or whatever had to be done, came back in, washed, changed, and had to walk almost two miles to school. And you better come right back home after school was out because you went right back to work on the farm. Then the girls had to help make supper. That was your life day after day on a forty acre farm. You had to fit school and homework in between after you finished on the farm.

We constantly did the grunt work, the weeding, planting. My father had to have everything cleaned. God forbid when you hoed, it had to be exact so that the soil came right against the plant, and if there was a weed, you bent down, and picked it. He'd yell like crazy if we didn't do it right. The guys worked hard too. They had to take care of the pigs, the tractor, and the machinery. They started the hotbeds with house windows, and covered them with heavy blankets in January. Everything you were going to plant on the farm, eggplant, tomatoes, and peppers. No greenhouses. If it snowed, you had to shovel them off. As the seeds grew, you had to transplant them. School was our vacation. But that was your life, day after day.

I never had a childhood. As the oldest daughter I was never too bossy with these kids because my father did enough of that, so I didn't have to. I always felt burdened. I don't know what a childhood is like. I didn't have one toy when I was a child. We learned nothing. I was so stupid. I never knew when my mother was having a baby. Talk about sheltered. She had all nine of them at home. After two, three days, she was back to work on the farm.

We canned hundreds of bottles of tomatoes in the backyard, with a huge pot on a fire to boil the bottles in the water. My mother saved every soda bottle she came across because we canned them with our own bottle capper. With a little stick and a funnel, the boys and girls put tomatoes in each bottle. It took a long time. It was a whole day process. Then we had to wait another full day to take all the bottles of tomatoes into the cold storage in the basement. We were ten children, and she made eight bottles of that sauce maybe twice a week for dinner because you had to make your food last.

We never knew what it was like to have a steak. We ate what we grew. We had tomatoes. We had sauce, and she made macaroni. We ate chicken because my mother raised chickens. We ate pork when they killed a pig. The only advantage of all of this is that we never went hungry.

"We Drank from the Same Cup"

Rose, Erminia, Mickey and Gloria Ruggerio:

Our family worked together with black people. They were hired from the neighborhood—Hosie Monroe, Haskell Clark, Mister Dempsey—and they were garbage collectors too. Not to disturb people, they used to get up at two o'clock in the morning, go into the backyards, empty the pails in the ground, put the trash barrels over their shoulders, and carry them out to the truck. My father had twelve hundred head of pig and they fed them the garbage. We fertilized the farm with it. That's why we had the best radishes and my father got the name "The Radish King." They used to come for dinners, and my mother loved them. They helped us a lot on the farm, and they ate with us a lot. They even came to one of our weddings. They were family. They worked hard. They were honest. When black people came to our house, there was always wine for everybody. We drank coffee out of the same cup. When they built the I-ninety-one highway, it ruined the farm and we couldn't keep pigs anymore.

"Working on the Tobacco Farm"

Marie Pizzanello Coburn recalled Jamaican workers in the 1930s coming to pick tobacco, "All you would see was their backs parallel to the ground, all moving like a formation, all the same way."

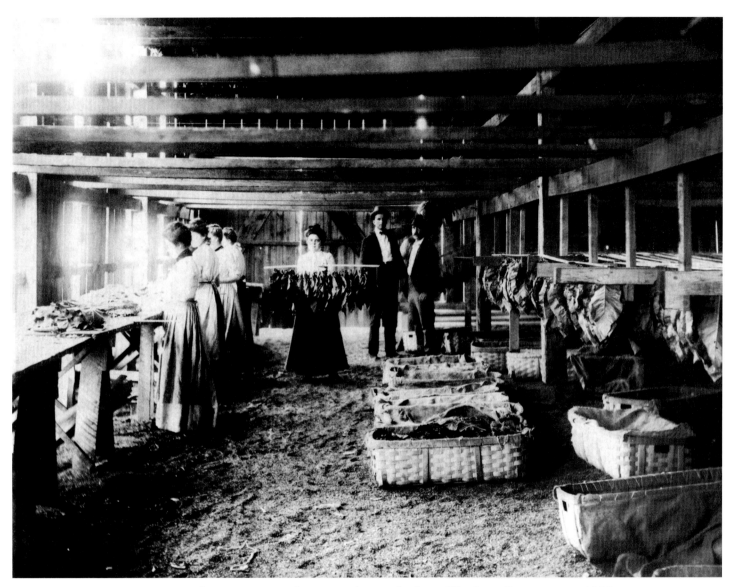

Figure 8.2. Italian women working in tobacco sheds in Windsor, Connecticut, 1920s.

There were many tobacco farms in Windsor, East Windsor, Windsor Locks, Glastonbury, Enfield, and Consolidated Tobacco was one of the big firms among others; they had farms all over the place. My great aunt, Antonette, worked in the tobacco fields until she was in her nineties. She started working in the nineteen twenties for about fifty cents a week. She was the watchdog, my grandfather's sister. She was in the barn, and that made it all right for my mother to go to work at age fourteen, around nineteen twenty-one. That's the age when all the girls worked on the tobacco farms.

The minute they were fourteen, a lot of Italian women went to work there. We used to take the bus from Hartford that took us out to the fields. The local boys walked downtown with little lunch bags and took the bus. It was hard work for the boys, and they came home filthy dirty. They planted shade-grown tobacco with the mesh nets over them. At the end of each row was a wooden barrel of water with a spigot for the boys to drink. When the boys finished, the bosses gave them each a short rest, and shouted, "Next row." Then they continued to the next row.

When it was picking time, they picked the leaves starting from the bottom, and put them in big white canvas baskets. Then they had kids drag these big baskets full of leaves by hand to the barns. The women's hands were stained from the tobacco. They started at six in the morning till around four or five. They were paid by the baskets. The women just sat in the barn, and with a needle and thread sewed the tobacco leaves together, and hung them up to dry on the rafters. They were paid by piecework, by the bundles of leaves they produced.

The tobacco was used for cigar wrappings, and they were supposedly the best in the world. It was probably true because the Connecticut River overflowed every year, which made the soil very rich, and there was a lot of land out there. You had to rotate the crops because it is very acidic, and they had the land to do that. Cigarette tobacco was grown down south. My mother worked there because my aunt was there. They allowed the daughters to go so my mother and Aunt Mary worked tobacco in the summer before they could work in a nonfarm environment. By the time we were sixteen we could get a job in G. Fox in Hartford, and we didn't have to do that kind of work anymore.

"Working Tobacco"

Natalina DiPietro worked at Connecticut Macaroni weighing and selling loose macaroni. She had been

a dressmaker making "Hooverettes," house dresses for women who didn't work, and later made clothespin bags in a factory. She also worked at Royal Typewriter making round letters for typewriter keys.

My first job was working tobacco in nineteen forty-two—sizing—at A. M. Shepherd. I lived on Front Street in Hartford, and walked to the shop on Mechanic Street. My mother, my mother-in-law, everybody worked there. Men worked, but it was mostly all women! We worked eight in the morning to three-thirty, and it was seasonal work during the winter.

In the summer some women took a special bus to work on the farms in Windsor where the tobacco was raised. They had all these sheds where after the tobacco was picked they dried it over the summer. They left the slats open in the sheds. My aunt was the inspector of the tobacco, the boss-lady. When I did sizing there were all different lengths of tobacco leaves, you just sized them and drop. My mother was a sorter and they opened the leaves out. They had to be a little moist, not dry because they tore. And you opened them out. With a needle we'd go through the bunch of stems, tied them, and put them in bundles. Then the inspectors came around, slid them out, brought them to their area, and in no time they had them sorted into the bins to make cigar wrappings.

The tobacco came from the farms around Hartford. When you worked in tobacco, when you came out, you could smell it all over you. You smelled of tobacco day in and day out. My aunt used to take my husband when he was fourteen to the shop, and for extra money she washed the floors and cleaned all the tables. She used to say to him, "Sit on the bench there" while she washed the floors. And I learned tobacco.

One day my mother was going to see her *comare*, her friend, after work, and she made a mistake. She went to the Chinese people's building nearby. My poor mother went up three flights and sees all these Chinese. She got frightened, the eggs she dropped. She ran downstairs. You know, little Italian lady—Chinese faces—come on. She ran down those steps and went into the bakery downstairs, and they gave her a chair to sit down. They looked different and they scared her. Our whole world was Italian.

"She Never Complained"

Antoinette Becce Padula and Vittoria Becce Semprini recounted one of their mother's favorite sayings, "È

meglio ricca di sangue che d'oro, Better to be rich in blood [relatives] than with gold."

We always had a lot of visitors. My father's relatives used to come from New York, and they'd come to Waterbury in the summer. Sometimes they'd stay a whole month, and they'd bring their children. One Labor Day we had forty people at our house, and we all slept on the wooden floor because we had to give up all our beds. They slept on the couches and the beds. Cousins, aunts, uncles.

The relatives from New York, if they could get a ride to Waterbury with a neighbor or a friend that had a car, they'd bring them along too. I never once ever heard my mother complain that all these people came, this is too much, I can't do this. Never. She was so patient all the time. And people would pop in on her at times, and right away she put a couple of *pollastros*, spring chickens, in the oven. She tell us, "*Piglia due pollastri, uccidile e pullirle, e portale a casa*, Go get me two chickens, kill them, clean them, and bring them home." We chopped their heads off, peeled them, and dipped them in hot water. We all had to do that. Right away she'd have a whole meal when she didn't even expect people. I don't think we ever had a Sunday without

company, some came every Sunday, "Let's go to the farm," it was a nice place to go on the weekend.

During the Depression, people came up to eat. We had homemade cheese, provolone, *a treccia*, braided cheese, dried sausage. We were always setting tables and washing dishes. The relatives from New York, the *paisans* from downtown, they took the trolley, and walked up to the farm. My sister Toni had to fill up the pitcher of wine in the basement. A few times she put too much in there, and she was afraid of spilling it going up the stairs, so she sipped some. One day the poor thing got so sick! These were the jobs we'd get on a Sunday, and then we'd be washing and drying dishes and setting the table again and making coffee again. They ate in the dining room, and we ate in the kitchen but only after they ate. We waited on them. We didn't mind. We enjoyed the company. We were stuck on the farm all week, and when the company came we enjoyed them. We were glad to see somebody come. Sometimes we'd entertain people all day Sunday. But we were always happy to see them.

Once, a distant, distant cousin came in August. He was in our spare room, and I went up to make the bed in the morning.

And hanging on the door was a winter coat! I got so upset. I went running down to my mother, and I said, "Ma, he's got a winter coat up there! How long is he going to stay?" She just shrugged her shoulders. And he did stay, he stayed a long time. He was a distant cousin, not anybody close. They used to just come and stay. My mother took them in. And none of them were from her side of the family. They were all my father's relatives.

"Your Sister's Ass!"

Kathryn Bozzi and Mary Carbone:

My mother came from Castello Pagano near Benevento when she was three years old. She had a baby every two years, ten children in twenty years, five of each. In the nineteen twenties, my mother had a black friend, Anna Butler, who was a neighbor of ours in the Highwood section of Hamden. Anna was a good friend to my mother who was raising a family, and she would teach my mother how to make fried chicken, and other Southern dishes, and also helped her with the children. When my sister Annabelle was born, the fifth in succession of ten children, they named her after Anna Butler. My parents must have really appreciated her friendship. At that time, the Highwood section of Hamden was predominantly Italian, and I guess Anna must have picked up some Italian. The story goes she was standing in the line at the movies, and behind her in line were some Italian men. They commented on her rear end, something to the effect of "*Che bella cul che tenn stu tuzzon,* What a nice ass this black woman has." And Anna turned around, and shot back to them in Italian, the put-down of "*Ó cul a sortita!* Your sister's ass!" Evidently my mother was very proud of her telling these men off because she always liked to tell this story.

"Farmer's Mass"

Mary Carbone said her mother wanted to go to grammar school but their father convinced the truant officer to keep her on the farm.

In the late nineteen thirties, during weekdays I went to school, came home, changed my clothes, got on the truck, and go to work on my grandfather's farm. And Saturday we didn't work because there was no market. But Sundays we had to get up, we had to go to the six o'clock morning mass at Saint Anne's Church in Hamden first. It lasted only thirty

minutes. They didn't keep us long because it was the "farmer's mass." They called it the "farmer's mass" because there were so many small farmers. So we'd go to mass, come home and change our clothes because we always got dressed for mass—we never went to church in our work clothes. And then we would hop on, jump up on the tailgate onto the nineteen twenty-eight International truck. It had seats on the sides like benches, and we held on to the bars. Aunt Katie, she was the oldest, she would come from the farm to pick us up. It was always full of kids, and people from the neighborhood. My grandfather paid them, but we got paid almost nothing.

We worked until four in the afternoon. But we went and we worked very hard. It would be very cold and chilly and damp in the morning. And then the sun would get very, very hot. I was so hungry all the time. I don't know why. And I couldn't wait for dinner time. And it was dinner at my grandparent's house on the farm. They would allow us to go in and have a dish of macaroni, and it was so delicious. And we sprinkled goat cheese on top, and it was creamy and delicious. Maybe some meatballs in the sauce. And that was it. Then you ate your dinner, and you had to go right back on the farm. And with a full stomach pick strawberries and string beans.

"She Was the Paymaster on the Maselli Farm"

Joe Fiore and Mary Carbone described the older generation of farming families in Hamden—Weir, Peters, Benham, and Warner—who sold their farms to Italians—Coco, Cricca, DeMatteo, and Pasqualoni—because their sons no longer wanted to work the land.

My grandfather raised raspberries. And only the women picked them. Because these baskets were pints, oblong, and they tied them with a *moppine*, a used cotton cloth around the front of them. And they'd pick the raspberries, which were very delicate and tender, put them in the baskets because the women had the more delicate fingers. My grandmother used to pay us and the workers with beans. She was the paymaster. You had the baskets and go to this shed, a lean-to where my grandmother used to put the little strawberries on the bottom of the basket for the market, and big ones on the top so that, "Oh, Maselli got beautiful berries!" There were different varieties—premiers, dorsets, catskills. She stayed in the shed. And you could take as many baskets as

you wanted, usually a half-dozen. Now, when you brought those strawberries in those baskets back to my grandmother at the shed, for every certain number of baskets, she'd give you a bean. You'd have to put it in your pocket, so at the end of the day they counted your beans and say "All right, you picked forty baskets of strawberries, you got eighty cents today." Two cents a basket. Lose those beans, you're out of luck! You lost!

"My Mother Rose Was All Business"

Pat and Diana Mastromarino:

They started their season by seeding in the cold frames in February, and they tended to the cold frames until the end of March, early April. Then they transferred the plants in April into the ground. That was the start of the growing season.

When they first started out on the farm, they would begin earning cash for the crops from May until November. By winter they may have gotten a loan to tide them over for living expenses until the next season began. They also had to pay for seed, fertilizer, and empty container boxes to sell the produce in.

Once the farm started doing well, they made enough to tide them over, and did not need loans any longer.

We had customers in the markets. Rose would take the orders in the growing season all week, and then usually on Saturday they

Figure 8.3. Rose Mastromarino's farm expense records, late 1950s. Mastromarino family archives.

would come and pay them. Generally, the buyers paid in cash.

The buyers were middlemen. They sold produce from our farm in New Haven, Hartford, Bridgeport, and Waterbury. Everything was on an account. Every once in a while my mother would get into a beef about the pricing. The buyers would buy the produce when they could get a high price for it. Then when the demand diminished the price would come down much lower, and buyers would try to settle up at the lower price. For example, if lettuce was six dollars a box at the beginning of the week, and it came down to three dollars a box at the end of the week, they would try to figure up the bill at the lower price. It was quite interesting. My mother Rose stood her ground. She was all business.

Some of the buyers were relatives. They were all basically good people, but there was haggling and bartering. It wasn't as sophisticated as it is today with computers. Sometimes she would write the order down on a wall near the phone. She had a page for each buyer, and every night she'd write down everything they picked up. She would have a page for each one until they were paid.

My mother seemed to have more of the responsibility for everything. At times she would even drive to the gas station and buy the gas for the tractor or the truck. The speculators would call in an order on a Saturday for pick up on Sunday. Sunday was usually the busiest day for orders, because the markets opened up on Monday. One buyer wanted a hundred boxes of lettuce. Another wanted a hundred of tomatoes, whatever. They would be picking the tomatoes, or whatever was ordered. And then they would get a late call on Sunday, "We need another hundred boxes," so all of a sudden, you're all exhausted, and you'd have to go pick an order for another hundred.

My mother picked and my father packed. Sometimes they would get frustrated because some buyers would come early and would take an extra hundred boxes that was meant for another buyer, and they would have to replenish the order. That would often make it very hectic. That was the work ethic then. You won't get that now. I don't think you'll ever meet a group of people like the people from "The Flats" [of Woodbridge] because we were like one big happy family. Even though we're

not related, we've kept that relationship. If you go to a wake, everybody from "The Flats" shows up.

"I Ran the Chicken Department"

Filomena "Phyllis" Consiglio:

My father was looking around for a piece of land, and he wanted to buy a farm. He wanted to have a family, and he didn't want to raise them in the city of New Haven. After my parents worked in the city for a year, my mother got pregnant, so he said to her, "You know what? We got enough of money saved, we gotta buy a little piece of land, and we gotta get away from here. This way, you take care of the farm and everything with the kids as they grow up, and I'll keep working."

First my mother had one. Then she had two. But they came every two years—they planned every two years they had a child. I was the eighth one out of fifteen.

He worked at the gas company, and he commuted back and forth every day. He bought a little house right before an apple orchard in North Haven. Then he found out that the land right across the street from the cemetery was for sale. There's a big barn there, it says, "Cristoforo Farms." Well, my father bought that land for three thousand dollars. See how smart he was? He couldn't read or write, but he had credit. He opened up a credit at the bank, and he got to know the guy at the bank. He couldn't write his name, but he'd go get a loan with an "X." He would sign with an "X" and get ten thousand dollars every year.

I had to get up at five o'clock and work on the farm with my brothers. In the early nineteen thirties, we started working when we were three, four years old. My mother used to pack in the barn with the baby. And my father would take the rest of us out in the field. We thought what the heck were we doing, we were so happy to go on the truck. And we'd bring baskets to the pickers. Three, four years old, we'd be right behind the pickers, and get the baskets ahead of them.

When you picked tomatoes, what you do is you pick them if somebody brings in the empty baskets, the older person takes the full ones out, and puts them on the end of the road, so when the truck goes by to load up, you make good time. That's what we used to

do. I'll never forget the time I was ready to pick tomatoes and all of a sudden you see a rattlesnake wrapped around the tomato plant. I never ran so fast!

We had cows, chickens, turkeys. So I said to my father, "I'll go out and work on the farm, but one thing I won't do is milk the cow." So my father would say, "All right, your job is to take care of the chickens." We had one big coop, which really was one large coop partitioned off, and it had two sides. As the hens started to get older, we put them in a separate section so they would lay their eggs. The chickens were my department, so I had to get water, and I used to lug the water with pails. I was lugging water from the barn to the chicken coop, and it took me ten, fifteen minutes because I had to put them on a wagon, and walk it up from the barn to the chicken coop. We needed the water for the chickens to drink, and we had to keep the coop clean because the chickens would go outside to eat, and that's where we fed them. So finally one day I said to my father, "Can't we get a pipe or something to the coop?" So my father said, "All right, we're gonna put an underground pipe," and the water came.

Any leftover vegetables from the garden, that's all we gave the chickens, the leftover tomatoes we couldn't sell, they were a little rotten, peppers, squash—they loved it. We had organic eggs. So every spring he'd buy four hundred at the hatchery in Wallingford, three hundred, and a hundred roosters, because we used to make capons. They [Italians] didn't have Thanksgiving and turkeys. We used to raise capons. My job was to get the roosters in the crate, and lock their wings, like giving them anesthesia. My mother, with her little scissors, would get in there and cut out the little bean in the stomach. With her fingers, she could feel it. There's a little bean [gland], and if you take it out of the rooster, he grows into a capon. My father and mother would put their little white aprons on, and my father would sit there and hold them. After my mother cut it, she took the bean out, and then with the little soft feathers she'd sew it up with a needle and thread. And it was my job to go out to the big shed and put blankets and old sheets—nice and clean—and put them there to recuperate. If the next morning he survived the operation, he was walking. But if he just lay there, I'd chop his head off, and we'd eat him. I had to. That was a way of living.

We never raised turkeys. Our turkey was a capon, the Italian version of Thanksgiving. Every Sunday, my job was to go down to the

coop, twelve chickens and two roosters, or two soup chickens. And the ones that used to go into the soup were the roosters that when I used to collect the eggs I used to go in with boots up to my knees because they didn't want me to touch the eggs. They felt as though they earned them, you know? And I used to have to take them, bring 'em, chop their heads off. I used to wrap their wings crisscrossed, and hang 'em on a hook with a piece of string. I had to catch the blood because my mother used to make a blood roll with cinnamon and rice, and it was delicious. And we used to get the fire going, and light the big galvanized tub underneath with water, and dump the chicken, and then I had a little table on the side, and I'd take all the feathers off and throw them into a pail. Then I'd put them in ice-cold water in another tub.

My mother was inside, and the natural chickens had a lot of hair, and she used to have a wood and coal stove. Every Saturday, to clean that stove! We used to have to shut it off. The soot was that deep in the stove otherwise you'd get a backfire. We had to polish it with black polish.

I'll never forget when I first got married. We had a chicken market right down on James Street in New Haven. And we used to go in the chicken market. It used to take the guy forever to give me two [cleaned] chickens, I said, "My God, I should teach you. I could do twelve chickens in less time than it took you to do two!"

"I Gave Them American Names"

Vittoria Becce Semprini recalled her mother's way of cooking, always starting her dishes the same way, saying, "She took *pancetta*, the salt pork, cut it into small pieces, and put it in the pan. Then she chopped garlic, added parsley and tomatoes, and that's how she made her sauce."

My first job in nineteen twenty-one, when I was seven years old, was to get up at six o'clock and milk the cows on the family farm in Waterbury. We didn't have steam heat. It was cold in the house. We had to put papers in the stove, get all the kindling wood, and get the fire going. I singed all my eyelashes, and I don't have long eyelashes anymore! [laughing]. We used to put a little kerosene on it, and whoosh! If you didn't duck, you got singed.

My sister just couldn't get up that early in the morning, so I used to milk both cows in the barn, and carried the two buckets home. Two buckets was better than one, so

you could balance yourself! [laughing]. So my mother made cheese and ricotta every other day. Dry it, and use it for macaroni. She made provolone, *á treccia*, braided cheese, *monte ca*, cheese with butter inside that she learned to make in Italy from her father's business. My brother never did that.

In those days, they built the barns right off the street, so when they came in with the horses they pulled right in. I used to raise chickens, and I used to set the chickens on the eggs. When it was springtime, the chickens didn't lay eggs, and they wanted to sit on their nests. After twenty-one days, they hatched. So you get the eggs under them, take the chicken off. Once I had a duck that wouldn't stay on the eggs, so I put a chicken on the eggs, and she hatched them. So we had a little pond across from the house, and the chicken is walking with her little ducklings. They get by the pond, and run into the water, and she's going "Cluck! Cluck!" And she's running back and forth hysterical, the poor thing.

I was about three years old, and we had ducks and geese. Near our house was a little slope, and nice pasture out there where the ducks were. I used to run down there, and the geese were honking, "*Carwa-Carwa-qua,*

Carwa-Caw-qua." But what I thought they were saying to me was, "*Curcáta ccà! Curcáta ccà!*" which in our dialect meant, "Sleep here! Sleep here!" So my legs weren't big enough to get me home fast enough. I went running home to tell my mother I didn't want to sleep with these geese! [laughing]. My mother was crying [with laughter]!

We had a lot of hens with little chicks. We had little houses for them, with little boards inside so the hen had to stay inside, and the little ones used to run in and out. So I used to have to go in when their mothers were inside to feed them so they wouldn't wander and get lost. I gave all the houses names, this is Mis-

Figure 8.4. The Becce children, early 1920s. Clapps-Herman family archives.

sus Jones, this is Missus Kelley, and they had their own little village. It was interesting. I had all these people to take care of, all these hens. I use to give them American names. I didn't give any of them Italian names. After they grew up I couldn't eat them when my mother cooked them. I didn't eat chicken for a long time.

"Driving the Stone Board, Milking the Cows"

Antoinette Becce Padula recalled the birthday gift her mother once received from her father in Waterbury. When his children asked why he bought her a goat, he said, "What else was I gonna buy her?"

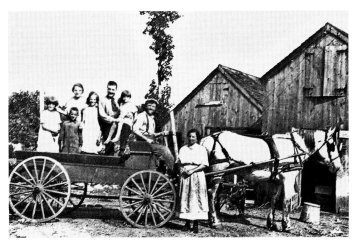

Figure 8.5. The Becce family on the farm in Waterbury, 1920s. Clapps-Herman family archives.

I was seven or eight, and I drove the "stone board," a flat piece of wood with big planks.

It had metal underneath, and they hitched the horse to it. The land was full of rocks, and my father had a crowbar, and dug up the heavy rocks. So I used to stand on the board, and hold the reins, and drive the team of horses—okay, now come up a little further, *viene àuto pòco*, a little more, they'd roll the rocks on the "stone board." Then we'd bring them someplace. I think a lot of them went in the lake nearby. I was nine or ten and our relatives, young guys, would come from New York all dressed in nice suits, "Oh, we gotta come and watch you milk the cow." It was embarrassing. "Okay, come on." I used to say. "Don't stand there, you'll scare the cow, move over there." So they'd move over and I'd take and squirt milk all over them with their suits on.

"The Girls Had to Work Inside and Out"

Filomena "Phyllis" Consiglio:

We girls had to do both inside and all the housekeeping outside. And laundry in those days wasn't automatic. We had the roller machine, you know. We had the hard water,

and we used to have to put the Calgon in the water because the soap used to get flat and wouldn't wash the clothes.

We had it tough in those days. This is what the girls did. Wax the floors, clean the bathroom. We didn't have a bathroom in the house until nineteen thirty-eight. We used to have a commode. And my father put in the heating system and a new bathroom. Oh, we felt like a million dollars because we used to drag the tub out. Because my brothers had to take a bath, and take off on their dates, and then we had all our time to take ours. We had to warm this water on the stove, put it in the tub, take a bath, then take that water and dump it outside. The kids today don't know, boy, how lucky they are!

And then when my father put in the furnace, and he put the water in, he put in a well, and it used to be so cold! Those winters used to be so cold that we used to have to put two railroad lanterns down in the well to break the cold, otherwise the motor would freeze. That was the boys' job. My brothers cut the trees down and made them into blocks, but when it came time that it was my week to chop the wood with an axe, fill the bushels, and bring them in for the night, I had to go out there.

The girls had to go out and chop just like my brothers.

I wouldn't let my kids do what I did today. Every spring, when the cow had a calf, we had to raise the calf, and my mother would make all homemade parmigiano cheese with the milk, and ricotta the girls made all that ourselves. My father built a big bread box with handles on each side for a fifty to a hundred pound bag of flour. At one time that was my brothers' job—to get it in there, because they had the muscles. We had to knead and make the bread. My mother would get up four or five o'clock in the morning, and we could smell— she already had the fried dough ready for us, or little loaves of bread with scrambled eggs.

When we came down for breakfast in the wintertime it was so nice, and my father would get a slab of bacon from the pig that we raised in those days. It was so cold in October that they had the carcasses hanging in the garage. Then when the weather started to get warmer, and it wouldn't keep, what we did right after we killed it, my father built another box in there, and my mother would put the salt pork, the bacon, to dry, and then she checked it every day. Then we'd make the homemade sausage and we'd dry it out. We'd bring it up

in the attic on newspaper, and we'd dry it out on waxed paper, or brown paper.

The summertime was beautiful because you didn't mind getting up at five, six o'clock. In the winter, we didn't have to get up because it was time to go to school. He made us go to school. But in the summer, when the crops had to come in, he'd get us up by five, five-thirty. My father just whistled, once! And only once. If he called you once, and you fell back to sleep, boy you'd hear about it! During the war, my brothers got married, and they used to come up at eight o'clock, they had banker's hours. But when we had stuff to pick, lettuce and tomatoes and everything, we were out in the field, six o'clock. My brothers didn't show up yet.

They used to get a hundred and fifty dollars a week. My sisters and I used to get five. Sometimes they'd get bonuses at the end of the year for hauling the manure and for chopping trees down by the acre to make new land for the following year. The old days, the men felt as though the boys needed the money because they had to get married, and the girls had to provide the dowry. See how it worked? We [girls] would go out before breakfast. Then when my brothers came up at almost

seven-thirty, eight o'clock, and then finally I spoke up. I said to my father, "This isn't fair. You're working us to death." Then at night they go home at six o'clock to their wives. We eat supper, then clean the dishes, and go back out in the barn and pack tomatoes, peppers, eggplants until twelve o'clock the next day.

And we used to have to pick up the boxes of cabbage. You pick up a box of cabbage, and it's about fifty to seventy-five pounds. And we had to dunk them in a big tank that my father built, and water them good. And to keep them fresh and moist we kept them in the barn. One day I was so dizzy, I was sick. I had my period. I got so dizzy I fell in head first, box of cabbage and all. But my father didn't excuse that, "Go up the house, go get something to drink, change your clothes, and come back." He figured if his wife, my mother, was tough, she'd have a baby, and the next day she was out in the fields working, picking beans. She'd be right along, especially if they were raising crops to sell to people.

My mother did all the baking, the cooking. She was constantly cooking. My older sister Rose didn't like to work on the farm. She liked to wash clothes and clean the house. So she had to do all that by herself while we worked

the fields. We didn't have to do any laundry. The only thing we had to do was help with the dishes. And then on Saturday help clean up the whole house, with a thorough cleaning. Then when my mother had a heart attack, my sister had to do it, and she couldn't handle it.

During the war, my brothers were Four-F, and in order to stay out of the army they had to raise food. My brothers got their friends, brother-in-laws, and they could come up for the day on the farm for the kick of it. And they had to eat! My father fed everybody. My father built a special room for a kitchen, and the table took six yards of oilcloth. He built the table right in the room. And right off that room is where we had the old well water. That's all we used to have, until my father "hit the market," made some money selling [first] crops. He put in the oil burner and the bathroom.

Down at the market on Minor Street in New Haven, the farmers would go down every day with truckloads. My father would go, and when you went to sell your stuff, you'd get orders, you'd get customers that used to go peddling to the grocery stores. They didn't have supermarkets in those days. So that's what they did, little mom and pop stores—they depended on these dealers.

"Wash the Shirts and Keep Quiet"

Filomena "Phyllis" Consiglio:

In those days when we used to iron with metal irons, the ones you had to put on the stove to heat, they [my brothers] would go out with a girl for an hour, take their white shirt off, and throw it in the hamper, five or six shirts in the course of a day. So one day, I complained to my father, I said, "Gee, you know this is ridiculous. It's hard to starch the shirts and everything and heat the iron—that's a lot of work. Why can't they wear the same shirt for the whole day?" You know what my father said? "You mind your business, that's their business. Your job is to wash their shirts. Wash the shirts and be quiet." This was all in Italian.

"Pa, Don't Shoot!"

Filomena "Phyllis" and Andrew Consiglio:

My father was out one day to shoot some woodchucks because they were eating up all the plants and cabbage. So my husband and his cousin Johnny decided to go on an airplane ride. I don't know who was driving, whether it was him or his cousin. They took flying les-

sons; he and his cousin went up. They rented the plane from Tweed Airport in New Haven. They're mooning my father with the airplane and they were swooping down, they almost hit him in the head, almost took his hat off.

He got so nervous, he was gonna shoot them. They thought it was funny, see that's what I mean, he [my husband] never grew up! He was ready to shoot and I was hanging clothes, "Pa! Don't! Don't go to jail for those crazy bastards! I'll find out who it is and when I find out, I'll tell you." And every day my father would go, "Did you find out who it was yet? If he comes back, I'm gonna shoot him!"

I said to him [Andrew], "Where were you today, did you go looking for a job?" He called me, he said, "Yeah." I said, "Yeah, you

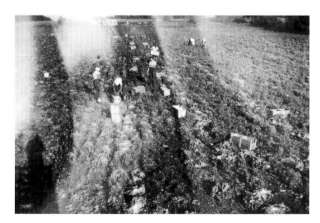

Figure 8.6. Christoforo family farm, North Haven, 1940s. Consiglio family archives.

went looking for a job in an airplane!" He said, "How do you know?" I said because I was hanging clothes and you don't know how lucky that you and your cousin Johnny are alive today! Because I knew he was hanging around with Johnny. I said to him, you better not do it again because next time I will tell my father and he will use the gun [laughing].

"Fourth of July on the Farm"

Filomena "Phyllis" Consiglio:

Right near the well was the woodpile. My brothers were very sloppy, they never did anything. So one day I went out there and I started stacking the wood. I took the wood far away. I put it where we used to throw away the garbage where my father had built a concrete bin to throw all the garbage in barrels. and I put all the wood on one side, nice and neat. Little by little I cleaned that up.

So my father said, "What are you doing?" I said, you know what? We used to get rats boy, if they ever got into the house, it was bad. I was scared of them. So I got rid of that woodpile. So I went in and I announced—my brothers used to get so mad because I used to always create work. So I cleaned it nice and

clean and I said to my father in the springtime, "Pop, could Charlie plow that whole field for me?" From when you came out the back door it was an area as big as two big rooms.

Well, my father was so thrilled, how neat and clean it was. I said, "Dad, I want to make a flower garden. And in the winter, when we plant the seeds, could I have a little corner of the field?" "Yeah," he says and he even got the catalogue, "Here, when I order the seeds, I'll get you the flowers." So I bought snapdragons, astors, everything. And he plowed it.

So I only cushioned off a small flower garden; for the rest I said, "Dad, can I buy some lawn seed?" He said, "What are you going to do?" "I'm gonna plant a lawn," I said to him, "it's gonna look nice over here." I went in the woods, I dug up a maple tree, I planted it before I planted the lawn and it took root. Then I planted the lawn and it came up—it was so nice and green! My father couldn't get over it.

So then all of a sudden we had a mason that used to do all our masonry work. So Mister Solo came and he said, "Phyllis, your father says you want a fireplace." I said, "Gee wouldn't it look nice if we had a fireplace over there near the tree so we could have hot dogs and roast them outside," you know, because I used to see it on the television and we never had that. So my father said, "That costs too much money." But I told him, "Dad, I'll pay for the bricks out of my allowance, just give me somebody to build it." I would have probably built it myself if he got me the stuff. So Mister Solo came and he says to me, "Design the thing you want and I'll build it for you."

So I designed what I wanted, the ledge to put the dishes on each side, the fireplace where I could burn the papers, and everything. That year my father invited everybody he knew for a Fourth of July picnic. I wasn't married at the time; I was going with my husband. We had a gang! We played bocce ball on my lawn. We had a Fourth of July we'll never forget.

"I Helped Him Build Our Farm House"

Angelina Julia Deleone was one hundred years old at the time of our interview. She said, "There are lots of things I've seen in my life I remember that my kids will never see and will never know."

My mother wasn't feeling good and the doctor told my father he should get her out of the city. So in nineteen nineteen my father sold

the grocery store on thirty-nine Silver Street, and he was a stone mason. He decided, "Well, I gotta buy a farm," and he bought a farm in West Haven. Well, the first time I saw that farm! No roads, just a dirt road and the trees were arching over the road. It was right across the street from where Armstrong Rubber was, and the stone house still stands.

Many a stone I carried from the farm to build that house! Many, many. And pails of cement, pushing the wheelbarrow to help my father build that foundation. That wall is twenty inches thick from the bottom to the top, all by hand. My father built a prairie shack for him to stay on weekends, because it was like a prairie—there was nothing there.

There were four of us kids; I had an older sister and a younger brother, and a younger sister. My two sisters grew up with my grandparents. My brother and I were the two that used to have to hike every weekend on the horse and wagon from New Haven and go to the farm in West Haven. My father would hitch up the horse, and off we'd go. My mother sat with him on the seat and my brother and I sat in the back. We used to enjoy it. That was your life, and that was what you were going to do.

He had seven acres, we had cows, chickens, pigs, you name it, and we had it. I had to feed the chickens, milk the cows, fill the wagon with cow manure and spread it through the farm. I did everything but run the plow! We even had a sheep—we'd call her and she'd come running to see us.

It was a good life; it was a tough life, but it was good. My mother couldn't take care of all of us; she was sick on and off, she was a sickly person. She almost died at childbirth. I didn't graduate from elementary school. Six months before I could graduate the eighth grade I had to leave school to help my mother at home. Hey, we had to live for one another, we had to do things for one another. It was my brother and me working all the time. My father was very strict. He had the iron hand and he would not let us have boyfriends. How could I have a boyfriend in the wilderness?

"To Work on a Farm"

Anna Perrotti Caccavalle:

My father raised twelve kids to work on the farm. Years ago they raised kids to work on the farm, you know. I know the DeFrancesco

family in Northford. The wife had a baby and they already had two boys. She had her third, a baby boy. So one of the brothers said, "Oh, we got another worker for the farm!" See? They had children to work on the farm.

My mother had six boys and six girls and she used to go downtown New Haven and get a burlap sack full of shoes, she used to go buy. All kinds of shoes, no boxes, all loose, all different sizes. She'd bring them home, put them down the cellar and if we wanted a pair of shoes we had to go see which ones fit us. So [laughing] we used to put them on. When we'd go to work in the wintertime, too tight. By the time the end of the day, our feet were hurting. And when we'd walk, too tight, so we took the shoes and threw them off. And then we'd bump our toes near the stones, break our toes. What a bad life we had. My mother wouldn't buy us sport shoes, never. She used to buy us high heel shoes. That's what my mother did, bought those kind of shoes. To work in a farm.

"They Used to Sing on the Farm"

Anna Perrotti Caccavalle:

In those days, my father's brother used to sing out loud. They used to answer back and forth with the songs at ten at night. All the Italian songs. My father's brother, "Zi' Francesco," Uncle Frank, used to sing a song, and then my father used to answer the song back from where he was. When my father started another song, my uncle, his brother, used to answer. It was about ten o'clock at night. Years ago, at that time, they could sing. But today you can't sing at that time. It's against the law. They sang all Italian songs they knew from Italy, back and forth, line by line. That's what they did for entertainment. They'd sing. My two brothers were about a quarter of an acre away from each other. She said when she was working on the farm in Italy, she worked with a lot of ladies and they all used to sing while they hoed, "O Sole Mio," "Wey Marie." She used to sing on the farm in Woodbridge too. There was no radio.

"Singing and Picking Beans on the Luciani Farm"

Agnes Luciani DeFilippo described how farmland was bought in the 1920s. "When you bought the farm, you got the land, the hayrake, maybe a plow, and maybe two ducks. My father, when he bought our farm in nineteen twenty-two, got one hundred cows, six teams of horses, and one hundred acres of land for twenty-five thousand dollars. My father had to

buy it through the bank because they would not sell to an Italian."

My mother Lena was very modern for her time. She was the first Italian in the school system. She went to school with the Newtons, the Pecks, and the Shepards. She was the first woman in Woodbridge with a driver's license and the first one with a telephone. My father was a tailor and he didn't know anything about farming. She taught him how to farm. She loved to sing, learned to read and write Italian by her grandmother and sing Italian songs. I was just a kid and we'd be picking the beans; other women from Woodbridge would come, and they got paid by the bushel of string beans. And they'd be singing all these Italian songs, "Santa Lucia," and we would learn them that way too. They would have a ball picking beans and they got so much a bushel.

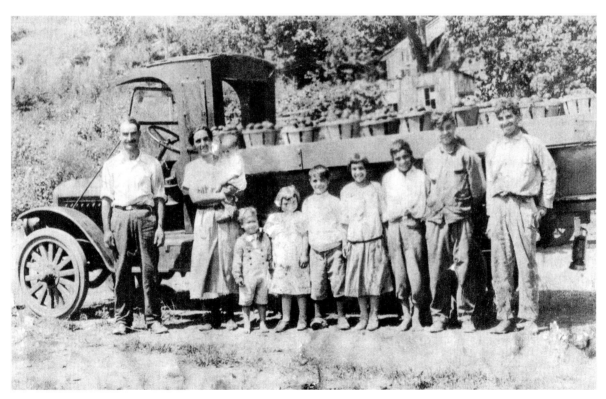

Figure 8.7. Luciani family in Woodbridge, 1920s: Ettore, Lena with two year old Ettore "Sheik," Alexander "Sonny," Agnes "Dolly," Guerino, "Goody," Rose, Emidio "Midge," Adolf, and Vito. DeFilippo family archives.

They'd pack them up in the baskets and got paid that way. Some of the women, Missus Fasula and Missus Buccieri—she had a very nice voice. And they would all be singing and working at the same time. So they seemed to be enjoying themselves.

"I Was His Best Worker"

Anna Perrotti Caccavalle said her father taught her to watch how quickly the hired farm workers ate their lunch to see if they were fast or not.

When my father came from Santa Maria di Capua Vetere in Italy in December, nineteen oh-five, he went straight to Woodbridge because his brother Frank had a farm. He sent for my father and took him in to work with him for a while. He was a farmer and very poor in Italy. When he made a little money, he bought an acre of land and was working his land and called for my mother. They got married at Saint Anthony's in New Haven.

So she came here and they worked the farm; as they made the money, they bought another acre from Mister Bradley, until they bought these fourteen acres, one acre at a time. Then he bought six acres on Bradley Road. Then he bought some properties in Mil-

ford, in New Haven. He really succeeded. And they raised twelve children.

My mother did everything we did. She hoed, picked vegetables, put down fertilizer, she worked hard. All the children were planting in the spring, so we had hired working men too, planting. My father didn't want the men to stall—he wanted them to really work. He said to me, "You go way ahead on the row when you plant, that way everybody will have to follow you," because I was a good planter. I used to plant fast, and I used to lead everybody. I used to go way, way ahead. I used to have my own *pastenaturo* [the shortened shaft of a shovel, sharpened at the end to make holes when planting].

A working man used to get mad, and they said, "Sure, *á cumarella*, the young girl, she goes ahead because she got money in her pocket, because she goes straight, she goes fast." It wasn't true. I did it [worked so fast] because I loved my family. So I'd make them go fast too, so we have a lot of stuff done. My father said I was the best worker, the hardest working one.

I loved my family, I loved my mother and father and I worked hard and I loved to work for them. I did it sincerely and I loved to do everything for them. When I got married in

nineteen thirty-five, my father was sick because he lost a good worker.

"It Was Equal for Everybody"

Filomena "Phyllis" Consiglio

Every year, we used to drive them crazy in the winter, you know. We used to scream and yell and run around the house. My parents used to say, "And those teachers don't have enough all summer long, they gotta have vacation in February!"

Well, anyhow, we used to go to school, but come the end of March, April, we had dandelions, broccoli rabe, those first crops, and that was our first money. And my father would keep us home from school, sometimes a whole week straight because it was a family business. The truant officer, Mister Baddick, would come by, "Mister Christoforo, you know your kids have been home from school for one whole week?" My father was out in the field, he had the hook knife in his hands, and he said, "When I get my crops in, that I can pay my bills. Mister Baddick, I'll tell you what. If you think I'm breaking the law to keep the kids home from school, you better give it to me in writing that you will feed my family all year long, pay for any doctor bills we incur. Put it in black and white, and I'll send the kids to school. This is a living, if we don't, we don't survive." "Okay, Mister Christoforo, I get the story," and he left. And the kids would go by on their way to school, "You rotten Christoforos, home playing hooky again?" Oh my God, we used to be so embarrassed.

Another time it was winter, and we had a blizzard. My father had two bad summers in a row, and the crops were bad. We were in debt, and we didn't even know where our next meal was gonna come from. My father said, "You kids are not going to school. Stay home because you don't have boots to go to school." The truant officer comes, "Now Mister Christoforo, why aren't the kids in school now?" We had the manure boots. You can't wear those to school—the kids would crucify us even more! My father said, "I can't send ten children to school in this snow. They'll get pneumonia, and I don't have money for a doctor." He said, "Okay, Mister Christoforo, you win again." But before he left, he asked one of us, "Give me everybody's boot size." I said, "Oh boy, we're gonna get something new." A half-hour later he comes back. He

got us all a pair of boots to go to school from the Red Cross. They were used, but we went to school. And that was the only time in all my years that my father got a handout. My father made it equal, everybody the same. We had to leave to work on the farm and nobody graduated from high school. I used to get all As. And when my mother got sick, my father said, "You're not going back to school." I never went back. I had to help the family.

"Come Work with Me"

Filomena "Phyllis" Consiglio:

My mother got sick, and my sister before me had to take over and do all the baking and the cooking. Don't forget, you had to cook for a crowd and make coffee every morning because we'd go out without breakfast, and then come back and have a hearty breakfast after working. What people would call brunch, that's what we had for breakfast, because then we'd go out and work until one o'clock again.

That gave my mother a chance to cook for twenty, thirty people. Because it was all family, and plus we had some outsiders that would come from the city and work. People

my father knew because they would get all their vegetables free, and they were men who weren't working, and they didn't have a job. My father said, "I need you, I can't pay you much, but at least you'll get food to bring home every night."

And we used to have so many poor families. There was the Cooley family that used to live down near the strawberry fields on Middletown Avenue. And she had about six, seven kids. We had the cow and everything, and they'd come up so pathetic, the kid would come, "Could we borrow a bottle of milk?" They didn't have anything to eat, and they were hungry. My mother would be baking bread, she'd say, "Here, wait a minute," and my mother would give the kids three or four loaves of bread, not one bottle of milk, she used to give them four or five.

Then one time they came, and my mother gave them cabbage because my father would raise a whole acre of savoy cabbage and dig them up just for the winter, put them in a pile, bed them down with hay, and then put turpins and put sand over them, and it was like a refrigerator. Then in the winter when you needed carrots and cabbage you went out there, you'd think you'd just picked them in the fields.

The father was young and wasn't working. So one day during harvest time, and that year my father hit the pepper and tomato market, we couldn't get people to help us because you can't afford to pay help. So my father went and knocked on the door, "Mister Cooley, all summer you're doing nothing. I need help. In the winter when you're hungry, you come and see me and even in the summer you're looking for free vegetables and everything. You come up and work off what I gave you." My father would wait till the end of the year, and he was very fair. Once the crops were in, then he would give them to him so they'd have a nice Christmas.

"Winter on the Farm"

Anna Perrotti Caccavalle:

In the winter on the farm we picked all the stones with the pails to clean the farm, and dumped them on the fenceline. We worked on the hotbeds from January to April. We planted the seedlings in early winter, January in the cold frames. My brothers used to do that, put the manure and stamp it down, and then put the loam, and then the seed. They had a two by eight, all around like a rectangle, and it was sunk in the ground a little and raised with window frames with little panes. And then they'd lift up one end, maybe prop it up with a stick, and open the glass windows that covered the beds to give them air.

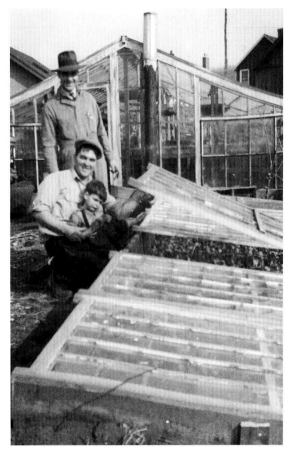

Figure 8.8. Cold frames on the Christoforo farm, 1940s. Consiglio family archives.

Sometimes we had the blanket on top of the plank so we could lie on the board on our chests and weed, and it wouldn't hurt our knees.

During the winter it was nonstop pinochle and whoever won had the most matchsticks. We used to play pinochle almost all night because they had to watch the weather to see if they had to go and cover the cold frames or uncover them. If it was too cold and freezing we had to go cover them. If the weather was warm or rainy we had to take the burlap blankets off and pile them up. So they had to wait all night. And if the weather would clear up and get cold, they had to go cover them.

The snow, we cleaned plenty of snow off the windows of the cold frames. We used to go help one brother clean all the snow off the cold frames. We'd get through with one brother, and then go help a sister take all the snow off their cold frame.

First we had to clean off the driveway. Our driveway, the snow was as tall as we were, and we had to go clean the driveway with the shovels by hand. There were no plows. We were very close to the family, to help them out. My father and I helped everybody, whether it was working in the fields or babysitting. We really

had a hard time. We worked very hard. To be where we are today, we worked very hard. Gee, those were hard days. We had no heat, just a coal stove and we used wood. My mother used to heat up bricks, put towels around them and put them near our feet in bed. And the snow used to come in on the windowsills in the morning.

"Spring on the Farm"

Anna Perrotti Caccavalle:

The planting season started in March, April, and you couldn't plant before the frost. It depended on the weather.

We'd go through the whole month of April. By the end of May the whole "Flat" [of Woodbridge] was planted, and they used to go down Amity Road, and it used to look so beautiful, a panorama. It was nice. All colors—yellow, red, green. The broccoli were green, beets were red, and the lettuce was yellowish.

They called that land "The Flats." We planted right from the seeds. We planted lettuce, cabbage, beets, everything. Then after that we started to "hook," to move the dirt and weed around the plants. It looked like an

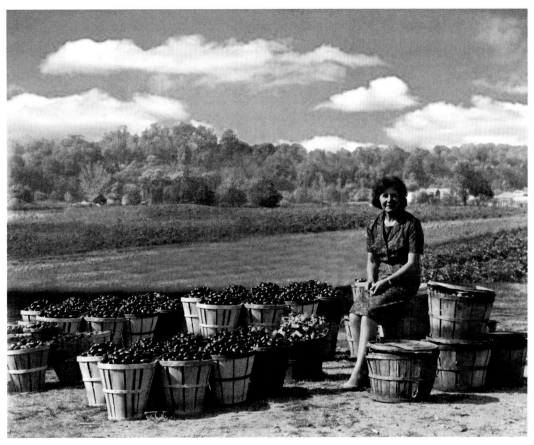

Figure 8.9. Anna Perrotti Caccavalle on the farm in Woodbridge, Connecticut, 1960s. Caccavalle family archives.

"L" it had a handle, and you bent over and scraped the ground around the little seedlings. You couldn't use anything bigger, or the seedlings would come out of the ground. All very intensive physical work, all by hand.

With the seedlings, when they were about an inch tall, it was a different thing. We used a thing, *ò rasolill'*, that was square and had a handle, so we moved the dirt around the seedlings. Sometimes they made their own from the wires around the barrels. My father used to cut them and then curl them a little bit and make *ò rasollil'*. Everything to save a dollar. When the plants got bigger we had to use

the hoe. And then at times, we had to fertilize them bending over all the time.

One of my brothers, instead of planting, he used to make a hole and put the bunch that he had in the ground. Instead of putting them in individually, we'd get to the end of the line, he used to throw them over the fence to finish the basket of plants quick. I would never do that, never. I didn't do anything like one of my brothers did. When he planted, he buried the plants so he wouldn't have to plant them. If I knew he buried them then, I would've taken them away from him and planted them because when my father tilled the ground with the machine, he found the bunch of beets stuck in the ground.

My father, we used to get up five in the morning and we'd be out there by six. My father never called us. He used to ring that bell—steady—until we got up. The doorbell downstairs, ring and ring. We had to pick the radishes before we went to school.

"Making Seeds in Springtime"

Filomena "Phyllis" Consiglio:

My mother used to make all her own seeds, the peppers, the eggplants. My father was known as "The Pepper King." Even Asgrove started getting seeds from my mother, and they started making it. I used to help my mother. We'd take *a scolapasta*, the macaroni strainer, to take the seeds. We wouldn't rinse them but we'd take all the fibers, the little white stuff in the pepper. The tomatoes you had to rinse, because they were slimy. On the dining room table she'd put loads of wax paper, and we'd dry them out for a couple days. And then, the next day, just go to another side to get the back part dried.

Once they were dried good she'd tie them in little old sheets, so they'd breathe, she'd tie the seeds in little bags. In the springtime, when she was ready—she was smart—to sprout them, because before you planted them, it was good to sprout them, that way they come up quicker in the cold beds. And she'd take that bag, soak it in the pail of water, let it drain good, and the wrap it in burlap. Then she'd put it behind the stove where it was warm. In two or three days, they broke up, and they had sprouts on them. Ready to go, to plant. Same with pumpkin seeds and squash.

"Easter on the Farm"

Anna Perrotti Caccavalle, Anna Dickenson Rose Di Girolamo:

Every Easter, my parents used to lay out a white sheet on the floor. Then the whole family, twelve brothers and sisters, knelt down on the floor at the same time, waiting for my father to bless them. Both my parents would bless us with the Holy Water, which I had to get in church by myself in the dark in the morning the day before. And the palm from the week before.

My father would bless all of us, make the sign of the cross and say out loud, "*Padre, Figlio e Spirito Santo,* Father, Son and Holy Ghost," and then he took the palm, dipped it into the glass of Holy Water, and sprayed it on all of us, like the priest on the altar, saying this prayer. "*Io vi benedisco dalla terra/A Madonna vi benedisce da ó ciel,* I give you this blessing on earth/Mother Mary blesses you from heaven." The whole time my father was doing this he was crying, tears coming down his face.

He cried because he saw his twelve children and grandchildren. He'd always wish for the following year, to see his children, "*Speriamo di vedere un àuto vòta, àuto anno come ammo visto quest anno,* We hope the way we saw this year, we'll see you again the next year." Then it was my mother's turn to do it with the palm. He gave the glass of water with the palm to my mother and she did the same thing. She blessed the children, sprayed the family. Then she blessed the food on the table. Then we'd go up to them and we'd kiss my mother. We had to kiss my father on the hand.

She would have all the Easter stuff on the table, but we were taught never to touch anything, desserts, nothing. In those days you didn't have a lot of this stuff in your house. It was a delicacy, and we couldn't touch it. But all my mother used to give us were the regular cherries in alcohol. We got two, three, four, ten, whatever, we all had a little shot glass with a couple of cherries in it and we would have it. That would be a treat. Of course, her older brother would be the designated person to have dinner with my mother and father. We [children] never had dinner there because there were too many people.

"A Typical Week on the Farm"

Anna Perrotti Caccavalle:

We never had breakfast, we only had a cup of coffee, and we used to dunk bread in it. That was our breakfast. At ten we'd go in and have *a marennà,* a morning snack. Get bread, wet it under the sink, put oil, salt and pepper, we used to eat that about ten o'clock.

Then at noon we used to go in. One of my sisters used to do all the cooking. And when it was very hot, she used to cook these recipes, *ciambotto*, with eggplant, squash, peppers, potatoes. It was too hot. So I used to go in there, I used to go, "Rae, how come you're cooking such a hot meal?" I said, "Oh, it's too hot, I don't want any." She used to say to me, "If you're hungry, you'll eat." I says, "No," turned around, go outside, get a head of romaine, wash it under the sink and ate it. That was my lunch. She used to cook a whole bushel of stuff. Then we'd go back out and work until late, till eight-thirty at night.

We worked seventy hours a week. We had to work, from six, seven o'clock in the morning to eight o'clock at night every day, then Saturdays we probably quit about three, four o'clock in the afternoon. Saturdays was the day of cleaning the farms. We didn't pick vegetables. We had to weed with a *rasollil'*, a small weed cutter, and hoe with *à zappa*, all by hand. We used to get three or four of the men, friends of the family. We'd be so many in a row, so many going, and so many coming, we used to clean up a lot! Then we used to go to the other farm and clean that up.

The boys used to pass "the machine": it had two handles, like long wheelbarrow handles with a fork, and on the bottom it had one wheel in the front with three prongs to cut the grass between the rows of the vegetables, like a tiller. It was manual. That used to heat up the ground too because when you moved the dirt, it would heat the ground up, and the plants would grow faster.

We picked vegetables, hoed with *à zappa*, picked stones in the pails, and threw them on the fence line. We cleaned the farm of all the stones, fertilized the tomatoes, the eggplants, peppers. I remember my father working hard, plowing at four o'clock in the morning. My sister Rose later got a farm. I got a farm, and my brothers Frank and Tony took over my father's farm and rented from him.

"Did You Bring Me Anything?"

Anna Perrotti Caccavalle:

We women worked with the men. They didn't do much work, my brothers, really. We had a horse and plow, and they did that. They seeded. Later years we got a tractor. I didn't know how to drive, but I drove the tractor.

When I had my own farm, I used to get up five o'clock in the morning. My husband used to call me from the market in New Haven, "Ya gotta start to go and pick," whatever—lettuce, cabbage because "I got so many orders." Five o'clock in the morning, I was so scared to go out. It was dark. It was near a mountain, and I used to go and pick before he came home. And he used to come, and I used to go, "Did you bring me anything?" Never brought me anything. Because I was working so long in the farm. He never brought me anything.

"Hauling Vegetables"

Mary Perrotti D'Eugenio and Anna Perrotti Caccavalle:

I worked very hard by myself. We didn't have a tractor then. We didn't have a truck, nothing. We'd pick cabbage, and all we had was the wheelbarrow in those days. And I would haul six to eight boxes of cabbage, from one part of the land to the other. It was terrible. My father used to load us up, put two boxes of cauliflower on my shoulders, they were heavy! And we had to carry them.

My father used to load us up. He used to hold the baskets. I'd hold one. Then he'd pick up another basket and put it so I could grab two more. So I carried three baskets of tomatoes, one on my lap and two over my back. We couldn't see the ground while we were walking. We were young. We were strong. Yeah, three baskets. Each basket weighed about fifty pounds.

We'd walk. Then finally our shoes started to hurt. We'd take our shoes off and we'd cut our toes on the stones and split the toe on our way to the washhouse. After a while they bought a tractor, and then it was easier. I believed in sending my children to college because I couldn't get the college. I chased my daughters off the farm. They didn't know how to do anything. Five years old, a bunch of broccoli was too heavy for them to carry! A bunch of broccoli! "Too heavy, ma!" I says, "Get in the truck. Go sit down there."

"My Mother's Closets"

Anna Perrotti Caccavalle, Anna Dickenson and Mary Perrotti:

My father never believed in us serving dessert when we had company, or when our friends came over. Because he said, "If the boys liked

us, they gotta like us for what we are, not for the dessert they're getting." When she made us the Easter cakes, she gave us one each, *a pigna,* the Easter sweet round bread. So, one each, but she used to lock them in her room. So when the time came we wanted some, she used to open the door, and she used to give us a slice from our *pigna.*

In the meantime, she had bags full of hazelnuts, walnuts, almonds, all big bags full. My brother used to run to grab some of those and run away while my mother was giving us the Easter cake. She used to keep that door locked whenever she baked anything. She had to give me the key to go in and get something.

She had another closet in the second kitchen next to the stove. I always remember she had this closet locked, and whenever we went over there she would open it and give us a kerchief or a handkerchief or some little thing she had in this closet. And I said to my mother [Anna], How come she kept that locked? And she said, "With twelve [children], wouldn't you keep it locked?" I mean she'd never have anything if she didn't have it locked.

She had another closet that when she cooked something for lunch, she'd put it up on the shelf. My brother used to lift me up to go get that dish so he could have something to eat on the sly of my mother.

"Having Babies and Picking Parsley"

Anna Perrotti Caccavalle:

I just had a baby, and my mother was picking parsley. I had the baby at home. She used to come over all the time, "Annie, come and help me on the farm." So I had to go help her. I was washing clothes. Those days we used to put the plugs in ceilings because we didn't have them in the walls. So when I was washing the clothes my mother came by and said, "Annie, wanna help me on the farm?" Pull the plug down, stop washing the clothes, go help my mother.

Then she was picking parsley, she says, "Annie, help me do the parsley," and I said, "I can't bend down and cut." She says, "Well, you cut 'em and I'll tie 'em." So that's what I did. She cut the parsley and I tied it in little bunches. I just had the baby a matter of days ago at home.

My first daughter cost me twenty-five dollars for the doctor. Doctor Capecelatro stayed

with me the whole day, until six o'clock at night, and then I had her. And his wife was having a baby the same day, but he couldn't take care of her because they weren't allowed.

Those days we didn't stay in bed long. We had to get up and work! When I had another daughter later, Doctor Sperandeo was playing pinochle with my brothers while I was in labor. And every now and then, I'd say to the doctor, you gotta come, come and check me. He said, "No, you're not ready yet," and go play pinochle again with my brothers!

When my mother had a baby on the farm, she was in bed. She just had the baby. My father would bring her all the parsley, and she would tie them while she was in bed. They never wasted any time. Even while she was pregnant, she had to work all the time. No rest. We had a hard life.

"The Strike"

Anna Perrotti Caccavalle:

All my sisters worked on the farms. So one time my mother didn't give us a raise. We used to get seventy-five cents a week to work on the farm. So my sister Rosie wanted more money. She used to sew dresses for me, sew for the family. She striked. She sat near the washhouse and waited for my father to give her this raise.

So my sister Rae, who always worked in the house, used to hear my mother and father talk. So she used to go say to my sister Rosie, "Stick it out, you're gonna win. You're gonna win, don't give up!" She was the spy. She used to go and tell her on the farm, "Don't give up, you're gonna get the raise." She got the raise. Five dollars a week, she got. From seventy-five cents.

We were sixteen, seventeen-year-old teenagers. This was the late nineteen twenties. We worked every day from six o'clock to dark. We never got any time off. On Sunday we only got maybe a couple of hours off, but we had to work on Sunday, too. I had a date one time with a boy. I was supposed to meet him downtown. My mother comes home with a big bunch of string, "We have to go pick rabe," so there's where the date went. I never showed up. Six o'clock we had to go pick rabe.

Italian American Women Join the Production Lines

Italian immigrant women entered Connecticut's workforce as early as the mid-teens. In a highly industrialized state, women often became the main breadwinners in towns such as Naugatuck, New Haven, and New London. Company shutdowns, work slowdowns, temporary layoffs, and prolonged strikes in factory towns like New Haven left many men unemployed or unable to provide for families. On April 6, 1929, the L. Candee Rubber factory in New Haven abruptly closed, displacing 729 employees, of which 464 were women.[1] Nick Aiello, a local historian, described working conditions during the Depression when men were unemployed and women found employment opportunities in the burgeoning needle trades to help families survive, "Women working in the shirt and dress factories made more money than their husbands or fathers did."[2] Connecticut's Italian immigrant women and their daughters planned strategies for the care of small children so they could join the workforce. Oftentimes, when mothers went to work, the supervision of children was assigned to the oldest daughter. In some cases, children were placed in free day care centers provided by employers, and some families appealed to relatives in Italy for help, asking unmarried sisters or grandmothers to help raise children in Connecticut.

In 1913, Saveria Paola, a sixteen-year-old seamstress, was busy at work in her street-level tailor shop in San Biase, Calabria, when she received a letter from her eldest sister in Brooklyn. With four young children and the pressing economic need to work, she asked Saveria to come to Brooklyn to help raise her children. If Saveria could take care of her little cousins, she wrote, it would mean she and her aunts could continue working as seamstresses in the sweatshops of New York's garment district. Saveria dutifully followed the wishes of her oldest sister. After a few years in Brooklyn, she married, and followed her husband to Danbury and Norwalk before finally settling in Bridgeport, Connecticut, in 1915. Saveria found an industrialized city in the midst of the munitions boom, with Remington Arms-Union Metallic Cartridge Company producing two-thirds of

the small arms and ammunition shipped to the Allies from the United States.[3] Rising early, Saveria took great pride in her personal appearance. Before leaving for work, she always made sure the whalebone corset conformed to the contours of her body. Saveria placed the care of her little daughter Giovanna with her oldest daughter, and joined legions of women of different ethnicities from Rhode Island, Massachusetts, and New York in search of munitions work.

Saveria found herself among the four thousand women making cartridge cases, a dangerous work environment where defective primers sometimes exploded prematurely, causing the loss of fingers, or even death. A fellow female worker described a scene where a girl beside her was killed in an explosion, "We always run, but you never really have time to get away."[4] Saveria's job was labeling bullets fed to her from a spinning rotary machine. At the end of the week, workers filled out reports of their individual productivity. Saveria's high numbers reflected the strong work ethic of many Italian working women throughout the state of Connecticut. Though unfamiliar with the ways of factory women, and unable to speak English, she earned more money than anyone in her department. One day, a female co-worker who felt the industrious young immigrant was making the rest of the women look bad, confronted her, saying, "Sadie, why don't you ever go to the bathroom?" After a few weeks of watching Saveria work at her machine without stopping, a woman in her department demanded she take a few breaks during the workday. Saveria refused, and kept working; no one could keep up with her. At the end of each week, Saveria was earning the unimaginable sum of twenty-five dollars. Word got out that Saveria's paycheck was much more than the other women. One Friday, as Saveria stepped into the office for her pay envelope, a group of co-workers waited outside. When someone called her scab, a word she did not comprehend, she lowered her eyes, and without a word, walked back to her work station. That night her husband explained the meaning of scab to her. The next day Saveria returned to her workstation, confident she could respond to any taunts. When payday came that week, she was called a scab again by a machine operator. Looking straight at her co-worker, Saveria answered in the best English she could muster, and told her, "I am here to work."

"I Was the Only One Working"

Gaetana DeLaura was ninety-six at the time of our interview. She recalled her mother Angelina bringing men's clothes from the factory to sew at home.

During the Depression, for a while there in New London, I was the only one working in our house of five children and my parents. Things were bad. My brother was laid off from

his job at Ship and Engine—they used to call it that before it became Electric Boat.

They were proud people, and my father was a mason. He didn't have any work, and nobody was working. Once in a while so that nobody would see him, he took a wagon and went back through the woods to the dump and got wood to burn.

I got seven dollars a week sewing at Kaybrook's where they made men's underwear and pajamas. That was a lot of money. Then I got a raise to eight dollars a week in nineteen twenty-seven. I was seventeen, and I worked from seven in the morning till five-thirty with a half hour for lunch. No union, God! Never heard of it! I gave it all to my mother. I'd get ten cents to see a movie, and if I needed something to buy, she'd give me money.

I was putting on sleeves with a machine that sewed double [stitch], you know when you see the double seam on things. You really thought you were rich if you had one of those machines, that was one of the special ones and the whole floor had those machines. It was mostly women except the boss. Everybody had a part. It was hard but we didn't notice.

My mother made all our clothes and did all the cooking. She died two weeks short of one hundred and three. She canned tomatoes and fruit and we helped. My father had a wine press built right into the concrete in the cellar and had grapes growing in the backyard.

"Give Me a Chance"

Betty Panza:

My mother-in-law Philomena Ardolino came from Italy at three years old. She came from a family of ten, and she had to go get a job. In the teens, they had to get weighed. She had to weigh over ninety pounds to get the job at National Folding Box in New Haven. They gave her a paper and she went to Wooster Street, to a Mister Iannucci, and they wrote that she was fourteen because she didn't have a birth certificate.

He was a big crook. He was like the big professor. He lived in one of those big houses across the street from Maresca's Funeral Home. He was Justice of the Peace; he was a real smart Italian. All the poor Italians used to go to him, "*Scriva 'na lettera all'Italia,* Write a letter to Italy," and he'd charge you ten dollars, and if you put in any extra words, or if the daughter played a little piano in between, you had to pay a little bit extra. Let me tell you something, he made a living on that.

So he made out the papers for my mother-in-law, and she went to National Folding Box. And they said to her, "But you can't be fourteen." "Yes I am," she said. "Here's my papers, I'm fourteen." Because the job was too strenuous. So she lied about her age. She told them she was fourteen, but she was only twelve. They said, "We can't hire you because you don't weigh enough." She weighed about ninety-six pounds. She said to them, begged them, "I need a job. Give me a chance, try me out for two weeks and if I don't do it after so many weeks I'll quit on my own."

Well, after only a month, she went on the assembly line doing piecework for twelve cents an hour. Then she got it up to fifteen cents per piece. She did it. They had to fold over the cardboard, speedily using their hands, flip them, and then put them through a machine. So, after the two weeks, she was so good the boss said to her, "Filomena, do you have anybody else like you at home?" She was so good at her work. And she said, "Oh yeah, I got two other sisters." So he said, "Why don't they come here, you're so good." And she got jobs for her sisters, Julia and Florence.

And they used to walk from Steven Street off Davenport Avenue in the Hill section to the factory in Fair Haven to save a nickel so they could buy a cupcake for their sister Florence, who was going with Pat. They wanted to serve him a cupcake when he came to the house. It was tough for them. She didn't have much schooling, but a very sharp lady. She went there begging for a job because they had ten children.

On the weekends, they'd go with a little wagon, her and her brother, to pick up coal so they could put it in the stove. During the summertime when we were young, the people at the National Folding Box wanted her to do their laundry, and she would do that for a dollar. They used to see her clothes hanging out nice and white, so they asked if she took in laundry. She used to boil the water on the stove in *á tine*, a big cast iron pan, and she'd put the sheets in there with the Octagon soap. I don't know how she did it. Then afterwards we got where you put the quarter in to heat the water in the tank—had to put a quarter in to get the gas—and it heated up your water tank so you could have hot water.

"Aunt Celeste's Accident"

Frances and her brother Gene Calzetta recalled their grandfather Giuseppe sending their father to America

in 1913 because the Italian goverment was using its young men as cannon fodder for the war in Tripoli. Gene recalled how farmland was purchased at the turn of the century. "It was like the pioneers, there were no deeds—you fenced it, you owned, just like the Bishops and Bartlett farms in Guilford. As long as you could see, that was yours."

My aunt Celeste worked in a dress factory. It was an era when first-generation girls finished eighth grade, and went out to work in the needle trades. They let the young girls, thirteen, fourteen work and cut off the little threads on the ends of garments. Celeste was twenty-nine, her son Gene was nine, Rita was six, and Lucille was five. She was working in the factory and my mother Sue was the caregiver of her children.

In those days the industrial sewing machines were huge and greasy and oily. It was very easy to touch your face in the lip area when using the needle on something or when they threaded the machines, and you could get a little bit of a cut in the upper lip. Sometimes just one little needle puncture in the lip could allow the grease to get in. What was not known at the time was that the infection didn't show on the outside but the infec-

tion went very deep. This is what happened to Celeste. She got some kind of a cut, and the industrial grease got into it, and caused a carbuncle. The area just around the nose and an oblong around the face is what medical people today call "the dead zone," where there is no natural immunity to anything, and there was nothing they could do about it.

Today we can take care of it with an immediate shot of antibiotics. But in nineteen twenty-nine, there were no antibiotics or penicillin. There was nothing that could be done except to lance it. At that point, when they called the doctor, they were medicating it with hot compresses. It didn't help her, and when they called the doctor for minor surgery they had no way of knowing how deep the infection had gone. So with Celeste this particular infection went very deep, and then it went up through her blood vessels and hit her brain. She died in three days.

This was an industrial accident in an era when there was no such thing as workers compensation or insurance or help for people injured in industry. She was brought in [to her home] and laid out on a sort of funeral bier like in ancient times. She wasn't in a casket like today's funeral homes, but on flat surface,

a four or five foot high slab, and she was laid out in the living room. Rather than try to get something six feet long through the doorway and then through the small hallway to the third floor, they took out one of the large bay windows, which was on the porch upstairs, and got her through the window. Whatever funeral directors did in nineteen twenty-nine, that's what they did to her. There weren't any funeral parlors, or if there were, it might have been very expensive. It was common practice in the nineteen twenties for the dead person to be laid out in the living room of their home. And that's where all the family came.

"The Inspection at Sargent"

Fannie Buonome:

I used to work repairing doorknobs in the mid-nineteen fifties. Then I became an assembler. Then I worked on the conveyor and then on the drill press. Because I was her sister, I got picked for all the asshole jobs. That's true. I said to her, "Why do you do that? I want to be treated like a worker, not as your sister." She said, "People will say, yeah, but you never give your sister the tough jobs." I had all the tough jobs!

My sister Jennie was tough with me at work because she was the boss and I was her sister. She was a wonderful worker, wonderful. So we used to have visitors, and they used to announce it over the loudspeakers. Anyway, this particular day I'm working on the drill press, and the intercom went on, and over the speaker, "We're getting visitors from Regina, Canada. So keep the areas clean and make sure everything is in order, because we want a good name for ourselves."

But all the girls heard was Regina. So they said to me, "What the hell did they say?" I said, "Well from what I gathered, the guys from Canada are coming, and they're gonna inspect our vaginas!" Here's my sister, "Why do you do things like that?" I was the jokester. I made sure they enjoyed their jobs. We used to sing. I used to tell dirty jokes. There were a lot of Italian women and some Irish. We were all for one and one for all, The Three Musketeers. And the bosses all loved me. And that's when I met this guy, and he used to ask me out. I used to say, "I'm sorry, I got to entertain the troops."

We had black people working with us too. There was "The Hawk," there was Johnny Jenkins, and Larry Henderson. I always got along with them. They were good workers, especially

"The Hawk." He was comical though. He had to clean the [industrial] drums and one day he's playing [rapping a beat] on them with his hands. So I get up, and I start rapping too. And here's Jenny, "What are you doing?" I said, "Jen, I'm testing ball point pens!" Then another time our boss, Ralph Buonome, said to us, "There's big shots coming from France, French students. Leave them alone. Don't bother them!" I said, "For crying out loud, you're always picking on me, who the hell wants to even talk to the lousy Frenchmen?" I'm at work and all of a sudden they're coming. There's me, Ta-dun, ta-dun, ta-ta-dun-ta-dun [to the French national anthem], Ralph came over and said, "Sonofa . . . what did I tell you?" I said I don't even know what I was singing. But I was an A-One-Plus worker and that's the truth.

"You Think You Own the Job?"

Antoinette Zuccarelli:

I was just lucky to get a job at U.S. Rubber. I went down to the employment office, and Miz McCann had been there a long time. I'd go in the morning thinking I was a go-getter. She didn't have anything for me so I'd go back in the afternoon. And she'd say, "Well, you were here this morning." And I'd say, "I know, I'm looking for work." And eventually she took me. I was hired at sixteen.

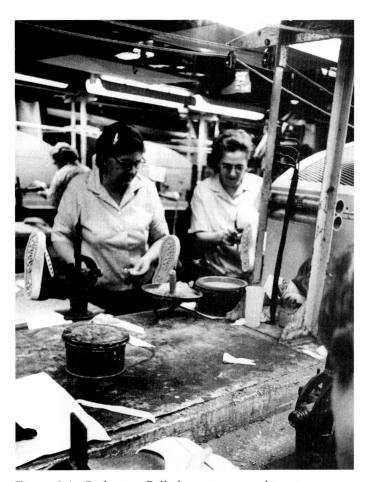

Figure 9.1. Catherine Palladino, tennis-making instructor, showing Claire Derby, a new operator, how to place the toe cap of a tennis shoe, U.S Rubber in Naugatuck, early 1950s. Naugatuck Historical Society archives.

My first impression—I never saw a conveyor because I was upstairs in the Gay-Tee Room where they made rubber boots. They had the oval conveyors, and later they made the long ones.

I was a fitter on the table working on rain tights with five buckles in the front, the kind the girls wore. They were flats and not high heels—today they don't even have them. I started on the table giving it to the girl that was feeding the metal "last" going down the line. I fitted the inner part where the buckle attached so it didn't open up and your foot wouldn't get wet.

I was kinda fast with my hands, you know. They had two girls doing it, and sometimes I'd be the only one. Then I got smart, why should I be the only one? Then I wouldn't work that fast. We were being paid by how much your line produced.

Annie Ostrom was our supervisor, oh God bless her! I never thought I'd be a friend of hers, she was really rough. She said, "You go over there and help them!" I said, "Why should I?" I always spoke up though. I said, "I belong on this line, and I'm getting paid from this line." She said, "I'm gonna send you to Marty Garrick, our foreman." He was rough-looking but yet he was nice. He was writing something on his desk, and I stood there. I didn't say excuse me. I waited for him to look at me, and he said, "Can I help you?" All excited, I said she wants me to do this and that and I'm working on my line. Why should I go on another line?

He sat back. He said to me, "Why, do you think you own your job?" I says, "No, but I wasn't hired for that. And I don't think you know that you don't own your job either because they could move you!" I never, ever remember saying that. Then he retired. He lived in Florida and came back. I had to give our governor the proclamation because I was active in politics too. Mister Barrick was there, and he came right over to me and said, "Zuckie, I could well remember you. When you stood there so nice that day to say to me, do you think you own your job?" I said, I don't think I said that. He said, "You certainly did!"

"They Taught Us the Jews Killed Christ"

Francesca Grillo recreated her bewilderment as an immigrant unable to speak English working alongside other ethnic groups in a factory setting.

In nineteen thirty-three, when I got here [in the Bronx] from Italy, it was the Depression, and nobody could find a job. There were sweatshops in the Bronx, and I used to go on the subway downtown with my cousins trying to get a job in a sweatshop, but I couldn't even talk English. How could they hire me? My cousins could talk English and they couldn't get a job, how the hell were they gonna give me a job?

It was awful [the sweatshops], it was so impressive that I could close my eyes and look at the lines and lines of machines and the women working, dirty, a lot of noise. Nobody was hiring at the time, and my uncle Humphrey [Onofrio], my father's brother in Norwich who owned the Connecticut Beverage Company, came over to visit my aunt Mary who took my mother's place, said to her, "I'm taking her to Norwich because Beatrice Barbarossa—she's from our town in Italy—is a good friend of mine, and she's a floor lady, and maybe I can talk to her and get a job for her at Majestic Pants Factory." Beatrice's parents lived close by to my family in Terlizzi in Puglia, which is a small town where people lived close to one another in a community. Norwich had a lot of pants factories.

So he talked to Beatrice and she said, "Sure, I'll talk to my boss," and sure enough she got me a job there. The job I got was on a high machine making buttonholes in men's flies. Bundles and bundles of flies, and I had to make buttonholes all day long. It was piecework at the time, so you want to hurry up, no talking to anyone. I couldn't talk to anybody anyway because I couldn't talk English. In Italy, who was the Jewish in Italy, the Greek in Italy? Maybe there were, but not where I came from. There were all Italians, so I figured, you go to America . . . stupid, you know. I thought, well I'm in America, they must be all Americans.

I'll tell you what I found. Eleanor Danbrow was sitting there, and I gave her my finished bundles. Now they have zippers, thank god. Everybody sat down, but I had to work standing up because it was high. So one day she said to me, "You like America?" I said, "*Si.*" She asked me two or three questions, and I said yes. Then she made one big mistake. She said, "Do you like Jews?" I was brought up, and in school in Italy—the family, the neighbors—they hated the *Jews*—and even the priests. They taught us that the Jews killed Christ, so when she asked that, I almost spat in her face

when she said the word Jews. Then I made the sign of the cross. She said, "What!" And she got up.

So Beatrice was working nearby and said, "Hey, Chechèlle, *che ser capita?* What happened?" I said, "Beatrice, I don't know. She asked me if I liked Jews and I said I didn't." Beatrice got all excited; she pointed to people all around the shop, saying, "Oh Mama mia! That one is a Jew, that one is a Jew, the boss is a Jew, half of the shop is Jewish!" All my bosses were Jewish. "Oh," I said, "*Corre! Corre, e vado a piglia a jacketa!* Run! Run, and I'm going for my coat. *Percè tutte chèsse Jeud, Madonna! Mò mi accìte,* Why all these Jews? Because now these Jews are going to kill me!" I wanted to get the hell away from there because I says if they killed Christ they're gonna kill me, I gotta go! I started to run away. And Beatrice ran up to me, "Come over here, *aspetta,* wait!" because I was flying. I was shaking like a leaf.

I said, "Okay" I said, "Beatrice, *per piacere di al padrone che non capisco!* Please tell the boss I don't understand. *No lo so che,* I didn't know that the Jews are over here, I thought they we were all in Jerusalem."

Mister Mandel came over, a nice man honest to God. He and Beatrice were talking English, and I didn't know what they were saying.

He was asking her what happened because the whole shop was in an uproar. These two sisters, Eleanor and Gus, said to Mister Mandel, "You either get rid of her or we're quitting." So there was a pow-wow with everybody, and I was wondering what the hell they were saying so I could defend myself. I didn't mean to hurt anybody. I was just brought up with that in my mind. You think I would have said it if I knew she was Jewish?

Mister Mandel came by and put his hand on my shoulder. He said, "Don't worry, don't worry." And Beatrice translated for me, "Mister Mandel said you're staying here and working." I was a good worker because I came from Italy and there was no bullshit—I worked. I wanted to make money because I had to pay the debt that my father sent me with. He borrowed money to send us here. Oh yeah. I also had to help pay my sister's debt for her trip when she came to Norwich after me.

The foreman said to the two women, "You want to quit? Quit, but Francesca [Chechèlle in Pugliese dialect] stays and works." They kept me because I was a good worker, I couldn't speak the language anyway, so I just kept working. I couldn't say a word in English. They used to look at me and ba-ba-ba-ra-ra, and I used to shrug. And work.

Eleanor and Gus quit and went to New York, but they came back after two years. When Eleanor came back, they had changed things around in the factory and her machine was facing me. I was shaking. She was nervous. If her looks could kill . . . so one day I said, this cannot be, we gotta talk, I can't work like this. So one day she went to the bathroom, and I stood outside the door until she came out. When she came out, she went, "Grrr," and I said, "Ellen, we got to talk." By that time I could speak English a little bit. I could make her understand that I didn't understand what it was all about, and that I didn't know America was a mixture of Polish, Jewish, Greeks. So we made up.

And honest to god, her family . . . her father was a little ragman, sold rags, and her mother, they were wonderful people. When I was looking for a place to live after I got married with my two kids—my husband was in the navy—and there was an empty apartment and her father gave it to me. They lived downstairs in my apartment on Fairmont Street in Norwich. When she introduced me to her father he was wearing a yarmulke. She said, "Pa, that's the girl that I told you about that she spit in my face and said she didn't like Jews." And may he rest in peace! So he said, "Come

on, my *kinder,* my child." So I climbed up the five wooden steps of their porch. Then he said, "Come over here," and he took my hand and sat me on his lap to say it was okay, that he understood.

And so, as life went on, there were days when I had nothing to eat and they fed me. I was as poor as a churchmouse. They fed me when I was hungry. There was never a holiday when they didn't send a plate upstairs to me. Every Saturday was a holiday for them. Every Saturday they sent up a chicken leg in a dish with some potatoes and carrots, every Saturday. I can never forget it.

"She's Still a Child of God"

Theresa Grazio Diamonte's's mother sent the wedding gowns and honeymoon suits of her daughters to the poor in Amalfi.

My father always used to say to me, "*Teresa nun ghì'a faticà, adda sta sempe a casa,* Teresa isn't going to work, she has to stay at home." Sometimes I used to think about it and say, well, I'm glad I was supposed to stay at home— they took me out of school! The day after my fourteenth birthday I got taken out of school and I went to work in the sweatshops. My

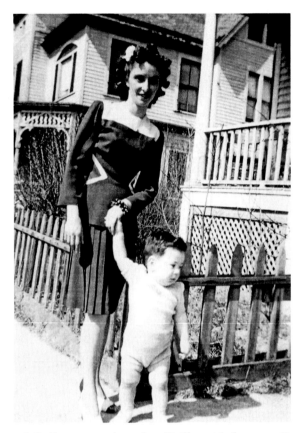

Figure 9.2. Francesca Amodeo Grillo with her son Sam in Norwich, early 1940s. Grillo family archives.

brother Mickey's wife worked in a shirt shop and that's how I went to work.

Terrible days, I tell ya. I started in nineteen thirty-one at the Ideal Shop. Sometimes I used to work a whole Saturday morning for twenty-five cents. I used to clean the shirts and cut off the threads. Then, with the help of my brother, we went to Lesnow's. It was a sweatshop, but it was a happy shop; we had a lot of fun there. No money. We hated it, but we made the best of it. We got to know all the girls. We used to have coffee break at ten o'clock, and we used to tell our own little stories.

We had a nice black girl working with us, Theresa Brown. We used to talk about my mother always having spaghetti and meatballs on a Thursday. And this black girl would always say, "Gee, I like spaghetti and meatballs." So one day my sister and I—we worked together—and on the way going home, I said, "Gee, wouldn't it be nice if we could invite Theresa Brown over for dinner? She's always telling us she likes . . ." So then my sister said, "Yeah, but don't forget, she's black. How would mama feel?" "Well," I said, "we'll see."

When we got home that day, I said to my mother [Madeline], "Gee ma, we have a friend. Can we take her over for supper?" So my mother said, "Sure, *porta bella e mamma, tu port a chi vo'porta,* Bring her, mom loves you, bring anybody here you want." So my sister nudged me and said, "Don't forget to tell her." So I said, "*Ma, sulo una cosa. Chella è nera,* Mom, there's just one thing. She's black." So my mother said, "*Oh, bella e mama, che ti fa?*

Chella è pure e figlia a Madonna, What does it matter? Mama loves you, she's still a child of God."

She came to eat and my mother made us translate, "*Diciel, bella e mamma, pigliata ò piatt' e spaghetti, pigliata á polpett,* Tell her, mom loves you, to make a dish of spaghetti and meatballs." And afterwards my mother and she became great friends. She always came to my house. My mother loved her. It was the

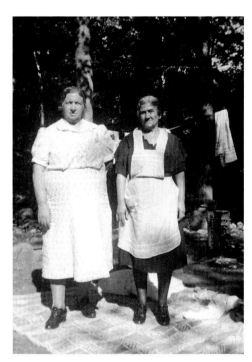

Figure 9.3. Rachela Proto Amatruda (left) and Madeline Grazio (right) on Fairmont Avenue, New Haven, 1920s. Acquarulo family archives.

first time that she was ever welcomed in a white . . . and she used to say, "What a wonderful family I got involved with."

That was one thing about my mother; my house was an open house, there was always room, and we could bring any of our friends, anybody. And one day she invited us to her house. So now, you know, we're a group of six of us from Lesnow's—Mary Hillo, Tommasina Santamauro, Mary D'Amanti, Jennie Santacqua, my sister Anna, myself—and we're saying, "Gee, we're going to eat in a colored lady's house." Well let me tell you something. When we got there, that table, the way it was set and everything! She had rubber gloves on, and serviced all the girls at the table with southern fried chicken, doing fast, because she wanted us to have it hot. I'll never forget. I could see this table full of food. When we left that house, I said, "You know what? I'm glad we all made a fuss about eating in a colored lady's house. You people certainly cleaned up that table fast!" [laughing]. We all stayed friends until they all died.

"Sisters, Black and White"

Anna Grazio Amatruda was eighty-eight at the time of our interview.

We were folders at the Gant shirt shop on Long Wharf in New Haven. Her name was Ronnie Stevenson. She was from down South. We were very friendly, and we would go out to dinner. She had me over her house. Anytime, if I was having special company, she'd make me fried chicken. There was no one that could fry chicken like the black people. You gotta give them credit, and she would do it all the time. I'd bring her macaroni for lunch. We were very close.

Now, she got sick with breast cancer, and she'd cry at work. And I'd say, "Ronnie, no, don't worry, everything will be alright, God has got to be good to you." She'd say, "Yeah, Anne, but I know I'm not gonna live long." I'd say, "Don't say that. Cancer is treatable if they catch it in time." But evidently they didn't. She was laid up.

So every Wednesday my husband would take me there on Thompson Street in the black section. She had a beautiful house with beautiful grounds. In the summer you'd think you were down in Florida. She was getting sicker. She had a ring made. This was the ring she had made [showing me the ring on her finger with two stones, an onyx and a diamond].

She was my white sister and I was her black sister. We were very close, very close.

So she was sick, and I would go to her house and kinda pick up for her, and she would say to me, "Anne, when you make my bed, make sure you put Jean Naté powder on the sheets." She was that type. And I would. My husband would take me after work and I would feed her.

It came the time that she died. We went to the wake, oh it was beautiful, all singing. The black service is beautiful. And her husband's family was wonderful. When they had the Freddy Fixer parade on Dixwell Avenue we were the only whites, my husband and I among all the blacks. First I was afraid to go. Instead they were all nice people, and we got well acquainted. So she treated me good, I treated her good, her husband loved me, and I loved him. He worked as a boss in Winchester at the time.

After she died they had the service. Her son had a big house up on a hill in Hamden and he had all the waiters and waitresses serving. It was a beautiful day. And a week later her husband Steve comes to my house. I said, "Oh, Steve, come in." He used to like Johnny

Walker Red, and my husband would have a bottle just for him, because whenever he came, that's all he would drink. I said, "Steve, it's a good thing I still have some left that you like." He said, "All right, let's have a drink together." We did and now he was ready to leave. And he said to me, "Anne, I came here for one reason. When my wife died, she said, 'Whatever you do, that little ring I had made, you make sure you bring it to Anne because that's my sister.'" And he gave me the ring.

"Making Lipstick"

Antoinette Becce Padula:

I got out of high school in June of nineteen thirty-three. I wanted to become a nurse, and I took all the courses, but my mother said she didn't want me cleaning people's behinds.

I starting working in September at Scovill Manufacturing in Waterbury, my alma mater [laughing]. I worked in the cosmetics department, and we made lipstick cases out of brass, and rouge cases, compacts, for eight cents an hour. We worked five and a half days a week for eight dollars a week. No union. But then Franklin Roosevelt went in and he put the N.R.A. in, and we were getting fourteen dollars a week for forty hours, and that was good money!

I worked at the conveyor at first. There was a girl on top of the conveyor and she painted. The lipstick cases were flat. The letters "COTY" were embossed, and when they'd put paint across it went into the indentation and the girl painted it. It came down the conveyor and we had a cloth and wiped the surface off. I'd take the rough stuff off, and then pass it to the next girl and she'd polish it up. That was all day long. Then we got smart and we used to put three or four together because they were flat and my partner could paint fast. We were on piecework, and we got paid by the piece. But then, your timers came along. A guy named Tom Riley, who I didn't like at all, stood behind you and timed you to see how many you could do at a time.

Then I worked at Eyelit Specialty, and I was on the conveyor at first. Everything was brass. The conveyor belt went around and we would put the lipstick tops on the pins and then they'd go under the spray. And we sprayed the lipstick with a clear lacquer. Then it went through an oven. It baked and came back to us and we'd load and pack them. I

could make good money because I was fast. One day the boss gave my partner Franny hell. He said, "You're not making your time, Fran!" She said, "Well, I can make my time with Toni." And he said, "Fran, anybody can make their time with Toni!"

I'd do my job and then I'd help them because it was on a conveyor. I didn't even know the boss was watching me, for God's sake! I would put on and take off, it got sprayed with lacquer, then go through the oven to bake and come to me and I'd pack. Well, I packed and I helped her set up because they were on pins, so I helped her do her work and do my job too. We had to make our money, you know. If I could help, it meant more money in my pay envelope too.

From nineteen thirty-three to nineteen thirty-nine, I gave all my money to my mother to help run the house. Sometimes my mother gave my brother, who worked very hard on the farm, money out of my pay to go out on Saturday night. She was the bank. When I got married, I had seventy-five dollars.

"We Melted Away at Siegman Tie"

During my intrview with Josephine DiGiuseppe, her husband Peter told me stories of landing on D-Day with the 97th Division and sustaining permanent injuries from shrapnel wounds after he stepped on a land mine.

I started as a packer first, packing ties all day around nineteen thirty-eight. We had to fold them, one to a box. My next door neighbor was a floor lady for the tie shop. So we knew her well and I got the job. It was very simple to get a job. You went in there and you automatically got a job.

Then I became a "turner" in nineteen thirty-eight. We stitched the whole tie, the inside of it, and then we turned it on a stick. It was piecework. If we ripped a tie we had to pay for it. At the end of the tie, there was a pin when we turned them. If we turned it and ripped it, we had to pay a dollar and a half or whatever the tie was worth. Sometimes I made no money! I was making seventy-five cents an hour.

It was a sweatshop, very hot. On a big bench, sitting across from each other, there were about eight or nine girls, turning ties. There were bundles and bundles of ties. And we stitched them first. Then we took them and turned them and piled them up. Then the presser took them. And if she found them ripped—she used to look them over—some-

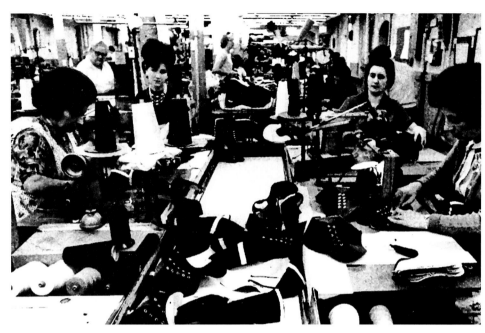

Figure 9.4. Italian American Women in the Stitching Room at U.S. Rubber. Photo List Naugatuck Historical Society archives.

times we used to hide them in there when we turned them. It was ripped, we knew it was ripped, and it went along in there. But they noticed it when they pressed it, and they'd call us over, "You ripped a tie, you pay a dollar and a half for it." No air conditioning. We melted away.

"Working Conditions in the Rubber Factory"

Catherine Cuccuru worked for thirty-seven years in the Gay-Tee room of U.S. Rubber in Naugatuck where they manufactured small boots for women. During WWII she made "pontoons," rubber landing craft, and combat boots.

They were sweatshops. I worked in the "Gay-Tee" room where they made short boots for women.

My first job was in nineteen forty-one at nineteen. They gave me the job of hot knife cutting. A hot knife, getting burned, you had to go around the boots, work maybe two or three hours, and you gotta go home because there's not enough work. You didn't get no

overtime. There was no steady work. We only worked three days a week. You got seventy-five cents an hour. I couldn't eat the food. My mother would make nice Italian sandwiches, but I couldn't eat them because of the smell, the stink of the rubber, and they used a lot of powder when the rubber wouldn't stick.

The men cut the work and the women had to assemble it, count it, and put them in piles so when they went to the assembly line, it was all set. I hated it at first, but when I started seeing my pay, good money, then I liked it. But we worked hard! No air conditioning in the summer, no heat in winter. Cement floors. And we had to go to work at six in the morning sometimes until five at night to put in the orders.

"She Was the Breadwinner"

Rose Pagano Onofrio recalled her mother making anginette cookies in Sicily using orange rinds "before things came in packages."

My mother continued to sew as a streamstress when she came here from Sicily. During the Depression she had all the walls in the house knocked down and started her own dress shop.

There were four rooms downstairs and three bedrooms upstairs on Front Avenue in West Haven. We had a woodstove in the kitchen when you first walked in where we spent most of our days. Who wanted to go into the dress shop during the summer? The other rooms were converted into one big room, like a small factory.

My father fixed the garage and put a little gas stove to heat it. Sometimes on the warmer days the women went there to stitch by hand. Not only did she feel so strong about her trade, but the family needed money. There was a bad recession in the middle nineteen thirties, and my father and a lot of the men had gotten laid off from Winchester Repeating Arms. He was really upset because he couldn't help out. No matter where he went he couldn't get a job.

He got a job in nineteen thirty-six with the W.P.A. And she took a chance like that. My father had nothing to say about it, mind you. She was the breadwinner. She made a go of it and she knew what she was doing. And God forbid if my father told her what to do, she wasn't listening to him. But she should have.

Once this Jewish salesman came in and wanted to sell her a couple more sewing

machines. And she bought them from him. And then he suggested that if she had a bigger place she'd make more money and "I could be your partner." He said, "I'll pay for the machines." So she agreed. He was going to pay for the machines but he never did.

They went to an old empty school in West Haven and rented it. While my mother was buying in New York he was helping himself to the money. She wasn't smart enough to know what he was doing. She had to close up and go back to the house again.

At the time they didn't chase criminals like that. He was a criminal because he stole from her. She hired all her Italian women friends, some Marchigians, Neapolitans. She knew "the Polack," "the Jew across the street," and they weren't hurt at all by it. In fact when I was little I said to her one day, "Ma, they're calling me a guinea." Half in Sicilian and half in English, she said, "Who?" I said, "Well, Ruthie and somebody else." And she said, "Did you ever look at her?" And I said, "Yeah, I look at her all the time." She said,"She's not American either; the only Americans are the Indians."

She was a very smart lady. My teenage brother took her to Fifth Avenue in New York to the dress shops. She had to learn patterns and zippers that were just coming in at the time. Up till then there were no zippers, only buttons. Imagine this immigrant woman. She learned the streets of New York on her own because my brother had to leave her on her own with his own work to do. She went. She ordered. She picked out and they delivered and picked up the finished product too.

She worked for factories that sold the dresses. She didn't sell at all, and they paid her for what she did. Imagine, she had to pay her help, about six or seven people working for her—finishers, people that did the hems by hand. She decided how much to pay each person, she sat at the kitchen table long after everybody went home and decided who was going to get what wage.

She said sometimes her friends weren't her friends and I asked her why. She said, "I heard them talking about me." So I said to her, "That's the women, you know. Girls in school talk about each other, so . . ." She said, "Yep, they're not my friends. I told your father and he says, 'What do you want from me?' [laughing]. He said, 'Are they working?' I said, 'Yes.' And he said, 'Well, that goes with the business and you have to live with it.'" My father often

heard one of the Marchigiano women talking about my mother. She didn't realize he heard everything she was saying about my mother.

I was little, and we all knew how to work the sewing machines because they were right in the house. My mother didn't talk about the business, it was just people coming in to work, and you didn't do those things at the time. Roosevelt was just getting ready to come in and they were happy about it because they hated Hoover, and they blamed him for the Depression. It was hard living, really. We had the gas and electricity turned off. They always threatened that the mortgage had to be paid. My mother carried the day. She always worked, right till she died.

"Siegman Tie during the Depression"

Lena D'Amato was ninety-three at the time of our interview and recalled her mother running Fasulo's, a variety store in the farmlands of Woodbridge.

I came from a family of twelve, nine girls and three boys. I think I was the worst one of all of them. Because my older sisters used to go to the show on Saturday nights, and they'd be home at eight o'clock. I was the type that wanted to go dancing, so I'd leave the house at eight. My father got mad at me more than once.

My oldest sister Ann used to be with her husband at the house all the time, and every time I went out my brother-in-law stayed later and I'd look in the window and see my father there. One time I went home late because the tie shop gave us a Thanksgiving dinner and I happened to win a turkey. When the guy at the party said, "It's two o'clock," I said, "What! Oh, we better go!" I saw my father in the window and said, "What am I gonna do?" So I walked in and said, "I'm late because I had to wait, I won a turkey." He said, "*Oh, hai fatto buon, mo' mettimo bass ó cella*, Oh you did good, and now we'll bring it down the cellar." I got away with it that night. But I got a couple of good ones from my father, and I'm not sorry. I turned out to be very nice.

In nineteen thirty, I worked as a presser at Siegman Tie on Daggett Street in New Haven, and we started at seven in the morning, and worked till five. I think I made about twelve dollars a week. We were Jewish, Polish, Italians, and a few men, but mostly women. My job was to put a gauge at the end of each tie to make sure everything was even. Then I pressed

it. People in the shop wanted more money, so they went on strike for six months. I didn't work on the picket line. I remember a couple of the big shots from the union were staying at a hotel on Meadow Street in New Haven, and once a week we went there while we were on strike and they gave us some money, fifteen, twenty bucks.

That's why Siegman Tie moved. They left New Haven and opened a place in New Jersey, and they picked a few girls to go there. I was sixteen years old then and my boss, Rudy Siegman, one of the owners, came to me and said, "Lena, you want to come to New Jersey to work?" I said, "Oh, I can't, I'm only sixteen." He said, "So what's the difference?" I said, "No, you have to ask my mother anyway." So sure enough, he came to the house and asked my mother and told her not to worry, that I would be taken care of and I was going with a couple of sisters, the Massaro girls from Congress Avenue. My parents were against it at first, but I told them at least I'd be able to make some money, and I could help the family. They knew I would be safe. Sure enough, I went to Passaic, New Jersey, for a year.

My mother and father came from Caiazzo in the Campania region of Italy. I was close to my mother, and she only taught us to be good, to always walk a straight line because people were always watching. They got me a place to stay and they paid for it. I had the same job there too. I didn't miss home too much. I met a Jewish girl who lived across from my place, and after a while she invited me to her house because her mother wanted to meet me, I was from Connecticut, you know. She invited me to dinner. And when I went in the house—she was making chicken soup—I said to myself, oh, I hope I can eat. I figured they were Jews. But when I started to eat, I couldn't stop, it was delicious. She introduced me to guys and we went to the movies.

"The Women Supported Their Families"

Ralph Marcarelli:

My mother was an extremely intelligent woman who had two jobs, a house, and two sons. But because of economics during the Depression like most of them in those days, they had absolutely no opportunity to further their education, to the degree that education if it was given at all, was given to the boys. The notion then was that the men had to support

their families and that ostensibly did not fall to the women, but in fact it did because the women went out and supported their families. But the man was going to be the head of the household, he was going to marry, have children, have those burdens.

The option of choosing the girl versus the boy, if that choice had to be made, was not even there as far as the parents were concerned because jobs of whatever caliber were given first to men and not to women. What women decry today, sometimes rightfully, as inequality in hiring and equality in pay, was certainly the case during the Depression years.

Not in the same sense as today because a man and a woman will compete for the same

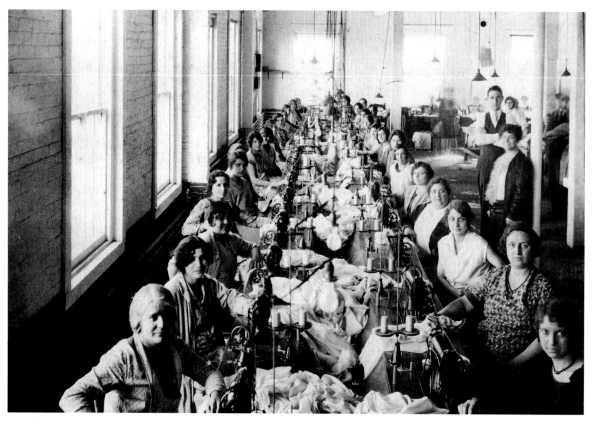

Figure 9.5. Fashion Dress Shop, Vernon Street New Haven, 1930s. Russo family archives.

job. Those jobs simply weren't open to women. They were very limited in what they were allowed to do.

It had nothing to do with the family; that was a societal thing here and elsewhere. The boys were given the opportunity, even if it was merely high school, which in the teens and nineteen twenties wasn't merely high school because that was already quite an accomplishment for anybody in those days. So the women were not given that privilege. But my mother, because of that, was absolutely intent on giving her two boys the education which she couldn't receive. She did not hesitate to take on even more than one job while she kept that house immaculately clean, while she did the cooking, the gardening, the sewing, the ironing, you name it. And my mother is only one of multitudes of women doing the same thing.

"They Always Timed Me"

At age one hundred, Angelina Julia DeLeone still baked a pie every Sunday to bring to her son's house.

When I was seventeen my mother said to me, "You better find a job because you're not gonna make any money on the farm." During the Depression, we had strawberries and eggs we sold. My parents always made something. But as far as my father working in construction, there was nothing around. He did very little. So he worked on the farm, it was the only thing he could do.

Everybody I meet, they always ask me, "What's your secret?" [laughing]. And I tell people, I worked hard all my life. But what secret? I worked all my life. I walked all my life. Work hard and you'll be okay. In nineteen twenty-nine, I went to work at Seamless Rubber in New Haven on Hallock Street where I was a packer, packing gloves in the Dipped Goods department. It was piecework. There was always work, but you didn't make much money, though, with piecework. They paid you five point eight cents for packing a hundred gloves. You made just so much and that was it. You couldn't make any more or they would cut you, cut your pay if you worked faster.

Every job had to be timed. I always worked fast, and every job that was timed, I was timed. And the other girls, they didn't move for nothing. So they weren't timed, but they always timed me. This Mister Harris used to always come around and say to me, "You're going to be timed today." I used to hate it. Even during

the war, it didn't change. So what I used to do. If I made too much today, I would save it, and would give it to one of the girls so when they got paid, they'd have to pay me back for it.

I'd make between twenty-two and twenty-four dollars a week. Because I could only make just so much. During World War Two, I was one of the speakers during the Army and Navy E awards. My husband was in the service, and I had to give a speech for my department. They picked somebody from each department to speak, and I spoke for the "Dip Goods" department where they dipped the gloves.

My father drove me to work every morning. My three sisters worked. Anna did the rolling of the cuffs on the gloves. I packed them in the packing department with my sister Connie. We worked for five hours a day, from seven to three. I used to walk home, all the way to Saw Mill Road in West Haven. Every single day, at least five miles. I had a friend that lived halfway, and when she got to the point where we left one another, she went home, and I walked the rest of the way.

If it rained, someone would give me a ride home or I'd take the bus. And before I went to work, I had to deliver the milk in the morning

at five o'clock, pick strawberries for the customers, pick up the chicken eggs and deliver them. Every time I'd go to the doctors and I'd see the gloves, I'd say to them, "I packed many of those, let me tell you" [laughing]. I went through a heck of a lot, but I enjoyed what I did. I was the saver in this family. I used to always save, made sure I saved a dollar. When my sons graduated from college, we got them new cars. They paid for some of their college and we paid for some of it.

"We Never Suffered on the Farm"

Mary Ruggiero told the tale of her father Anthony, who crossed the Atlantic eleven times, returning to Italy to have a child each time. Saving his money, he bought farm property on Pool Road in North Haven. In 1894, he returned to his native San Valentino in the region of Campania to bring his family to America.

We never suffered on the farm in North Haven during the Depression. In the beginning, my father rented the land on Frost Drive from Mister Culver because they didn't like Italians much in those days and he didn't want to sell his land on McArthur Road to an Italian. North Haven was all Yankees and they owned

most of the land. There were the Uhl, Bottume, Marx, and Turner families.

So my father hired Spaniards from Wallingford to work the farm. Finally, Culver sold my father only a corner of land because he had no money and needed the money to survive. He wasn't a professional.

My mother always had plenty to eat. When you have a farm, you have a lot of friends. They came out to work and helped us. The women came from New Haven to work here on the farm, a lot of them from the LaBonia dress factory. They'd go home loaded with stuff, God bless them! They helped my mother can the tomatoes for the year. They pickled the eggplants and the peppers. And my mother fed them. When they went home she gave them tomatoes, peppers, melons, cantaloupes, honeydews, whatever they wanted that was in season. My mother profited by them.

One daughter worked where they made dresses. So I was the best dressed girl in school. They made all the dresses in the shop. I went to school and the teacher asked me, "I like your dress, where did you buy that dress?" I wouldn't know what to say. I'd say, "Well I don't know, my mother bought it for me." The teachers in school couldn't spell Ruggiero so

they changed my name to Rodgers. Even my nineteen thirty-two high school diploma has Rodgers instead of Ruggiero.

"She Sold Her Ring during the Depression"

Betty Panza:

My father worked for the W.P.A. My mother, in order to get money, sent her gold wedding ring to Italy, her wedding band. And they gave her money. And she had to stand in line for shoes.

"I Didn't Want to Eat If I Didn't Earn It"

Anna Perrotti Caccavalle was ninety-six at the time of our interview. She described herself as the "family nurse" when someone got hurt. She said, "I wanted to become a nurse but my father wouldn't send me to school. I learned on my own. When somebody came around selling medical books, I bought them and learned on my own."

When I first got married in nineteen thirty-five, I used to go to the store and buy one stick of butter and three eggs during the Depression. Couldn't afford it. My sister came to visit me,

and when she opened the refrigerator she said, "You haven't got nothing in your refrigerator." I said, "I can't afford to buy anything." I didn't have my farm then, and my husband worked in the Gas Company and made sixteen dollars a week. We paid twenty-five dollars for rent and by the time we got gas, food . . . we spent a dollar a day for food, that was bad. One time we went to see my mother on the farm in Woodbridge. I said, "Ernie, let's go see my mother, we'll eat there." We got there. It got dark quick. So my mother said, "Yous want to eat?" I says, "No, we ate." We went home without eating because we didn't do enough work to eat. That was my decision, not my mother's. I was ashamed that we would eat without working. I didn't want to eat if I didn't earn it. If we didn't work for what we got, I wouldn't get it. We had to earn what we got, that's the way we were brought up.

10

Italian American Women Raise Their Voices

Empowerment in the Union Movement

Communal protests staged by women were not unfamiliar to Italian American women. Women in southern Italy had organized into unions known as "Fasci Femminili," and often took to the streets in solidarity to demonstrate against injustices in the workplace, or unfair taxes imposed by local governments.[1] In the early 1930s, Italian American women transported the tradition of protest to worker strikes in Hoboken, Boston, Lowell, Newark, Little Falls, Passaic, Hopedale, Providence, Cleveland, Rochester, Paterson, New York City, Lawrence, Lynn, and Tampa, helping to win union contracts by the strength of female neighborhood networks.[2]

Jennie Aiello Alfano was born in New Haven to an Italian American father who worked in the L. Candee Rubber Shop on East Street while her Italian-born mother stayed home to care for the family. Of the fourteen Aiello children, Jennie's mother often relied on her to shop, feed the children, and help cook for the family. During the tough times of the Depression in 1932, she quit seventh grade at age thirteen. Lying about her age, she found a job at Lesnow Brothers in the center of New Haven's garment district, a shirt factory that employed more than five hundred neighborhood people, the majority of whom were women. Eventually all seven Aiello girls joined the mostly Italian American workforce in New Haven's shirt and dress factories. To help feed the family, the boys worked as shoeshine boys, or delivered milk.

Jennie's siblings remembered their sister as rebellious, with the reputation as the defiant one in the family. They also fondly remembered Jennie as the only one who could turn their authoritarian father into a *fesso contento*, a contented fool. Despite his strict rule forbidding daughters from going to dances, Jennie devised her own plan. Climbing out of the first floor window, she timed her late night return so her sister could open the window, letting her back into the house undetected. Jennie's mother nicknamed her high-spirited daughter *gamba latara*, the milkman, because she made daily rounds through the neigh-

borhood, visiting friends on stoops and stairways and meeting in the streets. Jennie's wandering through the teeming urban enclave of Wooster Square, with its vibrant street life, was a far cry from the small village her mother had lived in southern Italy where staying close to home was considered a woman's mark of virtue. Jennie built a wide network of kin and neighborhood friends who knew her as someone with the courage to speak out against injustice when others remained silent. Her co-workers considered her "labor minded," a young woman committed to justice in the workplace. One politically active man in the community recognized her as a "great fighter and outspoken for her age, always vocal for the safety and health rights of her fellow workers—she was ahead of her time. She didn't care—she was always fighting for the welfare of her 'girls.' Once she told Marty Gant, the owner of Gant's, 'to clean up the goddamn bathrooms.'"[3]

In the early 1930s, Italian women comprised the majority in New Haven's garment industry workers. But without strong leaders or binding union contracts, young working women found themselves at the mercy of owners who exploited them with miserable wages of five dollars for a fifty to sixty hour work week. Despite stories of abuse and terrible working conditions, Italian parents—descendants of a peasant culture that deferred to authority—advised daughters to

behave passively for fear of losing desperately needed jobs, telling them, "*Fa vedere che non successo*, Act as if nothing happened."

The flashpoint between workers and owners in Connecticut's garment industry occurred at Lesnow Brothers in the spring of 1933. Seeking to capitalize on the desperation of struggling families in the throes of the Depression, the Lesnow brothers called a general meeting of their employees. Jennie and her sisters listened as the Lesnows announced higher productivity standards, increasing the number of pieces in a bundle from a dozen to thirteen, with no increase in pay. Prior to the meeting, women stitchers always handled bundles of ninety-six shirts, which were produced "by the dozen."

Jennie Aiello called a meeting with "her girls" that night, saying, "This is not right," and notified the local union official. Rallying workers the next day, she gathered new "bundles" and rode down the factory delivery chute to the first floor to show the pressers and cleaners. John Lauria and Mamie Santore—union organizers who had already been sent to organize "runaway" shops that had fled from New York to New Jersey, Massachusetts, Connecticut, and Pennsylvania—attended the first meeting in what became a showdown heard round the garment industry. For six weeks, Jennie and her co-workers walked the picket lines on Water and Franklin Street. Fights

often broke out between strikers and workers loyal to the Lesnows, and thugs were hired to physically intimidate women on the picket line. Jennie initially had to lie to her parents about walking the picket line with her co-workers "not to make them afraid of me getting hurt." During those weeks, Jennie's mother told her, "Keep still. Mind your business. Keep your job." But Jennie had the support of a large female neighborhood network and finally told her mother the truth, "Mom, I'm tough enough. I have a good crew circled around me. I'll never get arrested."[4]

On the evening of May 3, 1933, Lesnow Brothers became the first major shirt factory to sign a union contract, followed by other shirt factories around the city. Within six weeks, all of New Haven's shirt shops had joined union ranks. In August, women in the dress shops replicated their sisters' actions in the shirt shops, and after two weeks of picketing and protest, won union recognition under the ILGWU, with the formation of Amalgamated Local 125 of the Shirtmakers Union and IGLWU Local 151. Within a year, wages increased by 10 percent and the garment industry code reduced hours to thirty-five per week in the dress industry and forty among the shirt workers.[5] In 1934, the union newsletter *The Advance* reported that the momentum created by the victory in New Haven went far beyond the city: "The Lesnow agreement became the starting point for subsequent settlements, with strengthening clauses being added as the drive gained in momentum and power."[6]

Mobilizing the female Italian American network to support the union cause, firebrands such as Jennie Aiello Alfano, Carol Paolillo, and Jill Iannone invented their homegrown brand of industrial feminism in New Haven's garment industry. Betty Chessa Scioscia in Bridgeport and Beatrice Barbarossa in Norwich fought for the same justice in the workplace. As female activists, they spoke out in solidarity for fairness based on the idea of inclusion, part of the Southern Italian woman's ethos that focused on family survival and community welfare rather than the needs of the individual. As Italian American women, their grassroots strategy defined success "through the prism of household responsibility rather than purely personal gain."[7] The successful union movement in New Haven, and in other cities in Connecticut, signaled a transformation in Italian American women's self-image; it also changed the public perception of them as submissive to patriarchal authority. After the signing of union contracts, they found empowerment as union chairladies, vice presidents, secretaries, and shop stewards, who made sure union rules were followed in the workplace.

Italian American women, who spent their working lives in sweatshops and factories, came to maturity on plant floors and production lines. They confided in

one other when personal problems arose, and sought advice from older women on issues of sexuality they could not discuss with parents who considered it a taboo subject. They attended each other's weddings, baptized each other's children, mourned the deaths of loved ones together, and baked in each other's kitchens. In solidarity, and with deep inner strength, they overcame the cruel realities of life in sweatshops, determined to send their children to school to attain careers they could never realize. Working in factories and sweatshops from their formative years, Italian American women formed a sisterhood that lasted a lifetime. As Louise Bombace Savo told me, "You didn't lose track of your friends, like if you were friends with somebody, you stood with them. For all those years, you always kept in touch with them and say, 'How's everybody? How's everything?'"

"It Was a Women's Movement"

Nick Aiello and Natalie Aiello Adamczyk:

The women were the ones who went on strike. And they were never the elders. They were all teenagers, young women. When they went on strike, the cutters and the pressers, who were men, joined later because they made more money than the girls. The cutters and the men came out [went on strike] after, but it was basically the women.

In those days they used to give the men more money because they claimed they had to support a wife and a family. A woman's place was home. That was the scenario. The old Italians with the daughters, they protected the daughters. They had to stay home and the men went to work. But in those days, there was no work for men during the Depression.

Sargent always picked and chose. Then L. Candee Rubber left New Haven and moved to Naugatuck and became U.S. Rubber. I remember Wooster Street; the fathers weren't working. The sons and daughters were working. What was there? The men started to work after the war. You got to give credit to the women. They were brave young people. They took enough until they couldn't take no more, and they took it upon themselves do something about it. So where did my brothers work? They worked in the N.Y.A., the National Youth Association. They used to go work in the schools during the summertime and they used to get nineteen dollars a week.

My father worked on the W.P.A. and my older brother went to the C.C.C., Conservation Corps Camp. The girls were all in the fac-

tories by then. Not only the first generation, but the second generation, and their daughters went in, their nieces went in, and my cousins went in. It was like a family reunion.

"She Was Ahead of Her Time"

Nick and Jane Iannone fondly recalled their mother's indominable spirit and willingness to always fight for the underdog.

Her mother and father came from Santa Maria a Vico in Campania, Italy. She graduated from Fair Haven Junior High School in New Haven, and at fourteen, being the youngest of the four children, went right to work during the Depression. Her sisters were already working as dressmakers.

She was a spitfire, very ahead of her time in the sense that she wanted her independence, wanted to be self-sufficient.

She also kinda thought that she was better than her background would suggest. She was that kind of an independent woman. She was ahead of her time in the nineteen twenties as far as the women's movement was concerned as evidenced by the things that she did. All her life, once she made up her mind, that was

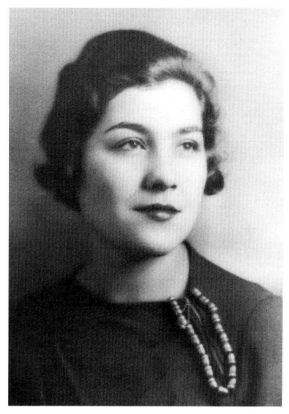

Figure 10.1. Portrait of Jill Iannone, 1940. Iannone family archives.

it. And she carried through on it. She was a champion of the underdog in ninety-nine percent of the issues. She was always in the forefront and she would lead the charge so to speak, right or wrong. Once she got committed to something, that was it.

She was the youngest, and she was always jealous of her brother who used to go to the

market with her father. They had a vegetable farm in North Haven. They would load up the truck with vegetables as truck farmers, and her brother would always come back and say we did this, we did that. And so she wanted to do that. One time she hid herself in the back of the truck after they had loaded it up. She got herself in there and she went to the market with them unbeknownst that she was in the back of the truck with all the vegetables. When they got there they unloaded and found her, so what could they do? They had to keep her that day with them. And so she said how her brother used to say, "Oh, I get coffee, or I get hot chocolate in the mug," and she wanted that so bad. And she said when she finally got the hot chocolate, she called it a barber cup, it was such a thick cup, and she didn't even want to drink out of it. Up till the end she hated mugs, and we always had to give her a cup.

If she wanted to do something, she found a way to do it. And being the youngest of three girls, she always felt she got all the hand-me-downs. And she didn't like that. Her older sister Vincenza, who they called Jane, always seemed to get everything. That added to who she was, being the youngest. That was typical of all immigrant families at the time.

The daughters were always there until they could go to work and support the family. All immigrant families faced that, you always wore the older person's clothes.

She hated her first job working in the shirt factory. She felt it was beneath her because everybody else was doing that and she didn't want to be doing what everybody else did. She found it very boring and not what she wanted to be doing. They played basketball, intramural sports, and she met Julia Formichella, another organizer from Granniss Corners in the shop. She met Ann Kramer. She was Italian, and came from New York. They were looking for worker organizers, and most of the women at the time were young Italian immigrants, either their mothers or daughters. The Jewish people from New York became the organizers because they organized in New York first. She started as an organizer at seventeen with Sidney Hillman.

The reason the dress and shirt shops came to New Haven from New York was because of the cheap labor force, the access to the railroad, and there were no unions. They went to New Jersey, too. They started organizing in New Haven because there was quite a population of Jewish and Italian immigrants at the

time, and there were a lot of empty factories, so everything was in place for them to move in, and that's what they [owners] did. And of course, at that time too, the immigrants here needed some kind of money, so they went to work at whatever job they could get. Lots of them didn't speak English, or they were very poor in terms of English, and that's how it started.

And my mother, of course, went right along with everybody else because that was what was available at the time. And when she realized what was going on, she had aspirations to improve herself, not intellectually, so to speak, but monetarily. She wanted to make it. So when they came in with the opportunity to start organizing with more money, I think that's what she saw. And that's how she got involved. And again, going back to her spirit, and the way once she latched on to an idea, that was it. And I think as an organizer at a very young age she got involved with the organizers. That was the avenue in the nineteen thirties to better herself.

There wasn't much else open to young women in the nineteen thirties than what was available in terms of jobs at that time, especially if you only went as far as junior high.

And of course, being able to speak Italian and English, she was able to act as an interpreter, and she would go out because it was important to talk to these people in their own language. Later on, I went with her a couple of times when there were strikes in Bridgeport. Now we are more into Spanish or Puerto Rican workers, and she would go down in the late nineteen fifties, early nineteen sixties, she would go out. She went to black and Puerto Rican houses, and they were afraid. So she would tell them what the Italians put up with in the 1930s.

She told us about the Spanish houses being full of candles and statues. Knowing Italian, she could sort of converse. She took Spanish lessons. They were truly afraid to join the union, because it wasn't the nineteen thirties, and in the nineteen sixties there was more evil going on.

I sat with her all night a couple of times outside of a factory to make sure they weren't taking clothes out of the factory to break the strike. She got beat up. She had her ribs broken in Bridgeport. They had a lot of respect for her, being a woman. Even if she was afraid, she would go in and get the job done. For a woman her age, for what she was doing—there

<p></p>

were men that wouldn't do what she did. She'd go at night into areas of Bridgeport no one would ever think of going, and she'd go into these houses. The Puerto Ricans even loved her there. They always took care of her, and they would have somebody go with her. And they would tell her where to go and how to be careful.

In a lot of ways she was very generous with what she did for people, and that's how she did it. She never wanted a thank you because she felt it was the right thing to do. And that's what she did. She said, "These people can't be treated like this—not today." Because she had been through it, and she knew what it was. And she said, "This is not right," and this is what gave a lot of her drive to what she did. And her believability to the people she talked to—"Look, I've gone through this, I did this. We want things better for you. This is why you have to do this." She had to convince them that they weren't going to get killed, or they weren't going to get fired from their jobs. Because if they got fired, that reputation would follow them, and they wouldn't be able to get another job.

To get into the factory she would pose as someone looking for work, and she would become a worker in the factory with the women. So she would begin to organize from the inside out as a worker organizer all over Connecticut in the nineteen sixties. She would make sure they'd have job postings, and that the bosses wouldn't stop them from talking about it. She couldn't do that going in as an organizer, so she became hired as a worker. All the time she was working for the union.

She'd go out in the morning and came home very late. She wouldn't take no for an answer. She exuded confidence when she said, "This is what you have to do," and she just signed people up [for the union]. She was really upset when we had the teacher strike in North Haven and Judge Sadden pulled us into his courtroom and there were three hundred and sixty of us—and that broke her heart that day that I had to go to court for striking—they arrested the schoolteachers in the nineteen seventies.

She had a tough time. She always came to the Yale union rallies when she was up to it. She walked in our marches at Yale in the nineteen eighties. Right up to the very end, she'd go to the senior center and she organized there. She was always in favor of the underdog and she was very tenacious, like a bull-

dog, when she thought somebody was right. My father was a business agent for the barber's union. He was the calmer of the waters, the negotiator, let's work it out. She was the go in and get them with guns blazing.

"We Blessed Eleanor Roosevelt"

Elizabeth Barbiero Hepp described the Bruce family in North Haven as a Scottish family who took her immigrant father in and gave him a job in road construction. On his wedding day, Mrs. Bruce dressed her mother in a dark brown bambagine dress and put her hair in a bun.

In nineteen thirty, I was twenty-seven and I went to work at U.S. Rubber Company in Naugatuck. I came here from North Haven when I got married. North Haven was no factory town, and it was all old Yankees.

We needed money in the Depression. My husband was only working nine days a month at Waterbury Anaconda, and I had to go to work. My first job was on a conveyor, and I thought, Oh boy, this is gonna be a good job, snapping Gay-Tee shoes in the Heavy Goods Department. The machine girls put the caps in the shoes and I had to snap them. Much

to my surprise at the end of the day my fingers were all blistered and they sent me to the nurse. She bandaged my fingers and wrote a note to my foreman saying, "She can no longer do this type of work." So my foreman put me on inspecting. I had to inspect that boot up and down, take the top part, flap it over, and put it on the conveyor. I handled three hundred of those an hour. And with that job, I can no longer raise this arm.

There was no compensation in those days for an injury such as this from the job. My doctor took an X-ray of my arm and said, "It's like a bar of cement in there. What kind of work did you do when you were young?" And I told him. He said, "Well, that's what happened to you, and I'm sorry to say, you're stuck with it." There's no pain, it's the only handicap I have, but I can cook, I can bake, I can clean my house and dust, run the vacuum. I'm a very happy, contented old lady!

In those days we worked ten hours a day, five and a half days a week. We earned fifteen dollars a week. We stood on our feet all day with no place to sit. At noon, when the classifier went out to have her lunch I sat on her stool to eat my lunch. Then she took my place again after lunch and I stood ten hours a day,

which was not easy. One night Eleanor Roosevelt went on the air saying she had toured factories where they employed child laborers. She was appalled that those children at the age of twelve and up were not even given a stool to sit upon.

In the meantime, the people were organizing and we had a union man, George Froelich, who was for the working people. People began to organize and realize that if they didn't get a union, the factory people were going to get nowhere. People began to organize all over, a whole union movement. George Froelich negotiated and we stopped working ten hours a day, only eight and no more working on Saturday. He was a wonderful man. And then we got an increase in pay, and we were earning twenty dollars a week, which was good pay in those days.

So when Eleanor Roosevelt went on the air telling about the conditions, we were all given stools. They passed a law that everyone had to have a stool whether they could sit on it or not, but it had to be. So we finally got our stools. Fortunately, at inspection I could sit all day, and I no longer had to stand, which was a great relief to my feet. And I'm telling you, we blessed Eleanor Roosevelt when she went on the air and we all got a stool to sit on.

"The Ku Klux Klan"

Betty Chessa Scioscia's parents emigrated from the poverty-stricken region of Sassari in Sardinia, the second-largest island in the Mediterranean. The Sardinian writer of Betty's generation, Grazia Deledda, wrote thirty-three novels and many short stories on Sardinian themes to become the first woman in Italy to win the Nobel Prize in Literature in 1926 "for her idealistically inspired writings which with plastic clarity picture the life on her native island and with depth and sympathy deal with human problems in general."

My parents were poor farmers from the town of Codrongianos in Sardinia. My father came here and worked in the coal mines in Johnstown, Pennsylvania, and I remember him wearing a light on his hat. My mother taught my oldest sister Pauline how to sew, and she taught all the younger sisters. Pauline made all our clothes. When my father got home he expected us to be busy crocheting the bottoms and tops of our slips that we made out of the cotton sacks the flour came in.

One of the first things I remember about Johnstown was seeing crosses burning on the hillside. The Ku Klux Klan kept burning crosses, and it was becoming more dangerous. My father started feeling threatened that any for-

eigner like us or the Russians who lived around us could be a target and that Pine Street wasn't a safe place for his daughters anymore. So Sam Lungi, my father's Sardinian friend in Connecticut, told him to come to Bridgeport, "It's safe and there's a dress industry with a lot of opportunity for women." And so all four sisters got jobs in the dress industry on the east side of Bridgeport.

"I Was Mouthy"

Betty Chessa Scioscia:

When I was fifteen my first job in Bridgeport was at I and J as a trimmer. I had quick hands so I learned the machine and how to do seams. Then I worked on the line sewing shirtwaist dresses.

Before the union came in I was always mouthy. I spoke up for the girls if the price for piecework they paid us wasn't right. And I spoke up for making us work on Saturdays and the poor pay. Before the union, I earned five dollars a week. The fans didn't work, and it was very dusty. There were Russians, Polish, and Italian workers. When the union came in nineteen thirty-five, Bert Cooper, a district representative of the International Ladies Garment Workers Union [ILGWU], came from New Haven to organize us. I walked the picket lines and there weren't any fights. Then after the union I got elected union representative. I used to go to monthly union meetings and bring the latest labor news to my co-workers.

I had to settle disputes between the favoritism of the bosses and the workers. I spoke out for the girls if the price [to make pieces or a garment] weren't right. I spoke up about working on Saturdays. One of the biggest things I had to fight against was the women taking their work home. The bosses sided with them to take work home but I told them, "You'll be better off obeying what the union says and you'll have better working conditions." But some of them didn't see it that way, even some of my friends who felt I was getting in their way. They wanted to take work home and have a big paycheck. And I argued with them to see that the more you take home, the worse it's going to be for everyone else in the future. So they sneaked the work home, but the bosses cheated the workers.

I used go home, cook meals for my husband and three kids, and we had a lot of heated arguments at the supper table. Maybe because I came from a family of girls. We all had to go out and make our way. All my sisters had

families and they worked in the dress industry. They came home and cooked full Italian meals, did all the big family events and the picnics. They were working and coming home aggravated, talking about the union, talking about their jobs, talking about how they were going to make it better, how come somebody's not willing to go by the union rules and because in the end it will be better for everyone if they don't take work home.

"The Strike in Norwich"

Francesca Grillo:

I worked in The Majestic Pants Factory in Norwich for many years. I had to work to pay board to my aunt. I had to pay my father in Italy the debt I owed for my trip to America. Every once and while I'd get a letter from my father, "The horses went blind, does my daughter have any money?" My uncle would say, "Eh, you got any extra money? Your father's horse went blind." Then another letter came, "The wheel came off the wagon." So, hey, I had to work to make up. So finally I got to the Greek bookkeeper in the pants factory, and I says, "Look, when you make my pay, can you cheat a little bit, so I can have some money for myself, like if I need a pair of stockings or something?"

We worked all week just for the small change because we paid for everything, and that's all we had. Then every other week there was a strike. That's the way it was in nineteen thirty-five, thirty-six, the shop went on strike for the union. But when the union came in and we started to go on strike, where was the protection? We had to go to union meetings all the time. We didn't make any money, four, five dollars a week, and thirty-five cents an hour. When we went on strike for two or three days, we didn't get paid and we had no money.

It was voluntary to either march or not. I could never march because my aunt had small kids and I had to help. Every once in a while when these organizers came from New York, I used to hear stories that in New York they went on strike and they marched the streets. I never marched. They looked like a Mafia because they had meetings in the office and they told the bosses what to do. It reminded me of Italy during fascism, when the union people told my father he had to keep a book and charge his workers so much in union dues, and then record how much each worker paid

every month with *francobolli*, stamps, that verified payments. He had to tell his workers, "You have to join the union." So these guys gave me the same impression I had in Italy, they way they told the boss what do, all about labor laws.

After they left, the boss asked us, "Do you want protection?" In other words, the majority of us had to decide if we wanted that benefit when we didn't like what the bosses did. Then they asked if we were willing to pay and have the bookkeeper take out union dues every month. So by paying dues we got that protection. And every month the bosses gave the union all our union dues. The workers wanted it because we figured the union would protect us.

I was working fifty hours a week and we got it reduced to a forty hour week for the same pay. Every time we had a raise, we had to have a meeting because we all had to say yes.

Beatrice Barbarossa was from my hometown of Terlizzi, and she was the union chairlady. She used to tell us before the union came. She used to get us all in a group. She shut off the switch and stopped all the machines. She stopped the work. She'd say, "The union people from New York are coming on such and such a day, and they are coming because of this or that, now what do you think?" All of us had to agree to what they were going to suggest. I didn't really understand, but she would explain it to me later in Italian. They took so much out of our pay for union dues and then for social security. I was like *ó ciuccio*, a donkey, working all the time, that's all I cared about. I had responsibilities. I was paying four dollars a week board.

"We Worked as Scabs"

Theresa Grego finished high school in 1936 because, as she said, "All my brothers worked."

I was getting thirty-two cents an hour in the nineteen thirty-eight at Insler's in New Haven. Insler's was on one floor, Buonocore's on the second floor. We had to hush-hush our work because we didn't join the union even though Insler's had a union. We were scabs. When the union workers went home, they'd close the doors and do the work behind closed doors after hours. We didn't get caught but then I didn't stay too long. I went upstairs to my uncle's shop, Buonocore's, as a floater. I got the work prepared for the operators, sorted the

different parts of the garment, and rolled them into bundles for the operators.

"Thank God for U.S. Rubber"

Antoinette "Zuckie" Zuccarelli reconstructed the technique of "skiving" in the hot blade department at U.S. Rubber. The rubber forms for boots and shoes

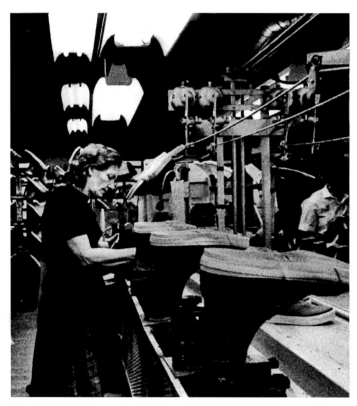

Figure 10.2. Deanna San Angelo on the production line at U.S Rubber, 1950s. Naugatuck Historical Society archives.

were sent to a conveyor where the first girl placed a lining on a rubber form, which then went under a roller where it adhered to the rubber by the force of pressure. Then it went back to the conveyor where the "hot knife girls" stood on either side of the conveyor, one for the left shoe, the other for the right. The girls used a hot knife with a blade to cut off excess material from the lining of the shoes, and threw it into bins to be used later. Cutting off excess material was called "skiving." The forms were then sent to the "making room" where the shoe was assembled on a conveyor belt, each girl having a particular job, putting on insoles, outsoles, "vamps," the toe covering, and "foxing," the strip of rubber holding the upper part of the shoe to the sole. The final "skiving,"was done for any excess material found on the shoe. Then the shoe was sent to be vulcanized and packed.

Before World War Two, they closed the rubber shop in Williamsport, Pennsylvania. They were unionized, and they wanted one here. Some had worked in the mines, some in factories. I said, "Union? I'm lucky to have a job. Who cares about the union!" I worked with benzene and I never thought of the smell, I was just happy to have a job. But when they were trying to form the union this guy Jack from Pennsylvania stopped the production

lines. The bosses wouldn't let us. At first we just stood still, and then when everybody ran off the line, naturally I followed the crew. I chiseled [hitchhiked] a ride with three or four girls to go to New Haven to go shopping.

I had a lot of guts and I think of the kids today, but I was never that crazy because my mother would have split my head open, I guess. They thought it was a slave shop. They wanted you to make more money. The bosses wanted us to make more shoes per hour, whatever. You were paid by line. If we made "an efficiency," it went like a hundred, a hundred and five. If we got a hundred and two, three, we were lucky.

My job was the lowest paid because I worked on the table, not on the conveyor. We couldn't leave our place. If you had to go to the john, you had to ask the supervisor, and somebody took your place. The ones who worked hard with their hands made more. The making lines, which were the actual making of the shoes, were paid the least and the different parts came from other departments, the insoles, the heels. The packing rooms made good money. And the union was formed there.

They wanted us to make more shoes on the conveyor and I was being timed. So I'm thinking, I'm not going to knock myself out because they'll expect more, which they did. So naturally I was stalling, got off the line, and bid on another job. Through the union you could bid on a job if they were posted. I bid on a job servicing the cementers on tennis shoes. These girls lined up all the shoes, cut the inside of the shoe, and cemented them, sticking everything together like a hem, and I was servicing them. I'd do different ones favors. Sometimes I'd take their place—not that I was a cementer because I was terrible.

I stayed there and walking around I began as the service girl bringing people supplies. I had to go upstairs and I thought, gee, it's so nice to work up here, I hope by the time I retire I work up here. It was easy and I made more money. I'm thinking, what a sap I was to work on a conveyor for twenty-five years! That was terrible. But I went upstairs servicing again with only thirty-five people in the whole room, a nice group. They did the insoles for the sneakers, got the parts together, and sent it to the making room for them to make them.

Each department had their own thing to do. I was skeptical when the union came in, but then I voted—we had to—the union in. I was clerk of small claims in Naugatuck, and I

was secretary to the Democrat Town Committee. George Froelich said, "Zuckie, how would you like to run on the ticket with me?" I said, "Oh, I can't do that." Don't forget I'm the secretary to the Democrat Town Committee, I have to go meetings and all this stuff. They put my name in, and it was supposed to be a good job as a traveling union agent, but I didn't get the job. Then I became active and I became a trustee for three terms. After that, I was recording secretary for the union.

The union people had meetings on their own time, and they had stewards in every department. Some of them thought of themselves, and they didn't care. Well, I never felt guilty because I always tried to do the right thing, and I helped them. I helped all the poor foreigners, the Polish, the Portuguese people, because my parents were foreigners. When my mother came from Ruoti in Calabria, she got a job in nineteen eighteen, in the rubber factory after one day without speaking a word of English. So even if I didn't know them, I'd get right in with them and help. I never woke up and said I hate to go into that place. I loved it. Everyone was so nice. We had so many good times. We'd get together and sing together. And groups got together and we'd

be on the line working and singing and then somebody would tell a story. It was always so nice. It was a joy. We were always concerned about each other.

People also came from Ansonia, Derby, and New Haven, and worked with us. I thank God we had the U.S. Rubber, what else would we have in Naugatuck? Peter Paul Candy Manufacturing Company came later. I'm very grateful and we have a good medical plan thanks to the union. You could have a major operation and our plan takes care of it. Now we fought for all these things. And when we got good raises or good benefits—we did all the work—management got it before us. Management didn't have a union, and now to get their benefits like ours they had to hire lawyers and they had to throw in some money.

"Seamless Rubber Was Home for Us"

Angelina Gambardella Maluchnik recalled her mother Virginia, from the town of Atrani, and her father, from Amalfi, calling each other "You Amalfitani!" and "You Atranese!" when they argued.

I got a job to make more money when I was seventeen during the war at Seamless Rubber,

because I was experienced in the box department. So my father said, "Angelina, you're gonna work in the Seamless Rubber company? You're gonna last two weeks." I says, "Pa, let me try it." I stayed there thirty-one years.

My father used to say, "Anybody that works for Seamless or Sperry and Barnes [the slaughterhouse on Long Wharf in New Haven], never worry, you'll never be out of a job." But everybody lost their jobs. They folded up! Seamless Rubber went to Atlanta, Georgia. I used to be a trimmer in the basketball department. Never made another basketball. Sperry and Barnes, I don't know what happened to them, they went out.

And everything went out of New Haven! We had a lot of industry here. Seamless Rubber was home for us. There were Polish, Irish, and many blacks. We got along good with them. For twenty-two years I lived across the street on Hallock Avenue from Seamless. The Dipped Goods where they made the surgical gloves department was all black workers. My husband used to go over there because they were working with those chemicals in Dipped Goods. You had to dip these gloves in this chemical, and you had to come out for air because the smell was too bad. They

had masks, but they still breathed it in. My husband used to give them a can of beer or ice tea. We used to give them food. Sometimes they'd ask him for money, and I told him not to because once you started, it wouldn't end.

I worked in the box department because I was too young to go into any other department. I couldn't even ride the elevators! There was a law. You had to be eighteen to ride the elevator. I used to walk from the fourth floor to fifth, and I couldn't work eight hours. I could only work seven, and I used to walk home, and sometimes my brother or father came to pick me up. When I was eighteen, I wanted to go into a different department, so I signed a bid to work in the packing room and I learned all the jobs there.

We made bathing caps, hard rubber combs. We made a lot of stuff. Then Japan came in during the nineteen fifties. They sold the machine to make the hard rubber combs to Japan. They sold the bathing caps. We used to make the best surgical gloves. What happened? They folded up. Now today, who uses surgical gloves and everything? That would have been one of the most popular things today. They didn't do it. Because of these people who came in, they wanted to break up the union, and this is what it was all about.

We had a union at Seamless and I went for the union, too, because they protected you. Today what happens to these people that don't have protections with unions? Look at Blue Cross over there. They have no protection. They don't want you, they'll let you go. There's no protection. I wasn't a union steward, but I was a fighter. If I was right, I wanted my rights. If I was wrong I wouldn't fight. I knew what was right and wrong. But you have to fight. The union is behind you, they'll back you up if you're right. If you're wrong they won't back you. It's a shame. Everything is out. How this place went down the river.

"I Was a Rebel"

Rita Restituta Ruggiero attended Post Junior College in the 1930s, taking courses in stenography. She worked from 1944 to 1974 at UniRoyal in Naugatuck and belonged to the Local 45 United Rubber Workers of America. Like many factories in Connecticut, Uniroyal closed in 1979, the victim of outsourcing to Korea and Taiwan.

I was a bit of a rebel at the time in nineteen thirty-nine, and when the union started coming around to sign us up in Naugatuck, ask-ing for your signature to belong to the union. It was the men who tried to form a union in order to improve our working conditions, our overall health conditions. There was no picketing. They were just petitioning, and they needed so many signatures. And I thought, I don't need anybody to fight for me, I can take care of myself. You're young, you gotta a mouth now, you know?

My father could not join the union because he was considered "plant protected" as a fire-man and watchman for U.S. Rubber Co., which became Uniroyal in the mid-sixties. People in the plant then would have to peti-tion to see if they had the allotted number of votes to be able to pass this. I was a holdout to the point that my poor father used to pay my union dues on a monthly basis because I refused to pay dues. It was against my prin-ciples at the time. I finally succumbed to it.

When the union came in the rules changed. The hours were set. Let's say you went to work and you were five minutes late. They could tell you, "Go home!" They could no longer do that. We had time clocks. If you were late, you were late. So your timecard showed it, and that was it. It evolved to the point where we had presidents and vice presi-

dents who were mostly men and the women were in the office.

My father used to go up to the office and pay my dues to this particular woman. My father would say, "I have a very smart daughter." And she said, "Well, send her up here." And I did go up. So she interviewed me and at that time George Froehlich was president. All I can remember is this man standing in the doorway of the office, this big imposing creature, and I was scared beyond what I can tell you. But Stella, who had this job, liked me so well, and an election was coming up and she was getting married. She was leaving the job as office secretary/treasurer of Local Forty-Five, United Rubber Workers of America. So we went to this election and Stella told me, "I'm going to do something that is unheard of." She was going to undermine the opposition. They thought the opposition was going to endorse Stella, and the other team was going to do the same so there was no competition at that point. And they asked if Stella would accept the nomination for the office and she said, "I ask for permission to speak before accepting the nomination." She ended up on the floor, and she said that she was going to decline the nomination, but she asked for the privilege

of nominating a person that she thought was more than qualified for the job. So she nominated me. There was no opposition.

And I was elected every year, for a total of thirty years. The treasurer's job was the elected job, but the office secretary was an appointed job, so if I was elected in, I was automatically the office secretary. I ran the whole office by myself.

I was office secretary and treasurer. At one time we had over five thousand members, and they were all my responsibility. There again, the union petitioned the company to have payroll deductions. Instead of us going up to

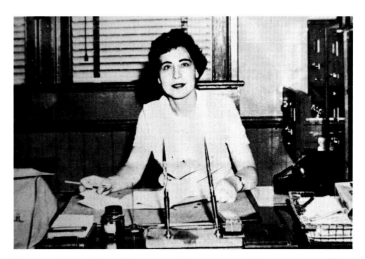

Figure 10.3. Rita Restituta Ruggiero at her union office in Naugatuck, 1961.

the union office and paying our dues they voted to have it taken out. So that put me in tune with Uniroyal. I had to go back and forth to speak to the officers, and I also to make sure that the deductions were correct. The home office was in Akron, Ohio, and we would be audited. In fact, I simplified a book-keeping system for them.

I never went to conventions, but I went to schools for treasurers, places like University of Connecticut. I gave them my version because other officers with the union in other places like Armstrong Rubber Company in New Haven belonged to the same union. When they had those sessions the office in Akron would send me to train newly elected treasurers that were having trouble. Because most of the people elected to office in the union were people that worked in the plant. What kind of training did they actually have? Not that I'm the smartest person in the world, but they liked my system, which was so simplified.

They took my training very well, from late nineteen fort-four until nineteen seventy-four. By plain math. You know what? If you go to school and learn your math one way, or book-keeping, you devise your own system. When you go to work someplace you put together whatever suits, whatever makes it easier. And they adopted a lot of things from me.

I worked for five years for UniRoyal but it closed in nineteen seventy-nine. Everything was outsourced to Taiwan and Korea. I was the first woman on the Board of Finance. We had town meetings, and if you were going to raise taxes or add this or that, you went to a town meeting and who had the loudest voice . . . and then Naugatuck decided to go into commissions, to break down into departments, into boards. It was an appointed job. They heard from people I was in a strategic position in the union office and people admired me for whatever. When our auditors came from Akron, we would go to the three banks in town that I banked for the union, and I'd take ten steps and someone would say, "Hi Rita," or "How are you, Rita?" and I remember the auditor saying, "Oh my God, do you know everybody in town?" Well, yes, pretty much.

"They Wanted Me to Become a Communist"

Florence Fusco:

When I quit school my mother said, "You're not going into a factory! Either school or you

learn the tailoring trade." So that's what I did. I learned to be a seamstress, a tailor by hand. We used to make custom clothing for Rosenthal and Moret's in New Haven. My mother was a seamstress there too. I worked until I was eighty-eight, and finished at J. Press.

We started from scratch, making the canvas, then the tape that would hold the edging firm. That was the beginning of the coat, then the lining, and we had to do the lining and the collar, the buttonholes. Everything was done by hand. Up until I was eighty-eight. But then when the Japanese took over, then the custom went out, and everything was by machine.

I was sixteen around nineteen twenty-nine on the Yale campus. Those fellows used to dress! That's where they used to have their clothes made because New Haven was known for custom tailoring. Because our boys used to go all over the United States to get the customers. They never had the customers just from around here. The different men went to the different colleges to get work. We had a customer that used to order fifty suits a year for him. And they were thousands of dollars. He was a millionaire.

But the union men from New York who used to come up and organize us, they used to wear black shirts. That's how we knew them, with their black shirts they used to wear all the time. I didn't like them. I used to say that they were communists. But the woman that was with them was a communist. She used to try to talk me into it. I said to her, "You don't have to talk to me about anything, I don't want to know nothing. I'll join the union, but don't tell me to join your organization," because she tried to get us to become communists. But I wouldn't do it.

I had to join the union in order to work. There was a place on Elm Street, Fraternal Hall, where they used to have the meetings. Before the union, at Rosenthal and Moret's, my pay was very little, twelve, thirteen cents an hour in nineteen twenty-nine. And you'd get five cents every time they'd have a meeting that you were going to get a raise, it was about a five cent an hour raise. We were making twenty-three cents an hour, oh that was big money! My mother knew unions. She was a widow with five kids, was a seamstress, and she went on strike when I was small, in the teens. And that's when she went to the laundry. She said, "I can't stay on strike, I have to work. My kids have to eat."

"The Strike at Siegman's Tie"

At ninety-seven, Mary Altieri won the Greater New Haven Labor History Association's Augusta Lewis Troup Award in 2009. She was honored for her refusal to cross the picket line during the strike at Siegman Tie in the early 1930s.

Around nineteen thirty, I worked at Siegman's Tie. It was a big shop, a couple hundred worked there. The cutting room downstairs alone was five people cutting, so they must have cut a lot of ties. They had at least ten, twelve girls in the slipping department. And they had people pricing the ties. They had ten in the packing room, twelve in the stitching room. In my room where I sewed, the pocket was another eight. The people upstairs made bundles of a hundred.

The work came in crates, in bundles from New York. And then they laid them out, and they got to cut them. Like the dresses, they

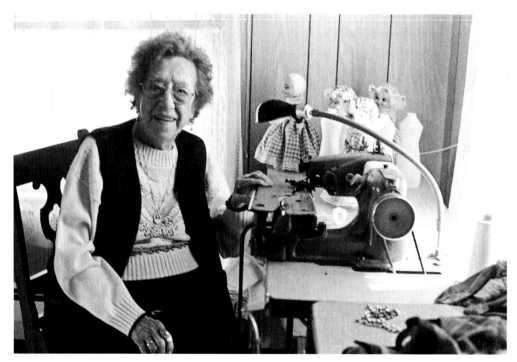

Figure 10.4. Mary Altieri at her sewing machine in 2007 at age 95.

came in rolls. They put them on the table, and rolled them off. Then they put patterns down, and then they gotta cut them through the pattern. Same with ties. They gotta have a pattern to cut that, the shape of a point or round. They had different styles. Striped, plain ties, ties with little flowers. We used to bring them home in bags, and we used to turn the pockets inside out. They were sewed, and we had to turn them. Then they went back, and then they had to stitch them all around.

My mother, my sister, we used to have extra work. At Siegman's my job was setting the little lining pockets on the machine, the linen lining. They call it "the pocket." I never worked on the "slip stitching," and they used to do that by hand when they closed the tie. They went on strike for two years, but they couldn't start a union. He [Arthur Siegman] was a very intelligent man, and he didn't want a union shop, so all the people that went on strike were out, and they lost their jobs. The union people told everybody in the shop what we were going to get. But Mister Siegman said to them, "You can join if you want to, but you're not going to work for me. What do you want? You get so much now." And that's why a lot people didn't come out [to support the union], they had a job, boy they didn't have to come out.

But we were stupid [to support the union] to get out, what are you gonna do? It must've been that way because they never came out and picketed with us. All the men cutters, the women in the shipping department, they never came out. The forelady used to give speeches to us, "Don't listen to him [Siegman]," and all that. But they stayed, and they never came out of work [to support us on the picket line]. They used to walk in front of us [crossing the picket line and going to work] and that's when they called them names. The cops were there, and once a girl pushed them, and they put her in the pie wagon. They couldn't fight them.

There were a lot of people who wanted the union. There was Mary Spignesi, and she was the boss, the Gelardi girl, the cutter, Benny Pelosi. Quite a few people worked there, but after the strike he didn't want them no more. He got all new people. A lot of people picketed.

My brother-in-law was a union man, Fiore Palmieri. He was a union representative. But they had a couple of guys from New York [who worked] for Siegman, and they used to come to the house and talk to you, say, "Look, you're

going to lose the job if you don't go back to work." The ones that were organizing for the union used to come and talk to you, saying, "Look at the conditions you're working in," and they wanted you to join, but the people wouldn't listen to them. They'd say, "Tomorrow we're having a big meeting for the union, come down there for the union." A lot of people wouldn't go. They didn't want to go against the boss. They were getting paid all right. For some reason, maybe the people who were working for the union were getting paid off or something, *chi cazz capisce,* who the hell knows what happened?

We were supposed to get ten dollars a week. We got shit, we didn't get nothing. They used to beat the girls, put them in the pie wagon. Oh yeah. A lot of girls on the picket lines, they used to call the ones that used to go into work, names, "You scab!" you this and that, and they used to get arrested. Sometimes, as they were breaking the line, they'd answer the cops. "You don't want to go home? Get off the line!" They wouldn't, and so they [police] used to take them in the wagon. Sometimes they hit the people going into work. Because they didn't want to come out [of work]. They wanted to stay because they were afraid of los-

ing their job. And they used to say, "Mary, come back to work, don't listen." But I was afraid because everybody was getting hit and "You scab!" and push you around. The cops were there every day.

In the shop they told my father, "Let your daughter go to work." My father was the janitor of the building. And he used to come home and say, to me, "*I' ti porto in do officio,* I'll take you to the office, you don't have to picket, because I have the key, and they won't know that you're going into the shop." I was afraid to take that chance. So I said to my father, "I ain't gonna do no more picketing, I'm staying home and you're not bringing me no place and I'm not going to go." I was afraid and I told him, "Pop, they put you in the wagon and everything, I don't want to go." My mother said, "*Lass a ghì', nun vuo ghì' e nun vuo ghì,* Leave her alone, she doesn't want to go."

I was out of work a long time, and it was bad because my mother lost all her home work at night. People today don't know poverty. Because all the other shops got in the union in nineteen thirty-four. Then after a while my father went looking for jobs for me and got me a job at Buonocore's dress shop, and there was another strike, and we were out picketing

in the street. I had to walk up and down, up and down. It [picketing] wasn't as bad as the [Siegman's] tie shop.

They had meetings at the Fraternity Hall on Elm Street in New Haven. They joined, and they made a parade. Everybody from all the dress shops—they were all out there, from Chapel Street, Chestnut Street, they were out the street yelling when they got in the union, "Hey, we won! We won!" They took pictures of all the shops, and put it in the newspapers. Of course, some of the bosses were mad because they never thought they were going to get the union in. For some bosses, they stuck to their guns. They didn't give a shit if they lost their business. But they make the business after, because when they get the hell out [of a union environment], they do whatever they want, know what I mean?

But we got in, thank God! We were paying thirty-five cents a week off the pay for union dues, and then they went up and up. We made a dollar ninety-five an hour. I worked in Buonocore's in nineteen thirty-five. Then I got married, and I stayed out for a little while, and then I went back. Later I was a forelady of my department, the "blind stitch" on the Merrow machine at Mode Dress. They wanted me to

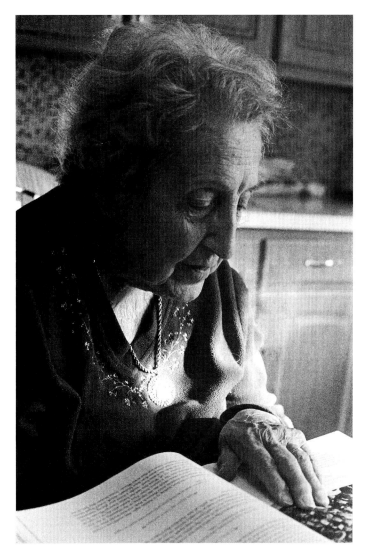

Figure 10.5. Louise Bombace Savo reading at her home, 2007.

get out of the union, and he [Harold Conte] was going to take care of me when I retired. Bullshit! I wouldn't have gotten anything, like

the other forelady. She didn't get a penny. I said, "Harold, I'm not getting out of the union and I don't want to be your shop steward. I want to work!"

"Jennie Aiello and Lesnow"

Louise Bombace Savo represented many women of her generation in the 1920s and early 1930s who quit school at fourteen and worked in shirt factories for three dollars a week during the Depression.

They had no choice.

There were no other shops around, only shirt shops. And Lesnow was the closest. So in order to walk there, who drove a car at that time [in the late 1920s]? I didn't know what a car was at fourteen years old. So we used to have to walk from Collis Street to Franklin Street in New Haven.

First, I used to clean the shirts. They used to hang them up on a hanger and put them on a rod, and there used to be all threads where the stitching left off. And there used to be all threads hanging. We used to take a scissor and clip all the threads off. Then after that, when you got a little older, they taught you how to run the machine because everything was run by electric. There was a pedal on the floor, and you pushed it, but you had to be careful of your fingers that you didn't catch your finger under the needle because if you didn't know how to run those machines, they were fast.

Then I did cuff turning. You had to turn it and stitch it all around. No piecework! My first pay was three dollars, eight to five, and a half day on Saturday in nineteen twenty-eight. We were paid by the hour. Flat rate. The older girls did piecework. They were older, eighteen, nineteen years old. They made more money. They were already there and older, and they gave them the job.

Jennie Aiello was one of the leaders. She was a nice person. She tried to help everybody to see what we could do to make things a little bit better. She would say, "Gee whiz, how are we going to get along to buy food for what we make? We gotta do something about it." There was no work around for people to work. There was only the Ideal Shirt Shop, Lesnow, and then Brewster came in. It was all shirt shops because that's all there was. And then the dress shops came in.

Things at that time—you didn't think anything of it—because that the way it was for everybody. Everybody was in the same posi-

tion that they didn't have money enough, and there was not a lot of work around. People couldn't say, "I'll quit here and go work someplace else." You were there, and that's what you were doing. You were working and that was it.

And you had to work at home too. Don't think you got away without working at home! I was fourteen years old, and I had to quit school and go to work. I always resented that. I used to tell my mother all the time that I wanted to keep going to school. It was unfortunate, but we couldn't help it. All of us. My brothers, too. Don't worry, I didn't have a good education, let me tell you! I cried so hard because I had to quit. I loved school, I loved it. I was a good student. I had all As and Bs.

I wanted to be a nurse. I wanted to help people. Because at that time, as the Italians called it, was *a leggiera*, The Depression. We had no choice. We had to help out the family a little bit. Unfortunately, that's the way it was. The families didn't want to *scumbari*, to feel embarrassed. Not because they wanted to, but they had no choice. Everybody was in the same position at that time. They didn't say, "Oh, that one there got a lot of money, they don't have to worry." Nobody had money.

Everybody had to work hard to make the family get along, to help out.

Nobody owned a house. You were lucky if you got a rent. There was no money around for anybody. They [my parents] said, "We can't help it, because we need the money." So my sister and I had to go to work. She went first because she was a little older than me. I went to work at Lesnow in nineteen twenty-eight. Three dollars a week! Eight to five and a half day on Saturday. Flat rate, no piecework. Oh, a lotta money? Well, at that time when I say that, they look at me like what are you crazy or what? But at that time three dollars a week was lot of money. A loaf of bread maybe was three cents or five cents at the most. You could buy a bag of groceries like this. Pasta. Maybe five cents a pound. Big, big boxes, for the spaghetti, smaller boxes for the pasta. No wrappings, no nothing on it. You just pick up a handful of macaroni, spaghettis, put them on the scale. They used have a little shovel for the smaller macaroni. Weigh them up. Put it in a bag. Paper bag, no plastic, and you used to bring it home.

There were no packages like now. Why do you think it's so expensive now? All right, you gotta pay these people to package these things.

You gotta buy the paper, you gotta buy all this stuff. It makes a big difference. But everything was so cheap that you'd be able to live on that money. I never went hungry. This is what I can't understand today, though. They say these kids go to school hungry. They don't eat. I never remember going to school without eating. My mother used to get three or four loaves of bread, and they delivered the bread, the milk. She used to slice the Italian bread. Stick in the oven, let it get nice and brown. At night, when we came home from school, she used to fix it with oil, dampen it a little bit with water, and then she put salt, pepper, oil, and if you liked it with garlic, she'd put a little sprinkle of garlic on it. And we used to enjoy it, okay?

Now today they say the kids go to school hungry, they don't have any breakfast. How could that be possible? A loaf of bread. You buy a loaf of bread and feed the kids. This I can't understand when I hear that on TV. Buy a loaf a bread, give 'em bread. We didn't die livin' on bread. When it came to the point where they figured, well, gee, how are people going to live like this? And then John Lauria said, "We gotta do something, we can't go on like this, how could these people work? Work all these hours and earn so little money?" And

then we went on strike. We started to walk the picket lines.

We used to walk all around, all around. They used to take so many girls at intervals to walk, and then they used to get another group to walk again, in other words, you didn't do it all day long. They used to have different groups doing it. I told my parents about walking the picket line, but they didn't know what it meant. My parents were from Amalfi and Atrani and they worried, and they used to be afraid that God forbid something . . . they didn't want us to get hurt. They used to say, "Are you sure you're not gonna get hurt?" Because they were afraid, and they figured what if a fight breaks out? They didn't understand what the heck the union was all about.

And we'd tell them, "Oh no, you don't have to worry, we'll be okay." Because we were kids! What the heck did we know, fourteen, fifteen years old? Today, you gotta be afraid of everything. In those times you weren't afraid. No, I wasn't afraid. I used to think, well, what could happen?

They used to have fights all the time. The owners didn't want the people to picket because they figured this doesn't look good for us to have people picketing. And then, before

you know it, someone would say something, and the other one would say something. And who would give them right, who would give them wrong. And then before you know it, they would fight. But not that they fought and hurt themselves bad. Sometimes only with words. They'd say, "What are you talking about?" between the people who were in favor of it [the union] and the people that were not.

A lot of people needed the money so badly that they didn't feel that they wanted to go on strike. If they had like say, six, seven kids, if they went on strike, where's the money gonna come from? How we gonna survive? So they figured why don't we settle and go back to work? At least whatever we made, we made. At least we can put a loaf of bread on the table. But then a lot of people didn't believe in that because then the union kept saying, "No, we gotta stick to our guns," which in a way was right, because how could you survive?

I went to the union meetings, and they used to talk about what they were going to do, and how they were going to do it. Nothing really drastic like they were ready to kill somebody or anything like that. No, no. They said, "Well let's see how much we can do." Oh yeah, because you don't know what was going

to happen. Because a lot of times fights used to break out. They used to say, "The union wants this," and they used to answer, "No, you can't have that and you can't have this." And so people used to argue, "What good is the union?" And the other ones used to say, "What do you mean? The union is good! At least we'll get more money!" And before you know it, they used to break out in fights [on the picket line], but not that anybody ever killed anybody. The cops used to come to make sure there were no emergencies of any kind. They'd say, "What are we going to do?" They needed the money. They had families to support. They couldn't be out that long. They needed money to feed their families, and there wasn't that much money around anyplace. It was everybody in general that didn't have money. Then they finally decided to give us a little more money when the union came in.

"Lucy and Jennie Aiello"

Sal Garibaldi:

They used to meet down on Waterside Park in New Haven. I lived on Chestnut Street, and being nosy, I'd go down there on a Saturday

because I knew girls working there [in the sweatshops]. It was a hush-hush affair. So Mayor Murphy and the Chamber of Commerce, the people who were the power in those days—they must have contacted the mayor to take those people out from demonstrating at Waterside Park. Well, the cops went down there and broke it up because they had no permit. The Park Department would not give them one. They used to have fist fights down

there with the cops. Cops came down and they whacked you, not only the men, but people like Jennie Aiello.

They tore her dress. She swore at them, and she had a dirty mouth. She was strictly union. Period. Where if I told her they don't like that, she'd say, "Go fuck yourself! Look at what the fuck they're doing!" If I said to Jennie or her sister Lucy, "Don't swear like that to the cop," she'd answer, "Fuck you and him!

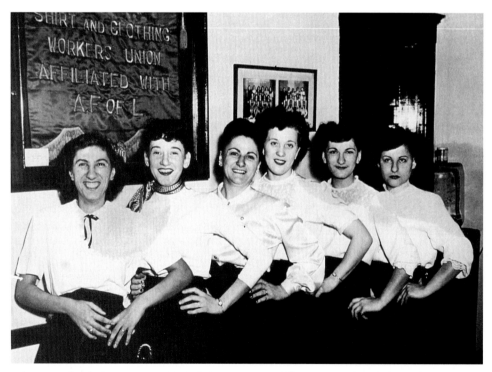

Figure 10.6. The Amalgamated Bowling Team: from left, Louise Aiello, Mary Christofano, Jennie Aiello, Ann Ardigliano, Natalie Aiello and Rosalie Gambardella, 1940s. Aiello family archives.

I'm fighting for my girls." She got whacked around. Today I wonder if some girls would do that. They'd pull back.

Lucy and Jennie Aiello weren't educated, but they had a big mouth. They feared nobody. They told you what they thought of it, whether you liked it or not. They'd stand up to you when other girls would never even talk to the boss because they feared him. Jennie would tell him in two seconds, "You're nothing but a crook." But what made them that way? Before the union, they didn't have to worry working for him. They could go to another place to work. They spoke up. Then the girls who had been keeping quiet and listening would get encouraged, and they'd say, "Tell him what he [the boss] does!" All the abuses.

Jennie had brothers. And they became floor workers too. Her brother Nick became quite the boy in the union [as a union representative] because of his sisters. Nick would be nobody without his sisters. All Nick would have to say to them was, "Tell him what he [the boss] does wrong."

"I Had a Union Contract Standing Behind Me"

Anna Calabrese Sagnella was one of the last surviving union chairladies of the dress factories.

As my children got older, they were on their own a bit, and I did my own thing and became a union chairperson at Mode Dress during the nineteen forties. The head of the garment places would say, "We need somebody who'll speak up for the company," and that's what we did. And of course they chose me because I had a big mouth. We'd say, "Well, who's going to be capable?" And they nominated this one, that one, the other one. I said, "Well, you know, I got my children, and I have to work around them." But before you know it, no one wanted it. So of course I took it.

I used to go New York with other dress shop chairladies from Insler's, Sunbeam, and A and M Dress. We all went to New York at the same time because it was one union. We all had contracts in New York. I worked for R and K Originals. We would meet at the railroad station, and we would go to New York where the manufacturers were and we'd get prices. Then we'd come back with the prices and address them to the factory workers. Sometimes they agreed, sometimes they didn't because they said the price was too low. Little did they know how we had to fight to get that particular price.

I dealt with R and K's manufacturers in the garment district. They'd get the garment, and

they'd break it apart and say, this much for this, this for that. Then they presented it to us, to our boss. The boss [Harold Conte] would come, "I got this, I got three thousand of these, and this is the price of them." Now the manufacturer gave him the price of what it's gotta be, put it out on the table for each part of the garment. So when the workers got it, they couldn't make any money. It was underpriced. So then they came to the chairperson, and the chairperson had to fight for them.

I was the chairperson. Each one came complaining, and I'd say, we'll sit down, we'll see what happens. Then before I knew it, the whole bunch of them [women] stopped working when they got three or four or five of them together, they stopped work. Now, if they don't work, it concerns me because I have to represent them. I had to go to Harold Conte, and he would fight with me, "Tell them to go to work. Tell them if they don't like it to go home." I said, "No I'm not telling nobody to go home. I'll call the union."

Sometimes he'd come down a little bit and give us a few pennies more per piece, but sometimes stubborn as a mule. Because he was playing with the company. So, he had a tough

one to work with, so he didn't get away with that much.

I would see to it that I got the proper prices for the girls that I worked with, to see that they were satisfied. If they weren't satisfied, I had the right to call them to stop working, and I would get the union officials to come and settle. I'd go to Harold Conte. I'd say, "Harold, I got a problem, my girls don't want to work," and he'd say, "What a ya mean? Ra, ra, ra," very, very arrogant towards me. I said, "Look, if that's the way you're gonna treat me, I'm not gonna stand for this. I'll just go out there and get the phone and call the union. I'll let them come in and settle because this is above my authority." So he didn't want me to call the union because he'd be put on a spot. So he'd come and settle a little bit, say maybe give them a half-cent more. And they'd be happy, and that would settle the problem.

But not always did this happen. Many times I had to stop them from going back on their machine, go in the hallway and call the union to let them come in because Mister Conte, the owner, would not agree on the price, or sometimes the hourly wage. We

worked garments as piecework setting sleeves for five cents, a waistline for ten cents. If it was a difficult sleeve to set it, it wasn't gonna be easy, and it was gonna take a little more time, so they wanted more money. So they wouldn't gripe at him. They'd gripe at me because they said I settled for the price. So I wasn't gonna take that, so I'd go back to him.

I fought him, Conte. He was tough, but we stayed as friends. He knew it was just business. It wasn't personal, just factory. He thought a lot of me and my family.

I was very strict. People used to tell me that [before the unions] it was either do this or go home. They needed a job, and they didn't want to go home, so they slaved. But my girls weren't gonna slave because I had a mouthpiece for them and a union contract that was standing behind me. Although when we first got into the union, the girls objected to union dues. So I said either you accept union dues or no union dues, and continue to work as you are. I had to address that. If we left it the way it was, if the owner said so much, you had to take that. Whereas we had authority now, and they had to listen to me. Because I went to New York and I settled for them.

I used to say, "If you don't want to listen to me, get another chairperson. I'm doing a job." I had a big job ahead of me, settling disputes. Let's say I said five cents to set a sleeve. I came back with the price. They didn't like it, the workers. They weren't going to work for that price, and they weren't gonna make any money. So now I gotta problem on my hands. So I go to the union officials. And I'd say, "What do I do with this problem?" Well, we'd have to call them all together to see if we could settle and come down a little bit or whatever, to satisfy them. And that's what we had to do. The sweatshops, that's what it was until we started all this, gradually getting out of it.

But it was a tough thing to go with these bosses that were making so much money. Then they had to cut down a lot. It was a drastic change for them. I could understand. I fought with Harold Conte on a very level base with him. And I told him I understood where he was coming from and the expenses he had. But I told him, you have to understand us women leave families to come here and we have to make it worth our while too. Spelled it out. Clear as possible. When you come down

to all this and start realizing what we went through, we did great. We got through it. We had a struggle, but at that time we didn't realize what we were going through. Now you look back and you say, Boy, did we go through that? Conditions. Where we had to live, how we had to live.

"Carol Paolillo's Union Rallies"

Sal Garibaldi described how Italian women in New Haven bought everything on credit: "A mother shopped all week in a grocery store and maybe spent twenty dollars for that week. When her husband got paid on Friday, she'd pay ten dollars and the store owner would 'carry her' for the other ten dollars because he didn't want her to go down to the guy on the next corner and lose her as a customer. The Italian and Jewish merchants along Grand Avenue who sold suits, furniture, and linens had a 'book' for their good paying customers. You never paid the milkman all at once. He got paid by the week, and he used to come by on Saturdays to get paid. So when your mother or father gained credit by always paying on time, they gave a son or daughter credit because they knew you were honest—now you were a good paying family."

In those days there were no labor laws. So once you reached the age of fourteen throughout the country, you could work. Here in New Haven it was Mister Marks in city hall. So when you wanted your working papers, you went down to see him. Now you had to take a test. He'd put his hand in his pocket and he'd say, "What's that?" And the girls answered, "That's money." And he'd say, "Who's picture is on it?" She'd say, "Washington." And he'd say, "There, you passed the test." It was comical. You had to do something that you questioned them. It was a trick.

And the same thing with citizenship. That's what made Anthony Paollilo party chairman of the Tenth Ward. And they were all Republicans! The whole country's going Democrat with Roosevelt, but not down here [Wooster Square neighborhood]! Here's where all the poor people were! See, but they believed in Anthony Paollilo.

Carol and her sisters helped Anthony filling out citizenship paperwork because he had so many to do. Like Carol would say, "How about making your father a citizen?" So you went to see Anthony, and for fifty cents you went to city hall and got your citizenship. So

to keep him quiet as an alderman, you didn't have to go through the examination. And if you didn't have the fifty cents, he say, "Don't worry about it."

As a kid, Anthony was my idol, and I started going to his affairs. He must have noticed me, and he heard about me, and I introduced myself and I used to help him out. Carol got wind of [bad working] conditions in the next room as a bookkeeper because the subcontractors had old lofts, like the old L. Candee Rubber factory that employed over a thousand workers. Fifteen watt bulbs over each machine, the loud roar of the sewing machine, girls who were prohibited by the boss from talking. So they sang to one another, "*Mo venne ó sfacime boss*, Here comes that bastard boss." Naturally they didn't understand, and a soon as the first girl spotted the boss, they started singing. And they all stopped talking.

There was a small bathroom with no security for sixty, seventy women, and they used a Sears and Roebuck book for toilet paper because the boss wouldn't spend the money. No wash basin. If a woman had her period there were no disposable cans to throw them away. In those days the women didn't buy things of that nature, and the mothers gave them cloths, and the women brought them home to wash them.

Carol didn't work on a machine in the Par-Ex dress factory, she was a bookkeeper. Naturally, the guys from New York, the subcontractors who got the bids to make shirts or dresses, came to New Haven in these factory lofts and hired these poor young girls. They wanted some reliable girl to keep the payroll and all that. And Carol was educated enough to do that instead of working on dresses in the next room. The owners didn't like her because she was organizing the women in all the shirt and dress factories. The owners were treating them like slaves with cheap wages.

The bosses made it so the women couldn't communicate. No talking about where and what hour. So they sang [singing to the tune of "O Sole Mio"] in Italian, the date and place of their next meeting to "O sole mio." *O sole mio/Sabato/Ci vidimmo a dieci à mattina*, O Sole Mio/We'll meet on Saturday at ten." As soon as the others got the message, they changed the song. There were male floor workers there, and they were very close to the owners. They sided with the owners, and they were the stooges.

They got a dollar more. Sometimes the younger boys carrying bundles to the women at their machines so they didn't stop working would be questioned. So the boss asked these young boys "Hey, what's your sister singing about?" And he'd say, "Yeah, they're talking about getting together Saturday for a meeting." They probably didn't realize they were giving their sisters away. And that's how they got around the owners. They couldn't stop it because they were singing.

Carol was the same way as Jennie and Lucy Aiello. She lived on fifteen Collis Street, right around the corner from Wallace Street, and that's where she held the rallies. She'd say to the workers, "Meet in my backyard!" Her backyard was pretty big, and you could drive two, three cars in there. Now it's on their property. They stopped the policemen on the sidewalk, "Don't you come in here, private property!" She knew the law because of her brother. The cops couldn't go in, and that's how she held her rallies with all the girls from the shirt and dress factories. Even the guys, some who worked in the New Haven Clock Factory were there to support sisters and daughters.

Carol had a little table and a wooden bench so people from all the different dress and shirt factories could fill out their papers.

She'd invited a union leader to come and speak to the girls. The rallies got so big they had to rent the Fraternal Hall on seven Elm Street. Being Jewish owners of building, the Jewish subcontractors got to the owners and said not to rent it to them. So they had no place to meet. They went from place to place to find a place to meet. They met a couple of times on the green in New Haven, and the Park Department called the police to get them off. They were manhandled. They couldn't meet in the schools. Mayor Murphy wouldn't allow it.

Carol joined the unionization movement because she believed in it. She was more educated than the average girl in the community because the Italian immigrants didn't believe in daughters going to high school. It was "Go to work at fourteen." You could ask [at fourteen], "Well, what will I get?" And the answer was, nothing. That was the attitude. But Carol's people were a little more understanding. They were Amalfitani too, and they lived across the street from the Sargent factory.

She was a very outspoken girl, well read and well spoken. She went to high school because the family could afford it, and all her brothers had good jobs. If you went to high school you were considered a smart kid. High

school girls like the Paolillos didn't work on buffing and stamping machines in Sargent. They were bookkeepers and clerks in the nineteen thirties, and they were more or less in with the leaders of the company. Carol was a bookkeeper at Sargent.

Most girls were deprived of going to school. They didn't know how to read or write, and they didn't know how to keep a timesheet. So these girls had that big edge. So naturally, the foreman of that department knew she was a high school graduate. He needed somebody to keep the timecards. So when the union officials came to New Haven to organize the workers, they said, "Who can we talk to? Oh, Carol!" Everyone pointed to her because she was hepped up, she had writing and communication skills, organizing skills, a personality. She was one of the first negotiators. If the union had paperwork, she discussed it with her fellow workers telling them what it meant to become a member of the union. She'd say, "If we do this, we get stronger, we'll get better wages and a little better conditions."

"Carol Paolillo Shut It Down"

Sal Garibaldi described how young women bought sewing machines in the 1920s and '30s: "Most could not afford the cost of a machine, so they had a 'book' [of credit] given to them by the merchant. A young girl, sixteen, seventeen, would go with her mother to buy a Singer sewing machine. The owner knew the mother paid on time, so they gave her daughter 'the right to make a bill,' knowing the future buyer would make weekly payments like her mother did."

At one of Carol's backyard meetings, it was all prearranged, "This is what we do on Monday. Come to work. Sit down. Take it easy. At eleven o'clock, we're going to do this." In other words, make out you're working. There was an electrical board with a big switch. Shut that and all machines stop. And that's what Carol did. Now the girls can't work. The owners come downstairs and ask what happened. One of the stool pigeons said, "Well, somebody took the switch down." Carol didn't say anything to the girls because it was all arranged on a Saturday in her backyard. This action didn't happen just at her shirt factory, but it happened at Planeta Shirt Factory, at the Ideal Shirt Factory, Fair, Brewsters at Lesnow. Carol was knocking them all off, a lot of people were told what to do. Sisters of the girls from her shop also worked in other factories. They went to her Saturday meetings.

"Carol Paolillo Had the Power Now"

Sal Garibaldi:

Carol became the president of the union in Par-Ex.

Now she could tell the owner, and the owner made sure when she talked that they paid attention to her. She had the power now. The girls had a lot of faith in her. There were other outspoken women, like Edith Macri on Chestnut and Greene Street. And she became a Democrat politician, because the Democrats were trying to organize the women. This was in the Murphy administration in the nineteen thirties. Her brother Anthony must have been instrumental as an alderman. It was unbeliev-able that he became an alderman during the Depression years. If Forbes Sargent, the own-er of the Sargent factory ran against him, he would have been trounced by Anthony Pao-lillo. And everybody in that area worked at Sargent!

"She Tried To Right a Wrong"

Teresa Vitale, Ferdinando Parlato, and Caroline Pompano told the story of their mother Carol manag-

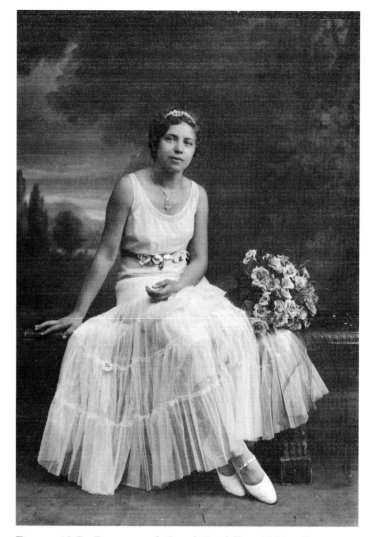

Figure 10.7. Portrait of Carol Paolillo, 1920s. Pompano family archives.

ing her children's money. She paid for her daughter's wedding in cash, pulling the bills from her bra. They recalled the Franklin Street Fire in 1957, when the

news reported the fire at the wrong address, where Carol worked. The panic-striken family frantically searched for her, learning later that she had gone to New York City to visit a niece without telling anyone.

Our mother, Carol Paolillo, was a leader. She was outspoken. When she saw right and wrong, she spoke out. If she saw a wrong, she would not only speak out, but she'd try to right it. These were sweatshops and these people who owned them were out to make money, and they used the immigrants, which is normal. And my mother—every time she tried to start something—they would do something so she couldn't do it.

She tried to organize by having meetings, even asking opinions, just doing anything at all, and they would sidetrack them. So one day she just went and shut the electricity off at Lesnow. If the sewing machines aren't running, then they can't do it. Don't forget, those machines made a lot of noise and everything. So when she got fired, my uncle Anthony Paolillo—a tall gentleman—had to go back to that place to get her job back. She went back to work, but what you have to keep in mind is once you were blackballed—these were all non-union shops [in the early 1930s] and there were plenty of people to work—so if you were blackballed from one, you couldn't go back to work in another one unless somebody did something for you.

Now my uncle Anthony Paolillo was an alderman from the tenth ward. When he walked down the street with us, the men would take off their hats and the women would bow. That's the kind of respect he had because he helped so many people get their citizenship papers. My mother had a voice that could stop a truck. She never had to raise her voice, and all she had to do was say our name and we would stop dead. And a lot of it had to do with working in the shirt shops.

She sounded like a man. She smoked Lucky Strike cigarettes. She was very opinionated, but she had a very strong sense of right and wrong. Honest as the day is long. If you gave my mother twenty-five cents extra in change, she'd give it back. She was a take charge person.

She was always good to people who were less fortunate. Down the street from us there was a Tasty Pastry Shop. My mother was a great baker, and she could bake anything. But she didn't have time once, and she had me buy a chocolate lemon pie because Joe Ruocco, the

farmer who lived with us, liked them. So I brought it home, cut it, and Joe had it in the plate, and he took a bite of it. My mother said, "Joe, what's the matter?" He said, "It doesn't taste right." My mother took it, and she took the chocolate off the top of it, and there was a little white layer. It was a lemon meringue pie that they scraped the meringue off and put the chocolate on it.

We knew what was going to happen. My mother said, "Give me that!" She puts the piece of cake back on the plate, and like the Pied Piper we're walking up the street. There was us, Joe Ruocco, the six Vitale brothers, and the sister from next door, walking down Main Street.

Now, Art, the guy who owned Tasty Pastry, is very short. My mother walks in the place, and now everybody is there. She says, "Art, is this pie fresh?" "Oh yes, Missus Parlato, I just made it." "Good, then you eat it!" and she stuck it right in his face. She went to the cash register and took out a dollar and seventy-six cents and says, "Next time don't lie to me!" My father was embarrassed to tears. We just stood there laughing. This was my mother.

There was a woman down the street that took in foster children, and my mother didn't like the way they were being taken care of. My mother, when she would see her daugther all dirty when she played with me, she'd bathe her and wash her hair. She'd feed everybody. She'd take care of people. She would take in anybody, any color, any ethnic group. You sat at my mother's table, you were accepted. If somebody was sick, she'd bring them stuff. She was a collector of people, of lost souls. Anybody who didn't have a ride, she volunteered our services to drive them, and I remember them [the women] talking after a day's work. They would be talking about who got two cents for cuffs, collars, who got this, and you could tell the favoritism that was there because somebody would do sloppy work, but they were a favorite, and they'd get away with it, or somebody would get the better job. When you're on piecework, some things are easier to do, and you can make more money, and they had to set the price.

The thing that always impressed me about my mother—because my father worked and my mother worked to help out—was that there were some women who were the main breadwinners of the family, and my mother would make the comment, "Well, you know, she doesn't have anybody to help her. So she deserves this." It might have been a seniority system, but every time they changed the style of a shirt, they'd have to figure out what each

part was worth. The boss has to make money, but the people had to make a living wage, too. So once they fixed the price on it, the stuff you could make money on, my mother would say, "Well, so and so took it, and they don't have anybody to help them."

"Chairlady of the Pressing Room"

Theresa Grazio:

After the strike at Lesnow in nineteen thirty-three, I became chairlady of the pressing room at Wales on Franklin Street. All the pressers were allowed to vote for a chairlady of the pressers, so once and a while, when it got too hot to work, they would come to me and say, "Tell him it's too hot, we don't want to work today. Shut the irons off." So I would go to Jack the foreman, and I'd say, "Jack we're not working today!" And he said [angry voice] "Whadaya mean you're not working?" "Well, we're not working. It's too hot, we're walking out." And then we'd walk out. We didn't have air conditioning. We didn't even have fans, nothing! [laughing]. It was a sweatshop.

Nothing happened. They wouldn't dare. I was the chairlady. And what I said . . . they had to follow through, so we all took the afternoon off. If we wanted a raise, if we wanted something like a Kotex box in the bathroom, we wanted a little more cleanliness around. No good conditions at all. They were sweatshops. We didn't have too much to do with the Lesnows, Harry and Sam, they weren't bad. Because don't forget, the union came in. Before the union they were no good bitches, I'll tell you, none of them were good. It was tough living, I'll tell you. Very bad. But there were times that we were happy in the shop. We had our own little group of friends. There was no money but at least we were happy with what we were doing. We had no choice.

"They Had to Convince Them"

Nick Aiello and Natalie Aiello Adamcyzk:

The union representatives used to come to my house, John Lauria and Aldo Cursi. They spoke Italian. My father used to be home and John Lauria would come over and talk to my parents about joining the union and what they had to do.

That's how we got into the labor movement originally. They had to convince them. When

we had social activities, bowling classes. I used to keep track of it, and at the end of the year we'd have a party and then go to New York, to plays and nightclubs. That was the social life. The married women, my mother, would enjoy Sundays when they used to have the Italian shows at the Fair Haven Middle School. And I used to go with my mother to the Italian show. That was their entertainment, Carlo Buti.

"They Had Daycare for the Children"

Nick Aiello:

Brewster's used to be at the edge of Waterside Park on New Haven's waterfront. In those days, the women had to go to work at eight a.m. But the kids got out of school at three-thirty, so they had to be home to get the

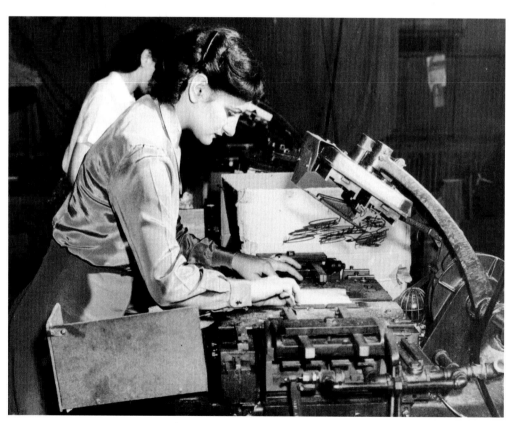

Figure 10.8. Natalie Aiello and Angela Sansone at work at Brewster's, 1940s. Adamczyk family archives.

kids out of school. Rather than let the kids go home, they made kids come to Brewster's. They used to sit them in the lunchroom, give them milk and crackers, and bring them to the park so the mothers could stay and work. And then at four-thirty they'd pick up the kids in the same building, on the third floor, a room with just the kids having lunch, having a nurse there take them down the park and play. And that was daycare. They had daycare before anyone else thought of daycare. They were no dummies.

"The Sunshine Committee"

Nick Aiello and Natalie Aiello Adamczyk

These women got harassed with pats on the ass when they walked by. They were the employees' favorite people. At the Lesnow fac-tory they had what they called The Sunshine Committee. The shop used to meet with the favorites, and they got the pay and they used take care of the grievances. This was before the union. The shops would have the Sunshine Committee, and they would contribute ten cents a week to this committee in case you got sick. They used to meet to solve grievances, but they were on company payroll, so any time you tried to organize anything The Sunshine Committee would go to work against your position. They were loyal to the Lesnows. The funny part of it was that after the union came in and you had a union contract, the employers were looking to get rid of the The Sunshine Committee because they were traitors, because if they did this to you, what the hell would they do with me? The first people they got rid of were the people on the The Sunshine Committee.

11

Women in Italy during WWII

Carlotta Fernicola emigrated to Connecticut after World War II. Like many Italian women, she lived through the horrors of the war as a young girl in Buccino near Salerno, the site of the American landing on September 9, 1943. Among the troops of the American Fifth Army were Italian Americans of Connecticut who could trace their roots to the villages dotting the Campanian countryside. Some died fighting in the same fields their grandparents had once tilled. With the Germans holding the American advance at the Gustav Line between the Mediterranean Sea and Monte Cassino, Italian women, often without husbands, found themselves trapped between retreating Germans and advancing British and American forces.

Carlotta's father, who traveled to the United States during work seasons, was stranded there during the war. With four children in her care and no hope for remittances from her husband, Carlotta's mother became the head of the household and assumed responsibility for her family's survival. To support the children she worked constantly at her loom, making socks and sweaters for people in town. Like most Italians in the wartime economy, she bartered her handmade clothing with local farmers for potatoes and oil. When stories of German soldiers raping local girls reverberated through town, she gathered her children and fled to the countryside, where they lived outdoors on a farm for months.

After the family returned back home for the winter, Carlotta reassumed her role as caregiver, helping with household chores. One summer day, after showing her *tessera*, government coupon, to an official at the town hall, she collected the family's weekly allotment of bread and olive oil, and headed home. Turning the corner to the familiar alleyway, she stopped for the daily *visita* at her grandmother's for chamomile tea and small talk. At the same time, children were gathering in the town square. Hearing the roar of engines overhead, a young girl pointed to the sky at the squadron of airplanes. Another thought it might be fun to count them as they soared by. Seconds later, bombs exploded around them, ripping

through the walls of Carlotta's house nearby. Carlotta raced to the scene where she heard frantic cries of women kneeling over dead children she had known her whole life. A cousin told her German soldiers had been handing out chocolates to a group of children in the piazza when they heard the British airplanes. Bombs followed, and in an instant, they were all dead. Lifeless on cobblestone squares, some still had chocolate in their mouths.

Early the next day, townspeople formed a funeral procession, weeping and looking to the skies on their way to the quiet cemetery beyond the walls of the city. Grieving men and women dressed in black bent over and gestured, gazing into the small faces of dead children laid out in Sunday clothes in wooden caskets. Seeking consolation from the tragic loss of innocent lives, they turned to one another, saying, "*Hanno fatto una morte sazia*, They look as if they died contented."

"Escaping the Holocaust in Italy"

Georgina deLeon Vitale recalled Jewish families in New Haven—Ascoli, Fano, Rieti, and Voghera—that took their name from Italian towns.

The Italian Jewish community in Italy is older than Christianity, older than the Vatican.

The Jews were brought to Italy as tutors to the Roman emperors, and as slaves by the Emperor Titus when he occupied Palestine and brought the Jews as slaves to Italy. They did not remain slaves very long because they were ransomed by other Jews in Italy who freed them.

So it's a very old community in spite of the fact that it is so small. And of course it's smaller since the Holocaust, when about eight thousand Italian Jews were killed. It seems like a small number compared to six million [in the Holocaust] but for the small Jewish community of Italy, it's a considerable number.

I was born in Torino, Italy, in a Jewish family; Jewish for generations probably from the time the Jews were expelled from Spain in fourteen ninety-two. My maiden name is deLeon and it is from Leon, so probably my family was expelled from Spain at the time of Inquisition and the Catholic Church and emperors. They went by France and then to Italy. Some stayed in Italy, others went to Eastern Europe. Others were already in Italy before from the old days.

We lived near the synagogue with most of the Jewish people, and we identified with the Jewish community which included an old age home and an orphanage, all part of the Jewish

community. We went to a Hebrew elementary school in the early nineteen thirties, and we followed the Jewish holidays with the family. My grandmother had the Seder for Passover at her house. There was no ghetto anymore, there had been a ghetto in Torino, but it was convenient to live near the synagogue and the school and the old age home. At that time people just didn't get into the car and go, and we did a lot of walking.

Mussolini came to power in nineteen twenty-two, and fascism was just a way of life, there was no other choice. People didn't vote. We lived in Fascist country and Mussolini did a lot of good things for Italy. He came in right after the First World War and there was a lot of unrest. There was also the fear of communism, so that's why he came to power. In a way, he was a better choice at the time rather than a communist. He did a lot of construction, draining the marshes in Emilia-Romagna and Tuscany. There was order, the economy was good.

In general, middle-class women in Torino stayed home pretty much, were housewives, and usually had live-in maids. To prepare lunch, it took the whole morning to go shopping, and you'd cook the whole morning because the big meal was at lunch. Everything just had to be so, a day to polish the brass, a day to iron, a day to wash and wax and polish the marble floors. So you needed help. People lived well and we children in school were also part of the Fascist Party. The girls were called *Piccole Italiane*, Little Italians, and the boys were called *Ballila*, for the fascist beret, and then the *I Giovani Italiani*, The Young Italians, and *Avanguardisti*.

We were all part of it, but there was no politics. The girls wore a uniform of black skirts and white blouses, the boys wore black pants and black shirts and the hat. We learned about Italian history including fascism in school. Many people were antifascist, and they had lived it before, and it was something people never said in front of the children.

My father was never in the Fascist Party. He never joined it. My grandfather did because he was in business. I remember him in his black uniform, and my uncles, too, because the business grew into two factories, and they built motors for the railroad. They had their own brand of batteries and sparkplugs.

Mussolini became enamored with power. He saw England had many colonies, and Italy is a small country and we didn't have all those

riches. So that's why he invaded Ethiopia and occupied Abyssinia, Libya, and Eritrea. They became Italian colonies and Mussolini made the king, Vittorio Emmanuelle the Third, the Emperor of Ethiopia and King of Italy. He became crazed with power.

And the next step was when he saw Hitler was gaining a lot of power occupying a lot of countries in Europe, and he thought he could bring the destiny of Italy with that of Hitler. Before that there was no anti-Semitism in Italy. We didn't feel any of that. There could have been a few little instances, but not where we lived. We found out later that priests from pulpit preached, "They're Christ killers!" But that happened before. If you go back to the Middle Ages in Italian history, there were pogroms in Italy, too, especially during Easter when the priests preached that the Jews made the matzo with the blood of Christian children. There was a lot of that, unfortunately.

A lot of anti-Semitism was born in the church as a way for Christianity to establish itself, and it had to speak negatively of the Jews. Because the Jews were supposed to disappear when Christianity was supposed to take over. It was the new order. And they did not disappear. They stayed, and they kept on believing their own belief, and not believing that Jesus was God because there is only one God. That didn't sit very well with the popes.

The worst part was when the ghettos were born in Italy in the fifteen hundreds. The pope decided that Christians could not live with Jews. So the first ghetto was in Venice. The word *ghetto* was born in Venice because the Jews were isolated in this part of Venice that had been a factory where iron was thrown, in Italian the word to throw is *getto*, and became *ghetto* in Venetian dialect. All the major Italian cities had ghettos, and all the Jews had to live in them.

By the time I was born in the late nineteen twenties, there were no more ghettos. The Jews lived wherever they wanted, and there was no discrimination in jobs. They could be professors, or be in politics. In Mussolini's government there were many Jews. We did not feel it at the time. But then it started to change. The first time I became aware was September eighth, nineteen thirty-eight. We were at my grandfather's home celebrating his birthday, and one of my uncles opened a newspaper and he read, "Jewish children will not be part of the school system anymore." We were not allowed to go to public school

anymore. Teachers were not allowed to teach under a law promulgated on September eighth, nineteen thirty-eight, called "The Nuremburg Law."

I felt desperate, and I loved going to school. I was twelve and had just started public school in nineteen thirty-eight. The racial laws began against the Jews. Our Catholic friends did not change their attitudes towards us. Most of the people didn't pay any attention to it, but the restrictions were there. You could not own a business anymore. My father and his brother formed a corporation, which they named deLeon, and it did not appear anymore. People could not teach in the schools, and it was very serious because they had to find other jobs.

In nineteen thirty-eight, we moved to Milano. The Jewish community there formed a school for the Jewish children, from nursery school to the first year of college because if you were already enrolled in college, you were able to continue. That was part of the craziness of these laws. My best school experience was there because we had the best teachers who had been university professors and were out of a job. My music teacher, Vittorio Veneziani, was the director of La Scala Opera Choir. He was thrown out of his job. He formed a choir

with us children and he had a tremendous influence on me, that school.

I was always a good student and breezed through. When I started this school it was so difficult because the students were ahead of me, more advanced, so I had to work hard, and I finally became proficient and enjoyed school very much. So we went on in the face of all the restrictions and life went on.

In nineteen forty, the war started. So at that point, beside the discrimination against the Jews, we also had to live through countless air raids by the Allies. When the war started, they bombed Milano, and all the major cities. We spent countless nights in the shelters while it seemed like the whole world was coming to an end. My baby sister was born in nineteen thirty-eight, just when the discrimination started, and it was a joy in our family, she was just such a wonderful child. It was such a joy to have a little sister. When we went into the shelter we brought her down in her crib and put her to sleep there.

By nineteen forty-three, the air raids were so continuous that they closed the schools in Milano and in the major cities, all the schools. It was my last year of high school, and my father decided to move the family to

Torino, to the villa my grandfather had up in the hills and out of danger. I wanted to finish school so my parents sent me to Rome, to my uncle and aunt who had converted to Catholicism, and their children were going to parochial school. One school run by the Dominicans, where my cousin went to school, did not accept me because they didn't want to take the chance. I'm not blaming them, but another parochial school run by the Franciscan Order did, but only as an auditor. They knew I was Jewish, but they accepted me even though it was against the law. I couldn't take exams or get marked, but I could follow the classes, so I spent my last semester there and went back to Torino in September, nineteen forty-three.

In July, there was a short armistice between the Allies and Italy when Mussolini was taken prisoner and General Badoglio became the president of this new republic. So everybody was happy and we thought everything was finished. We thought we could finally go back to our regular life. The boys in the army put down their arms and went back home. Italians were never happy to fight with the Germans against the Allies; it was just against the nature of Italians to fight with them. So they went back home. But in a matter of days the Germans occupied Italy.

September eighth is a date I'll never forget because that's when in nineteen thirty-eight the laws against the Jews started, and in nineteen forty-three, that's when the Germans occupied Italy. That's the day we went into hiding. My father was able to procure false identification papers. We all went together to city hall, and my father had a friend there who made false papers for us. There was a lot of movement at the time, people were going south because the Allies were coming up from there, or the people were escaping the South and coming north. We got false papers because we said we left this town from the South, and the papers had been destroyed, so we took new names, and my father had found a place to escape if things got really bad. One of my cousins married a Catholic man who had a small house in small town near Asti. So we took his name, DiGiorgis. Our papers said DiGiorgis, and we kind of changed our first names.

On September eighth, nineteen forty-three, my grandparents, my two sisters, and parents left our house by a station wagon, and went a town called Piea d'Asti, and my father rented a small house next to my cousin. We brought

whatever few things we could bring with us. Even though my cousin had married a Catholic, you were still considered Jewish and you weren't safe. So they came there with my aunt and uncle. And we started a new life. It was a very primitive house without lights, no water and plumbing, nothing but walls and rooms. My father was very handy. He put a sink and water in the kitchen, did the electrical work for lights, and made an outhouse in the corner of the barn. We met the farmers and we became friends with them because we loved friendly people, they liked us and we liked them. We helped them in the fields.

I loved it. When they were cutting the grass I'd go with the women with rakes and make piles. When they had to cut the wheat, we'd go into the fields and weed it. When it was harvest time this big harvesting machine came into the courtyard to process everybody's grain. I used to help. I liked to do heavy work so I'd go on top of the machine and push the grain down the chute. My sister wasn't as strong as me so she took care of the small

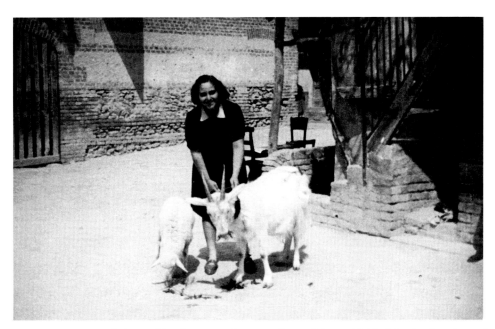

Figure 11.1. Giorgina deLeon Vitale on a farm in Piea d'Asti, 1943. Vitale family archives.

animals, the chickens. I took care of the big animals. For the whole summer I spent the whole time with the goats and two cows and sheep bringing them out pasture, holding them by ropes so they could eat at the edge of the road because we didn't have fields. I didn't mind, I enjoyed it.

We rented a field so we could have hay for the winter for our animals. I was one of the farmers, and we became very good friends with them. Eventually we bought a cow because my little sister needed milk and we couldn't buy it. The farmers used the cows to work the fields so they didn't make a lot of milk. Whatever milk they had, they used it for themselves. So we bought a cow, and when it had calves, we bought another one. Then we bought a horse because my father couldn't sit idle. This was wine country, and you know the Asti Spumanti comes from that area, so he brought the wine barrels to the *osteria*, the public house, for the farmers.

Being young I couldn't say I suffered because I enjoyed doing those things. It was much more of a hardship for my mother who was used to having a beautiful apartment with all the conveniences and here we had nothing. We stayed only three months and left in

December when we realized the Germans were rounding up Jews from wherever they found them. During these years of fascism, from nineteen thirty-eight, we had to register at city hall as Jews, so our papers said, *Di Razza Ebriaca*, Of Jewish Race, so it was easy for the Germans to find Jews because they had records of them.

We felt we were too conspicuous being all together. We were a family of six. My aunt and uncles and cousin had moved out. My cousin was working as a surveyor for the government, and they were building things not far from Venice, so he felt it was the safest place for them to be. Being right in a military center, they never would have expected Jews to be there. So we decided to separate. My grandfather stayed there, and my parents went back to their apartment in the city where a Catholic family was living. They had lost everything in an air raid, and lived right across from one of our factories and my father had let them use our apartment. So they were living there and my parents went to live with them.

My two sisters and I went to another little town with a traveling salesmen friend of my father by the last name of Alpozzo, who was Catholic, and had brought his family there

because of the air raids. He said, "Let them come to this town, my wife is there and I'll tell the people they are my sister's relatives from Genoa." My little sister was five by now, and we told her, "Our name is now Alpozzo." She said, "Oh, when we were in Torino, our name was deLeon, then we went to Piea and we became DiGiorgis. Now we're in Montanaro and our name is Alpozzo. If we went to Venice, what would our name be?" My oldest sister and I felt like crying looking at this little girl—she thinks this is normal, going from one place to another and you change your name.

So we went to this little town, Montanaro, and we rented just one room and it was full of furniture because people were bringing their furniture out of the city to save it from the air raids. The people we rented from rented it twice, once to the people and their furniture and once for us. So we had a bed and a table. It was a very difficult time. It was a very cold winter. We bought a little clay stove, just like a box with two holes, and you put the wood inside and cook with that and warm yourself. That's all we had and it was very cold.

This room was on a balcony, like a motel that has a balcony room. The outhouse was downstairs, and the water was at the public fountain across the street. My parents came to visit us every other week on a cattle car, because the trains were used only for the military. My mother went into disguise. She was beautiful woman, and she wore a babushka. My father grew a beard and wore a beret. When he came to visit, we sat in front of the little stove, crying the whole time they were there.

We spent a couple of months there. My sister who was eighteen was in charge and I was seventeen. We had to go out to buy food, and *fascine,* bands of wood for the stove, and we rented a little cart to bring it home. We brought it upstairs and stored it in a hayloft over our room. We didn't think of being afraid because Germans did not go looking for Jews in small towns. It was mostly in the big cities. Somehow we just looked like everybody else. We dressed poorly because that's all we had, several layers of sweaters because it was very cold.

I remember one type of food we made, *la tufea,* like the Jewish *cholent* [prepared by Observant Jews and cooked at a low temperature on Friday before the Sabbath] they make here, beans and potatoes, and you cooked it in clay pots for a long time. We'd bring it to the public oven and leave it there overnight.

And then when we brought it home it was cooked. Everybody else did the same thing. It was very good, it was thick.

My sister made very good rice and potato and spinach. Everything was very good. When you are hungry you eat everything. I don't remember eating much meat. After a few months, it was just too difficult, and we decided to all go back to Piea again. We went back, and lived there the next two years until the war was over.

The Germans came. They were there every week because the partisans were hiding around there. They were also looking for guns, and for men who had deserted the army. So they were there, and they rounded up everybody in the square. They went from house to house searching, but they weren't searching for Jews in this town. They were searching for young men and for guns. One day they came to our place, and they saw that the dirt in our vegetable garden had been freshly moved. So with a machine gun drawn, a German soldier had my father dig. Our dog had died and he had buried it.

It was a life full of anxiety for us, and for the other people whose children were hiding. One day the Germans came and established a lookout in a large courtyard where our farmer friends lived. Their sons were hiding in their *crutine*, down in a dark cellar with yellow dirt, from *tufo*, a very soft rock. Our friends felt that if they didn't hear any noises, the boys could come out. So they asked me and my sister to go talk to the German soldiers. So we did. There were people in the town that left the city because of the air raids and it was natural for us to be there. We talked to them. I remember one who showed us a picture of his wife and children. We were young, you don't feel the danger. We were doing a favor for our friends, and we were talking and talking so the boys could stay down in the cellar.

There were a lot of battles between the *partigiani*, partisans, and the Germans. And one day two young boys from the town were killed because they had joined the partisans. They were kind of wild kids, we were afraid of them. They were going around in a truck shooting guns in the air. But one day one was hit, and the other went to rescue him and was hit too, and they both died. They buried them in the same coffin. They were kind of embraced together.

My uncle and his wife went into hiding where his son-in-law was working. But my uncle was the restless type, and he couldn't

just sit there. He didn't even have false identification papers. One day he took a bus from Maastricht to Venice. There was a raid and the bus was stopped. I don't know if it was the Fascists or the Germans looking at everybody's papers. He had his papers, "Attilio deLeon, Di Razza Ebriaca," and they took him. He never came back, but he survived. One day after the war we went to the movies, and there was a newsreel of the liberation of the Dachau concentration camp. There he was, still alive!

So of course, right away we tried to find where he was through the Red Cross, through the Vatican. He disappeared. He probably died right there and then. The liberator told us, "They were dying like flies with typhoid fever, or dysentery, because they hadn't eaten for years, and all of a sudden now they were given food." He probably just died, and we never saw him again.

Many died in my husband's family. He lost his uncle who was the Rabbi of Pisa. They brought him to Auschwitz and he never came back. I have a picture when my husband left on the last boat to leave Italy, the *Rex* in nineteen forty, just before the war started. And this family of cousins living in Genoa, the mother, father, two children, and grandparents went to

say goodbye to them. And my husband took their picture from the boat. All of them were taken. And that's the last picture we have of them.

When the war was over our farmer friends who we had lived near when we went into hiding told us they knew we were Jewish, that they knew our real name. I don't know how they found out. They never said a word to us or to the Germans. They saved our lives. The whole town saved our lives. Just recently the Jewish community of Turin had this town of Piea recognized as a town of righteous gentiles. There was a beautiful ceremony—my sister was one of the people that started the whole thing in the town, and the mayor, priest, and the children of the people who saved us, went to it. My sister invited everyone there to dinner, and they had a lovely get together. It was a combination of a desire of my sister to have them recognized because they saved us and a couple of other families, too.

"They Are Christians Like Us"

Maria Sciarini described growing up in the town of Angera in Lombardy at the end of the feudal system she called the *coda*. As she showed me around her

expansive garden in Branford, with sections of neatly tended rows of tomatoes, eggplants, zucchini, and lettuce, she said that on a *giorno limpida*, a clear day, "you could see the Alps from my second floor bedroom."

Not much was said even in the family about Mussolini. Our parents didn't say too much about him. When the war was coming, we didn't want to go, and we thought he was crazy that he wanted to go to war, Mussolini. He did a few things that were pretty good, but then we started to register for Saturdays when you had to get all dressed and march and learn "Children of Il Duce." And then came the war. In schools they would tell us whatever they wanted, that we're always winning down in Africa. I can still see the teacher telling me, "Oh, we are here, we are advancing, glory, glory to Mussolini."

And then pretty soon came the hardest time because when the war was going bad, the Germans didn't trust us anymore. At first, Mussolini tried to get Italy away from persecuting the Jews and that is a fact. He tried to. Until he changed the law and they did all the bad things. The Italians themselves— we didn't believe in that. Because, after all, we didn't want to throw the Jewish people in the lake like the Germans did, and we helped them. My aunt helped some Jewish people in her house. She took them in and gave them a place to live. She never said anything to anybody. Nobody knew that they were Jewish.

We used to say, "*Sono Cristiani come noi,* they are Christians just like us." That was our way of saying they were human beings. I remember them, the Jewish woman was a nice lady. They were successful people. They were able to escape to Switzerland. My mother used to say, "*L'ultima volta perche la guerra è tremenda!* This has to be the last war because it is just too awful." I never forgot her words. She was right. Greed comes along too much and that's no good. It brings nothing—I'm not a historian, nor smart—but it never brings anything good. Mussolini came, Franco came, and look at the mess we're in right now [in Iraq], it hurts me so.

"Nino, the American Intelligence Officer"

When Italy surrendered to Allied forces in 1943 during World War II, the town of San Salvatore Telesino found itself at a crossroads between retreating Germans and advancing Allied forces. To slow the American Fifth Army, the Germans destroyed bridges

and deported or imprisoned many of the town's adult population. Luigi Rapuano was sure the American soldier the family had befriended and hid from the Germans was Italian American because he spoke the same Neapolitan dialect. Luigi Rapuano and his son Eraclito reconstructed this family story at supper in North Haven.

During the war in San Salvatore Telesino, near Benevento in the region of Campania, my brothers and I were sent out in the fields at dusk, or in the early morning to tend the family's animals. We went out to a pasture near a small river they named *il vallone* because of its fast-moving water that ran along a walking trail that only the local farming families knew about. After the Germans blew out the bridge, the farmers had to go all around and use this trail. This was one of the few areas where we could let our family cows roam, away from the German soldiers who shot them for food, or just for the fun of it. We let the animals roam so the Germans didn't know who they belonged to. To avoid detection by the Germans, we had to go out and feed them, often at night or in the early morning.

One day while we were in the fields we saw a man about twenty-five years old on his knees in the overgrown bushes. It looked like he was talking into a tin can with a long wire attached to it. So we watched him and heard him talking in English and then in Italian. We noticed his ripped American civilian clothes. He said he was lost and asked us if we knew anywhere he could get something to eat and some dry clothes, but that we had to wait because the Germans were patrolling the area. He told us he had no family and didn't know his way around. We talked it over and agreed to take him to our *nonna's*, grandmother's, house. We realized he must be American because we knew a little English since our grandfather had fought for the U.S. in World War One, and he taught us some words.

When *á nonna* saw him she was shocked to see this stranger, and she knew he didn't belong to any of the villages nearby even though he spoke Italian like us. She used to say, "*Í guaglióne hanno portato un àuto nin a casa di Luigina, ma chi é chist guaglióne che pare cómme nu strascione che avete portato?* The boys brought another kid to Luigina's home, but who is this homeless-looking boy you brought me?"

At first, he made believe he had amnesia and everyone started to call him *ó strascione*, the homeless-looking one who dressed

in rags. He called my grandmother *Mamma*. Our grandmother called him *Nin*, a nickname in our dialect for all the other boys who lived nearby and used to always come by the house to visit her. She told us to to hide him in the basement of the house, down the stairway of the *cantina,* our wine cellar, where we dried and cured our supply of yearly meats and produce from the farm. All the farmers had a room like this.

At first we brought him cheese, wine, fruit, dried figs, and olives. He would come up to eat with us, and he'd ask questions about the area and how many kids were in the Rapuano family. For the next six months he would leave at night and come back a few days later. Sometimes when he'd be away for a while my grandmother would send us out looking for him to come home to eat with us.

Nin è venuto arreto àuto vòta, the kid came back again, and just before the bombing started, he'd appear with others who were probably part of his circle of intelligence agents. Finally one day, he warned my grandmother that the houses near them were going to be bombed for the next two days, and we ran to the hills into the caves at Montaggine to hide from the Germans. My grandfather wasn't happy, and he worried that if the Germans found out *nonna* was hiding an American intelligence officer, they would all be killed and our houses burned down. She told him not to worry about the Germans. And just like Nino warned her, the houses he pointed out to her were all bombed.

As time went on, he finally told my grandfather that he was an American G.I., and that

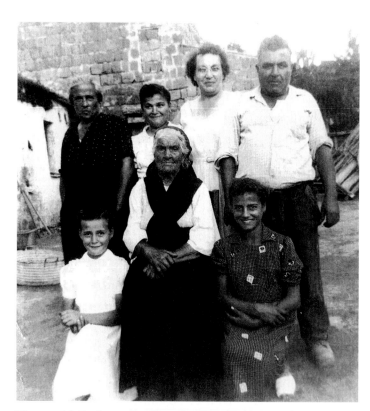

Figure 11.2. Luigella Pacelli Rapuano seated at center of the Rapuano family, San Salvatore Telesino, 1940s. Rapuano family archives.

he had been reporting his findings to the American Command in Italy. He said that if it wasn't for *nonna*, the bombing of Monte Cassino and the missions in the Campania region by the Americans could not have gone forward. Nino thanked *nonna* for her bravery, and shortly after that, U.S. army trucks filled with clothes, sacks of sugar, coffee, chocolate, containers of milk, and canned foods began pulling up in front of her house. Nonna would come running out of the house telling her kids that Nino had arrived. Nonna distributed a lot of it to the other families in town, and she knew all along she was helping the Americans the whole time.

"Noi Siamo dei Vostri"

Maria Cusano worked in Italy as a *donna di servizio*, a house servant, for wealthy families washing clothes on a washboard. She lived through the horrors of the German occupation of San Salvatore Telesino.

I was twelve, and remember when the Americans arrived in San Salvatore Telesino. My mother was making homemade noodles and beans at home. A German soldier, a really honest man, went to my mother's house and warned her to get out of the house, to run away because they were planning to bomb all the houses on her street. She took as much food as she could, and ran to Signora Pacelli's cave, a rich woman who had a cellar under her garden. My mother went there so she could feed all the people from town hiding down there. Just as she was leaving her house, a bullet came through the window, and she was lucky to escape. She got to the cave white as a ghost and she said, "I am alive because of a miracle."

By the time she got into the cave the whole street was on fire and the houses were destroyed. Then the Germans and the SS rounded up all the young people from town, young kids, lined them up, and shot them. The Germans had burned the houses on our street. They occupied our town and shot people because of the Italian partisans who were hiding in the mountains.

Then after, as the Germans were pulling out, the Americans began to arrive in Jeeps, and they came by throwing candies, cigarettes, and chocolates to us. Everybody was so happy, screaming and yelling as they went by. When the Americans arrived, I ran down into the cave and asked if anybody could speak English.

There was an old man, Zi' Carminuccio Guarino who spoke English because he had lived in the United States. He translated what the American soldiers were saying to us, "*Noi siamo dei vostri*, we are with you."

"Fleeing the Germans"

As a young girl Marietta Scalzo Novataro often cleaned the church of San Bernardo in Decollatura in Calabria. She dressed the mourning Madonna in black and on Good Friday placed a white handerchief on her arm because she was crying over the death of her Son. She said, "For us kids, *la nostra soddisfazione era la chiesa*, our satisfaction was the church, because there was nothing else."

During the war in Decollatura, the town used to issue a *tessera*, a ticket, to get a kilo of bread once a week for five people. When the bread finished, the baker had nothing left to give out to the people. There was little bread, macaroni, or olive oil. My mother gave us boiled potatoes, plain. No soap to wash clothes. We were terrified when the Germans came to our town that they would seduce our young girls and take them to Naples. My sisters, my friend, and I hid from them.

The Germans had fuel storage areas in our town, but when the war turned against them, they began to bomb us. They blew up the bridge and the roads. Then they blew up the fuel storage depot, and a lot of townspeople were killed. We left the town for ten days and fled to the country to my grandparents' house. I used to have to wash my clothes by the river on a brick with no soap. As we fled I can remember my sister Rosina putting her sewing machine on her head and walking for more than a half hour to save it. At the same time the Germans retreated, many Neapolitans were fleeing the bombing of Naples and were placed in small towns around our area. Each of us took in a family of Neapolitans. My mother had to give a family one of our two rooms, and five of us lived in one room with only bed. No electricity, only oil lamps. No bathrooms. (Translated from Calabrian dialect)

While the Boys Were Gone

Italian American Women in Connecticut during World War II

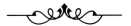

When Laura Maresca DeGregorio graduated from Hillhouse High School in New Haven in 1941, she had no career plans. After her father had forced her to abandon her lifelong dream of becoming a nurse, she went to work at Siegman's Tie Shop, where her aunts were known as top-notch slip stitchers who could turn out dozens of finished ties with lightning speed. After a few months, Laura realized that life on the production line of a sweatshop was not for her. When the Japanese attacked Pearl Harbor on December 7, 1941, America was suddenly thrust into a war that changed the lives of many women of Laura's generation. One night she read an advertisement in the newspaper from an army captain looking to hire women in Winchester Firearms. She applied for the job, and became the first woman employed in the department, inspecting rifle receivers. After a few months at her job removing potentially hazardous burrs from rifles, she was promoted to inspector.

With Americans fighting on two fronts, women all over the country joined the war effort to manu-facture war materiel. Strouse-Adler, a corset factory in New Haven, and Moore's Mill near Pawcatuck converted to parachute production. Toy and appliance factories such as A. C. Gilbert in New Haven, which manufactured American Flyer trains, converted their motor production for the war effort. To keep worker morale high, and establish a sense of solidarity with the men fighting overseas, sections of the Train Packing Department displayed placards "Burma Road" and "Rickenbacker Concourse." Naugatuck's mammoth U.S. Rubber factory went into high gear, adding round-the-clock shifts to mass produce landing craft, rubber fuel cells to protect gas tanks of airplanes from bullet puncture, and combat boots. In Bridgeport, women arriving to work in G.E.'s twelve cavernous plants on Boston Street heard "The Victory March" playing in the background. As the war went on, young women who had never worked in Connecticut's heavy industries replaced men called into the service. Imbued with a deep sense of patriotism, women earned the respect of co-workers and

supervisors for their ability to learn new skills in an array of production jobs, always meeting high-pressure deadlines that helped win the war.

Connecticut's Italian women joined the war effort sending sons to fight in the Pacific and Europe. In 1943, Maria Ceruzzi, an immigrant from Caravella in the region of Basilicata, gave her blessing to her youngest son, Luigi, to join the Navy at seventeen. A few weeks later she answered a knock on her door and let a Navy recruitment officer into her kitchen. Though Maria spoke little English and could not write, she managed to scrawl her name on her son's enlistment papers with a simple "X." Speaking to Maria in Italian, the officer verified her signature, enlisting Luigi with two older Ceruzzi brothers who were overseas fighting in the Philippines. Surrounded by her children at the kitchen table, she smiled, saying to them, "*Sì, quando Luigi se ne va, tutti i fratelli ritornano sùbbeto*, Now that Luigi has gone off to fight, his brothers will come home that much faster."

"Susie the Riveter"

Assunta Celotto Sirico recalled her mother's excitement when she recognized Mother Cabrini in a photograph from a newspaper article. Her mother had taken care of the young Mother Cabrini in Italy when she was in the convent's infirmary.

While my husband was fighting in France, I was working for the government. They called me "Susie the Riveter," and I was the fastest worker in the factory. I was making what they called vital parts for airplanes, little rivets to hold the airplane together and small screws, and it was tedious work. All I remember was that word *vital*. They needed these parts very badly for the bombers, and I worked fast. I was working on lathes, a long machine. Once I turned my head and my hair got caught in it. I pushed back really fast, and it tore a piece of my hair out. I was lucky, and after that I wore a helmet. Then I worked on a riveter machine. There were a lot of men and some women who were mostly Italian. Phil Scarpellino was my boss from Wooster Street in New Haven. They said I was the best and fastest worker. I never talked to anybody because I knew it was important. In July nineteen forty-four, I won the Army-Navy E Award for being the best worker at the New Haven Screw Machine Company. E was for efficiency. I wanted him [my husband] to come home, and I wanted to help in any way I could.

"They Sent Him Meatballs and Wine"

At the beginning of World War II, Julie Ursone started a four-year courtship with her husband through

letters. Before leaving for the war, he said, "I'll write." She answered, "Well, if you write to me, I'll write to you." Whenever her daughter Adele went on trips, she always waited for her mother to recite the old Italian proverb, "À *Madonna t'accumpagna*, May Saint Mary walk along with you."

My husband was stationed in an army hospital, which moved from England to Wales, and then to Scotland during the war. My mother used to send my husband packages with glass jars filled with meatballs and gravy. My father used to open up the big gallon olive oil cans and put wine in it, and send it to him in England. He sealed it in such a way that he was able to send it and he got it. Imagine? I can picture him in a tent somewhere warming up meatballs and gravy and everybody coming around wanting to eat it!

"My Sister Lena's War Letters"

Mary Scrivani told the story of her sister Lena's speech impediment. On the way to visit their brother Frankie at the hospital, they were pulled over by the state police for speeding. "Lena was sitting in the back seat, but she couldn't say 'Frankie' right. She always called Frankie 'Fahkeeyu.' So when the policeman came to the car, Lena started saying 'Fahkeeyu!'"Fahkeeyu!'

The policeman got very angry thinking Lena was saying F-you! We couldn't help laughing as we tried to explain what was going on. When the policeman realized Lena wasn't telling him where to go, and that she was mentally disabled, he let us go with a warning."

I grew up on the East Side of Bridgeport in the nineteen twenties, along with my five older brothers and my younger sister Lena, who had Down syndrome. My mother Nunziata (Nancy) was Napolitana. My father, Salvatore, came from a small town in the vicinity of Palermo, called Canicattì, in Sicily. We lived in a neighborhood among many other immigrant families, people from Poland, Czechoslovakia, and other European countries. Even though people back then usually associated with those of the same background, we all respected one another.

No one in my family went to college. In fact none of us ever finished high school. That's just the way it was. Only rich people went college, and we certainly were not rich. Work was what mattered to people back then. I had a wonderful childhood. Besides my sister, I was the only girl, and as a result I helped my mother with household chores—cooking, cleaning, and caring for my brothers, who in turn were very protective of me and Lena.

By the time I reached my twenties, the war broke out and three of my brothers joined the Army and were sent to Europe to fight. Those were very difficult days. We prayed and prayed for their safety. My mother and I would send packages to them often, with blankets, canned goods, and other things that wouldn't spoil. I was very scared. I did what I could to help around the house, to keep my mind occupied.

During the war, women took the place of men in the factories. I got a job on the three to eleven shift at Remington Arms. I was not much of a sleeper with everything that was going on. So after work, I'd go home to get a little rest and then get dressed up and go out dancing with my future sisters-in-law, Anna and Freda. We loved to dance and at that time there were ballrooms in Bridgeport where we'd go to listen and dance to the music of people like Glenn Miller, Gene Krupa, Benny Goodman, and Cab Calloway.

Bridgeport was a bustling town at the time. People from all over the country came here to work because of all the munitions factories and the very large General Electric plant that was located on the East Side, not far from my house on Shelton Street. At home, we always kept an eye out for military vehicles in the neighborhood. They were a dreaded sight because we knew that if we saw one, it usually meant that one of the boys from the neighborhood was killed in action. My mother and I were so anxious when a car showed up, but then we were so relieved when they didn't come to our door. It was always terrible, though, because we knew that one of our neighbors was getting the bad news. Our hearts broke for them. When that happened, people really did whatever they could to help and console the family.

When someone lost someone in the war, they would hang a black star in the window to let people know they were in mourning. Just the sight of one of those stars was horrible and very, very sad. One day we learned that my brother Mario, my favorite, was captured by the Germans. We thought that was the end for him. It was awful. Fortunately, the commandant of his camp was a decent man and treated the prisoners well.

Mario eventually came home safe and sound, as did my youngest brother Johnny, who was a real character. He was very handsome. I can't tell you the number of times he wrote to us telling us he got engaged. He had girlfriends all over Europe. My other brother

Frankie was not so lucky. He was hit by shrapnel in battle and returned home a cripple. He was able to walk eventually, but with difficulty.

That reminds me of a very funny story. My sister Lena was very, very particular and although she couldn't speak, she was very smart. She used to love to sing, write, and color. Her writing was very, very neat. She would write in symbols that didn't mean anything, but were always in straight lines. Well one day, one of her "letters" got mixed in with our regular mail going overseas, which was inspected by the government. So one day our doorbell rang. Two F.B.I. men dressed in suits came to our house. They had one of the letters Lena sent with our mail. They thought we were sending coded messages overseas! When they met Lena, they saw for themselves that our explanation was true. She showed them how she wrote. Once the men realized that Lena was innocent, they thanked us and left satisfied that Lena was not a spy! I'll never forget that.

"From Farmer to War Worker"

Althea Gabriel Simmons was the first woman allowed to make fertilizers at U.S. Rubber, mixing dangerous chemicals and powders, loading them into factory reactors, then heating and cooling them down for packaging. The job had been traditionally reserved for men.

Both of my parents came from Italy. They met in Italy and got married here. My mother was fifteen. Our family was poor, and we lived on our farm on May Street in Naugatuck. My father bought the property from Mister Walker. We'd go to work, come home, change our clothes—because you never played in the same clothes you went to school with—do our chores, and help our mother cook and clean the house, and go to bed. Get up the next morning and go to work. They never gave us much homework. We had plenty to do at home.

We didn't go anywhere, or attend any parties or anything because we weren't really allowed to go. That was the way it was. We were up on a farm hill. And we were afraid to even go into a restaurant. I wouldn't even think of going to a restaurant to eat . . . we were just bashful I guess. Now you can't keep me out of them! [laughing].

We never went on vacation. If we went on vacation, we'd go to my aunt's in New Haven,

and while we were going we'd cry because we were leaving home. We stayed overnight, and we were kinda afraid because we never did anything like that. We just worked constantly.

Our big treat was when we'd come down from the farm to the corner where American Pie in Naugatuck is, to my grandmother's house on the corner of South Main. We used to go down there to take baths. Where we lived, we didn't have a bathroom, we had an outhouse. We'd take baths at home, but only in set tubs made of soapstone. You had to heat the water.

Saturday nights, we scrubbed the wooden floors, and at night we made bread for the week with twenty-four pounds of flour we'd mix and bake. That was a must. In the morning we'd have to get up and milk cows and get the milk delivered to the houses. My father used to sell milk, and he worked at the Uniroyal Chemical Company and still did the farming. The farm wasn't enough to support eight kids.

We used to put cardboard on our shoes when we had a hole in them and heat up bricks in the woodstove to take to bed with us to warm the bed. We had to quit school our sophomore year in high school and went to work. In nineteen forty-two, my sisters, two

sisters-in-law, my two cousins, and I went to U.S. Rubber, at Footwear, because they were hiring part time. They called them "war workers."

We worked for forty cents an hour at the time on rubberized boats they called pontoons that were for landing in shallow waters during the war. The men put out the big rubber sheets. We cemented and stitched them. Everything was done standing. We bent over and stitched all the parts together. We were told not to tell anybody anything that was going on. We often got sick to our stomachs from the rubber smell of those fuel cells, from putting layer over layer of cement. I never got used to it.

We breathed in bad things all the time. We constantly had to get our blood checked. Ventilation was poor and there weren't any showers. We used benzine to wash our hands, to get the cement off our hands. They wouldn't tell us too much. "You do this, you do that," and that was it. You had to wear a badge, and you had to show it to get in.

My boss counted everything I was doing when I was making war boots in the cement section of the Gay-Tee room. You had to get so much out because everything was efficiency. So many boards, and they were like cookie

trays of fifty fleece linings that went into the boots. We had to measure each one a quarter inch, laid them flat, cement the linings. When we had fifty linings on the board, we put them on a rack, so when they got the racks on the line they just took them off the board and attached the sole to them and finished the boots. So I'd say to myself, I'll just put an extra lining on the board. And there was the boss, Bernie, hiding behind a pole, counting every one that I put down. He came over and said, "Why are you putting extra ones? You're wasting money. You're supposed to give them fifty, not fifty-two."

You were being watched constantly, and they made sure the line was running all the time, you couldn't stop it. You couldn't blow your nose. My aunt rolled up tissue and put them in her nostrils because she had bad allergies and couldn't stop the work. I was sixteen, afraid to speak up. Some of the older workers hollered and cussed at you on the line, "We're not making any money!" You were afraid to even move, or do anything, because you didn't want to lose your job. So we just did what they told us, and we would do it and that was it. It was tough. We'd come home and hand over the pay to our mom. We thought that was great—we were proud—when we came home with the pay and gave it to her. If we needed some money, my mother would give it to us.

"From Making Ties to Inspecting Guns"

Laura DeGregorio's grandfather loved to fish and built his own boat. He took his nine kids to the waters of Lighthouse Park, threw them into the water, and said, "Swim! You gotta learn!"

I graduated from Hillhouse High School in June nineteen forty-one. I didn't know what to do with myself. So I tried working at the Siegman's Tie Shop on Green Street in New Haven. It was like a dungeon to me. A gang of women, my god, all the women in there! They were mostly all Italians.

I didn't like the group of women there. First of all, I was young, I was nineteen, and you get these women talking trash, laughing all day, talking, and showing dirty pictures. Then all of a sudden I find a book in front of me [gasps], Holy Jesus! And they said, "Get the book! Get the book away from the kid!" That's all they did all day was talk trash. I'm sorry to say that but it's true. Not my mother, she didn't do that.

The first day they sat me down near this rack with all these ties hanging off, and I had to make a knot at the bottom and put it back. For three cents a bundle! And there were a lot in the bundle. And you'd be so careful, you go up there and the woman inspector, "This is no good and shhh"—throw the things all aside. She had her favorites though, that's why.

To get along with Siegman, you had to cater to him, and bring him food, sweets. Even the women, they all pussyfooted around him to get good work. He used to give them good bundles to who he wanted to. A good bundle was one that wouldn't open up at the end like mine. They give you a stick with a pin on it, and you have to tie it. By the time I got through, my ties were all opened at the bottom. Oh, I couldn't stay there. I didn't like the element at all.

I used to do slip stitching, and they put it together, and then they do it by hand. But I was on a slip stitching machine. You put the tie on it, close it down, and we girls had to turn it inside out, tie it at the bottom, and turn it inside out. I used to make mine not so high, so that when you opened the tie to tie it, it was too big. So one day my aunts helped. They brought all these ties to their house and sewed all the ends for me.

You had to make sure you tied it in the right place. My aunts, the Espositos, were very good slip stitchers. When they made a tie it was beautiful, you know. One of my aunts, she was one of a kind, and she worked there from when she was a young girl. She made good money as a slip stitcher.

I graduated from high school in June and in December the war broke out. I was very unhappy at the tie shop, used to go home with a long face. But then all of sudden I got a hold of this captain who advertised for war work for women workers and I spotted his add in the *Register*. We went into this room at Winchester, and there were these heavy square boxes with receivers for rifles.

And all the parts went into the receiver to make the rifle. I was an inspector, and we had to look for burrs. We had to make sure there were no burrs in them because it could cause the gun to go off in somebody's face.

But I liked the work there. I was the only woman there. I walked in, and I was the only woman in that department, a nineteen-year-old girl walking in, and a bunch of young and kinda middle-aged men waiting to get drafted. A lot of them were young and they all got drafted. We ended up being all women, two by two by two, they all went away and women

Fig. 12.1. Italian American women during WWII on the production line at Winchester. Ludwig family archives.

started coming in. Before I knew it, the whole room was all women. I was the boss because I went to work there first, so I handed out all the jobs.

It wasn't an easy job, either. They had these oily-looking containers that held the receivers, and they were heavy and hard for the women to lift but they did it. After a while that smell of oil, because Winchester was all oil, some of them couldn't take it. But nobody left, because it was good money.

There were Irish, all different nationalities. There were no African Americans, though there were other rooms full of blacks, men and women. When I started out as an inspector there were no blacks, but over the years they started coming in. But it was nice work, and I loved it. I was an inspector during the whole war and taught a lot of people, too. We used to get paid very well by the government, a beautiful check every two weeks for about four years. I was a good daughter, and gave

my mother the money and she gave me five dollars a week.

They gave us what they called annual and sick leave. We used to get so much money every month. They used to give us so many days sick leave, so if you were sick, you got paid so many days annually. At the end, I hadn't used much time off, so I had a pretty good nest egg.

They used to finish their work, set them aside then I'd lift the receiver of the rifle and look for burrs. So you're doing your part by being there. I felt good about that. You had that feeling that whatever you were doing, you were doing it for the boys. We got to know each other because we were young and we were dating, and some of us got married and went to each other's receptions. It was fun. We all got to know each other, being we were all left behind as the boys in my neighborhood in the Annex got drafted.

"Frank and Salvatore Carbone"

Laura DeGregorio:

Cooper's drugstore put a big cardboard plaque in the window, from Farren Avenue to Fulton Street, full of pictures of the boys. And there were a lot of boys, let me tell you. They were all good kids though, none of those boys got in trouble, none of those boys ever got arrested, and they were all nice boys from nice families. And as the boys got drafted, they gave Mister Cooper their pictures, and he made a collage of all the kids in the neighborhood, from Pardee Street, Quinnipiac Avenue, Fairmont Avenue. We had a lot of boys that went and a lot of them got killed. We used to watch and see which ones.

The biggest tragedy was when Salvatore and Frank Carbone were killed. Frank was the big one, and Sal was the smaller one, but very handsome. He was always whistling, happy-go-lucky, and the girls used to chase him, he was so cute. All of sudden one night we heard a big scream come out of their house. They got the telegram that Sal got killed, and the whole neighborhood got upset because we knew him from when he was small.

A few months after that, another big scream. My uncle lived next door to them, and when the screams came he said, "Oh, not again, we just did it!" And three months after, the other brother? The telegram came for Frank. He got wounded in Leyte in the Pacific.

He gets better and like a fool went back into action. When he went back in they got him. He was a big, strong strapping guy. And I'm telling you, it took a long time for the neighborhood to get over that. It was too much at once to take. In three months, two brothers. Missus Carbone became a recluse. She didn't go out anymore. She didn't want to see people, and she used to stay in the house all the time. She was always a fun-loving woman. Those were her only two sons. What a heartache. She never was herself anymore till the day she died. She really pulled away from society.

"The Short Wave Radio"

Annunziata and Florence Adriani recalled their mother from Castelfranco telling her children stories during the transatlantic voyage so they wouldn't worry about the ship sinking.

During the war, someone from the government came to our house in Bridgeport and my mother, being Italian and not a citizen yet, [they] came to check the short wave radios. They checked my mother and removed some of the tubes so she couldn't receive anything on the short wave radio. They did that with the Germans, too. A guy who worked with me was right from Germany and they did a job on him, gave him a hard time. They used to go around checking all the time during the war.

"Making Parachutes at Strouse Adler"

Angelina Gambardella Maluchnik recalled her mother baking cookies for customers like Mrs. Lupoli who owned a funeral home.

When the war started my brother went into the service and my mother went out and got a job. I couldn't see my mother working so I wrote a note to the teacher when I was sixteen, and I had my girlfriend sign it that I quit school. My mother and brothers didn't want me to leave school, but I wanted to help my mother. I got a job at Strouse Adler in New Haven. She worked upstairs in the parachute department, and I worked downstairs. She put the ropes on the backs where the parachutes opened. Strouse Adler made parachutes during the war instead of bras and corsets. Before, she used to make the corsets, and she put the steel pieces in the garments. I watched the girls dip them in white paint and then turn them over on the other side to dry. I was the youngest girl there. I worked

in the box department and made the small and large pizza boxes for Sally's Apizza every week and boxes for Malley's too. My brother was the truck driver. We were family.

"They Played 'The Victory March'"

Elizabeth Paul talked about her role during the World War II, proud to have been of service to the country's war effort in Bridgeport.

I wanted to go to work. All the men were gone, and it was all women working. You know the song, "They're too young or too old," well, only the older men and really young kids worked in the factories.

A lot of people had victory gardens and cultivated the land in another area G.E. owned raising vegetables with their kids. Everybody helped. General Electric was on Boston Avenue in Bridgeport and there were twelve huge buildings. On Fairfield Avenue, Bridgeport was booming. There was a brass company, the Bassick Company, all these metal companies like Warner Brothers. My sister went to work at G.E., and she looked older and they gave her the job. Then they found out she was only fifteen and she had to leave.

There were wiring sets that went into the airplanes. We had a process sheet that we had to wire it to such and such a number, and we had to crimp the color-coded wires, some were yellow and brown, some red and white. Then you crimped them to a lug and solder them and crimp them all across the top and down to the corresponding lug. We had to install condensers and capacitors, and all the different parts that went into that radio chassis for the airplanes, or whatever they needed them for.

When I first went to work at G.E. the windows were painted black so that the night shift couldn't have lights showing just in case enemy planes came over, or for some reason they sneaked through. They would have had a good target so they were painted black. But what I enjoyed most of all was walking in in the morning and they played "The Victory March." And that would just boost you up, and you feel so good that you were doing something for the country, and get the boys back because most of them were my friends that went off to war.

They were just kids. I remember all the east side boys from Bridgeport. My brother was at the railroad station downtown, and it was packed with boys going in, and all the parents

were out there crying. It was sad. What a terrible, terrible experience we went through. It was tough. It was a tough time. One of the worst times you could have ever been through.

Our paperboy Augie was sixteen, and didn't come back. The Porto boy. There was John Hillary who lived next door. They never came back. The two that were most important to me were our neighbors who lived downstairs from us, Joey and Emilio Mete were both in the infantry. They made it back and most of the boys in the neighborhood made it back, my brothers, too. The most wonderful part was when the war was over. Everybody came out of their houses, everybody was in the streets. We all went downtown to Main Street in Bridgeport, and it was full of people from one end of the street to the other. It was just jammed. Everybody was celebrating. It was a marvelous time, it was a happy time, yes, it was wonderful.

"My Brother Biagio"

Mae Dell'Amura often sat and talked with friends and customers at Libby's, named after her father "Liberato," who started the original pastry shop in the 1920s on Wooster Street in New Haven.

My brother was killed in World War Two. He was in the Pacific. He was a hero. He jumped on a grenade and saved the whole platoon. He received all kinds of medals.

My father used to pray to Saint Trofimena. We had a marble fireplace, and on it we had all different saints with the candles always lit. So one morning there's a knock on the door and a soldier is there. My brother answered the door. He had a telegram, "Your brother died in the service of his country." So my brother hid the telegram not to show my father. So my father said, "What's that? I know it's a telegram." He said, "Yeah it is." In a rage my father swept all the saints off the fireplace. They all went down except Saint Trofimena because he always prayed to her.

We always said, "How could it happen? That saint was right in the middle on the fireplace, all the saints went down, but Saint Trofimena didn't go down?" So my brother said, "He must have been so afraid of Saint Trofimena, or either he bypassed it." He said, "I can't believe it." I said, "You're an atheist." He said, "No. Why would all the saints go down and not her?" Then right after, my parents went crazy.

We had his body brought back. Up at the cemetery they had all the soldiers who gave

a twenty-one gun salute. They folded the flag and gave it to my mother. My mother broke down, so they handed it to me. I didn't know what . . . you can't imagine the feeling. That's why today I think of all these guys that died. My brother went in at nineteen. He died at twenty-one. Why? To be a hero. To save the whole platoon because he jumped right on that grenade.

"The Tears and the Black"

Norma Barbieri eloquently recreated the deep sense of loss that she and her neighbors felt when word came that a son had been killed in the war.

Our mothers were proud of us, women that had a job. They were making good money too. The women were very strong because some of them had three or four sons in the service, and you'd see the stars they put on the windows to let people know they had boys in the service. I remember one April around Easter time when three of our boys—all from very good families—and Joe Lenzi, who was absolutely handsome in the Marine uniform and went to sign up as soon as the war started.

Joe and Benny Amarone and Tom Fisko were all killed in the Pacific. All three killed and oh, it was horrible. We were all inter-cous-

ins, you know? Who was married to who, everybody was related. The tears and the black. It was horrible . . . to lose an eighteen, nineteen-year-old boy. I don't want to live through that again. It was just a very bad time.

I went to school with Joe Lenzi's sisters, and they were lovely. The mother was Irish and the father was Italian, a beautiful combination. They had four girls and two boys, a great family. My sister wanted to become a doctor. The men predominated when the war ended. Every school—law, medicine, and graduate schools—all the men went first. The women had to take a back seat. After the war some of the veterans never had the financial ability, but because of the war they got four years of free education under the G.I. Bill. We always took back seats, all the time. That's why I'm so happy Hillary Clinton made it in Texas and Ohio in the primaries. I think she's terrific. We'd be honored to be in her hands, really.

"Making Military Buttons"

Theresa Rubino Cipriano said that all her brothers and sisters were delivered by a midwife who lived down the street in Waterbury. At the end of our interview she showed me several examples of wartime buttons she had crafted at the factory.

We never had cars in Waterbury. Every place we went, we had to walk. I quit school when I was sixteen, and went to work doing housework for a woman who owned a mom and pop grocery store. I had to wait two years to get a job because they couldn't hire you until you were eighteen. The woman needed somebody to clean her house when her three sons went off to school. She used to give me a bag of groceries and maybe a dollar and change for working a few days. Once a week I'd do her whole house, and that's how I got to know all the boys, how I met my husband, one of her sons.

It was five miles to work and back from the Waterbury Button factory. It was an old building they made into a factory with old floors, not like the Timex factory, which was luxurious. The place was right in the middle of the houses in the French neighborhood in the south end. There were little restaurants, nothing elaborate. Once and while, when I had a few pennies, I went to the restaurant to get pea soup for lunch. It was a French neighborhood. You're not gonna get spaghetti and meatballs, that's for sure! To this day I still like pea soup, and that's where I picked up the taste for peasoup [laughing].

My first job was working on military buttons. I lived five miles from the factory, and I walked back and forth every day. I walked from one street to another street in all kinds of weather, put in eight hours, then walked back home. My mother used to cry, especially in the summer with all the humidity, seeing me in a mass of sweat walking back home. She could see how rundown and frail I looked.

I made twelve dollars for the whole week. Eight hours a day. Sometimes we worked on Saturdays. That was a treat for us because that meant extra money. I'd go to work, sit down at a plain bench, and it had a brass "chuck" that spun. I'd sit down sideways, my arm rested on the bench. I had a hand tool to press up against the button as it spins to give it an indentation. As soon as I stopped pressing against it, it stopped spinning, but when I pressed it with the tool, it would spin so I could make a ridge, a rim around the button. With the chuck, though, you had to let a fella come and inspect the button and say, "Oh, it doesn't look too good, it doesn't look too shiny or it's going off," which meant that the chuck had to be cleaned. The guys came—the tool setters—and filed and cleaned that chuck, it was a big brass thing. He'd clean it and sharpen down to highlight the eagle's wings so they stood out.

Then I was promoted and transferred to the opposite side of the room. Big deal. Instead

of using the machine with the chuck on it, I had a hand tool. I worked with all fellas all lined up on a production line. It was more delicate work because you didn't have the chuck doing all the work. I'd bring out all the highlights in the wings with the hand tool. It wasn't piecework. As soon as you filled up your little dish, then they'd put another one, check the one you finished, take a handful to check the work, and make sure they were coming out good.

I worked as an inspector on a different bench to inspect the buttons. We didn't have a union so we went from one place to another, wherever they needed you as a floater, "Hey Theresa I need you over there, Theresa I need you over here." We made twelve cents an hour during the war. After the war I worked in cosmetics on the caps of the lipstick tubes on a conveyor. I didn't like the lacquer, and I worked in the lacquer room with no masks.

"I Couldn't Get Letters"

Fannie Buonome:

I was writing to a fella in the service. But I couldn't even get mail from him at home because I wasn't allowed to. They were strict. How many times I wanted to get fixed up, and mother said, "*Ti manna a Longa-Lane a Farms,* I'm gonna send you to a Longa-Lane Farms," like Niantic prison for girls. And that's what I used to think of. I thought I was going to get a physical every time I went home! Anyway, we had supper one night, and there's a knock on the door. Who comes in but this fella I was writing to. And my parents, "*Chi siete? Non é manc Italian,* Who is it? He's not even Italian." And he said to them, "I want to take your daughter out for supper." They said, "*Va, vatene che chella mangiava!* Go! Get out of here, she already ate." I was so embarrassed. He ran down the stairs so fast. I said, "*Pa, chillo teneva á nu cumplimentà' pe' me,* Dad, he had a gift for me." They said, "*Non era per te,* It wasn't for you."

"I'm Not Passing Them!"

Fannie Buonome:

During the war, I was an inspector of twenty-inch shells for the Navy at Winchester Repeating Arms in New Haven. I had to throw the bad ones aside. But let me tell you some-

thing. When it came time to get your quota out, say you had to get a hundred thousand pieces out and we didn't reach yet because of the pieces we rejected, they used to pass them.

It had to go through this gauge, and if they didn't go through, they were bad. Another woman did another part of the shell, and it went down the line until it was all done. We used to put all the good ones over here, and the other ones we rejected. I had a fight with the foreman, and I went down to Personnel to tell them. I said, "I'm not signing nothin'. I'm not putting my name on them or anything. Those shells are going to our boys! And I'll be damned if I'm gonna sign and say that we passed them because we didn't! You passed them!" He said, "There's a reason, some are good, you know they're in doubt . . ." I said, "I think that's terrible. Our boys went into the service, and now you want us to pass these? I'm not doing it. You pass them." And that's what he did.

And I got my ass chewed out though. They said, "At the end of the month don't let Fannie see anything." But I still saw them. *Si vuoi mètte con un Italian?* You want to mess around with an Italian? And the big shots, just because they had to make the quota to get their money! And our boys were getting killed!

Then I became an inspector directly as they were coming off the machines. Every fifteen minutes I had to do all the machines and pick about a handful of the fuses. If the pieces were bad, I had to shut down the machine. And I used to get hollered at by the guy, "I think we ain't gonna make a goddamned penny today! You're shutting down the machine!" I said, "The things are bad." He answered, "They're not that bad."

"Working at Connecticut Hard Rubber"

Josephine DiGiuseppe:

I got a job right away during the World War Two. They needed help. They had two shifts, morning and night. Sometimes I had to work nights once in a while, but mostly during the day. The only thing about that job was a lot people couldn't handle it. They broke out with rashes and they had to leave. The smell of rubber was very bad. You could smell it from outside. It smelled bad anyway because the water from the Mill River in New Haven was polluted with so many chemicals. We breathed

that air all day long. I happened to be one of them that could stand it, so I stayed about five years.

They had a bunch of girls sitting at different assembly tables. They were painters, and they painted steel rings of all sizes, and hung them on hooks. Sometimes if we painted them too fast, and they weren't done right, they gave them back to us and said, "Well, you didn't do the paint right." The paint had to be just so, and we used to thin it out with thinner. Then the men in the back used to bake them in the fire and make motor mounts for airplanes.

After a while the guy decided they wanted more, so he put us on piecework, and we had to go faster on them. These girls were taking all their time. So when I first went in there, they said to me, "Don't rush! Don't rush!" I said, "Why should I rush? I got to paint these things!" And they didn't want me to rush because they said, "The guy's gonna set us up for piecework." So they wanted me to take my time, then when it came to piecework, then they kept going [laughing].

So then we were making quite a bit of money. We were getting seventy-five cents an hour plus a little piecework on the side, and that's how we made a little more money. We used to buy our own little brushes. We wore white smocks. We had paint. Every month or so we used to go up to the lab and the doctor used to examine us with a needle because of the lead paint. After they tested they used to say, "Go to your own doctor." It was against us to do that kind of work, but we did it anyway. It was lead paint, who knows what it was. We had women alongside us using sulfur, and they used to put all this yellow stuff that we breathed. And that's why they made us go upstairs. It was all chemicals.

"I Made More Money Than My Father"

Antonette DeAngelo recalled the streets of her Wooster Square neighborhood covered in wood instead of asphalt.

I worked in Sargent during the war. We loved it, even though there was no air conditioning then. We used to sweat! But I enjoyed it, and I worked till the war stopped, and then I got out.

I worked on the bomb shackle. How well I remember that big piece of metal. And we had to put them together, and we used to test it on a machine, and it would click off and let the bomb go. All the women worked side by

side with me—Italian, Irish, and Jewish. Oh, I used to run those big press machines. I loved it. And you know what used to get me? My father worked there.

So one day he came down the aisle, and he saw me near this big press. And they didn't have any kind of safety guards. He couldn't speak good English: "You no do that!" Ai! I was making money! To me it was money. When you put the piece in with your hand, it would pull you, like handcuffs. A girlfriend of mine lost her four fingers on it, and I'll never forget that. I wasn't working on it. But he looked at it and he got mad. But I made more than him a week! I used to make sixty cents an hour. That was money. My father used to cry that I took home more than he did. He didn't like the idea. He was making fifty cents an hour smelting all the crucifixes and the handles for the coffins.

"Making Bullets for the War"

Lucille Asor Ferrara's maiden name was originally Rosa, which had been changed to Asor, a palindrome of Alessandro Asor Rosa born around 1821, the illegitimate son of Giuseppe Rosa. The Bologna Office of Vital Statistics stated, "Concerning the last name given to the illegitimate Alessandro, it is possible that the natural mother tried to avoid acknowledging him. In similar cases the child was given a fictitious last name that often would refer to a condition of abandonment. In this case the last name would make us think of special attention given to the natural father, that being, married to another woman and could not legally carry out his paternal rights."

I left school when I was sixteen, and I went to work in the Hotel Taft and stayed there till nineteen thirty-nine. First I was a hatcheck girl, and it was very interesting. I met a lot of people, and then they transferred me to the front desk. I was a cashier checking out people. And all the actors that came to the Shubert Theatre in New Haven, so it was very interesting. And then the war came along, and I went to work in Winchester because they were paying a lot more money.

In my area there were over a thousand people. It was a huge factory. They were making guns on one end. They worked three shifts, around the clock. They were looking for help. I was only making about a dollar twenty-five cents an hour in the Taft. When I first went there they gave me a job with a machine that gauged the bullets to make sure that the primer was even. Then they just kept feeding us finished bullets with the primer on it. They

would dump them in bins. And then I'd have to put them on this machine to gauge them, and pass them on to the woman that worked next to me, and she put them in a tank. She boxed them. It was all piecework, the more you put out, the more money you made.

Then the government decided to put these bullets in these little cans, and they had a lacquer room. It was just before where I was stenciling. I could always taste the lacquer in my mouth from smelling it because the rooms were one after another. I made friends with a couple of the girls that worked in the lacquer room. I understand that a couple of them died with cancer in later years, and they attributed it to breathing in all that lacquer for all those years. I think this is why today I'm very allergic to hair spray or any kind of detergents because the odor bothers me.

Everything was on conveyors, and the containers with the bullets in them would go through the lacquer and come up and go through a dryer to dry them off. And then they would come down to where I was—this was another job I had—and I had a long conveyor belt in front of me with a stencil, and I had to stencil the can that was already lacquered. The stencil was yellow, and when I'd put the stencil on it, I had a brush and it described . . . all I remember is that it said "British three-oh-three," that was the bullet. And they just kept coming on the conveyor, and I kept stamping them all day long. Then it would go back on up a conveyor, and they had a fella there that worked for the government, Eddie Vitale. He worked up on a thing with a big tank of water, almost the size of a living room, and the cans then would go through the tank of water to make sure they weren't leaking. That was a boring job, to just sit there looking at these cans coming through to make sure that they didn't leak.

In nineteen forty-two, the government came up with a new machine and they asked me—because I was fast—if I would work on this brand new machine to see how many they could produce, and to make sure that the primer was even. I had all these government people standing around me while they watched me do my job.

"They Wanted a See a Little Bit of Leg"

Cecilia Ferrara Asor:

It was all women, all with different jobs. There was a mixture. We were young, and most of us were Americanized. The real old Italian women went to work in the sweatshops, sewing. My generation, my sisters and her friends, we went to work in Winchester because that's where the money was. In those days, poverty was bad, and you wanted pretty nice clothes. As a matter of fact, the first job I had, I worked next to an Italian woman and she said, "That's why I'm working here, I have to send my son to Duke University."

And the other job I had, I worked next to an African American girl, Lucinda. There weren't that many black people at that time, but there were some. She came from Down South, from South or North Carolina. And they came up and settled around Winchester Avenue. We used to talk. She told me her husband was a cop in New Haven, and sometimes after work we'd go to a bar on one of the side streets, and we'd go sit in the bar and have a little root beer or something.

Then I worked next to a French girl, and all she did was tell me jokes all day. My mother used to make eggplant parmigian, and I was the envy of all the women there because they would see me eating all this Italian food. They gave us maybe a half-hour lunch break. We wanted to keep working, you know, because the more we produced, the more money we'd find in our paychecks. We averaged about two hundred and fifty dollars a week.

During wartime a lot of the movie stars would come to Winchester Repeating Arms to sell the war bonds. Victor Mature came between sea duty in the Coast Guard to promote them at these War Bond Rallies. I never forgot that because he was good looking [chuckling]. And they were going to have this big rally, and oh, so many people came because they were going to sell the war bonds.

This friend of mine at Winchester Repeating Arms—oh she was a beautiful girl, Madge Riley, she still is—we were selected to ride the float in the parade with Connecticut Foot Guard, and a few others with fancy hats for the war bond rally. I was approached by my foreman, Frank Canning, because the rally organizers were looking for "nice-looking girls" to be in the parade. Pin-up girls were very popular at the time. They took the picture of us at Winchester Repeating Arms,

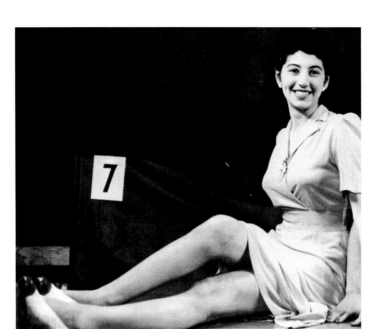

Figure 12.2. Cecilia Ferrara Asor, 1943. Piontek family archives.

and I figured it would be a good way to meet Victor Mature. They wanted to see a little bit of leg.

Then we found out they didn't want us on the float. They wanted us to walk, so we backed out. Oh, it's a long walk all the way up Winchester Avenue. There were so many people, and there was a big bandstand, and Victor was up on the stand making his speech because they wanted to sell the bonds. It was very exciting. Of course everybody went to see Victor Mature! [chuckling].

And that's another thing. They took our so much out of our salary for the war bonds, which I was grateful for because I think for seventeen dollars, you got a twenty-five dollar war bond, and I accumulated quite a few of them and I was helping the war too. It was voluntary, but everybody did because we were saving money, and I had a nice little nest egg when I got married because the fella I married didn't have any money when he came out of the service. In nineteen forty-five, the war ended, and they let us all go.

Italian American Women Entrepreneurs

Businesses, Mutual Benefit Societies, and Charities

In 1903, Luigi DeGennaro, a young tenant farmer—often unemployed during winter months and barely surviving with his wife—left his farming village of Maggiarata in the region of Campania. Luigi had recently received encouraging letters from his brother inviting him to "The Flats" in Woodbrige, Connecticut, where tracts of virgin land were available for farming. Luigi found work on the Sperry farm, renting ten acres of prime farmland. A few months later he sent for his wife Serafina, and the two lived in a small farmhouse adjacent to Mr. Sperry's homestead, overlooking the wide expanse of his farm. One night after work, Luigi came home with exciting news. That afternoon, the elderly Mr. Sperry had called him to his house and offered him ten acres of land for seventy-five dollars. Like many Yankee landowners in Woodridge, Sperry reminded Luigi of an American version of the *latifondisti* of southern Italy who owned the great estates. An offer such as Sperry's would have never occurred in Italy where tenant farmers found themselves in constant debt to owners. Money rarely passed through the hands of the poor farmer, whose meager earnings were consumed by rental fees, high taxes, and loans with exorbitant interest rates.

Serafina had descended from a family of subsistence farmers, in which female responsibilities overshadowed those of men. Typical of Southern women, she not only worked in the fields and did agricultural chores, but also stayed busy during winters spinning wool, making clothes, raising animals, washing clothes, preparing and preserving food, and tending gardens.[1] Serafina adapted well to her new life in Woodbridge, maintaining the same lifestyle she had in Italy. After minding the children and doing household chores, she helped Luigi with the afternoon delivery to the farmer's market in Waterbury. Picking tomatoes, zucchini, eggplants, and peppers, she carried bushels to the dirt road running along the farm. There she waited for Luigi to arrive, driving his team of horse and wagon. After they loaded the wagon, she stood and watched her husband ride past the farmhouse and out to the paved street for the trip to Waterbury. At the end of the day, Luigi followed Italian custom by handing Serafina his money, but he

did so with a slight variation. Instead of keeping some for personal expenses, as men did in Italy, Luigi told his wife to keep his change for *sfizi,* any little thing she might desire.

With six children and bills to pay, Luigi believed his chance to purchase the farm of his dreams could never materialize. Little did he realize that Serafina would come to the family's rescue. A few nights after Sperry's offer, Serafina waited until the children were in bed. She called Luigi into the kitchen, and the two sat at the porcelain-topped table. They talked about their future, the children, and the Sperry offer. At the end of the conversation, Serafina stood up. Reaching into her dress, she pulled out seventy-five dollars of *sfizi* money she had never spent, and handed it to her astonished husband. America had provided Serafina something Italy could not: the steady flow of cash and the opportunity to save or invest.

Serafina's money management skills reflected those of many Southern Italian immigrant women, who had experience controlling what meager money their families could earn in the poverty-stricken South. Despite dire economic conditions, owning land and running businesses were not unfamiliar to many women. In Sicily, 38 percent of women owned a home or a piece of land in 1881.[2] In Sardinia, almost 60 percent of stores were owned by women.[3] The DeGennaro farm had no professional bookkeeper or accountant, but was efficiently run according to the sound business sense of Serafina, who carefully tracked inventory, expenses, and invoices. The majority of Italian women, who arrived poor and illiterate in Connecticut, practiced the art of multitasking long before it became a catchphrase in American business culture. Besides working and raising children, they started charities and women's guilds in mutual benefit societies that had been the preserve of men.

Years after the purchase of the family farm, Serafina's children often recounted the tale of the money coming out of their mother's dress. Occasionally at the supper table, they teased Luigi, saying the farm belonged more to their mother than to him. One thing the DeGennaro children knew and respected about Serafina was the fact that she was the family accountant, lawyer, and the kind of stern disciplinarian who always had the back of her hand ready.

"My Mother the Storyteller"

Michael Mele was 105 years old at the time of our interview. He spoke with great pride about his mother, Rosalina.

> It must have been her idea to open the store because she wasn't allowed to go to work in a factory.

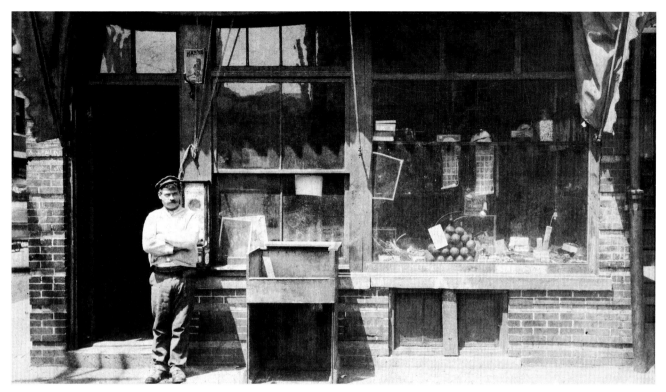

Figure 13.1. Rosalie Mele's grocery store on Wallace Street in New Haven, early 1900s. Mele family archives.

My father wouldn't open a store, and he couldn't write his name. Before I was born on December sixteenth, nineteen oh-six, at five-thirty in the morning, my mother had opened a store in New Haven, two doors down from where we lived at the beginning of Hamilton Street, which now is buried under the highway. My mother used to tell all of us at what time we were born.

My father was with her. He worked in a lumberyard with a lot of Swedes who didn't like Italians or Catholics. So they had it in for my father. So one day he was on the side of a big pile of lumber. They pushed the pile on him, and an Irishman saw what happened and ran over and said, "If you guys ever touch this man again, you gonna see to it to me!"

All [my father] did was go out into the country and get vegetables. One day he got kicked by a horse, I think that was the end of him, with his heart. He was in front of the store, and had just come back from the farm with a lot of vegetables. So a gypsy woman went by and she asked him for money and he told her, "Go away!" So the gypsy woman said, "Aaah," and she hit the horse. And the horse kicked my father.

But it was my mother who ran the store because she could read and write Italian. Half of the store was dry goods and the other was groceries. The whole neighborhood, when they received a letter from Italy, they couldn't understand it, so they went to my mother to read it. They trusted my mother. I remember my mother used to say us, "*Esce fuori*, Go out and play!" She chased us out of the store, and the reason was she didn't want us to know the news of the different families. Then she went behind the counter near the dry goods and either wrote a letter for them or read for them. She was trusted.

She used to go to church every morning, and when the women came out of church, they gathered to talk. My mother would say, "Hey, I gotta go home, I've got things to do," and she'd leave. She'd say, "They talk about this one, about that one. I don't want any part of it."

In the beginning she only spoke broken English. We had a sister-in-law who was Irish, and they lived with my mother. The Irish girl told me, "You know, when your brother is not around, your mother and I get along beautifully. I understand her in her broken English, but when her daughters are around, she's ashamed, and she won't talk English."

She ran the store. My father couldn't read or write. He wrote an X for his name. We lived behind the store, and at night when the store was closed, we had a kitchen in the back, and we sat around the kitchen stove and we'd get my mother to tell us a story. And we'd say, "*Hey Ma, dici a nu cont,* Tell us a story." So to get her started, we start with a story that we heard, and she get right into it. Before you knew it, she'd tell the story all night long. I remember opening the oven door to put my feet in to keep warm while she told us the story.

In Italian, she told us the story of a man who was very stingy. So one day his friends were out walking on the road, and they saw him standing by his donkey that was laying dead. And they said, "Hey *cumpare*, what hap-

pened?" He said, "Aah, I was teaching him to eat less and less each day. Finally, when I came to give him nothing to eat, he dies on me!" Then she told us about another man who was so stingy that when he went in the house he used to pull down his pants before he sat down. They said, "Hey *cumpare*, what are you doing?" He said, "Eh, my pants will wear out." He would rather sit on his cooley so his pants wouldn't wear out. To scare us, she told us about a man, *chillo con ó cap í fuoc*, the man with his head on fire, who came out at night. She'd say "Watch out!"

When she went out of business, I remember the salesman said to her, "You're the only one we know that's going out of business and you don't owe anybody any money." My mother kept the books. She learned in Italy. And we used to say to her, "Hey ma, why do you keep those books?" She said, "Aw, I want to show you, so and so, when I look in the book, they still owe money from when I had the store!" She kept those books for a long time.

"She Was the Main Ingredient"

Vittoria and Silvio Suppa owned Del Monaco's on Wooster Street in the heart of New Haven's Little Italy from 1972 to 1997. The restaurant became a neighborhood landmark for its authentic "New Haven Italian" cuisine. At the time of our interview, the Suppa family owned the Café Allegre in Madison and the Woodwinds in Branford. Vittoria Suppa was born in the town of Valle di Maddaloni in the region of Campania.

We were going to come to America in nineteen fifty-five on the *Andrea Doria*, but we were "out of quota," and couldn't come. After my little brother died in nineteen sixty, my father wanted to start a new life, and we came to America on the *Vulcania* in nineteen sixty-one. The trip took eleven days.

In nineteen seventy, my brother John heard that a restaurant on Wooster Street in New Haven, Papa Coppola's, was available. We got together with my mother, and she encouraged us. The whole family went in, cleaned the place up, bought new equipment, and we fixed what had to be fixed, and we opened Del Monaco's in January nineteen seventy-two.

She was in the kitchen cooking the old-fashioned food that she learned from her mother and grandmother on the farm in Italy. She was the only girl, and she had eight brothers.

That's what they do in Italy. When she got married she was a housewife and she had no job in Valle di Maddaloni. People liked all the food she cooked, and my husband Silvio was right there with her, and she taught him. He made everything exactly the way she taught him, how to make bread, homemade macaroni. She used to tell us, "*Í t'imparo a fa chest per la tradizione che a pass a 'nnanze ai figli tuoi,* I'm teaching you this tradition so you can pass it on to your children."

A lot of old Italian people lived on Wooster Street, and she befriended them and sent them food. Sometimes she invited them by the back door of the restaurant kitchen to eat. She used to feed this eight-year-old kid from Naples, Gennaro Iannaccone, who came from a family of ten. He'd come in from Warren Street, "*Wey, á zi' come sta?* Hey auntie, how are you?" She'd say, "*Venne a ccá,* Come here," and sit him on her lap and make him sandwiches. She'd send him to buy the *Il Progresso,* the Italian newspaper. It was a dollar and change, and she'd tell him to keep the change, "*Mette in da sacco,* Put it in your pocket." When we rented a cottage in Pine Orchards in Branford, she made me go all the way back to Wooster Street to pick up

Gennaro. He reminded my mother of her son that died in Italy. After I had my children— Ilario, Antonio, and Giuseppe—she stepped back and took care of them.

Then we opened Valentino's in Mount Carmel because she had to be involved in the cooking. The main thing was she made the sauces, the homemade pastas. Her sauce was the main ingredient of the restaurant. She made her own cheese. She used to tell the waiters who used to try to sneak something behind her back, nothing got by her! If she caught them, she'd let them have it, and threw them out if she had to. She didn't speak English, but they understood when she started getting mad. They called her Mama. But if you asked her, she'd give it to you. She'd say, "When you want something, just ask for it and I'll give it to you." She used to always say, "*À cosa non è rubato è mezzo pagato,* If you ask for something it's half paid already." But if you don't ask, it was stealing to her.

She was the classic Italian lady. Very old fashioned, very protective of her kids, her family. Nobody could touch them, right or wrong. She would jump on you, she'd kill you. She had lost her son in Italy. She always wanted to keep the family together, and we bought all

our land together in North Haven. She was the one that held the whole family together, that was her main thing in life. She was afraid to be alone.

She had eight brothers, and her father was a big guy. She always felt protected. Now she left them in Italy and she came here by herself. She didn't feel protected here. She had to leave her mother and it bothered her a lot. She called her mother Vittoria, and she always used to say, "*Una figlia fémmena che teng e si ne ghiut a America. Che disgrazia!* The only daughter I have went away to America, how awful."

Nothing was done unless she gave us the okay. Everybody had to be involved. If somebody bought a house we all had to live together. She was a strong lady, and my father didn't know nothing without her. She ruled everybody. She used to say because she was in control of everything, "*Quando muore ío, e vulessi torna á veni per vede che fine facete,* When I die I'd like to come back and see how you end up." My mother rubbed off on me, the way she used to feel sorry for people, how to always be nice. She used to say, "*Fa bene alla gente. Jesù Cristo è vecchiariéllo, ma non è scurdariéllo. Jesu Cristo tené' i piedi di vammàcia, ti tocco quand mai ti credi,* Be good to people, Jesus is a little old but he never forgets. He has feet like cotton balls, and He touches people without them knowing it." It's in you. It's in your heart. She came from a big family, and she was raised on the farm, and they had hardship in their life. It was hard for them to make a living and they helped one another. The aunts, the uncles, they would get together to eat.

We came from nothing. So when my mother saw people who had nothing, she wanted to give back to them in the restaurant.

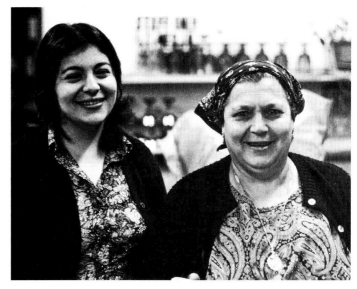

Figure 13.2. Stella Del Monaco and daughter Vittoria Suppa at Del Monaco's Restaurant on Wooster Street in New Haven, early 1970s. Suppa family archives.

And today we still do the same thing. One of our dishwashers, a Mexican kid who used to sleep upstairs, got a toothache. We felt sorry for the kid. I made sure the bartender brought him to the dentist, to go get him the medicine. I always say to Silvio that we're running this business with our heart, not with our head. We have to make business decisions, but we're not like that. We always make the mistake of being too nice, and people take advantage of us. But God helps us in the long run. A lot of restaurant people say they're surprised at us, that we're still together. A lot of people don't last. They either get divorced . . . it's a crazy life. We've been together for forty years.

"Molly's Taven and Molly's Dress Factory"

Betty Chessa Scioscia was ninety-four at the time of our interview. She described her youngest sister Molly as a "feminist before her time."

When we lived in Johnstown, Pennsylvania, World War One just ended, and I remember walking with my father to the victory parade. We were cheering because of the American spirit even though we'd only been here a few years and we only spoke Sardinian at home. It was a great accomplishment for Americans. But that memory was, this is America, the land of opportunity. If you work hard enough, and if you become part of the culture, then you can do anything. And that's what my father did, and you could see it in all of his daughters. We all picked up on the "American Dream" even though we'd been in the U.S. for a short while. But walking with my father, and with the war declared over, the American Dream, that you can do anything, became a matter of fact for us.

So in nineteen forty-five, it was, so you want to open a tavern? Wow, it's there, and it's for sale. I have the money, why not? We'd never been in the tavern business before. So my sister Molly and I opened up a tavern called "Molly's Tavern" in Bridgeport, and because of the name it attracted a lot of women and made them feel welcome, women who wouldn't normally go out to a tavern in Bridgeport.

It brought out more women in a family-type environment. After we sold the business in nineteen seventy-two, when a lot of the dress industry was moving south, Molly decided to try her hand as an owner of a dress

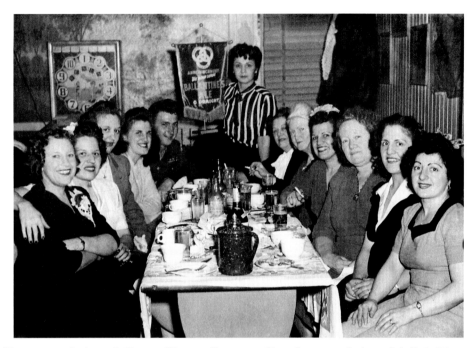

Figure 13.3. Molly (first on right) and Betty Chessa Scioscia (fourth on right) at Molly's Tavern, February 2, 1946. Scioscia family archives.

factory provided I'd leave my job to join her. I left a secure job at I and J Dress to work with my sister Molly. She was shy, couldn't speak up. I was the fireball, and could always stand up for myself, and this became our sister team. I presented the ideas since I'd been a forelady and a union representative. Molly put up the funds to buy the outgoing Weiss Dress Industry. I became the floor lady, and because I knew prices, I did all the negotiating for fair prices with New York buyers. And I continued sewing dresses as a union representative while I was raising my family.

We did a lot of things beyond home in the community. We organized Columbus Day and Italian parades, helped make clothing for the Red Cross, and some of us even became active members and presidents of the Marchigiano club in Bridgeport. We didn't let gender interfere with our ability to participate fully in

the community. We kept our Italian heritage, but it was combined with the American spirit. And that's who we were.

"My Own Dress Shop"

Mary DeNittis:

My mother taught me in the dress shop she started in West Haven in the nineteen thirties. I was always handy with the needle. She had to support her daughter after her first husband died. I took care of the girls on the machines. I showed them what to do, whether you had to stitch it by hand, had to mark them. Girls who work on the machine are seamstresses, but the ones who work on the floor do other different kind of work. So I had to put them on the form, make pleats and stitch it by hand, buttons, I taught them. Some of them were pretty good. There were twenty seamstresses, and three or four pressers. Truckers came and brought the dresses to Seventh Avenue in New York.

"My Sister Louise"

Theresa Cipriano said when her sister Louise died days before her eighty-seventh birthday, the family went to back to her hat store in Waterbury, and picked out hats to wear at her funeral mass. They kept the hats as special tributes to Louise for all the years she ran her store.

Nearby Danbury was the hat capital of Connecticut where the store originated. The owner moved and opened a store in downtown Waterbury, which like New Haven and Bridgeport was very vibrant, and that's where my aunt worked. She eventually bought the store from him. It used to be Oekler's, and she kept the name.

My sister Louise was a real pacesetter. She took the train by herself to New York on Mondays to buy hats. Quite often she'd go depending on how fast she sold her hats. She'd go to these rundown places in the hat district around Thirty-Fourth Street to negotiate and bicker with Jewish vendors. She used to win, but you know how they are. They would go up on their prices, and she'd bring them down. She'd tell them which ones she wanted and how many and they'd mail them to her. We had to go up these narrow stairways into firetraps where they sold the hats. As far as going for lunch, I wouldn't eat in New York. I wouldn't eat there if you paid me. You know what I'd order? I felt safe with just an egg and toast.

In Waterbury my younger sister and I used to sit on the porch every Sunday and watch the black people going into the Baptist church across the street, dressed to the hilt. You know, we didn't have much to look at as far as clothes. The hats, the furs! That's one thing. They thought nothing of going into my sister's store, buying a hat, and spending a hundred dollars for it. They didn't even blink an eye! And they wanted one of a kind. They didn't want to see anybody else wearing the same hat. My sister Louise had to make sure that hat was the only one of its kind, and nobody else could have one like it. They're the ones who kept my sister in business.

One of my best friends was black. No racial . . . it wasn't like it is now. There were Italians, Jews, and blacks living in the North End of Waterbury then and we all got along. All different people. When they found a rent they'd call their friends and that's why you had the Italians, the Polish, and Blacks all in one place. But they all got along. The only thing was the Irish guys across the Baldwin Street Bridge. The Irish lived on the east side of Baldwin Street, and the Italians lived in the north end of town. They had to stay on their side, and we had to stay on our side. But so many Italian guys married Irish girls! And the same thing with the Lithuanians. We lived on the top of hill, and they lived below in the Brooklyn section of Waterbury. In the beginning of the North End there was a mixture of Polish people. The East End was all Irish and the South End where I worked was all French.

Once the war broke out, the church passed a ruling that we didn't have to wear a hat to church on Sunday. When my mother passed away, my sister Louise bought a one-family house with six rooms, and she took my sister Susie, me, and my father in. She was like a mother to us. She wanted us to be together, and we stayed there until my husband came back from the service. Mind you, we bought a house on the same street as my sister so we could still be close enough, so she could watch us. We were able to buy it because of the money my husband had from the service. It was a good down payment for the house and I lived in that house for sixty years.

"Una Faccia Pulita"

Maria Cusano worked making pocketbooks at Henry Richards in the early 1960s. She said, "We came with the ambition to work, not to hide ourselves or go on welfare. We worked hard. The more they gave us, the more we did. We worked like jackasses."

Uncle Marco was the type of man who always told people what to do, like a dictator with a cigar in his mouth. I started washing dishes and preparing food for him in his catering business. He took a little bit of advantage of us [when we came from Italy] because we needed the work. But I'll never forget, he gave me my first ten dollars and I went to buy a clothes iron. I worked with his daughter Lena who tried to teach me the business. One day he came to me and said, "My wife can't work anymore. Can you be a partner?" I had just married my husband Pasquale, and asked his opinion, and he said, "Why not? Let's try." Because the boss had all the equipment and we had nothing.

Partnerships are no good. Even if you're with your own mother, sister, brother, it's no good, and he used say to me, "*Quando vengono quella gente mia la, faccia ó piatto chiù grosso*, When my people come to eat, make a bigger dish for them." "Okay, Uncle Marco," I used to say. But when it was my party, people that I knew, I tried to do the same and he didn't like the idea. He used to say, "Don't forget, you use my stuff."

Things started to go very bad. He had a temper and I was in the middle. We had a big job for the Paolillo family, and we had to make a lot of lasagna to deliver to them. He said to me, "I don't want you to do the job anymore, and I don't want you to use my stuff anymore." I said, "Uncle Marco, I'm making lasagna for . . ." and he said, "I don't care what you do." He stopped me right on the job and I had to throw it all away. I'm small but I use my head. I called Al Cognata, and said I need three dozen of this, three dozen of that, and right away they delivered all the pots and pans and dishes I needed, and I made all the food for this party we were supposed to do together. But when they paid me I still gave him his share. I said, "Uncle Marco, they paid me, and this is what I owe you and we're finished." He didn't like the idea. I said, "I'm sorry. But one thing I want to ask you, if you want to sell me all the equipment, I'll buy it." He said, "I'd rather throw it all off of East Rock rather than give to you!"

But I knew what to do. I knew all the distributors because when they delivered I was always there to sign. I had a good reputation. The first years as Cusano Catering on my own was tough because you make money, but you have to pay for everything you need, but at least I used the new equipment.

My uncle went crazy. He didn't like the idea. He said, "But you learned from me!" And I said, "Yes, I did I appreciate that, but I worked." Number one, I like to talk with people, to work with people. I knew a lot of people, and I used to say, "If you're gonna get married, I'll cook for you, if you gonna have a baby, I'll cook for you." *Il coraggio che aggia avuto era perche teneva una faccia pulita*, I had the courage [to start my business] was because I had a clean face [a clean reputation].

"The Power behind the Throne"

Joe Criscuolo wrote "Roses for Mama," and "Roses Forever" based on his experiences growing up in New Haven. He captured the culture of the downtrodden poor in Italy with proverbs he often heard as a young boy, "A *vita e nu pass e via*, Life is nothing but a step on a long road," "*Statevi accort! Ò munno è 'nfamità'!* Watch out! The world is evil!" and "*Povera chi si mette in bocca della gente*, Pity the poor person who gets into the mouths of people who gossip and ruin your life." He described a woman in the old neighborhood of Fair Haven known as "*spaccopenny*," because she split wooden matchsticks in half to save money.

Historically speaking, the figure of the Italian man is the patriarch of the family, the boss who commands everybody. But the power behind the throne was the woman very often in my experience, and what I saw from my grandparents, the woman was much smarter than the man.

In Italy, women were enslaved in a position of inferiority. They had to live by their wits. They outsmarted their own men, and sometimes their own men were tyrants. When they came to this country, because of the fact that they had been held down, but here they had a little more liberty, they were going to make money, and they were going to make do, make something, and that's what a lot of Italian women did.

In the old country they had no say about anything except finding the food to cook. If you go back to the places they came from, these small little villages go back to the medieval ages. It was like a caste system. If you were born into that class, that was where you stayed. If you were a farmer, a peasant, a vendor, that was it. You had no opportunity. And of course you had no opportunity for education, especially for girls over there. But over here with the opportunity that you could have money in your pocket! Unheard of in the old country! Because even the men didn't have

money over there, not even a pocketful of change. They had to barter or trade.

The force the women had behind the throne, even though it seemed like the man was the boss, was that they were the smart ones, because they really took advantage of the freedom that they had in this country. Here there was money to be had. They bought property, accumulated money, saved money, being wise on how you spent your money. Now, my own grandmother, Luisa Candido, who came from Scafati in the region of Campania, was strictly a peasant, couldn't read or write yet she started a dry goods business. The drive that the women had! Because having had nothing in the old country, but coming here she had the opportunity which they never really had. My grandmother was strictly a peasant over there, but she came here and started a family.

Then she started a business, very small at first. You couldn't cheat her out of one penny. Now you're counting ten dollars or fifteen dollars, holy cow! Even a dollar, two dollars, three dollars. That was something that the women never experienced. And to handle money? That was why they were so careful about every penny that they could amass and put it away, *sott ò mataràzzo*, under the mattress, because

they didn't trust the banks. But the idea that you could keep money in your hands, that was the thing.

She started by selling sheets and pillowcases right from her home. She peddled them all over Fair Haven in New Haven in the early nineteen twenties. With her prompting, she made my grandfather buy a house. She inspired him. She bought the house with the money they had. My grandfather was a nice man, a musician, but he wasn't very aggressive. Even during the Depression they always had money because he played music. But she saved every penny. As they accumulated more money, they bought a house, and as they accumulated more money, they bought what they called *ò palazzone*, a big building, which had two stores on one side and three rental properties up above it on Grand Avenue in New Haven. Then with money from the rental money she got, she made him invest his money in another house. By that time they had quite a bit of money. She had the store and she got rental money.

My grandfather bought her a house on Munson Street, a beautiful Victorian brick house in an affluent area. But she wanted to go back to "the avenue" and went back to

Grand Avenue. Her element was not there. It was too lonely, too elitist for her. She wanted people all around her all the time. She was always in the store with my aunts running the store, and my uncle Joe did the route, peddling dry goods on trust. On Saturdays he'd collect and mark off what they gave him, two dollars, and three dollars off the [credit] books. Everything was "on trust." They had big books, and you had a page with your name on it. They came in and paid three dollars on their fifty dollar balance.

The drive that they had! Because having had nothing in the old country. Then coming here they had the opportunity, which they never really had in Italy. They would go to New York at four in the morning, drive the station wagon to the East Side. And we would go to the different wholesalers who were all Jewish. The interplay was comical. This is the way it would go. My grandmother would step into the store. They knew each other because they'd been buying for years. "Missus Candido, dahlink, hov are you? Come on over here, I wanna show you something special, just for you!" My grandmother, in her accent, would say, "Eh, whatta you got over there?" The Jewish guy said, "Look at these shmocks! For you? Fifteen dollars the dozen." And my grandmother answered, "Ma get outta here, you crazy! Get outta here fo' fifateen dollars! I give you ten dollars!" "Missus Candido! [indignant voice] Please! I have five children!" And she'd say, "Eh, I gotta seven!" And they would bargain back and forth until they got to maybe eleven dollars a dozen, and he would be happy as a pig in you know what because he still made a profit. And she would be happy because she thought she put one over on him. And there they were, the Jewish guy with the Jewish accent and my grandmother in her broken English accent. It was a riot.

Then the Jewish salesmen used to come from New York with their big suitcases to show samples. They'd walk into the store with samples of new dresses, new aprons and smocks. She'd say, "Wait a minoots, you gotta come up a stairsa, you gotta eat because you come all the way from New York, you hungry." "That's all right Missus Candido, that's all right." "Come on up a stairs, you gotta . . ." and she'd haul the guy upstairs, and make him eat whatever she was making, and drink coffee. They'd have lunch and everything, and then she would make him open up the suitcase, and she would buy.

He would show her. They would haggle back and forth, he'd show her the new style, and sometimes she'd say, "No, I no lika, no nice." And back and forth, and then she'd make her selections, and they'd put in an order. He'd write down the order she wanted, two dozen of this apron, a dozen and a half of these slips, and they would ship them down in boxes. I'd rip open the boxes and my aunt would check off the item, how many with the invoice, and that's the way it went. But my grandmother was always in the store, sitting and watching everything.

"She Wanted to Help Her Family"

When Vincenza Parise's brother told people on Wooster Street he was driving home from California in 1948, they asked if his car would make it over the mountains and warned him to watch out for Indians.

My mother Maddalèna celebrated her eleventh birthday on the boat. She came from Minori with her cousins, near Amalfi in the region of Campania. Her family was all poor fishermen. Then she went to live with sister in Brooklyn near the navy yard on seventeen Vanderbuilt Avenue because she was sent to help her raise her children. Her sister had a lot of children so she stayed there. She went to school and graduated from grammar school in Brooklyn. In those days, that was something big. She was smart. She knew how to write beautiful in English. Read Italian. And they told her how to run the business, how much you get on a dollar. They taught her all that, although my cousins were all smart, and she learned.

All the Minorese used to come to New Haven to see their *paisans* and *cumares*, their friends. Then she met my father from Minori, too—but she didn't know him in Italy—in New Haven at the feast of Saint Trofimena. My mother had greenish blue eyes and she had her hair like a reddish color because her mother was a redhead, really red. My mother was a tall woman. They were both from Minori. They got married, and my father wanted to live in New Haven because he had his family here, and he wanted to be among all his *paisans*. Wooster Street was all his friends.

That was the good days. She wanted to open a store but he said, "*Nun a ghì' a faticà', sta a casa a sta accort ì figli tuoie!* You're not

going to work, stay home and take care of the children." My mother was more American. She talked very good English, and she had no accent. But my father used to say, "No! You gotta talk Italian!" She'd answer, "I'm happy, I'm happy to know [the language]."

My mother's family taught her in New York, my aunt's children, who were older and smarter, and they took her to the wholesale places in New York to show her the ropes, to Canal Street and Grand Street. They taught her how to run a dry goods business—women's and men's clothes, underwear, blankets, dresses, wedding blankets, because when girls got married, they had to have a pretty blanket on the bed, drapes. My mother opened up a small dry goods store around nineteen twenty-six, and she named it "P. Manzi" after her husband Pasquale. She had to. My father was against it because he didn't want us to be running around the neighborhood, so my aunt turned around and said, "Send your daughter here on Vanderbilt Avenue," and I went to my cousins in Flatbush for the summer when I was about eight years old. We had good times in New York, we had to.

So she started a little store on Collis Street.

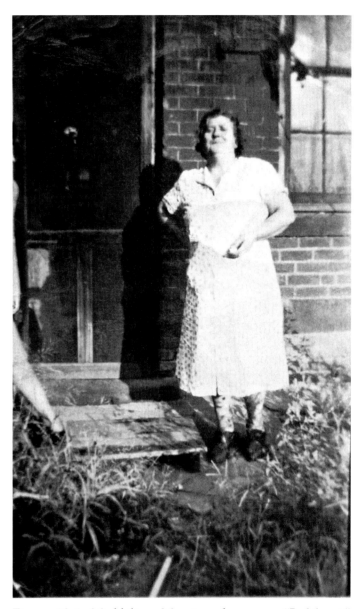

Figure 13.4. Maddalèna Manzi at her store "P. Manzi," on 11 Collis Street in New Haven, 1930s. Parise family archives.

My father worked a little at Seamless Rubber Company—it wasn't big money. She said she had to do something to help her family, and she brought her mother here from Italy. Then she got a little help from her sister to establish her. She [my mother] helped her sister [when she came from Italy], so her sister helped her. She gave my mother the money to buy the dry goods.

She didn't buy nothing in New Haven. Everything was bought in New York because New Haven was too expensive, and New York was where she got her buys. Her family told her how to run the business, how much you get on a dollar, how to deal with vendors, and they taught her all that because my cousins were all smart. So she learned. But she was nobody's fool! One time, when she was having trouble with her eye a doctor a told her, "You're going to die bleeding to death with your eye." She said to him, "Go to hell!" She told him in Italian, in American, and I think in Jewish, too. She said to him [laughing], "Who the hell you think you are, God?"

She knew all the answers. I'd say to my mother, "Ma your dress is ripped." She said, "À vest è stracciata ccà, pe i soldi teng i' in pett, The dress is ripped here, but here's where I got my money, right here on my chest!" My

father couldn't really stop her anyway because whatever she wanted to do, she did. That was it, she said, "I' aggiu faticat e voglio spendere, I worked and I want to spend it." Anything she wanted to buy.

She knew all the words in Yiddish. She got along with the Jews, the Irish. The Irish used to throw rocks at her in Brooklyn, even my cousins who were born there made fun of her because they didn't like the Italians. It was like that even here in New Haven. They called the Italians "guinea," "wops," but then, as time went by, everybody got to love one another. The Jewish [merchants] were very nice to her because she told them where to get off. They couldn't fool her. She fought for her prices! And she got it.

She took the train all by herself. Sometimes I used to go to New York with her. Oh, she used to fight! I said to her, "Why are you fighting?" And she said, "Shut up! Sit there!" Let's say it was twenty dollars a dozen. She tried to get it down because she used to figure what she had to make on it. She didn't want to pay the shipping costs. So they would package it right there, and she'd carry it back on the train to New Haven. And walk from the train station with the packages, four or five blocks back to Collis Street.

During the war my mother had connections. She got us nylons even if they were a little irregular [laughing], but we got it. People were poor in Italy before and after the war, and they said, "Help us out, we're poor in Italy, we'll make the cutwork, handmade sheets and tablecloths, children's clothes, and we'll finish the product." And she sold them here and started building herself up. She paid them, and they used to mail it. It wasn't a lot of money to mail things. She went back and forth to Italy on her own a lot of times during the nineteen forties and fifties. Sometimes she used to make trips just to give things to them because they were poor. She used to say, "*In America, tenim bellezza, ricchezza, e denari,* We have beauty, richness, and money in America!"

My mother had a book of whoever bought stuff from her on credit. One of them said to my mother, "I hope she falls and breaks her leg." This woman didn't want to pay my mother. Then my mother saw her one day. She had a broken leg. She said, "*Ò munno è 'na ruota, si gira e si riposa,* The world is a wheel, what goes around, comes around." Everybody was jealous of my mother. That I can swear to on the Bible because she came from Italy and she knew how to run her business. After my mother closed the store on Collis Street because the highway came through [during urban redevelopment in the 1950s] I decided to go to work. I didn't want to deal with it because I saw what my mother went through, running here, collecting money, who would swear at you. But they had everything. My grandfather bought a Cadillac, he had a boat. My mother used to say, "*Voglio vivere ricca e mi muore povera,* I want to live rich and die poor."

"She Was Tremendous"

Marion Sperandeo DeNegre recalled the artist Mr. Fusco convincing Frank Pepe, the owner of "Pepe's Pizzeria," to use cardboard boxes instead of wrapping his pizza in paper. He designed the logo, brought the box to National Folding Box in Fair Haven, and invented the first pizza box in 1930.

My mother was the oldest of four children, and she came from Naples with her parents. She wasn't allowed to go to school and had to help her parents. She was allowed only to go to the fourth grade in New Haven. Being the oldest, she had to go out to work.

She decided to work in the corset company on Olive Street, Strouse Adler, which is known as the Smoothie Company. And so she started there with her sister Mae. And they

worked piecework, which meant that they would give them a whole basketful of things to sew. My mother, in order to beat the quota so she could make more money, wouldn't stop between each piece and cut it. She'd run it through the whole basket, and at the end she'd cut them all [chuckling].

Her little sister got her finger stuck in the sewing machine needle and lost a part of her finger so she couldn't work anymore. My mother worked for Berger Brother Company, which is Spenser Corsetieres on Derby Avenue. And they would recruit women to go out door to door and sell corsets to people in their homes, so that my mother became a "Spenser Corsetiere," and we had the shingle on our door. We were small and we couldn't say a word because she had business to do and we had to respect that. She'd go in and measure all these people, and of course, they'd want to talk, they'd want to eat. And they'd just be sitting there waiting. She'd write down the measurements on the chart so that when she sent it to the company they'd see this and make the garment according to those custom specifications.

We had so many kinds! The front lace, the back lace, the braces, and the one piece.

It covered the whole body so you had to make those measurements right, so when you brought it to the customer, it had to fit. At that time in the late nineteen thirties, these garments were selling for fifty, sixty dollars, which was a lot of money.

In our house we didn't have toys to play with. We had corset steels, which were the long bones that go into the corset, all kinds, all shapes, so that when she decided to make garments for people, we had to measure which size had to fit into the different casing. My mother had all different kinds for different garments. Those were our toys. She sewed the casing and bought the material from the department stores—Stanley Horowitz—they had wonderful materials. Then she left Spenser's and went on her own making garments.

In the early nineteen forties, I had two sisters in college, at Anherst in Putnam, Connecticut, who got scholarships from the French nuns because my sisters were smart. So then we decided I couldn't go to school because they couldn't afford it. I was eighteen years old, and my mother sees this ad in the paper, "Famise Corset Company looking for people to open Famise salons." So she signs up. And she signs me up with her, and we take the train to

Philadelphia, to Famise Corset Company, and we were there for two weeks, taking a course—teaching me more than her—because she knew all that stuff, all about how these garments are made. My mother and I had two weeks of wonderful time in school at the Famise Corset factory of Philadelphia. So we come back, and we're all gung-ho because we're going to open our business. And the first one we opened up was upstairs on Congress Avenue.

So we open up this salon, and we're all gung-ho because we're going to have people come and sign up for corsets. But it wasn't a good location so we didn't do very well. At that time it was something new in the area, so it wasn't very popular. They wore them [corsets] but we weren't getting the people, so we decided we better drop it. That didn't work. My mother wasn't disappointed. She was always ready for another challenge. Very upbeat and nothing really bogged her down that much. She was very determined and very aggressive.

She went to work at the M and B ammunition plant in East Haven, the midnight shift, from twelve to seven making bullets, getting on a trolley at eleven o'clock at night. When I used to see her go out that door it used to break my heart.

My father was a gentleman. He wasn't very aggressive—he worked for Congress Clothes—and he didn't think too much about anything. My mother ruled the house. She was the matriarch. After the war we decided we were going back into the corset business. Because when she was out selling a lot of handmade garments she dealt with a lot of people from Ansonia, Derby, and Shelton. So she knew she had a lot of people that would be interested in store that would sell corsets and girdles and bras and everything.

So the first store she had was in Derby. Then we opened a second store in Orange. So the three of us sisters are in it with our money. And that's how Saks and Kent was born. She got the name when she went on a retreat in Kent, Connecticut, and she fell in love with the retreat house there. She was a very smart woman and did research on it and found out the original people who lived in Kent were called Saxons, so that's how she came up the name. No name to indicate it was Italian, and no name to indicate it was a woman's specialty shop either. That's how she operated.

She was tremendous, phenomenal. She always had so many things going all the time, big things, not little things, big projects. She

was a good businesswoman. She was the god-
mother. I remember women used to come to
the house and put in a dollar, two dollars, and
then when somebody needed money, they'd go
to her because she would lend them money.
These women used to come with their books
every week, and she would sign the two dol-
lars and they'd take back their books. She
attracted a nucleus of women because of her
aggressiveness. She was in every church orga-
nization and very active. She donated a lot of
money to the churches.

"The Feast of Saint Joseph"

Gaetana DeLauro recalled her mother making *cuccia*
using whole grain wheat and ceci beans. "It was boiled
with a little water to cook the skin and it swelled
into a thick soup. No salt, pepper or butter was added
until we made our own dish. It looked like couscous."

Mary DiPelina promised to have the Saint
Joseph's feast in her house in New London
every year with the children and the moth-
ers of the other Italian families she knew. She
made a promise to Saint Joseph. She was Sicil-
ian and came from New York. She had her
feast even before we went to her house in the
nineteen twenties, because she lived in one
of houses my aunts owned. She had children,
and whatever the reason was, she made that
promise to Saint Joseph, and she did that feast
until she died. And she was a grandmother by
that time. On Saint Joseph's Day in the spring
she made had all the special food, no meat.
Every year the meal was the same. She made
some kind of fish and fresh bread She made
sfingi, and it tasted like a donut, but it's round
like a golf ball, dipped and cooked in oil, and
then she rolled them in confectionary sugar.
And of course, the kids loved that. Then her
parents gave all the kids money to go to the
movies.

"The Founders"

Josephine Parlato Bonfiglio was a "war baby" born in
1918. She never realized her dream to become a nurse
because her father forbade her to see nudity. He told
Josephine, who worked during the day, "If you want
to go to school, you have to go at night." When her
mother fell ill, she took over the cooking and clean-
ing responsibilities for her seven brothers and sisters.

When we moved to Quinnipiac Avenue in
New Haven, we were not allowed to go to

Saint Rose church. We had to walk over to Saint Donato. Father Kelly was the priest there. So that long walk in the summertime, we put pennies in our shoes to buy lemonade on the way back. He made us take our shoes off, and he took the pennies away from us.

Then when Father Seifferman came to Saint Rose, that's when the Italians were allowed to go to church there. There were no Italians in that parish, and they were all Irish. We weren't welcomed there. We were turned away because there were Irishmen all over. You couldn't get a rent around there. Father Seifferman changed all the rules, and that's when we started going to Saint Rose. He couldn't see that ruling because the Italians were migrating into Fair Haven and all the surrounding streets near the church, so the rules had to change. The Irish were dying off, and they weren't supporting the church, so we went back to the church. In fact we formed "The Founders" to raise money, asking people to donate money to buy pews. There was a big sign, and recently Father Burbank was going to take it down. I said, "You can't take that down. We're The Founders. If you take that down we're going to picket in front of the church!" It never got taken down.

We had a hurricane, and one of the stained glass windows blew out and we needed money. I raised twenty-four thousand dollars selling names on the pews, and we put plaques on each one. And we replaced the window. Our Stations of the Cross were stark white. I thought they should be painted to match the stained glass windows. I got an artist and we met with Father Burbank who thought painting the Stations would take away from the windows. So the artist said to him, "I think you should. It would pick up the colors of the windows." And that's why those Stations of the Cross are painted. I ran the bingo at Saint Rose for thirty years.

"The Italian Motherhood Club of Hartford"

Marie Pizzanello Coburn's grandparents met in Hartford at the boarding house run by her great-grandmother and got engaged in 1927 on the banks of the Connecticut River.

In nineteen twenty-one, it started as the Italian Motherhood Club. Then it became the Italian Mothers Club. They were a charitable organization and very social, too. They were mostly middle class, a little bit educated, and

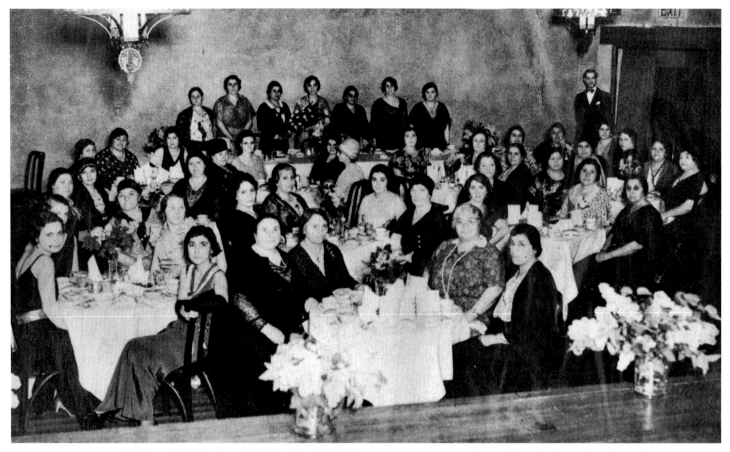

Figure 13.5. Italian Motherhood Club, Hartford, Connecticut, 1940s. Photo list Coburn family archives.

their husbands had businesses, and they were involved in the business. They were smart women. They didn't have the opportunity to go to college.

My father was a painting and decorating contractor, and my mother did his bookkeeping. They had a mission statement written by Missus Vincent Motto that went like this: "Keep us O God from pettiness/Let us be large in thought, in word and in deed/Let us be done with fault finding and leave off self-seeking/May we put away all pretense and meet each other face to face without self pity and without prejudices/May we never be hasty in judg-

ment and always generous/Teach us to put into action our better impulses, straightforward and unafraid/Let us take time for all things/Make us grow calm, serene and gentle/Grant that we may realize it is the little things that create differences, that in the big things of life, we are as one/We may strive to touch and to know the great common women's heart of us all and the Lord God, let us not forget to be kind."

They had a lot a lot of events, and they all ended with a little fundraising. They sometimes took a political position. They had a position on abortion, too. They hosted Italian dignitaries. They donated to the Red Cross, The Heart Fund, held dinners for Italian patients at the Municipal Home and Hospital, sponsored Savings Bond drives during the war, and they even sent money to the Mutilated Children of Italy after the war. They gave money to Newington Home for Crippled Children, to the Times Farm Fund for underprivileged children, and they sent the kids out to camp.

It's still going. The women's names were prominent to me because I used to hear their names as a twenty-year-old, and they used to meet at their homes. And my mother was always on the phone with them doing different projects and different things. But she

always called them—they were a little bit older because she was one of the younger ones—but she always called them Missus Privitelli or Missus Bartone out of respect, and never called them by their first names. And they weren't that much older, maybe four or five years. They didn't talk about what they were doing at home much, or the next project. She'd go out to a meeting, and my mother always drove. She had her license from nineteen thirty-five.

"Saint Andrew Ladies Society"

During the feast of Saint Andrew in New Haven in 2010, Theresa Argento said proudly, "This feast represents our heritage, the culture and traditions that were handed down to us by our grandparents and great-grandparents."

The Saint Andrew Ladies Society was formed on July first, nineteen twenty-three. They were a young group of women, and most of them were born in New Haven. They were all of Amalfitani lineage. They all worked in the sweatshops, those poor things. I used to do payroll in the factory office my last two years of high school and those women—it was terrible! We saw them work. How they sweat in

Figure 13.6. Founders of the Saint Andrew Ladies Society, 1923. Argento family archives.

that Ideal Shirt Shop! And if you talked to them they wouldn't even lift up their head because they were doing piecework. And that's all you heard was that zoom! The zoom of the sewing machines. It was terrible, terrible. They really worked so hard. And they used to even take work home to earn extra money.

Then on Saturday they had to help their mothers with housework, so they had only Sunday. They needed to be helped, and to be independent. They were able to buy clothes for themselves, high heels and silk stockings when a few years before they weren't able to do that. It was wonderful, a breath of fresh

air. Women started to be independent. And they had that mentality of not wanting to be dictated to. And now they're in a new country, America. And they thought, "Well, we can't stay home." Families were big then.

So the men had their Saint Andrew Society clubhouse on Hamilton Street, and they played cards there. They used to see the men on Hamilton Street play cards. They worked all week, and they felt they wanted to relax, so they asked some of the men, "Can we come?" Not that they wanted to play with the men, they wanted to go to the club and play cards.

The men didn't like the idea, and said, "No, absolutely not. It isn't ladylike for the women to play cards." Even my father felt that way, that it wasn't ladylike, so we didn't learn. I still don't know how to play cards, neither do my sisters. That's the gospel truth. So they did the next best thing. They started their own clubhouse in an apartment they rented on Wooster Street, and that's where they had their first meeting. And that's how the Saint Andrew Ladies Society got started.

They worked hard, and they weren't given the opportunity to go on to higher education. They only had a grammar school education. Their brothers had that opportunity, which

wasn't fair. The mothers and fathers allowed the sons to go to college, but never the women because they felt they should stay home, get married, and have children. But the men were the breadwinners.

In the beginning you couldn't join if you were married, only single girls. Then they had the married women come in and my mother joined. They called it the Saint Andrew Ladies Society, not an auxiliary because they wanted to be independent. They were American-born, and they weren't under the men anymore.

And they had bylaws. Very serious. You had to be Amalfitano, or married to one. The women were to help and assist the men in any endeavor or function if they need help, which we do. It doesn't say that the men had to help the women because we don't want that. And that's why we never became an auxiliary. We always wanted to be independent because we didn't want anybody to dictate to us.

I joined when I was twelve years old. Are you kidding? My mother said we had to join! The three oldest sisters, my sister Louise, Yolanda, and I became members of the Ladies Society. That's the way it was in those days. We went on hayrides, to Halloween parties, and we had a lot of fun. We did a lot, and the men know [today], and they appreciate what we do. We're thick-headed Amalfitani sisters [laughing].

But they dressed in white during the Saint Andrew's procession to emulate what they do in Amalfi. Originally they dressed in sailor outfits because many of the Amalfitani were sailors, but over the years that changed. My mother Antoinette was sixteen when she came from Amalfi, and she had this love for her country, for her home town. It was my mother's idea. We were five women. My mother Antonette, my aunt Vincenza Prodigo, Ann and Lucy Amodeo, and myself.

Right after the war there was a lot of damage done to the cathedral in Amalfi. We had different functions. The first ones were very simple in the Saint Michael's Hall. We'd have six long tables from the stage to the end, two for my mother, two for my aunt, and two for Ann Amodeo, the past president of Saint Andrew Ladies Society. We'd sell Sunday dinners and the three Marchigiani sisters—I was most friendly with Anita Pagnotti—they're noted for their homemade noodles—the caterers charged us two dollars, and we'd charge maybe seven or eight. We made more money than we do today with the dinners we have now.

All that money we designated funds for certain projects, and sent it to Amalfi to install a new organ in the cathedral in Amalfi. There's a plaque which shows our names, the five ladies, and the devotees of Saint Andrews of New Haven, Connecticut. We raised money for oriental rugs, and helped buy a new marble chair for the archbishop. In nineteen seventy-five, the archbishop sent a young monsignor to help raise funds. My mother and the five women and my uncle, we raised ten thousand dollars in a week's time! I had five hundred envelopes printed with Saint Andrew's cathedral, and I didn't have one envelope left.

"Uniting the Societies in New Haven"

Theresa Argento was eighty-seven at the time of our interview. She was recognized for uniting New Haven's seven Italian religious societies under one roof.

First of all, I was always very proud to be Italian. We used to see all the parades of all the other societies—the Maiorese, the Minorese, the Castelloni—with the saints being paraded around the neighborhood on their feast days in New Haven. We were thrilled to see all of them when we were growing up. As time passed, I noticed that things were falling along the wayside.

It started with my mother Antoinette when she went to a dinner with the great singer Giuseppina Pane, and the city of Amalfi was really destitute right after World War Two. My uncle Andy was a barber, and there was a clothing store on State Street, and he'd go in and say, "How much do want for this?" And he'd send clothes galore out of his own pocket after the war because they needed it. Amalfi also had an earthquake and a landslide. So my mother goes to this dinner, and they're having a wonderful time, and it was a fundraiser. So she said to me, "Gee, why don't we have a dinner and whatever money we make, we'll send to Amalfi." My mother loved getting donations and selling the tickets at our store on Chapel Street.

When Anna Amodeo passed away, I was appointed president of the Saint Andrew Ladies Society. Our bylaws state that we remain independent, that we are to help the men at any time they need help, but always remain independent. I'm still very particular when women join. They have to be of Amalfitani origin, or married to one, but I want to know their background because we are a

close-knit group. Everybody helps one another. Everybody loves one another and we do help the men. Over the years I think we've been their right arm, and I'm not ashamed to say that. We've helped them with the feast, with dinners, with the procession, and the planning. We work together. That's the only way you get things done—is working together. So we got that started.

When I was appointed the head of Sister City project by Mayor Ben DeLieto, the men helped tremendously, especially Andrea Colavolpe when the kids came over from Amalfi. He was right there with me and he still is. If I need something I call Andrea. He's got the heart of Saint Andrew right in him, and he's very dedicated.

Then in nineteen eighty-seven, I got the bright idea of unifying all the societies, some were bigger than others, some were more active. Someone said to me, "How come your society is so big, but we have such a small society?" So I got all the presidents together and said, Why don't we unify? We'll keep our own identity. We decided to call ourselves the Southern Italy Religious Societies, S.I.R.S., The Santa Maria Maddalena, Saint Andrew, Saint Catello, Santa Maria Della Vergine,

Santa Trofimena, Saint Andrew Ladies Society, and Santa Maria Maddalena Ladies Guild. We help one another, and we support each other. Isn't that what life is all about? Helping one another? And not only that, but with so many community projects we do, you're promoting the Italian community.

"The Women's Auxiliary of the Sons of Italy"

Sal Garibaldi:

In those days in New Haven in the nineteen twenties, there were more family relationships with your children. Then, when they got married, they always stayed and lived in the neighborhood. Today they get out of the neighborhood, and therefore you lose the friendship of your own children. I don't expect my son to visit me every day because he lives in North Haven.

In my neighborhood everyone worked nearby. As a child my father was very active in the Sons of Italy. Then my mother became a member of the Ladies Auxiliary of the Sons of Italy Lodge on Wooster Place, and I remember people coming to my mother's house to give her a dollar for the membership. She belonged

to the Sick Committee, and became one of a group of four women they called *a cortadisce*, a guardian, who visited to sick members. They'd spend a dollar to buy a basket of food before they came to your mother's house and stayed for the afternoon to pay their respects. That was all over the neighborhood.

My mother couldn't go to Fair Haven unless she took a trolley car, and they didn't take trolley cars. They were more intimate, and that's why all these organizations became so helpful to their own people. We were born friendlier in those days. Some people were a little better off, but only the professionals, and the doctors and lawyers had cars. Everything in the neighborhood was within walking distance. So we were friendlier—my mother came to visit at your house once a week. Where were you gonna go? They didn't take trolleys. All their friends were right there. That's how we lived.

"Stay Together and Carry On"

Marion Sperandeo DeNegre:

My mother was in every church organization and very active. She attracted a nucleus

of women because of her aggressiveness and she had a lot of faith. She founded the Saint Anne's Pilgrim Society. She wrote the bylaws. It started off with nine charter members, and from that it grew to over a hundred members under the auspices of the French nuns of Saint Louis, and they gave her all the information of how to do this.

We used to have our meetings down in the convent on Three Eleven Green Street in New Haven. And from there she started organizing pilgrimages to the shrines in Canada, most particularly Saint Anne, only for the explicit purpose of bringing the sick and the handicapped there. During the year this society raised money through card parties, teas, tag sales, and whatever the money they raised, they'd get names from people who recommended this child has spina bifida, this child has this, this man has this [sickness]. All year they would fundraise. She was strong—you never sat idle in her company. She'd see you sitting there and she'd make you get up and do something. She was a taskmaster. Tough, very tough. A hard worker. And they would go and interview these people, and whoever they thought would be worthy, or would gain from the experience of a pilgrimage, they were

honored to be their guests and come as free, as well as their companion.

My mother used to charter three trains from New Haven to Montreal. Then we'd transfer from Montreal up to Saint Anne's. Can you imagine? Three trainloads of people and she coordinated all of it. Of course the people from the Saint Anne Society would come with her on the pilgrimage and help her and delegate and watch over them. They always donated lots of money to each shrine they went to, and built lots of things at these shrines. We have chapels up there in Canada. We have Stations of the Cross, all in the society's name, and stained glass windows.

When mama died in nineteen seventy, her final words to the three of us, was "Stay together and carry on." Little did we know what she meant by carry on. She left us this pilgrimage, the society, and she left it all to us to carry on. My mother was a Third Order member and she was entitled to be dressed in habit of the Third Order as a Dominican. She was the "Prioress," which meant that she was leading that particular year for the group.

When she died, she wanted to be buried in her habit. But we didn't know anything about this habit except that it was something she had to be dressed in. So we called the undertaker Joe Rapuano, and we said, "Joe, mom wants to be buried in her habit, what should we do?" He said, "I'll tell you what. I'll take her body with you people up to the monastery in North Guilford, and we'll have them dress her." So we drove the hearse to the monastery, and we brought the casket into the monastery, and all the nuns are all around the casket and they dressed my mother.

Italian American Women's Success Stories

Education and Careers

Courageous Italian women who decided to take the daring leap across the Atlantic in the great migration severed centuries of inherited poverty and stagnation as peasants trapped in southern Italy's archaic feudal class structure. Eager to help their families climb out of poverty and into the working class, they worked alongside men in Connecticut's industries as female proletarians who helped set the foundation for the social and economic improvement of their children and grandchildren.

Many of their daughters completed high school, which qualified them for low-paying white collar jobs as secretaries, bookkeepers, nurses, social workers, and teachers. Second-generation women set the stage for their daughters to earn advanced degrees in the 1960s and '70s to become lawyers, university professors, accountants, administrators, businesswomen, and psychologists. Granddaughters of Italian immigrants became the full beneficiaries of the American dream, completing the hard-earned journey from the dire poverty and deprivation of their grandmothers' generation in southern Italy to the affluence of the

American middle class. Though assimilated into the American mainstream, they nevertheless retained the invaluable lessons they had learned from their grandparents.

In the 1970s and '80s, many grandmothers in Connecticut lived with children who continued the Italian tradition of taking care of parents in old age. Granddaughters were blessed with the opportunity to absorb the Old World culture of their grandmothers who taught them loyalty to family, concern for neighbors and community, the dignity of hard work, the value of education, sacrifice for the good of others, and the importance of family name. Professional Italian American women never forgot life lessons from grandmothers who taught by example, and they adapted the values of compassion, fairness, and social justice to their workplaces. Adelina Esposito, a retired seamstress who lived in New Haven with her son and daughter-in-law and their two children, enjoyed watching Westerns, what she called her "cowaboy an Indiana show." One day, after watching another episode of cowboys winning the battle against Indians,

she recognized the inequality between people in her adopted country, and asked her granddaughter, "*Ma chest Indiani, perche non vincono mai?* But these Indians, how come they never win?"

Grandmothers embodied the accumulated wisdom of Southern Italian peasant culture and became lifelong role models for many second and third-generation Italian American women. Their strong beliefs intersected, and at times collided, with middle-class lifestyles. Antonia Morrone, who emigrated from the small village of Cescheto in the Aurunci mountains of Campania, gave her daughter Lena advice for the ages, "*Fai la figura tuia, e non importa che fanno chill auti,* Never mind what other people are doing, always do what is right."

In 1983, Janice A. Piccinini, a lifelong educator, received the American Award from the Maryland Order of Sons of Italy. During her acceptance speech, she paid homage to her grandmother's influence in words that spoke volumes for many successful Italian American women: "I want to mention my grandmother, Rosa Piccinini. She shared the deprivation and hardship with her husband and raised and nurtured her family with a quiet strength born of love and devotion. The role of women as pioneers is seldom fully recognized, and I would like to believe that I am here tonight, receiving this prestigious award as a stand-in for her and for all Italian American wom-

en, whose strength, dedication and loyalty built the foundation and framework of the Italian American culture."[1] Lorraine Mangione, an Italian American psychologist and college educator, spoke for many Italian American women when she pointed to her Italian upbringing in Southington, Connecticut, as the key to her success, saying, "Everything I needed to learn, I learned at home."

"Everything I Learned At Home"

Lorraine Mangione is a PhD and Professor and Director of Practica of the Department of Clinical Psychology of Antioch University New England in Keene, New Hampshire.

I think that's why I am a psychologist. If my mother had been born in a different time she would have been a U.N. diplomat or the head of the U.N. Where my father was that kind of a brash, fiery Italian, my mother was the kind that sat back and said, "Well, let's think about this a little."

And she could talk to anybody. Years ago somebody asked my mother, "Gee, are you surprised Lorraine is a psychologist?" And she said, "No, this is just how Lorraine has always been, this is how we are in our family. We talk,

we're Italians. We talk about everything, and we're always talking. We talk about people, about what's going on. We always tried to understand things. This is what we do in our life, so it doesn't surprise me that Lorraine is a psychologist."

When I was in my twenties, and the whole women's movement was going on, people always wanted to paint the picture that because you had Italian parents that somehow we women were oppressed and that we were told we couldn't do anything. And I used to say, God, I never heard that. My parents didn't feel like that. There was that stereotype which made me crazy. Some people grew up with that but so did some Irish or so did some Polish. It wasn't an Italian thing. My parents instilled in me that you can be president, that you can do whatever you want. Their values were trying to understand things, relating to people. It was all about relationships, communication. And I learned that all at home.

People used to come to my house, and I had a huge list of friends who considered my parents their parents. People thought of my mother as their psychologist long before we had that word in our vocabulary. When we were growing up there weren't psychologists around. My mother was always the listener. She was the one who would help you. At her funeral that's when my cousin got up and she said, "I would always call your mother when I needed to talk to somebody." People loved coming to our house. She was just that kind of person. We talked, you ate, and that's such an Italian thing. Hard work, and you just kept going.

"Biculturality"

Linda Barone, a licensed professional counselor in New Haven, was active in designing advocacy programs for newly arrived immigrants under the auspices of Integrated Refugee and Immigrant Services.

Growing up as an Italian American in the nineteen fifties and sixties in New Haven wasn't as cool as it is today. When my parents moved from Westville to Woodbridge, they didn't have a lot of money. I was in the highest track in middle school, but when my mother registered me at Amity Junior High in Bethany the guidance counselor said, "Well, your daughter has to take an entrance exam to see where she places." And my mother said, "What? She's got straight As in the highest

tracks." He said, "Well, Missus Barone, the people here are educated and professional and not from . . ." He phrased it in such a way that she interpreted it as being anti-Italian and anti-working-class. And he was an Italian American! The implication was that you're out of your league lady. Well of course I scored off the charts, but they still didn't put me in the top track. They said, "We don't want her to fail."

When Nancy Pelosi became the Speaker of the House, I was more excited to see her as the first Italian American than I was to see her as the first woman Speaker. I felt more discriminated against as an Italian American than I ever have as a woman, to be honest. And being an Italian American woman in my family wasn't always so easy. My father believed in education, but my uncles thought he was crazy to send me to college. I was the first person to go to college. I remember someone saying to me, "Oh, you're a pioneer, just like your grandmother Susie."

But there was a conflict I struggled with for many years, what's called in my field as "biculturality," which is you don't quite fit into this very homogenized American world that you've entered, even though you're smart and you've got all the credentials. But you don't quite fit into family anymore, I mean you do and you don't. Now you're different. Now you're maybe a little bit of a threat. Where are you going to go with all this education? So that's a hard tension to hold, and I counsel a lot of people who are second-generation Americans—their parents came here—and I'm the first person who identifies that feeling for them. They're trying to bridge that tension of how do I keep attached to my family and yet enter this world that I'm aspiring to? And in some ways my family wants me to aspire, but they're afraid of losing me. I felt that way on both counts as an Italian American and as a woman. It was a really mixed message. Achieve but don't achieve too much maybe, stay close. You can do anything you want but . . .

I always wanted to be a therapist. I was fascinated by why people did what they did. You could have two people having the same set of circumstances, and one takes it one way, the other another way. I always had the ability to identify with "other," to identify with a person who feels on the outside looking in. Because if you have a mental illness that's how you feel.

Even though I was offered a good job when I was forty, I said, it's my turn now after tak-

ing care of my mother and father. I scraped together three part-time jobs and went back and got my master's as a licensed professional counselor. I think that was a lot of my grandmother Susie. I cleaned houses in the morning, in the afternoon. I was the associate director of a nonprofit. It was wild, but I got through. My guiding light was my grandmother. She really believed in being true to yourself, no matter what. No matter what the price was. And she compromised for no one. Not even her husband.

"I Went to Syracuse"

Norma Barbieri spoke from personal experience as a social worker during Mayor Richard Lee's administration in the 1950s. She viewed Lee's urban redevelopment as a disastrous project that destroyed the fabric of New Haven's neighborhoods.

My mother exposed me to the circus, ice skating, and the movies every week. That's how she learned English. She was a lovely looking woman and easy to be nice to. My sister Mary and I always blessed ourselves for having both parents in spite of the fact my father could be extremely difficult.

I studied with Maestro Riggio for seven years, from when I was thirteen. He was an opera conductor and singer. I was on the stage on the Shubert Theatre on the stage with him. He taught us some of the course music so we could be on stage and get the feel of it. We had no prom in nineteen forty-five because of the war when I graduated. When I applied to college, the nun at Albertus College told me Commercial high school was not recognized as an academic school, so I had to go back to Hillhouse. So I told my father, and went to Hillhouse for a year and a half to get the accreditation. My friend Ann Cretella went to Larsen College on Whitney Avenue, a junior college. And I went there for two years.

Then I met Ruth Lailor at Larsen, what a wonderful girl. Come graduation, what do we do now? She had a cousin who was the registrar at Syracuse University, and she was going there. My father liked Ruth and her father was my father's insurance man. He knew they were a good family. So I went home and said I wanted to go. He said, "*Ruth è una brava ragazza. Tu vuoi andare a scuola con Lei?* Ruth is a good girl. You want to go to school with her?" "Yes Pa, I want to go with her." I didn't even know where it was. We never expected

to go to a college and check it out with our parents.

They didn't know where they were sending me. In the woods of New York, hey! I loved Syracuse. He agreed to it. He came only once, to my graduation in nineteen fifty-one. I was in a dormitory, and because we were already seasoned people so to speak, they didn't want to put us in freshman buildings. They put us off campus. There were all Jewish. Eighty percent were Jewish. I think I was one of two Italians in the building, and the rest were Protestants. It was quite interesting, and I got quite an education.

I used to love listening to them. Their parents were so outgoing, way above mine as far as doing things, traveling and talking about different places. And of course, they were extremely surprised I spoke fluent Italian. They asked, "Does it confuse you with English?" I said, "No, no, never did."

I got my degree in sociology, and I became a social worker. I went back to get my master's at Syracuse, but I missed my girl friends, and I didn't get the feel of it. So I went back home. My father knew Anthony Paolillo, and he asked what I was doing. He said, "Why don't you have her sign up for a course in social work?" So I did. I passed, and worked for the city of New Haven from nineteen fifty-one to nineteen fifty-seven. I was working during urban redevelopment.

I remember when I was at Syracuse and our sociology book pointed to New Haven as one of the best examples of so many ethnic groups living together and respecting each other. Until Mayor Dick Lee. He destroyed the city, destroyed it completely. *Quello stronzo e merda,* He was a no good bastard, but I'm sorry because I use that language with him. I saw all the people have to leave the city that didn't want to.

My mother and father left Lucibello's Pastry and my father, in desperation, sold it. He wasn't ready. I was very angry that my father felt we could not carry on the business and yet we were educated. It really hurt, my sister and my mother were badly bruised because of urban redevelopment. Judge Toscano called me up. I had worked with him because of my social work background, and he said, "Is something wrong with your dad?" I said, "Like what?" "Has he been under stress of any kind?" I said, "Well that's what redevelopment did to him. He's giving his business away." I know he was depressed.

"You're My Life"

Linda Barone recalled being inspired by the mother of the Berrigan brothers who always set up an extra place setting at the table for "Christ the Traveler" in case someone would show up.

Both grandmothers influenced me as an Italian American woman. I'm named Linda Susan after both grandmothers. My grandmother Assunta, they called her Susie, was from Benevento in the region of Campania. She grew up kind of privileged on a farm. One night her dad went to the local *taverna*, got into a card game, and the next thing you know, no farm! He bet the farm and lost. So she went from a privileged young woman to being penniless.

Her brothers came ahead of her to New Haven, and she followed shortly thereafter, and became a domestic. She earned her own money, saved, and bought a house. Now she was married to an interesting man, a wonderful man, but not the most responsible, and she figured out early on that I only have me to depend on. She bought a little farm in Hamden, Connecticut, and farmed it herself. She worked on the barter system, and all the Italian women came and helped Susie. And her husband did whatever he did. And she raised two sons, one was my father.

But her driving force was Catholicism, and to her that meant social justice. If you needed a place to stay, you came to see Susie, if you needed anything, you came to see Susie. She didn't go to church, but she lived and walked as a total Christian. She was a huge giver to the Saint Joseph orphanage in New Haven. She donated tons to that, nobody knows where she got it, but she donated money to them.

She bought a second house and she came to the closing with a paper sack full of coins. The bank attorney laughed at her. Her attorney said, "Oh yeah? We'll see who's got cash to pay for a house" Because she couldn't write her name. So she sold fruits and vegetables that she raised, and gave so much to those charities in addition to opening up her own home.

I was born on that farm. My grandmothers really taught me about hospitality, and it translates beautifully into the refugee work that I do. I am always told that I take after Susie. I'm very much into social justice issues, and I was always teased, "Oh, you're just like Susie," which I was actually proud of. I'm not sure it was always a compliment [laughing] in my family, kind of like, you're a sucker. But

I was really proud of that, and that piece of Catholicism is what I've kept even though I'm not a practicing Catholic, I really believe in those issues.

So that's one thing I learned from her. The other thing was that a woman had to be independent even though my grandmother was very different for her generation. When I was born, I was the youngest grandchild on that side of the family, and she had three grandsons. And I'm told she was very upset that I was a girl. And I said, well, why? And she said, "Because a woman's life is so hard, that's the only reason."

But she learned to take care of herself. I learned from the legend, from the stories. Having her own money. Working the farm herself. They say as unreliable as my grandfather was, she adored him. But she also knew she had to build a separate life. And she did it without resentment, without any ballyhoo. She just acted.

My other grandmother was Irmalinda, and she became Linda when she came to this county when she was four from the island of Capri. She had a different kind of hospitality, but hospitality was the key. The phrase in Italian that my grandmother Susie referred to was

Christ the Stranger or Christ the Traveler. It's an old concept in Catholicism, and the reason why you greet everybody the same at your door is because you never know when it's Christ. There's Christ in all of us. My grandmother actually identified a person coming to her door as this could be Christ the Traveler or Christ the Stranger looking for shelter, looking for food. She radically believed in that.

Irmalinda's house was like Grand Central Station. Everybody went to Linda's in Bridgeport. The food, I don't know how these people afforded to feed the people that they did, and no matter what time of day you went, you'd be given a meal. On her ninetieth birthday one of her granddaughters said, "So grandma, tell us, what's the secret of living to be ninety?" And she said, "Three things. Take good care of yourself, greet everybody with a smile, and at eleven o'clock every morning have a shot of brandy." She was a character. She was wonderful, and she did greet everybody with a smile.

I remember after one Easter dinner, she was into her eighties, had this houseful of people. And I was getting old enough to realize how much work was involved, and I said, "Grandma, how do you do this? It's so much work." And she said, "Oh no honey, it's

a labor of love." And she really meant that. One of the most poignant stories I have of her is when she was in a nursing home and not doing so great. I walked in one day, and I said, "Grandma, do you know who I am?" And she said, "Know who you are? You're my life." They were such compassionate women and such empathic women. It was just part of who they were, and I really think it is a part of our Italian culture, a very compassionate, loving culture.

"Things They Could Never Do"

Rosalind Proto spoke at her home with her first cousins, Mary Forenzano and Therese Incarnato.

My mother was taken out of school when she was in the seventh grade. My father didn't complete more than that as well. When she said it was homework time, it was instilled in us from the time we were little that we had to study. There was never a question about doing homework, it was just an automatic response, and that this was part of life. We would review spelling words every Thursday night.

My father was self-educated and he loved to read. When I was in high school, I'd say,

"Dad, I have a test tomorrow. Do you want to go over some notes with me?" And he would love to sit down at the table and be thrilled to do that with me. And that's how we'd spend many a night, going over our notes and textbooks, and they'd be so happy for us. Things they were never able to do, go to school and college. They had to go to work to support the family.

They tried to put away as much money as they could for us, but times in the nineteen fifties were very difficult. My father lost a lot of customers in his grocery store because they moved out of the neighborhood to the suburbs during urban redevelopment in New Haven. So all the more, they stressed to do well, to get scholarships to pursue your career. Even though the tuition wasn't much at Southern Connecticut, for us it was difficult. But our grandmothers were happy we became schoolteachers. That was the thing then, women schoolteachers. We were the first females in our families to get a college education. I remember my grandmother being so proud when I graduated from eighth grade, and that was a great thing to do. It was like you were graduating from college for her. She was from Amalfi, and never made it that far. We never

looked down on our grandparents because they didn't have an education. We loved them because we knew how hard they worked and how much they loved every one of us. They were so devoted and loyal to their husbands.

"Make America Better"

Diana Avino was the 1998 recipient of the prestigious Milken National Educator's Award for the state of Connecticut.

First of all, we were all brought up to give back. Everything you did was to help one another, so that you could go outside and be a productive person. It was almost like you had to be strong in the family so you could go out and make America better. You had to talk about things in the family, and that strength then would give you this courage to go out there and do the kind of things that you could do, and that you were going be the person that you could be. That's because of what we learned in the family.

My mother always used to say, "You're put on this earth to make a difference, so you need to be doing something well." And she was always into us working for the public. She so believed in the public school system. For me, to become a public school teacher was always so important. She so believed in America, and it was always about us giving back to America, always to give back to the public cause.

She was very civic minded. My parents were involved in all politics for so long, not as politicians, just as community leaders with people discussing the best way things should happen. They were articulate, and my father would go out and sign up people to become voters. They were so involved in that civic work, but they didn't want anything from it. They didn't want to run for office. They did their duty. My mother used to say, "I always want you to think smart, I want you to use your mind and your talents." For her, it wasn't just about your brain. It had to do with thinking. Whenever you solved a problem, "I want you to think about it first, and then don't just jump into an answer."

She used to say "You should always talk to people about it," and it was always about the family, to listen to the family. "You don't have to agree with the family, but you should listen to them, and you should consider what they have to say." The strength of the family was everything. That's what it has always been

about. And when you learn how to depend on each other within a family, it just builds up so much self-esteem in you that you can go out there and you can build that same feeling in other places. And so for me, I built that feeling within my classroom with my students.

I really took what I learned from my family situation, and I just brought that right into my classroom. And when my mother used to say to me, "Use your mind and your talents," it wasn't just about my kids' minds, it was about, what are they good at? Are you good at music? Well, let me see if I can incorporate that music into learning. Are you good as an artist? Let me incorporate that. And so for years I was an "integrated day teacher," which means I don't teach reading, writing, and spelling. I'd teach something like, let's learn about the Revolutionary War, or let's learn about that time in history. Let's read about, let's look at the art, the music. Let's invest, let's have conversations, lots of dialogue. And that the only way you ever really learn about a topic is to take from all the different sides because that's how life is. And that's how my life was, my roots. I was fortunate to be able to teach that philosophy.

My mother realized that her three kids had fulfilled her American dream. And I was the last one, the only girl besides my brother Neil and Richard who both left the area for public careers. But I taught in New Haven, in Fair Haven Middle School. I made the circle, not only back to the school I went through, but the community of my father's family. From where I was born, I circled right back and I taught. That was big. That was like, Oh my God, this was it, and you did what you were supposed to do. I'm sure that they felt, "We're done, we came here, and we fulfilled what we felt it was to give back."

I am the transition now. It's my job to transition what I know was important to that generation to my kids. And not only that, it's bigger than that. It was to my students. What would my mother want to say here? She would want to say, "Be smart. Use your talents, use your mind. Don't make quick decisions. Talk to people, listen to them. In the end you have to do what you need to do, but listen to what they have to say." And those are the things that I would say to all my students. So I think for this generation we have an opportunity to expand the message. Because of whom we became. To build up, to make a difference, but always to remember where you came from, always remember how it started. That's the

Italian lesson, the one you want to teach your kids. Where did you come from? Where did you go? And always to go back and to say, this is how it all started.

And remember where it started, because those people were critical in who we all are today. They made us. They gave up a lot for us. They gave up their families to come here. And yeah, they thought they were going to come to a better place, and it wasn't as easy as they all thought it was going to be. And they scrimped, and they saved, and put most of our generation through college, something that they never had a chance to experience.

America has benefited so much in the field of education from so many dedicated Italian American educators. When you look at public education and see who's leading the way, there are so many Italian Americans out there that are really good at this. And you have to say, why are they good at this? Well, I think they're good at this because it comes right back to family. We educate, we help kids do better, be smarter, and we're good at that. Why? Because our parents were good at that. They taught us how to do that. In Italian American family life we empathized with each other, we could feel someone's pain. We could feel some-

one's joy. We internalized it, you feel what I'm feeling, and I feel what you're feeling. I think that's what makes us good educators, makes us important in this society where you need a lot of people to be helping and listening along the way.

"Family Honor"

Congresswoman Rosa DeLauro's mother Luisa had been an alderwoman for thirty-five years, the longest political career in New Haven's history.

The sense of growing up with a set of values that talked about integrity, honesty, responsibility . . . you had care for someone else. The strength you gained from your church, your family first, and foremost your community, and that you give back to your community.

I am a product of an Italian Catholic household. Who I am today, what my service is about . . . all of that is a reflection of that experience. That's how you proceed, how you face issues, how your face crises, how you face good times, and whatever it is that comes up in your life. It has provided me with great strength. Illness, whatever it is. When you think about the power of the institution that

I work for, often times it doesn't do what you want it to do. But it has potential to make a real difference in people's lives, which for me reflects on my heritage, my Italian culture, my base. It's a touchstone, and I say it over and over again. No matter where I go, no matter what I do, those are traceable to that Italian Catholic household in Wooster Square in New Haven, Connecticut. And as a lawmaker that informs what I do.

How do you approach the issue of senior citizens? It comes out of watching a family that took care of its own, of making sure they had the dignity and the respect in their older years for what they had contributed. What does it mean to look at minimum wage and workers and people who struggle everyday for a paycheck? It's my mother in the dress shop. It's my grandmother in her pastry shop. It's my aunts and the people from my community. Every day they worked as hard as they could. Why? For their family. For their community, to make sure their kids had a better future. Education. Why do I want to provide the opportunity for families to be able to educate their kids? Because it was what I learned. That if you get yourself an education, you can realize your dreams.

But it's a sacrifice of the people who worked. It was their value system that said education was important. Watching my mother in that sweatshop, watching those other women. It was all about what their kids were going to have. So for me, when you see that and somebody says, What do you do? We have an opportunity to pass a piece of legislation that allows a family to deduct their cost of their kids' education, or that says we're going to have a Pell Grant to go to a family that may not have all the resources to get their kid educated. What side of that issue am I going to be on? It's easy.

Medicare. The cost of prescription drugs. Watching people struggle. They can't afford health insurance. They can't afford those prescription drugs. What side do you come down on when you see a system that was meant to assist people at a time of need? What did my family do in times of need? You reach beyond yourself. You went to help Rosina. You did whatever you needed to do. You took people in when they were out on the street. So what do you do about homeless and housing?

And what was the struggle with my family? To this day my mother says, "I wish I had a home of my own." She wanted to own her

home, not rent. Still the tug of that dream. So how do I try to help people get to where they're going? And for me, it was the experience of watching my folks who were in public life. They didn't write high policy! What they did was writ large. They helped people navigate the beaurocracy so that they could find a better way. And that experience says to me, what is my job primarily here? I am an advocate. That's what I do, and I do it in a different venue. But my job is to take those interests and translate them into public policy that makes a difference in people's lives.

I'll give you an example. The Social Security system today is intergenerational as you know. The genius of it. It says if my mother works, now it's me, and I'm here to help her. My kids will assist me. But if you do what some people want to do—to break that tie, take your money and put it into the stock market, have it there? The tie is all about who we are, generationally. And that comes to me out of my grandmother, and my mother who took care of her mother. My mother who took care of her sisters, and so forth. And now I can do that. And that is the structure of our families. You are a product of the environment. And I say it's an Italian Catholic household. My church

comes from a tradition of great social justice. When Leo the Thirteenth talked about a system that would take care of the elderly, he didn't say Social Security, but that's what he was talking about. Those were the pieces they were talking about.

Minimum wage. When you're looking at labor unions and when you're looking at labor conditions. I saw what hell my mother was working in! And what she was doing. Why wouldn't I be for changing these conditions? Helping people to work. Immigrant families.

Running through all of that was that sense of integrity, that you are honest, that you don't lie, you don't cheat, and you don't steal. That's who we are, except what the stereotypes want to say we are. You never do anything to disgrace your Italian family name, because it is a badge of honor. You don't just carry who you are. It's not just about Rosa DeLauro. It is about the DeLauro name. It's not about being the granddaughter of Luisa Canestri. It's about who she was, what she stood for, and what that Canestri Pastry Shop on Wooster Street in New Haven stood for. And it's about protecting that name and that honor. You do not only disgrace yourself, you disgrace your entire family.

It's about the values that we grew up with. And that's every Italian American, that sense of the values we have grown up with, which informs what our lives are. And how to act and behave. What's right and what's wrong, and there's no gray area. You know when you're doing the right thing. And when you didn't, they told you. Or they would just say, "You know, we trust you, you're going to do the right thing, you will make the right decision because we've given you a structure in which you can make that decision." Because it was the structure they knew from their parents, and it worked with them.

I've had a lot of benefits in my lifetime, I really have. I've attended the best schools, traveled. For me, when I took the oath of office eighteen years ago, it wasn't about me. It was about my father. It was about my mother. That's the legacy. That's what it's about. I got married at thirty. I didn't change my name. There was never any thought. I am an only child. It's about the name DeLauro, what it means in the community, and bringing honor to that name. It's to honor the name, but it's to honor the work, the hard work and the sacrifice that they were engaged in that brought me to where I am. I've often said that if my mother had the same benefits and opportunites I had, she could have ruled the world. But they provided me with such a rich education, a rich heritage, that the thing I can best do is to honor who my folks and family are. By serving in office, by trying to represent the needs of the people who sent me there. By doing the very, very best that I can so that I know I tried to do everything I possibly could in the profession I have chosen. And in my personal life, to make a difference the way my parents and grandparents made a difference.

Finding Her Voice

Italian American Women's Narratives

The contribution of Connecticut's Italian American women to the genre of women's writings in the form of poetry, journals, autobiographies, and cookbooks had improbable beginnings.[1] Southern Italy's archaic school system reserved advanced writing skills for the wealthy, who could afford to send children to high schools and universities. Few girls of the peasant class went to school beyond lower elementary school, and their writing skills were limited to composing simple letters. Between 1899 and 1910, 53.9 percent of children fourteen and over were illiterate.[2] Young girls spent their lives working fields, raising children, and tending households. Raised as caregivers, they had little time to think as individuals, or aspire to write their personal stories.

Connecticut's Italian immigrants found a state with mandatory school laws, which were often enforced. Italian women who had managed to learn writing skills in Italy, and those who graduated from Connecticut's high schools, began a shift in women's consciousness, translating the female voice from the ancient storytelling tradition to the written word of

the pen. Italian women's autobiographies and narratives reflect the meditative journey into the self, a realization of the importance of personal experience for the benefit of a wider reading audience.

Mary Lou Calamita's autobiography, which is included in this chapter, offers a glimpse into the quiet inner strength of many Italian American women. Her story reveals not only the physical drudgery of farm life, but also the suffering mind of a girl yearning to be a typical American teenager.

As a young girl in Sicily, Lucia Falbo Fulin learned to write, taking dictation for the book her father was writing on the lives of country doctors in Melilli. Years after she immigrated to Middletown, Connecticut, she coped with the death of her husband by writing a journal that took the form of daily conversations with him.

For three decades, Anna Luciani, an immigrant farmer who had taught her husband the business and skills of farming, kept written journals to record daily life on their farm in Woodbridge, Connecticut.

Maria Carmen Tito Riello was born in 1894 in San Lorenzo, near Salerno in the region of Campania, and

immigrated to New Haven in 1915. Living on Wallace Street in the Wooster Square neighborhood, she knew the hardships of many men and women who worked long hours in local sweatshops and factories. Knowing that many non-Italian wives wished to please their husbands by cooking like their mothers-in-law, she wrote down recipes she had learned from her mother in San Lorenzo. She tested each dish to make sure it had the exact flavors she remembered in Italy. In 1936, Maria hired a typist, wrote, and self-published *The Italian Cookbook* as an affordable cooking guide for working families to prepare meals in the southern Italian tradition of *le cucine dei poveri,* the kitchens of the poor. Her cookbook's narrative advised women to "be sure to do your hardest work before noon as that is the time you feel like working more."[3] She also included a recipe section with a handy timesaving chart for making Italian meals "in case you have to go away and will be back within an hour of dinnertime."[4] Documenting her mother's original recipes passed down to her through oral tradition, Maria's book represents a historical artifact of southern Italian culture. *The Italian Cookbook* takes its place in culinary history as an original work of technical and literary transmission of authentic southern Italian cuisine that would have been lost to the interpretations of American chefs and food companies.

"Fifty-Nine Inches of Courage"

CAROL CANGIANO

It was a cold and dreary day. With heavy pickaxes and shovels on their shoulders, the humble but valiant men from the mountain village of San Marco La Catola in Puglia once again began their descent from their simple village that crowned the mountain. Once again the men faced another long day of backbreaking work, carving out a road at the base of the mountain. The work was hard, but the men were grateful because it was the only work available. Life in the village was difficult for everyone, even for the women who tended their meager gardens, baked bread, and attended to the various chores that life dictated. All this in addition to caring for their children. The only diversion the women had was the camaraderie of each other. Michele, a handsome, well-respected member of the village "road gang" never complained about how exhausting work was because he had a dream, the dream of someday bringing his wife, Antoinette, his four sons, and two daughters to America, the land of opportunity. This particular day, the road to the mountain seemed more tedious than usual for Michele. He had not been feeling well lately, was often out of breath and troubled by the constant pain

in his left arm. Michele, not one to complain, was grateful to God to have this job because they were scarce and he hoped it would help him realize his dream. The "boss" who hired the men and was in charge of organizing the workers did not come to work this one day. No doubt he was selecting and instructing another group somewhere in the area so more road could be cleared and extended further. The men from San Marco labored for several hours until cold and hungry, they stopped to rest and eat, taking a brief break to satisfy their stomachs with some hard bread and cheese wrapped in coarse cloth they had stuffed into their pockets. When they were almost ready to resume work, Michele suddenly shouted, "Dio mio!" grabbed his chest, and fell to the ground. His friends rallied around him but it was obvious their friend was dead. Solemnly, they carried his body back up the mountain returning him to his young wife and children. A pall fell upon the tiny village and he was quickly laid to rest, but everybody said, "Dio mio, what will become of Antoinette?" But Antoinette, all fifty-nine inches of her, knew exactly what she had to do. With a vow of secrecy among the villagers, Antoinette like all the men, donned Michele's heavy work clothes, gloves, boots, his wide-brimmed hat, lifted his heavy pickaxe and shovel and with the others began the long trek down the mountain.

Desperate to help Antonietta, no one revealed to the boss that Michele had died. The work gang still had the same numbers, and since Antonietta was small like her husband and disguised by the heavy clothing, she went undetected. Fortunately, the boss was seldom there since he was constantly organizing new work gangs to allow the road to penetrate further and further into the countryside. Without a complaint, this strong, determined fifty-nine inch woman worked side by side with the men. She continued this back-breaking work day after day for many months, working faithfully until she finally eked out the passage for herself and her children, honoring Michele and booking passage to America. How she dreaded leaving her beloved Italy! But she knew it was necessary to provide a better life for her family. The year was 1920, and finally Antoinette and her children set sail in steerage for America. I know this story to be true, for this fifty-nine-inch bundle of courage was my grandmother, Antoinette Malaspina Santoro.

"My Life in Sicily"

Lucia Falbo Fulin

Lucia Falbo Fulin wrote her autobiography at age ninety-three for her cousin Enza in Italy. Lucia had

learned writing skills as a young girl taking dictations from her stepfather, a doctor who wrote *Memorie d'un Medico di Campagna* (*Memoirs of a Country Doctor*), published in 1918.

I thank God that up until now, at one hundred and two, He has given me good health, and what's more important, a lucid mind. Even at age ninety-three I still enjoyed reading and writing. Since I was young, whenever I saw something written I liked, whether poetry or prose, I would read and reread it, and learned to memorize it. Even now, from time to time, I recite one of them mentally and it gives me a lot of satisfaction as if I were hearing a melody. That said, I don't want to give anyone the impression of being an intellectual, far from it! I wanted to say all this so you could know me better since you asked me about my youth in Sicily and my early years in America.

I was born in America you might say by chance and I was just three months old when my parents brought me back to Sicily where I lived for a good part of my youth. My father died when I was three years old and therefore I didn't have the good fortune to have known or remember him. The man I remember as a second father was Doctor Sebastiano Crescimanno, a prominent character from a prestigious family with political influence. Besides being a doctor he was the head [mayor] of the political party in town and at the heart of progress in the town of Melilli where he governed for some years without accepting any salary. He wrote different short novels on the old customs and traditions of the town and he enjoyed writing even in Sicilian dialect. Since I was small I always loved literature and music and if it was the opera, I read it as if singing a song as well. During summers as a little girl, we spent some weeks in Catania or Siracusa, often going to the opera. I remember being so little and how much I enjoyed listening to the beautiful arias that I used to memorize them and then I used to sing them.

Sometimes instead of going to the city we went out to the country to vacation. How many memories and how many experiences I can still recall! I remember the time of the *vendemmia*, and I can still see women with baskets full of grapes on their heads, holding them with one hand to keep them balanced. Then they unloaded them where the men stomped them as the grape juice, with an aroma that would almost knock you out, dripped down into large wine vats. I remember the *mietitura*, or the reaping: a group of men stooped over and pouring with sweat from working in the heat, cutting the ears of wheat with scythes with the characteristic smell that scattered in the air. On the farm there was every type of delicious and scented fruit from the fertile soil of our beautiful Sicily, as you said, a dark gem of nature.

When I was eleven years old I received my diploma from elementary school (I was promoted without having to take my exams) and being very good in school (speaking modestly) I was going to continue my studies but because of family circumstances it was decided to send me into a different profession since I had an outstanding talent for design in sewing and embroidering. I had an innate talent for observing a design and copying it. I was already designing and tailoring little dresses and aprons which I decorated with incised embroidery. Two years later, it was decided to send me to a school in Catania as an apprentice in the art of sewing and design. But those times didn't last long from when I was five to around twelve, when things changed when the doctor became ill and we stopped going on vacations. When I left for sewing school in Catania he was already very sick, spending his days (sometimes sitting with a shawl around his shoulders) like he was the day I left. It was February 1923, and he wrote it just before he died, maybe foreseeing his death. His note to me read: "I am happy that you are making progress at school; I hope that you complete your studies—Addio." He died while I was in school in Catania on April 20, 1923, three days before my fourteenth birthday.

When I finished taking all my classes in school in Catania, I returned home to Melilli as a tailor at age fourteen. Having come from the city, people considered me an expert (which frankly, I wasn't). I quickly became the preferred tailor of the wealthy who considered me an expert, not only because of having gone to school and learning the trade, but because I could copy any type of pattern to make clothes or create my own. On occasion I made wedding gowns, coats, and a lot of other items. At a time in my life when I should have been carefree as an adolescent, I was taking on the burden of work responsibilties, which I did willingly and with a lot of satisfaction. At this point my life took on a new direction. When I was fifteen, I met the man that God had destined for me and after a few months of being engaged we got married in January 1925. I was married at fifteen and eight months and my husband was twenty-six. In December of that year I had my first son, Alessandro, and we called him Sandro. Two years later I had my daughter Elisabetta (Elisa), and by the time I was eighteen I had two children. In the meantime, my husband couldn't find work and we lived just scraping by. By the will of destiny at the time, a new law came out in America allowing people living abroad but born in America to return with their husbands and children. Being born in America, we started all the paperwork and after a year we left Melilli in Sicily to come to America, to encounter an unknown destiny.

"Leaving Sicily"

I don't have to tell you how difficult it was to leave my home and all the things dear to me. Being the sensitive person you are, you can sense in fact the sacrifices of the immigrants which you alluded to in your letter. I had so many conflicting thoughts running through my mind, but at the time we were so young with hearts full of hope that we would find a better life, if not for us, at least to give our children for a better future. Sandro was six and Elisa was four. On Saturday, March 23, 1932, we left from Naples aboard the transatlantic ship *Roma*. It was the night before Easter. On the platform of the dock, a great crowd of people, some with tears in their eyes waving to friends and relatives, making goodbye gestures and sending kisses with their hands as the ship slowly left the famous sea of Naples and Vesuvius. It seemed like a dream to me, it didn't seem real that we too were part of that group of immigrants. Sandro and Elisa were still too young to realize the importance of the moment. The passage wasn't all that bad even though for me those eight days for me were an eternity. I never had a night of sleep. Just the thought of being on the high seas terrorized me. There were two days when the seas were so rough that the water threatened to come through the portholes. But, for the grace of God, nothing happened out of the ordi-nary and we arrived at New York safe and sound the Monday morning of April 4, 1932.

"Arriving in New York"

Arriving in New York proved to be a great disappoint-ment. I imagined a country of marvels in 1932, but instead it was in the darkest depths of the Depression and unemployment was at a point where thousands upon thousands of people were living on welfare. We were worse off than in Sicily, but fortunately one of my cousins found work for my husband but for only three days a week. I went right to work at home in Middletown just like I had in Melilli; I had plenty of work but I earned very little. You can understand how I felt at the time: the difficulty understanding the language around me, and I always had to have some-one interpret for me so I could communicate with my customers. Beyond that, I found ourselves living in a rented apartment furnished with used furniture bought secondhand, while in Sicily we had left our comfortable home well furnished with all the con-veniences. And let's not even go into Sicilian that I found spoken in Middletown: the old and young people used terms and words (which they still use) so archaic that even my grandparents in Melilli didn't use any more. Even worse was how they pronounced these words. For example, instead of saying *il colletto*,

or shirt collar, I would hear *u cudduru,* a dog's collar. You can imagine how bad it sounded when they spoke words like that, especially from the young children. But little by little I got used to it and I didn't mind it. In the meantime I started to babble a few words in English, enough to communicate with my customers. It took quite a bit of time to master the language and to have the pleasure of being able to converse with my customers, some of whom became my friends.

I have so much to tell you that it would take volumes and I don't want to steal your precious time dwelling too much on these things. I'll conclude by telling that I let my life stream by without many demands. It was enough for me to have the satisfaction of working and the joy of watching my children grow up like I wanted them to. They distinguished themselves from grammar school all the way through college and they gave me the pleasure, a mixed joy, of seeing them get married and even the super joy of becoming a grandmother and a great-grandmother.

There was a period when I considered myself fortunate; I enjoyed the comfort of my children (Sandro and Elisa were already married). Laura was still a student and close to graduating and I was working which gave me a lot of satisfaction. But that period didn't last long. Our jewel of a son, the oldest, when life smiled all around him was suddenly striken with a terrible disease (a brain tumor) and after three dif-

ficult years of suffering on the Via Crucis (The Way of Sorrows), left us. Three surgeries and all the tests that modern science offered were useless. He left his wife and two sons, the oldest twelve, the younger, nine. Even though thirty years have passed since his passing on July 26, 1969, even though the pain has eased, there is still a wound that will never heal! There's no need to describe him so I'm enclosing an article about him with his photograph from the local newspaper in Middletown as he was rising and having so much success. And then it all vanished! You have to forgive me for making you feel sad, but you are a mother and can understand.

And now, to deviate from the sad subject, I want to tell you about Italian culture in America, that in New York and in every major city, there are Italian cultural centers as well as all the universities that offer courses in Italian literature. I can say with pride when we arrived here our countrymen were progressing, gaining the respect of other ethnicities. We have a great number of professionals of Italian descent that hold somewhat important governmental offices. In Middletown where we live, there are more people from Melilli than in Melilli itself. We have doctors, lawyers, judges, architects, dentists, heads of construction companies, and other commercial enterprises who are sons of immigrants from Melilli who have brought pride and honor to our society.

"Farming Life on Ruggiero's Farm"

Mary Lou Ruggiero Calamita

As if the stigma of being Italian—black to most people—wasn't bad enough, we were also farmers. We were an Italian family still farming in New Haven as late as the early 1960s. My mother and my sisters were amazing people. They were women who worked from sunup to sundown singing the latest pop songs in the fields. My mother was born in this country. She was originally a city girl with all the makings of a diva who married a farmer and her life took a turn she never expected. Despite many moments of regret that she would tell us about years later, she loved the farm and forged ahead with this foreign life. When we worked from sunup to sundown, my mother used to say she loved to hear us sing. She loved the music, but it was one of her ways of giving us strength to get through the days. We sang at least until late afternoon when our bodies began to turn on us and slow. Then we were all very quiet, drifting into our private thoughts that would sustain us through the rest of the day.

"Spring at Age Five"

Spring. At age five, up at five a.m. Threw on clothes. Out to the farm to pick up radish bundles. My mother and sisters kneeling in front and back to me, picking the radishes, bundling them to just the right size, ripping a cord hanging on their waists, tying the bunch securely and leaving it on the ground for me to pick it up. Their hands move quickly plucking the muddy red radish bulbs from the ground. The radish leaves, when alive in the ground, are firm. If you have to tug at them to get the radish out of the ground, they pinch. You picked them first thing in the morning when the ground was still cool and moist from the night and we worked fast to finish before the sun came up and dried the ground. We tried not to break the leaves off and leave the radish bulb in the ground. But the leaves of the radish bulb always dry first and pinch a little girl's hands. The dew on the firm, alive leaves, especially if heavy, seemed to heal the pinches and soothed the wounds on your hands. Your hands got used to it after a while. In those days kindergarten was optional, so that meant not at all for five-year-old girls on this New Haven farm. My older sisters would disappear soon and run home, throw something clean on and run, not walk, to school. School was about a four to five mile walk. I stayed in the field with my mother.

"Summer at Age Eight"

Summer and a girl at age eight is now old enough to really give a hand. Summer was beautiful, the sun was

up as early as we were, the morning was no longer chilly. But with the beautiful day came exceptional heat. It was relentless. Walking up rows of beans and peppers, rows that extended more than a quarter mile, pulling weeds that would choke the plants. You wanted to pull them early, if not they would dry and they would cut your hand if you didn't bend and grab them low before you tugged. Being a young girl, the boredom took over. Your mind wandered to boys and ribbons and jumping in the river when we were done. It took hours, from the beans to the peppers to the cabbage fields, pulling weeds with your hands and your fingers. When we were finally through, we were loaded onto the back of the truck and off to another farm, away from the river. Dreams of jumping in the river were gone. It didn't really matter because we were too tired anyway. Off to a rented piece of land where the corn was starting to get tall. Time to lay pipes. Laying pipes was just what it sounds like. Piled in a corner of the field were fifty to sixty twenty-five foot length aluminum pipes. We lifted them to our shoulders, one on one end and one on the other. They were hot from the ninety degree day and your shoulders burned through your clothes. You would lift them off your shoulder quick to get relief, then rest them again until you finally put it in place and connected it to the one already left by the others. Then do it again until all the pipes were in place. Now you

waited. You could hear the generator turn on and the thumping rush of water from the river in the woods starting to flow through the pipes. The sprinkler heads began to sputter and swoosh, the water would then fly sprinkling water, and you'd stand and wait until it hit you. It reached fifty feet of land and plants; and you would be right there catching the cool water in your face. Cool soaking through your heavy clothing, water on your face and head and suddenly you where brought back to life and you felt like a girl again. Bizarrely, even pretty. But even then as a girl again, you looked around to see, where to next. It seemed like we were never done for the day.

"Summer at Age Twelve"

At age twelve, summer went by slowly. Some of the days were lovely, with the morning dew cooling an expected hot early morning and afternoon. It's possible for the dew to prepare you for the heat. It cools you through your hands as you pick the beans and other early summer veggies. Strawberry picking time, I dreaded it. The heat from the ground under the strawberry plants was stifling. It rose up into your face, you could barely breathe; you would raise your head for a moment, just to catch some air, but just for a moment. You had to be careful that your fingers would select only the mature berries, leaving the small ones for

another time. You had to pick strawberries early. If not they'd melt in your hands. Your hands were pink after the picking, but it washed away. As an older girl now without prompting, you knew there was more to do, always more to do, on the farm. Weeding and hoeing, you got through these tasks by slipping into a world of your own. Dreaming of a pretty sweater, a good memory of school last year or you indulge yourself and feel sorry that you weren't born a princess. That was the name farm girls gave to your friends whose mothers had time to starch their clothes. Your imagination grew and kept you from whatever might have happened to you, if you didn't have one. It was no longer just boring. Now you knew you were different. The world of friends—cheerleaders, beaches and getting together at each other's homes was in front of your eyes. Now you knew what you were missing. So while you picked the beans you went deep inside yourself and used your precious imagination. Dreaming of a pretty sweater, one to wear to the fair if you got to go this year. Thinking about how strong and in shape you were. Maybe I'll try out this year. I can do the splits and jumps that a cheerleader needs to do and I was certainly pretty enough. I would make the team and my parents would have to say yes, they would have to let me go. Who am I kidding? Not a chance! Even if they could spare me on the farm, which they wouldn't, I wouldn't make it. Only the in-crowd, the girls who lived in the city. The ones who talked the same language, actually had something to say to each other. Who knew secrets about each other. The girls with pressed clothes and clean fingernails. They were smarter than me. They were headed for college. I had no plans for the future. Reality, ugly reality returns and you take a moment to indulge your emotions and feel sorry that you weren't born a princess and get back to work. It was sad. Now when all was done on the farm, you no longer retreated to the yard on the swing or to your thoughts by pretending that you were someone else. You had to do what women do. What my mother and sisters have been doing all this time. It's six o'clock. Time to start preparing dinner, what my mother had already planned to cook. When did she plan this? We never knew. She worked all the time. I now know her as the most extraordinary woman I had ever met and ever will meet. It was hectic, everyone was hungry. Quickly, we peeled, chopped and tossed into pans and cooked whatever was planned. No gourmet here, just hearty well-seasoned foods. Beans, pasta, fish. Whatever we could do quickly. Once done, then we cleaned. Dinner was no sooner over we cleaned. My sisters and I cleared the table and did the dishes. We cleaned the floors and made it look as if no one was ever there. It was done. All was quiet. What do you do now? Now was you time to be a girl, a woman. Not really enough time.

You were so tired all you could do was fall asleep. Until tomorrow when it started all over again.

"My Mother Josie"

My Mother was always on call. She worked on demand all her life. As a farmer's wife, she grew into a doctor, nurse, midwife, farmer, and secretary. Whatever was necessary she was. The strength and love she worked so hard to share with her husband and all of us was often missed. Her time was so precious and shared with our extended families more often than her own. As they started having babies, the one they asked for help was Josie. And she was careful to give them the right answers or do it for them herself. Having had nine of her ten children at home, she had more to offer than any trained midwife or nurse. I laugh when I remember her saying how spoiled women were today because they were having babies in hospitals. But I also remember her upset whenever she heard one of her daughters was pregnant. It was so hard for her. She didn't want that for her children. She had so few friends, the Swedish woman up the street, the black family who lived nearby; no time. Tomorrow, it would all start again. She had to be ready to push her children again, her girls, to keep going through the day. She needed to know what they were all going to eat tomorrow. She needed to know who might need her at a moment's notice and she would have to be ready, ready to work on the farm. Because you lived with so much solitude during every day of your life, it would be years before girls who grew up and worked on farms as farm hands (as girls on New Haven farms did) would understand themselves, why they craved solitude. However, having built so much inner strength it was difficult when we did get involved not to overcompensate. Today, I realize that my beautiful Italian sisters and my beautiful Italian mother could have been anything if they had led a different life. My mom was the real Wonder Woman and my sisters are probably the most intelligent women I know. We converse on what would appear to most to be an insurmountable level of understanding of women; we converse on the same level and laugh harder than most Italian women. Growing up on farms in New Haven when there were few farms we were so different than other women. We had a foundation (bricked by our Mom) that was hard core and soft all at the same time. Brave and scared all at the same time, too. Smart and almost simple all at the same time. Sent off into the world with more to offer, but none of the tools to serve. Forging ahead into womanhood, strong and brave, but always for her children. Italian women born on a farm were so different than other women. I consider us incredible alien children of Wonder Women.

Mission Statement

Mrs. Vincent Motto wrote this uplifting narrative as part of the mission statement for Italian Mothers Club in Hartford in the 1920s.

There is a vast difference for all of us in suffering on our own account and suffering out of the sympathy of others. Our own sufferings may make us bitter, wear us down, make us self-centered and self-pitying. But suffering for and with others is genuine Christian compassion. It has a curative effect. It ennobles and inspires and strengthens us and always helps to redeem those for whom we are willing to suffer. Our burdens fall away when we get to tugging at someone else's load; sadness turns into song and we clear a spot of sunshine between the shadows, even if we take the way of The Cross, that Cross is glorified and becomes the symbol of victory.

"My Roots of Strong Women"

Frances Calzetta

Frances Calzetta was a retired educator.

What led to my achievements? Let's start with my grandmothers who were from southern Italy born during the unification of Italy in the 1860s. Women were not formally schooled. Schooling was for boys. Rosa, my maternal grandmother, came from a family of vintners and olive oil merchants in Castelvenere in the province of Benevento. Her family was devoutly Roman Catholic and she brought her faith and traditions with her to New Haven at the turn of the century. Grammy Rosa raised seven children while working the family farm. Her seventh child was born while she was working in the fields. She just lay down, delivered a healthy boy, wrapped him in one of her aprons and brought him into the house. She washed him and told the older siblings to watch him. Gutsy, yes! My paternal grandmother Antoinette endured long separations from her husband in San Carlo, near Caserta in the region of Campania. Her husband came across the Atlantic every six months to work on the Brooklyn Bridge. In his absence, Antoinette displayed her strength and love raising her four boys and two girls. In 1968, I met her daughter, Aunt Lucia, also a woman of strength. She worked her own family farm with her husband and children and two enormous oxen. Still with terror evident in her voice, she recounted the raids during WWII, the Germans coming over the hillside to kill them and their dropping bombs that killed her baby. Aunt Lucia was surely a woman of courage and strength. But my mother and her two sisters tell another story. Unlike their mother, they had the benefit of an eighth grade formal education

in New Haven. In the family division of labor Mom stayed home and took care of her sister's children so Mary and Celeste could work in sewing shops. Career choices for Italian women of the first generation were sewing, manufacturing, and office work. In the 1930s, Italian women faced anti-Italian prejudice and office jobs became an option. Aunt Mary took bookkeeping lessons but didn't like it and eventually became a forelady in the International Ladies Garment Workers Union. Celeste sadly passed away at age twenty-nine from an infection she got working in the factory. It coincided with the Wall Street crash. I am sure that had there been modern American opportunities, Mary and Celeste would have gone to a fashion institute of design because of their enormous creative talent and machine operating skills. My mother's artistic and musical skills would have brought her into a career in the arts. The Great Depression had taken my two sisters' opportunity for higher education. I was born in the heart of the Depression. My father worked in the steel industry at the time and was cut to a two day work week. My mother wouldn't let me help with household work. Instead she told me to read books. My older sisters supported and encouraged me to go to college. I have spent a lifetime as a teacher in higher education achieving a master's degree in education and Certificates of Advanced Study. While marriage was always an option I enjoyed the freedom of being single. I come from a line of women who faced adver-

sity courageously and went on with unusual strength and sensitivity. These wonderful and exemplary women were my role models. They were my helpers, the best teachers anyone could have. They are my heritage. I could not have had a more wonderful legacy.

"Qui Tacet, Consentit"
(He who is silent, consents)

LOUISA CANESTRI DeLAURO

Louisa Canestri DeLauro, the recording secretary of the Young Men's Tenth Ward Democratic Club, wrote a letter to appeal to working women in her Wooster Square neighborhood. It appeared in their bi-monthly publication on September 1, 1933.

> It is not my intention to be critical, rather my motive in writing this article is to encourage the female members of this organization to take a more active part in its affairs. We are not living in the middle ages when a woman's part in life was merely to serve her master in the home, but we have gradually taken our place in every phase of human endeavor even in the here-to-for stronghold of the male sex: politics. I have noticed that the girls unlike the men are timid in asserting themselves, and many a good idea is lost, having been

suppressed by its creator. No doubt you have all heard the excuse some people have offered for their timidity—they often claim that they belong to the quiet type of person. In my estimation, there are several types of quiet people, the real timid ones naturally are those that don't know anything. No one will ever know which type you belong to unless you make yourself heard, and there is a possibility that you may be misjudged. Come on girls, let's make ourselves heard.

"I Was a *Taglialegna*"

MICHELINA VENDITTI

This is my life's story written by hand at eighty-two years old. From when I came into this world, I grew up in the woods. My *mestiere*, my job, until I was twenty-three was a *taglialegna*, a lumberman. My father taught me everything about tree cutting. We cut down the biggest trees in the mountainous area around Gallo Matesa in Campania! I used to cut trees with what we called an *accetta Americana*, an American hachet. And after we cut them we had to carry them on our shoulders. I lived in a one room shanty, constructed of *legno e terra*, wood and earth, where we all grew up, five brothers and three sisters

and my parents, ten all together. To get our water to cook our food and to wash, we had to walk about two hours to get spring water and carry it back in wooden barrels, balancing them on our heads. To get food it took us three or four hours to get to the store to buy macaroni, wine and everything we needed. I never could go to school, yet I learned how to read and write by watching my parents teach my brothers at the dinner table. (Translated from Italian)

"Farewell Letters of Celeste Proto"

Shortly before she died, Celeste Proto composed farewell letters to her family. Her daughter Diana told me the reason why she did not leave her a letter. "Every single thing she felt, I felt. And she expressed it through me, and I was going to be the one who was going to give it out. So she passed it on to me by not writing me a letter. I am the transition, and it's my job to transition what was important to my generation to my kids."

To my son Richard (June 27, 1991)

Richard,

Watch over my brood. Now you're the father. Keep my family together. (I can't believe I said your father

needs a father—imagine that!) If anyone is in trouble please make sure you help each other. Don't ever give up on each other. *Never!* I'm counting on you. I will love you forever. You were my first born.

<div align="right">Mom</div>

To my Son Neil (June 27, 1991)

Neil,

I love you. We had so much to do with each other. You made my life so much better. We both had serious illnesses and we got out of them. Always remember the family. If anyone is in trouble please make sure you help each other. Don't ever give up on each other. Never! What else can I say but that I have loved you forever. Remember if you need me just whistle and I'll be there. I will always be with you.

<div align="right">Mom</div>

To Grand Daughters (June 27, 1991)

Theresa and Jennine,

I want to tell you now how much I love you. You are growing up so beautiful. Try to be as good as you can be—you can't always be good, but don't let anybody put anything over on you. Be smart, use your mind and your talents, do good in school. Don't ever let anyone make a damn fool of you. Listen to your mother's advice—you don't have to agree with her but make sure you consider it and have used your common sense before making a decision. Teach your children our good traits and remember the family. Count on them to be there for you. Please carry me in your heart. *Always!* You are the best. Never forget that you were born to make a difference in the world. I will love you forever.

<div align="right">Grandma</div>

To my son-in-law Eugene (June 27, 1991)

My lovely Eugene,

I can't explain to you how much I love you. You helped to make this a better family. Always be there for each other. You made my life longer. I know I would have never lasted so long without all the wonderful things you did. Thank you for letting me have (my daughter) Diana. Keep my grandchildren on a straight path. Guide them to use our good traits. Be there for Diana and keep my family together. You were the best.

<div align="right">Love Forever,
Mom</div>

Epilogue

On a warm summer afternoon in 2011, I had the chance to interview ninety-eight-year-old Antoinette Tommasi Mazzotta with her daughter Marie in Middletown. I knew the town's strong connection to the town of Melilli in southeast Sicily, and I was anxious to meet Antoinette and hear her story. I sat spellbound listening to Antoinette who smiled with eyes glowing at the high points of her stories. At the end of our fascinating oral history session, she said, "Oh, Anthony, by the way, you should meet my cousin Lucia. She was born in Sicily, she came to Middletown a long time ago and she knows a lot. Oh, yes, you'd love talking to her—she's one hundred and one and sharp as a tack!"

A few months later I returned to Antoinette's to meet her beloved cousin Lucia Falbo Fulin, regally dressed and smiling at the kitchen table. The two women had been very close during their long lifetimes, and they wove a colorful tapestry of their life experiences in Sicily and Middletown. At one point during our table conversation, it suddenly struck me how fortunate I was to have the rare chance to capture their life stories from a period of time that reached back to the late teens and early 1920s. At the end of our session, Lucia mentioned that she had written down a list of old proverbs she often heard recited by townspeople in her village of Melilli that spanned centuries back in time. We made plans to meet again to record them for this book.

A few months later, I received an email from Lucia's daughter, Laura, saying her mother's health was failing quickly, and that she was spending her nights at her mother's side in the hospital. Despite Laura's pleas for Lucia to drink or eat, she refused. In her courtly manner of speaking, Lucia told her daughter one morning, "You don't understand. The hour has arrived." As she faded in and out of consciousness, she managed to remind her daughter, "Make sure you give Anthony my proverbs so he can put them into the book." When I realized Lucia's life was coming to an end, I wrote to tell Laura her mother was one of the finest people I had ever met and she could take comfort knowing her words and stories would never die. Laura sent me a response. "She is in and

out of sleep these last few days, but when I went in just after reading your note, she had her eyes open. So, I brought my IPad into her room and read her your email verbatim . . . then, I repeated your lovely sentiments to her again projecting my voice to be sure she would hear it . . . I think she absorbed it because she made a sound as if in response."

The next day when Laura wrote to tell me her mother had passed away peacefully, I realized the arc of Lucia's life reflected that generation of Italian American women in Connecticut. Her keen awareness of finality and her gracious farewell in her last days echoed many selfless Italian American women who had spent a life dedicated to their families yet wanted nothing in return other than to be remembered. Unfortunately, during the eight years it took to write this book, the hour arrived for many of the women storytellers like Lucia who would never see their remarkable lives in print and image. Few women of Lucia's generation—those who could speak in provincial dialects and reconstruct small village life in southern Italy—are left to tell their stories. Once their collective voices are silenced by the passage of time, the legacy of Lucia's entire generation will fade from history. Respecting Lucia Falbo Fulin's simple wish to be remembered, like the rest of the Italian American women of her generation, this book concludes with proverbs she recited to her daughter Laura during her final days.

Ogni fichiteddu i musca e sustanza.

It literally means every little liver from a housefly is sustenance! Imagine how tiny the liver of a housefly would be! This would be said when the speaker would be eating a small portion—perhaps when no more could be had; the idea being that even the tiniest portion of food has its nutritional value.

Cu nasci tunnu, nun po morrire quadratu.

It literally means that whoever is born round cannot die square. It means a person's basic nature stays the same throughout life. The closest idiomatic expression in English is the saying that one cannot put a square peg in a round hole.

Cu si sapi arripezzare, mai 'o munnu povara pare.

It means the whoever knows how to mend her clothes will never look poor (shabby) to the world. This saying extolled the value of mending/altering clothing when new items were perhaps not affordable or unavailable for poor country folk.

Ogni naso sta beddu a sa facci.

It literally means every nose looks beautiful on its own face. It meant that each person's features were

suited and proportioned to his or her face, that what's natural is best. The proverb's philosophy was meant to encourage the listener to have pride in his/her appearance.

Nun poi aviri a utti china
e a mugghieri 'mbriaca.

It literally means you cannot have a wine barrel that's full and wife that's drunk at the same time. It meant that you cannot have it both ways in life: A wife who is drunk would use up all the wine in the barrel, and the barrel would never be full.

Chist é á zita, Orvu d'un òcchiu, È sapuritu.

It literally means the bride is really cute, but she is blind in one eye. It meant not to complain about something, but you have to accept the situation.

U cane abbatt'a cura quannu viri u patrune picchi
non avi u cappeddu di luvarisi.

It literally means that a dog wags his tail when he sees his owner because he doesn't have a hat to remove or tip to his owner. When a dog wags his tail, he's greeting his master. The *cappeddu* was also known as the man who wore a hat, the rich landowner who controlled the peasant farmers.

U diavulu quannu e vecchiu, si fa monacu.

It literally means when the devil becomes old (elderly), he becomes a monk. It meant that people who are sinners (or wild) when they are young, become holy (religious) or reformed when they are old.

U Signuri avi peduzz'i ghiummu

It literally means The Lord has feet made of lead. It meant that since His feet are made of lead, they are heavy and he walks very slowly, but signified that, though slow, He still moves along, slowly but surely, and either the person being spoken about will get his or her due or whatever is being speculated about will come to pass eventually.

Chissu e nenti su parenti

It literally means that "that" and "nothing" are relatives—as in a family. One thing is such a tiny amount that it's almost nothing—hence, they are related. It is a metaphor signifying that whatever item(s) or food is/are being discussed, is such a small amount it may as well be nothing!

La fretta invecchia

Haste or hurrying causes one to age.

ZZoccu sapi u piazzu in casa so',
nun po sapiri u saggiu in casa d'autru.

It literally means what a crazy man knows in his own house, a wise man would not know in someone else's house. Even a crazy man knows what goes on in his own house and knows it better than any sage could ever know about what goes on in the house of another.

Spesso le donne e quasi tutte per farse belle
si fanno brute.

It literally means that women, in an effort to make themselves more beautiful, often make themselves ugly. It was meant as a warning not to overdo makeup or go overboard with daring fashion looks which can be overkill and make a woman look foolish rather than stylish.

Mi satau na iaddina 'na
ucca i (di) l'arma

It literally means a chicken jumped onto the mouth of my soul, which was the expression for the upper abdominal area. It was the Sicilian way of saying one had butterflies in his/her stomach.

Notes

Chapter 1. The Historical Roots of Southern Italian Women

1. Giuseppe di Lampedusa, *The Leopard* (New York: Pantheon, 1960), 205.

2. Lorena Jannelli and Fausto Longo, *The Greeks in Sicily* (San Giovanni Lupatoto: Arsenale Editrice, 2004), 7.

3. Leonard von Matt, *Ancient Sicily* (London: Longmans, Green, 1960), 7.

4. Jannelli and Longo, *Greeks in Sicily,* 128.

5. Matt, *Ancient Sicily,* 8.

6. Fabio Bourbon and Furio Durando, *I Greci in Italia* (Udine, Italy: Magnus Edizioni SpA, 2004), 38–39.

7. Robert A. Orsi, *The Madonna of 115ᵗʰ Street* (New Haven: Yale University Press, 1985), 75–78.

8. Rosalie N. Norris, *Customs and Habits of the Sicilian Peasants* (East Brunswick, NJ: Associated University Presses, 1981), 52.

9. Phyllis H. Williams, *South Italian Folkways in Europe and America* (New Haven: Yale University Press, 1938), 20.

10. For an in-depth description of daily life of women in Magna Grecia, see Bourbon and Durando, *I Greci in Italia,* 42.

11. Francesca Izzi, *Viaggio Nell'Universo Femminile Della Magna Grecia* (Fano, Italy: AltroMondo Editore, 2009), 85.

12. Mary Ellen Waite, *A History of Women Philosophers* (Dordrecht, Netherlands: Nijhoff, 1987), XX–XXI. Also, see ch. 1, n. 14–15. Aesara of Lucania wrote the home was a microcosm of the state, and women had the responsibility of maintaining law and justice (or harmony) within the home. She believed women bore responsibility for creating conditions under which harmony and order, law and justice existed in the state. A woman who doesn't understand this, she wrote, is likely to contribute to disorder, discord, and chaos.

13. E. T. Salmon, *Samnium and the Samnites* (Cambridge: Cambridge University Press, 1967), 63.

14. Charlotte Gower Chapman, *Milocca: A Sicilian Village* (Cambridge, MA, and London: Shenkman, 1971), 32.

15. John Dickie, *Darkest Italy* (New York: Saint Martin's, 1999), 1.

16. Victoria De Grazia, *How Fascism Ruled Women* (Berkeley and Los Angeles: University of California Press, 1992), 68.

17. Pagan gods and goddesses venerated in Magna Grecia were incorporated into Christianity and transformed into saints and Madonnas with special powers to

grant favors to the faithful. For more examples see Phyllis H. Williams, *South Italian Folkways*, 135–40.

18. Cesare Pavese, *Lettere 1924–1944* (Torino: Einaudi, 1966), 489.

19. Leonard Chiarelli, *A History of Muslim Sicily* (Malta: Midsea Books, 2011), 152.

Chapter 2. Italian Women Journey to America

1. Mark Wyman, *Round Trip to America* (Ithaca and London: Cornell University Press, 1993), 39.

2. Ibid., 134. From 1901 to 1911, the number of landowners increased by 280,000, and doubled in the next decade. In Sicily, the number of landowners tripled between 1911 and 1921.

3. Linda Reeder, *Widows in White* (Toronto: University of Toronto Press, 2003), 5. Also see Robert F. Foerster, *The Italian Emigration of Our Times* (New York: Russell & Russell, 1919), 39. Foerster reported males constituted 90 percent of emigrants from 1870–71, and four-fifths for the following thirty years.

4. Ibid., 7.

5. Wyman, *Round Trip to America*, 10.

6. Ibid., 38.

7. Ibid., 78. The male to female ratio of returnees to Italy in 1905–06 was twelve women to one hundred men. The trend of male repatriates increased steadily to 92 percent by 1917.

Chapter 3. Pioneer Italian Women

1. Diane C. Vecchio, *Merchants, Midwives, and Laboring Women* (Urbana and Chicago: University of Illinois Press, 2006), 16.

Chapter 4. From Italy to Connecticut

1. Chapman, *Milocca*, 2.

2. Norris, *Customs and Habits*, 58.

3. Giovanni Verga, *I Malavoglia* (Verona: Arnaldo Mondadori Editore, 1974), 56.

4. Reeder, *Widows in White*, 57.

5. Louise C. Odencrantz, *Italian Women in Industry* (New York: Russell Sage Foundation, 1919), 41.

Chapter 5. Midwives and Giving Birth

1. De Grazia, *How Fascism Ruled Women*, 65.

2. Vecchio, *Merchants, Midwives*, 15.

3. De Grazia, *How Fascism Ruled Women*, 68.

4. Chapman, *Milocca*, 116.

5. Ibid., 120.

6. Vecchio, *Merchants, Midwives*, 85.

7. Chapman, *Milocca*, 90.

8. Pietro DiDonato, *Christ in Concrete*, (New York: Bobbs-Merrill, 1937), 56.

9. G. Chiodi Barberio, *Il Progresso degl'Italiani nel Connecticut* (New Haven: Maturo's Printing & Publishing, 1933), 620.

Chapter 6. Going to School

1. Leonard Covello, *The Social Background of the Italo-American School Child* (Totowa, NJ: Rowman and Littlefield, 1972), 246.

2. Ibid., 250.

3. Luisa DeLauro (garment worker), in discussion with Jennifer Noll, November 23, 1993.

4. Ibid.
5. Ibid.
6. Ibid.

Chapter 7. Betrothal and Marriage

1. Norris, *Customs and Habits*, 180.

Chapter 8. Italian American Farming Women

1. Williams, *South Italian Folkways*, 22.
2. Odencrantz, *Italian Women in Industry*, 28.
3. For an example of how Italian Americans in Connecticut maintained the ancient custom of hospitality, see Joanna Clapps Herman, *The Anarchist Bastard: Growing Up Italian in America* (Albany: State University of New York Press, 2011), 7–17.

Chapter 9. Italian American Women Join the Production Lines

1. E. Wight Bakke, *After the Shutdown* (New Haven: Institute of Human Relations, Yale University, 1934), 7.
2. Jennifer Noll, *Italian-American Women in the New Haven Garment Industry*, undergraduate senior thesis, Department of American Studies, Yale University, 1994, 42. For wages earned by women from 1933–34, see U.S. Department of Labor, Bureau of Labor Statistics, "Conditions in Connecticut Needle Trades under N.R.A.," *Monthly Labor Review* 40 (June 1935): 1500–02.
3. Cecelia Bucki, *Bridgeport's Socialist New Deal, 1915–1936* (Urbana and Chicago: University of Illinois Press, 2001), 21.

4. Amy Hewes and Henriette R. Walter, *Munitions Makers* (New York: Russell Sage Foundation, 1917), 34.

Chapter 10. Italian American Women Raise Their Voices

1. Jennifer Guglielmo, "Proletarian Feminism in the New York City Garment Trades," in *Women, Gender, and Transnational Lives*, ed. Donna R. Gabaccia and Franc Iocovetta, 252–55 (Toronto, Buffalo, and London: University of Toronto Press, 2002). In the aftermath of the Unification in 1861, Southern women became *brigantesse*, militants who fought alongside men in guerilla groups against Northern troops occupying the South in bloody reprisals. See Simona De Luna, *Per Forza o Per Amore* (Salerno: Marlin, 2008).
2. Jennifer Guglielmo, *Living the Revolution* (Chapel Hill: University of North Carolina Press, 2010), 3.
3. Salvatore "Gary" Garibaldi, Wooster Square resident at age ninety, in discussion with Anthony V. Riccio, Feb. 7, 2007.
4. Jennie Aiello (garment worker), in discussion with Jennifer Noll, Feb. 28, 1994.
5. Frank R. Annunziato, "'Made in New Haven': Unionization and the Shaping of a Clothing Workers' Community," *Labor's Heritage* 4 (Winter 1992): 29.
6. Amalgamated Clothing Workers of America, *Bread and Roses: The Story of the Rise of the Shirtworkers, Two Eventful Years, 1933–1934* (New York: Amalgamated Clothing Workers of America, [1935?]), 16–17. After

the success in New Haven, union organizers next went to Elizabeth, New Jersey, and Allentown, Pennsylvania, where they won union settlements (ibid., 17).

7. Laura Ankar, *The Mythmaking Frame of Mind* (Belmont, CA: Wadsworth, 1993), 271–72.

Chapter 13. Italian American Women Entrepreneurs

1. Maddalena Tirabassi, "Bourgeois Men, Peasant Women: Rethinking Domestic Work and Morality in Italy," in *Women, Gender, and Transnational Lives*, 106–23.

2. Reeder, *Widows in White*, 114.

3. Vecchio, *Merchants, Midwives*, 14.

Chapter 14. Italian American Women's Success Stories

1. Connie A. Maglione and Carmen Anthony Fiore, *Voices of the Daughters* (Princeton: Townhouse, 1989), 5.

Chapter 15. Finding Her Voice

1. For a history and analysis of Italian American women's writings, see Ilaria Serra, *The Value of Worthless Lives* (New York: Fordham University Press, 2007), 116–31.

2. Williams, *South Italian Folkways*, 126.

3. Maria Riello, *The Italian Cookbook*, (self-published, 1936), 58.

4. Ibid., 59.

Bibliography

Albright, Carol Bonomo. Christine Palamidessi Moore. *American Women, Italian Style.* New York: Fordham University Press, 2011.

Amatangelo, Susan. *Figuring Women.* Madison: Farleigh Dickinson University Press, 2004.

Amfitheatrof, Erik. *The Children of Columbus.* Boston: Little, Brown, 1973.

Amore, B. *An Italian American Odyssey.* Staten Island: Center for Migration Studies, 2006.

Balducci, Carolyn. *A Self-Made Woman.* Boston: Houghton Mifflin, 1975.

Barberio, G. Chiodi. *Il Progresso degl'italiani nel Connecticut.* New Haven: Maturo's Printing and Publishing Co., 1933.

Bok, Anton. *The Mafia of a Sicilian Village.* New York: Harper and Row, 1974.

Bourbon, Fabio e Durando, Furio. *I Greci in Italia.* Udine: Magnus edizioni SpA., 2004.

Bologna, Sando, and Richard M. Marano. *Growing Up Italian and American in Waterbury.* Self-published, 1997.

Bruhn, John G., and Stewart Wolf. *The Roseto Story.* Norman: University of Oklahoma Press, 1979.

Bucki, Cecilia. *Bridgeport's Socialist New Deal, 1915–36.* Urbana: University of Illinois Press, 2001.

Caetura, Linda B. *Growing Up Italian.* New York: William Morrow, 1987.

Camillieri, Salvatore. *Vocabolario Italiano-Siciliano.* Catania: Edizioni Greco, 2001.

Ceccheti, Giovanni. *Giovanni Verga.* Boston: Twayne, 1978.

Chapman, Charlotte Gower. *Milocca: A Sicilian Village.* Cambridge: Schenkman, 1971.

Chiarelli, Leonard C. *A History of Muslim Sicily.* Malta: Midsea Books, 2011.

Clark, Claudia. *Radium Girls,* Chapel Hill: University of North Carolina Press, 1997.

Clayton, Barbara. *A Penelopean Poetics.* Lanham, MD: Lexington Books, 2004.

Cohen, Mariam. *Workshop to Office.* Ithaca: Cornell University Press, 1992.

Cornelisen, Ann. *Women of the Shadows.* Boston: Little, Brown, 1976.

Covello, Leonard. *The Social Background of the Italo-American Schoolchild.* Totowa: Rowman and Littlefield, 1972.

Cronin, Constance. *The Sting of Change.* Chicago and London: University of Chicago Press, 1970.

Cupelli, Alberto. *The Italian of New Haven.* Privately printed, 1972.

D'Ascoli, Francesco. *Nuovo Vocabolario Dialettale Napoletano.* Napoli: Adriano Gallina Editore, 1993.

DeGrazia, Victoria. *How Fascism Ruled Women*. Berkeley and Los Angeles: University of California Press, 1992.

Deledda, Grazia. *Honest Souls*. Leicester: Troubador, 2009.

DeLuna, Simona. *Per Forza O Per Amore*. Cava de' Tirreni: Marlin Editore Sri, 2008.

Dickie, John. *Darkest Italy*. New York: Saint Martin's, 1999.

Douglas, Norman. *Old Calabria*. Marlboro: The Marlboro Press, 1993.

Dupuy, Trevor N. *Land Battles: North Africa, Sicily, Italy*. New York: Franklin Watts, 1962.

Faure, Paul. *La Vita Quotidiana Nelle Colonie Greche*. Milano: RSC Libri S.p.A, 1998.

Finley, M. I. *Ancient Sicily*. New York: Viking, 1968.

———, Denis Mack Smith, Christopher Duggan. *A History of Sicily*. London: Chatto and Windus, 1986.

Foester, Robert F. *The Italian Emigration of Our Times*. Cambridge: Harvard University Press, 1936.

Fusco, Idamaria. *La Seta E Oltre . . .* Napoli: Edizione Scientifiche Italiane, 2004.

Gabaccia, Donna. *From Sicily to Elizabeth Street*. Albany: State University of New York Press, 1984.

———, and Franca Iacovetta. *Women,Gender, and Transnational Lives*. Toronto: University of Toronto Press, 2002.

Gabriel, Mabel M. *Masters of Campanian Painting*. New York: H. Bittner, 1952.

Gambino, Richard. *Blood of My Blood*. New York: Doubleday, 1974.

Gentile, Lorenzo, and Enrica Gentile. *Nuovo Dizionario Dei Baresi*. Bari: Levante Editore, 2007.

Gesualdi, Louis J. *The Italian Immigrants of New Haven, 1880–1940*. New Haven: The Connecticut Academy of Arts and Sciences, vol. 54, July 1997.

Gilbert, James, Amy Gilman, Donald M. Scott, and Joan W. Scott. *The Mythmaking Frame of Mind*. Belmont, CA: Wadsworth, 1993.

Grimaldi, Lennie. *Bridgeport*. Northridge: Windsor Publications, 1986.

Guglielmo, Jennifer. *Living the Revolution*. Chapel Hill: University of North Carolina Press, 2010.

Herman, Joanna Clapps. *The Anarchist Bastard*. Albany: State University of New York Press, 2011.

Hewes, Amy. *Women As Munition Makers*. New York: Russell Sage Foundation, 1917.

Izzi, Francesca. *Viaggio nell'Universo Femminile della Magna Grecia*. Torri di Quartesolo: AltroMondo, 2009.

Jannelli, Lorena, and Fausto Longo. *The Greeks in Sicily*. San Giovanni Lupatoto: Arsenale Editrice, 2004.

Kertzer, David I., and Richard P. Saller. *The Family in Italy from Antiquity to the Present*. New Haven: Yale University Press, 1991.

Koenig, Samuel. *Immigration Settlements in Connecticut: Their Growth and Characteristics*. Works Progress Administration Federal Writers' Project for the State of Connecticut, Connecticut State Department of Education, Hartford, 1938.

Lampedusa, Giuseppe. *The Leopard*. New York: Pantheon, 1960.

LaPalombara, Joseph. *Democracy Italian Style*. New Haven: Yale University Press, 1987.

Lassonde, Stephen. *Learning to Forget: Schooling and Family Life in New Haven's Working Class, 1870–1940*. New Haven: Yale University Press, 2005.

Levi, Carlo. *Christ Stopped at Eboli*. New York: Farrar, Strauss, and Giroux, 2000.

Levine, Louis. *The Women's Garment Workers*. New York: R. W Huebsch, 1924.

Lilliu, Giovanni. *La Civiltà Nauriga*. Sassari: Carlo Delfino Editore, 1999.

Maglione, Connie A., and Carmen A. Fiore. *Voices of the Daughters*. Princeton: Townhouse Publishing, 1989.

Magnano, Paolo. *Melilli*. Palermo-Siracusa: Arnaldo Lombardi Editore s.r.l, 2001.

Malpezzi, Frances M., and William M. Clements. *Italian American Folklore*. Little Rock: August House, 1992.

Mangione, Jerre, and Ben Morreale. *La Storia: Five Centuries of the Italian American Experience*. New York: HarperCollins, 1992.

Martino, Giuseppe A., and Ettore Alvaro. *Dizionario dei Dialetti della Calabria Meridionale*. Vibo Valentia: Qualecultura, 2010.

Mautner, Raeleen D'Agostino. *Living La Dolce Vita*. Naperville: Sourcebooks, 2003.

Miller, Arthur. *A View from the Bridge*. New York: Viking Press, 1955.

Monagan, Patricia. *The Book of Goddesses and Heroines*. St. Paul: Llewellyn, 1993.

Morris, Penelope, ed. *Women in Italy, 1945–1960*. New York: Palgrave Macmillan., 2006.

Napoli, Mario. *Pittura Antica in Italia*. Bergamo: Instituto d'Arti Grafiche, 1961.

Norris, Rosalie, N. *Customs and Habits of the Sicilian Peasants*. London and Toronto: Associated University Presses, 1981.

Odencrantz, Louise C. *Italian Women in Industry*. New York: Russell Sage Foundation, 1919.

Orsi, Robert, A. *The Madonna of 115th Street*. New Haven and London: Yale University Press, 1985.

Pavese, Cesare. *Lettere 1924–1944*. Torino: Einaudi, 1966.

Pedley, John G. *Paestum*. London: Thames and Hudson, 1990.

Pozzetta, George E. *Pane E Lavoro*. Toronto: The Multicultural History Society of Ontario, 1980.

Pulgram, Ernst. *The Tongues of Italy*. Cambridge: Harvard University Press, 1958.

Reeder, Linda. *Widows in White*. Toronto: University of Toronto Press, 2003.

Riello, Mary C. *The Italian Cookbook*. Self-published, 1936.

Romanazzi, Andrea. *Guida alla Dea Madre in Italia*. Roma: Venexia, 2005.

Rossi, Adolfo. *Un Italiano in America*. Rovigo: Editrice Turismo e Cultura, 1995.

Salmon, E. T. *Samnium and the Samnites*. Cambridge: Cambridge University Press, 1967.

Salzano, Antonio. *Vocaolario Napoletano-Italiano*. Napoli: S.E.N., 1980.

Scavuzzo, Carmelo. *Dizionario Del Parlar Sicilano*. Palermo: Edikronos, 1982.

Serao, Matilde. *Il Romanzo Della Fanciulla*. Napoli: Liguori Editore, 1985.

Serra, Ilaria. *The Value of Worthless Lives*. New York: Fordham University Press, 2007.

Schneider-Hermann, G. *The Samnites of the Fourth Century B.C.*, London: Institute of Classical Studies, School of Advanced Study University of London, 1996.

Schneider, Jane, and Peter Schneider. *Culture and Political Economy in Western Sicily*. New York: Academic, 1976.

Snowden, *Naples in the Time of the Cholera*. Cambridge: Cambridge University Press, 1995.

Stave, Bruce M., and John F. Suther. *From the Old Country*. New York: MacMillan, 1994.

Trigiani, Adriana, *Don't Sing at the Table*, New York: HarperCollins, 2010.

Vecchio, Diane C. *Merchants, Midwives, Laboring Women*. Urbana and Chicago: University of Illinois Press, 2006.

Verga, Giovanni. *I Malavoglia*. Verona: Oscar Mondadori, 1974.

Villari, Luigi. *Italian Life In Town and Country*. New York: Knickerbocker Press, 1902.

———. *Italy*. London: Ernest Bean, 1929.

Von Matt, Leonard. *Ancient Sicily*. London: Longmans, Green, 1960.

———. *Magna Graecia*. New York: Universe Books, 1967.

Waite, Mary E. *A History of Women Philosophers*. Dordrecht: Martinus Nijhoff, 1987.

Webster, Gary A. *A Prehistory of Sardinia 2300–500BC*. Sheffield: Sheffield Academic Press, 1996.

Whatmough, Joshua. *The Foundations of Roman Italy*. London: Methuen, 1937.

Williams, Phyllis H. *South Italian Folkways in Europe and America*. New Haven: Yale University Press, 1938.

Wyman, Mark. *Round-Trip to America*. Ithaca and London: Cornell University Press, 1993.

Yans-McLaughlin, Virginia. *Immigration Reconsidered*. New York: Oxford University Press, 1990.

Essays and Theses

Annunziato, Frank R. "Made in New Haven." *Labor's Heritage* 4, no. 4.

———. "New Haven in 1886: A Study in Working Class Unrest." Essay, Department of History, University of Massachussetts.

Noll, Jennifer. *Italian American Women in the New Haven Garment Industry*. Undergraduate senior thesis, Department of American History, Yale University, 1994.

Petriccione, Michael J. *The Immigrant City of New Haven: A Study in Italian Social Mobility 1890–1930*. Senior honors thesis, University of New Haven, 1979.

Triolo, Nancy, *The Angel-Makers: Fascist Pronatalism and Midwives in Sicily*. PhD diss., University of California at Berkeley, 1989.

Articles and Pamphlets

A. C. Gilbert. "Teamwork Production for Fighting Men," *The A.C. Gilbert Co.*, 1944.

The Amalgamated Clothing Workers of America Publications. "The Story of the Rise of Shirt and Clothing Workers of Connecticut 1933–1943."

Gabaccia, Donna. "Housing and Household Work: Sicily and New York, 1890–1910." *Occasional Papers in Women's Studies*, Michigan Occasional Paper No. XX, Spring 1981.

Hardman, J. B. S. "Bread and Roses: The Story of the Rise of the Shirtworkers: Two Eventful Years, 1933–1934." *The Amalgamated Clothing Workers of America New York: A.C.W of A. Publications*, (1935?).

Index of Photographs